# HARD TIMES

## FORCE OF CIRCUMSTANCE, II

### 1952-1962

# THE
# AUTOBIOGRAPHY OF
# *Simone de Beauvoir*

## HARD TIMES
### FORCE OF CIRCUMSTANCE, II
### 1952-1962

With a New Introduction by
## TORIL MOI

Translated From the French by
## RICHARD HOWARD

## PARAGON HOUSE
### NEW YORK

First Paragon House edition, 1992

Published in the United States by

Paragon House
90 Fifth Avenue
New York, N.Y. 10011

Manufactured in the United States of America

Beauvoir, Simone de, 1908–1986
    [Force des choses. English]
    Hard Times: Force of Circumstance, Vol. II: the autobiography of Simone de Beauvoir /
translated by Peter Green ; introduction by Toril Moi.—1st
Paragon House ed.
        p.   cm.
    Translation of: La force des choses.
    English translation originally published: Putnam, ©1963. With new
introd.
        Contents: v. 2. Hard times.
        ISBN 1-55778-524-4 (v. 2)
        1. Beauvoir, Simone de, 1908–1986—Biography.   2. Authors,
French—20th century—Biography.   3. Feminists—France—Biography.
I. Title.
PQ2603.E362Z46713   1992
848'.91409—dc20
[B]
                                                                      92-15064
                                                                      CIP

# INTRODUCTION

*"I am an intellectual: I take words and the truth to be of value," Simone de Beauvoir declares in this volume of her autobiography. The truth she has in mind is the truth about the war in Algeria (1954–62). Written from 1960 to 1963, the second half of* The Force of Circumstance *is above all an account of that war as seen by a Frenchwoman ashamed and outraged by the behavior of her countrymen: "I could no longer bear my fellow citizens," she comments. "When I dined out with Lanzmann or Sartre, we hid away in a corner; even so, we could not get away from their voices." Sick with disgust, and violently angry, Beauvoir in fact ends up penning a remarkable chronicle of one woman's personal experience of political conflict.*

*A young Algerian girl, Djamila Boupacha, was viciously tortured and raped by French military personnel: Beauvoir collaborated with Gisèle Halimi on the book about the girl's life (1962). Frenchmen buried Algerians alive with bulldozers. They starved Algerian women and children in desolate concentration camps. They shot thousands of Arabs in indiscriminate reprisals for Algerian bombings. Soon the war invaded the streets of Paris; at one point Arabs were rounded up and herded into a sports stadium. Some were found floating in the Seine; it became clear that the French metropolitan police participated in beatings, torture and killings. By forcing her readers to face such facts, Beauvoir is doing her best to fulfil her fundamental intellectual commitment to words and the truth.*

*Her analysis is simple: to massacre and torture another people in the name of racism and colonialism is absolutely evil. By consenting to such policies, the French in her eyes were no better than the Nazis. Even the few who opposed the war could not escape the collective burden of guilt: "Now we know what it was like to be a German under the Nazis," one politician comments. Out of this crisis Sartre's play* The Condemned of Altona *(1959) was born: in this haunting*

*evocation of the problem of individual and collective guilt in postwar Germany the central character, an ex-SS officer, is called Frantz, a name which in French comes across as a transparent pun on "France."*

*To her horror, Beauvoir realizes that the very fact of being French makes her responsible for crimes she abhors: "whether I wanted to be or not, I was an accomplice of these people," she writes. "I needed my self-esteem to go on living, and I was seeing myself through the eyes of women who had been raped twenty times, of men with broken bones, of crazed children: a Frenchwoman." Torn between her identity as a French intellectual and her absolute opposition to the war, Beauvoir feels more alienated, more truly exiled than ever before in her life: "We stopped going out," she writes. "Just having a coffee at a counter or going into a bakery became an ordeal. . . . I had liked crowds once; now even the streets were hostile to me, I felt as dispossessed as I had when the Occupation began."*

*1958 turns out to be the darkest year of Beauvoir's narrative: it is the year in which the Fourth Republic collapses, De Gaulle seizes power and the war in Algeria reaches the point of no return. When she learns that almost 80 percent of the French voted in favour of De Gaulle in the September referendum, she bursts into tears: "I'd never have believed it could affect me so much," she writes in her diary. "I still feel like crying this morning. . . . Nightmares the whole night. I feel torn to bits. . . . It's a sinister defeat . . . a repudiation by 80 percent of the French people of all that we had believed in and wanted for France. . . . An enormous collective suicide."*

*In this period Beauvoir traveled extensively, above all in China, the Soviet Union, Brazil and Cuba. She was constantly meeting some of the world's most influential politicians and intellectuals: Fidel Castro, Nikita Khrushchev, Albert Camus, Alberto Moravia, Jorge Amado, Nicolas Guillén and many others defile through her pages. Beauvoir is particularly impressed by Frantz Fanon, the author of* Black Skin, White Masks *and* The Wretched of the Earth. *Born in Martinique in 1925, and educated in France, Fanon settled in Algeria, and in the late 1950s he had become one of the leaders of the Algerian revolution. When Beauvoir met him in the summer of 1961, he was marked by illness, yet she found him "intensely alive." Praising Fanon's "wealth of knowledge, his powers of description and the rapidity and daring of his thought," Beauvoir testifies to his intellectual stature. "He was an exceptional man," she writes, "endowed with a grim sense of humor—everything he talked about seemed to live again before our eyes." "When one was with him," she adds, "life seemed to be a tragic adventure, often horrible, but of infinite worth, They were never to meet again: in December 1961 Beauvoir notes with sorrow Fanon's tragically premature death from leukemia.*

*Beauvoir never wavers in her commitment to telling the truth about Algeria.*

*In her accounts of Cuba and the Soviet Union, however, the truth becomes more elusive. Having more or less reluctantly aligned herself with the Soviet cause in 1952, Beauvoir now sticks to her positions. Courageously attacking the persecution of gay men in Cuba, for instance, she nevertheless accepts—and excuses—Castro's political purges in the early 1960s. Even harder to reconcile with her commitment to truth is her upbeat account of the Soviet system, including its continued use of labor camps. At the end of a long journey in the Soviet Union in 1962, Beauvoir concludes that in the West automatization and rationalization makes life absurd. In the Soviet Union, however, man is being created in a new image and, as a consequence, "all the things that happen to him are heavy with meaning." The Cold War aside, only a wish to retain at least some illusions in an intolerably evil world, can explain such moments of blindness in a work otherwise so committed to lucidity.*

*If 1958 was a depressing political year for Simone de Beauvoir, it was no better on the personal level. For 1958 was the year in which she turned fifty, and her relationship with Claude Lanzmann, a journalist seventeen years her junior (later to gain fame as the director of* Shoah*), finally came to an end. When their relationship started in 1952, she had shed tears of joy: "Lanzmann's presence beside me freed me from my age," she writes. "Thanks to him, a thousand things were restored to me: joys, astonishments, anxieties, laughter and the freshness of the world. After two years in which the universal marasma had coincided for me with the break-up of a love affair [with Nelson Algren] and the first warnings of physical decline, I leapt back enthralled into happiness."*

*Lanzmann, then, became her bulwark against the fear of growing old. When the relationship disintegrates, the horrors of old age close down on her again. To compound her distress, the final break-up with Lanzmann coincides with a serious decline in Sartre's health. When Sartre barely escapes a stroke in 1954, Beauvoir felt the chill of her own mortality: "Sartre recovered. But something irrevocable had happened; death had closed its hand around me; . . . it was an intimate presence penetrating my life, changing the taste of things, the quality of the light, my memories, the things I wanted to do: everything." When he falls ill again in 1958, she feels that her whole future has been erased: "From now on," she writes, "death possessed me. . . . Basically, there was nothing for us to look forward to except our own death or the death of those close to us."*

*At the end of* The Force of Circumstance *Beauvoir is fifty-four. Her autobiographies are best-sellers in France; she enjoys international success as one of the world's foremost writers; she is certainly one of the most famous women in the world. Yet she tirelessly insists that her life is over—"Yes, the moment has come to say: Never again!" she writes in the epilogue. "It is not I who am saying good-bye to all those things I once enjoyed, it is they who are leaving me; the*

*mountain paths disdain my feet. Never again shall I collapse, drunk with fatigue into the smell of hay. Never again shall I slide down through the solitary morning snows. Never again a man. Now, not only my body but my imagination too has accepted that.*" In France in 1962 the social convention concerning women in their fifties probably differed from those of the United States in the 1990s. Even so, Beauvoir's renunciation of life remains puzzling: most readers of The Force of Circumstance *find it hard not to ask* why *she is so eager to embrace death and decline at such an early age. What is it that drives Simone de Beauvoir headlong into renunciation and an obsession with death?*

*The fact that Sartre's illness makes Beauvoir reflect on mortality is hardly surprising. Her complaints, however, do not simply signal the usual human concern with our inevitable fate: in her memoirs her fear of old age and her obsession with death surface too early and too insistently for that. Throughout her adult life Beauvoir suffered occasional bouts of uncontrollable crying accompanied by intense distress and anxiety. As a teacher in Rouen at the age of twenty-seven, for instance, Beauvoir regularly experienced such crises: "If I drank a little too much one evening I was liable to burst into floods of tears," she writes in* The Prime of Life, *"and my old hankering after the Absolute would be aroused again. Once more I would become aware of the vanity of human endeavour and the imminence of death."*

*In the very next paragraph she complains that she "had another worry besides this: I was getting old." The main symptom of the aging process, she adds, is not to be found in her health or her facial appearance, but in the fact that "from time to time I felt that everything was going grey and colorless around me, and [I therefore] began to lament the decrepitude of my senses." Instead of blaming her own emotional state for the peculiar discoloration of the world, Beauvoir chooses to blame her senses: in this passage, age is clearly made to stand in for depression. As might be expected, her melancholia resurfaces with particular virulence every time she experiences a loss of love. The anxiety crises in Rouen, for instance, actually occur exactly at a time when Sartre is looking around for new experience, only to find it in the shape of a young girl named Olga. (A vivid account of the triangular relationship that ensued can be found in* The Prime of Life, *and also in Beauvoir's novel* She Came to Stay.) *In the same way, the break-up of her affair with Algren, Sartre's serious involvement with Dolorès Vanetti (both of which are chronicled in the first volume of* The Force of Circumstance), *and the end of her liaison with Lanzmann all bring on particularly painful bouts of depression.*

*As long as her sexuality is reaffirmed by the desire of a man, Beauvoir feels protected against the threat of old age. Or to put it differently: under such circumstances she does not feel depressed. The presence of Lanzmann, for*

*instance, delivers her from her own moods: "It did away with my anxiety attacks," she comments. "Two or three times he caught me going through one, and he was so alarmed to see me thus shaken that a command was established in every bone and nerve of my body never to yield to them; I found the idea of dragging him already into the horrors of declining age revolting." In spite of the evidence—she has after all had such attacks since childhood—Beauvoir clings to the belief that they can be explained by old age alone.*

*There is, then, in her memoirs a tension between the honest acknowledgment of her own depressive feelings, and the displacement of those feelings onto something else, mostly age or death. Intimately linked to the theme of age is that of loneliness or, rather, the fear of it. Beauvoir's main antidote to solitude is clearly Sartre: it is no coincidence that the epilogue of* The Force of Circumstance *starts by stressing the unbreakable unity of the two: as long as the two are one, Beauvoir feels protected against her inner demons. This is surely why she chooses to affirm their perfect harmony at the end of a volume chronicling their increasing distance from each other. When, at the outbreak of World War II, Sartre was sent to the front, Beauvoir sought refuge in relationships with women. In the end, however, women—whether friends or lovers—were powerless to fill the gap left by the absolute presence of Sartre. A manic defense against depression and loneliness, Beauvoir's desperate timetables, her frenetic efforts to leave no hole unplugged, her immense need for emotional "filling-up," led to the creation of the "little family," a little clan of people looking up to Sartre and Beauvoir as gurus and breadwinners, and consisting entirely of her own and Sartre's lovers and ex-lovers. Lovers refusing to join the "family," such as Nelson Algren and Dolorès Vanetti, for instance, were cast out in the cold. The ones who did join the support network were rewarded with intense interpersonal relationships, and often with money too. The transferential bonds between the members of the clan and the parent-teacher couple were intense, always encouraged, never explicitly broken. During the war it was Wanda, Olga, Bost, "Lise," Bianca. In the 1950s and 1960s some dropped out, others were added (Michèle Vian, Claude Lanzmann, Arlette Elkaïm, Sylvie Le Bon): this little group of people squabble and fight, fall out and make it up again; their lives may not be admirable, their sense of moral responsibility may not be quite what existentialist philosophy claims it ought to be, but none of this matters. What truly matters to Simone de Beauvoir, is that they are there. Filling the void, they are her very own antidepressants.*

*This volume of* The Force of Circumstance *is at once the most melancholic volume of Beauvoir's autobiography and the one in which the themes of age and death coexist most clearly with that of exile: politically isolated because of her stance on the war in Algeria, personally isolated because of her fame, Beauvoir is thrown back on the dwindling resources of the "little family." In the*

*1950s, however, tensions build up in this circle, and the protective closeness so eagerly sought by Beauvoir is no longer so easy to find. However intimate, however incestuous, in the end even the* petite famille *cannot shield her against the hollow emptiness she finds at the heart of all things. As she grows older, Simone de Beauvoir's depression catches up with her: "I have lost the power I had to separate the darkness from the light, to create some moments of radiance at the price of a few thunderstorms," she writes at the end of* The Force of Circumstance. *"My happiness has grown pale. Death is no longer a brutal adventure in the distance, it haunts my sleep, in my waking hours I can feel its shadow between me and the world: it is already here."*

*Whether it is due to death, as Beauvoir claims, or to depression, as I tend to believe, this darkness produces the famous final sentence of* The Force of Circumstance. *Looking back at herself as a credulous young girl, Beauvoir's bitterness is obvious: "I realize with stupor just how much I have been swindled," she writes. The bourgeois girl setting out in life in the late 1920s had been promised the world: now that she has it, she is finding the misery of it hard to bear. In 1962 Beauvoir's disappointment in her life would seem to be at once philosophical, political and personal. Yet her life was not over. Ten years later, in* All Said and Done *(1972), the last volume of her autobiography, it is clear that she has regained her tranquillity: "I was mistaken . . . in the outline of my future," she notes with evident relief. "I had projected the accumulated disgust of the recent years into it. It has been far less sombre than I had foreseen."*

*Eventually she managed to turn the process of aging to creative use. For if the experience of becoming a woman under patriarchy inspired her to write* The Second Sex *(1949), her magisterial study* The Coming of Age *(1970) emerged from her traumatic encounter with old age. Simone de Beauvoir's struggle against loneliness, age and depression may not be particularly unusual or even particularly heroic: what makes this volume of* The Force of Circumstance *so moving is the fact that in her anguish we are forced to recognize our own longing for community and love. The difference between Simone de Beauvoir and us is not the quality of her feelings, but the unflinching honesty and courage with which she chronicles her own unhappiness, even as she reaches the very pinnacle of fame. In the end, then, the very existence of* The Force of Circumstance *demonstrates that, for Beauvoir, personal and political disappointment can only be overcome through the act of communicating her experience to others. Fame and money will never save us from loneliness, she seems to be saying, but writing will. That, surely, is the deepest reason why Simone de Beauvoir became a writer.*

*Toril Moi*

# HARD TIMES

### FORCE OF CIRCUMSTANCE, II

## 1952-1962

# CHAPTER I

Young women have an acute sense of what should and should not be done when one is no longer young. "I don't understand," they say, "how a woman over forty can bleach her hair; how she can make an exhibition of herself in a bikini; how she can flirt with men. The day I'm her age . . ." That day comes: they bleach their hair; they wear bikinis; they smile at men. When I was thirty I made the same sort of resolution: "Certain aspects of love, well, after forty, one has to give them up." I loathed what I called "harridans" and promised myself that when I reached that stage, I would dutifully retire to the shelf. All of which had not kept me from embarking upon a love affair at thirty-nine. Now, at forty-four, I was relegated to the land of shades; yet, as I have said, although my body made no objection to this, my imagination was much less resigned. When the opportunity arose of coming back to life, I seized it gladly.

July was almost over. I was about to drive down to Milan; Sartre would join me by train, and we were going to tour Italy for two months. Meanwhile, Bost and Cau were happily preparing to fly off to Brazil, where the publisher Nagel was sending them to gather material for a Guide. They bought white dinner jackets and Bost invited us to celebrate their departure around an aïoli. I suggested he invite Claude Lanzmann as well. The party lasted late, we drank a lot. Next morning my telephone rang. "I'd like to take you to the movies," Lanzmann said. "To the movies? To see which film?" "Oh any one." I hesitated; my last days were crowded, but I knew I mustn't refuse. We agreed on a place and time to meet. To my great surprise, as soon as I had hung up I burst into tears.

Five days later I left Paris; standing on the sidewalk, Lanzmann waved as I put the car into gear. Something had happened; something, I had no doubt of it, was beginning. I had rediscovered my body. Distracted by the emotion of our good-byes, I got completely lost in the suburbs before I finally emerged onto Route Nationale 7, delighted to have ahead of me that long ribbon of kilometers on which to remember and to dream.

I was still driving in a dream two mornings later as I left Domodossola, where I had spent the night; I had two passengers, English girls hitchhiking from Calais to Venice with return plane tickets from Munich to London in their pockets. It was raining over Lake Maggiore; I skidded and tore a milestone out of its socket; neither girl so much as flinched. Some Italian men straightened my mudguard and soothed my pride by telling me that the road was notorious for the camber that caused innumerable accidents; but the shock, far from bringing me to my senses, simply confused me more than ever. I dropped the English girls at a crossroads, went on into Milan, meandered along looking for a garage and suddenly noticed that my right door was flapping open; as I was trying to close it I went over the curb. "I'm losing my head," I told myself, and stopped the car; then I noticed that my purse with all my papers and a great deal of money in it was no longer on the seat beside me. I left the car there and ran back the way I had come as fast as my legs would take me. Then I saw a cyclist coming toward me, holding the purse at arm's length with a disgusted look on his face.

The car finally entrusted to a mechanic, I went to the Café della Scala and collected Sartre and my wits; but I was still upset that afternoon when I got back behind the wheel. Would this new mode of traveling appeal to him? I was afraid I would discourage him for good by some awful display of clumsiness; but no, my awkward maneuvering in the towns didn't make him at all impatient; on the open road, nothing disturbed his phlegmatic attitude except the boorishness of certain Italians, who would pass and then dawdle in front of me: "Pass him, go on, pass him." The Italian would accelerate or even start zigzagging to keep in front; Sartre wouldn't leave me in peace until I had finally got in front again; if I had yielded to all his exhortations, we'd have been killed a hundred times over; but I preferred this enthusiasm to prudent warnings.

From Cremona to Tarento, from Bari to Erice, we rediscovered Italy: Mantua and the frescoes of Mantegna, the paintings in Ferrara,

Ravenna, Urbino with its Uccellos, the Piazza d'Ascoli, the churches of Apulia, the troglodytes of Matera, the *trulli* of Alberobello, the baroque beauties of Lecce, and in Sicily those of Noto. We went last to Agrigento; we revisited Segeste, Syracuse. We went through the Abruzzi. I took a ski lift to the top of the Gran Sasso and saw the gloomy-looking hotel where they had shut Mussolini away. Thanks to the car, we were no longer restricted by timetables, and nothing was inaccessible. All the same, something had been lost, Sartre said, and I agreed: the surprise of finding yourself suddenly plunged into the center of a town. If you arrive by train, or by plane, a city seems like a new world; when you travel by car, a city is the end of a stage on the journey, a knot linking it to the next, and not a universe; its streets merely extend the roads outside and lead to other roads; its originality fades, for the color of its walls, the design of its squares and façades, are already adumbrated in the little towns nearby. The advantage is that although the city becomes less striking, it is also more easily understood. The real meaning of Naples came to us only after we had seen the extent of the poverty in Southern Italy. A new familiarity sprang up between the countryside and ourselves; we stopped off in villages and mingled with the *braccianti*, who sit in the cafés for hours without drinking, without hoping; often men along the road would make timid signs to us and we would stop to give them a lift; most of them were unemployed; they asked us if we could find them work in France.

Besides, the car also had surprises in store for us. I remember the 15th of August; we left Rome for Foggia in the morning, drove all day under a blazing sky, continually delayed by roadwork and barriers; night had fallen; for two hours the white glare of the Italian headlights had blinded me, and I was exhausted. At Lucera we stopped and got out for a drink; I parked the car against the city wall and we walked through the gates. Suddenly we were in a great hall streaming with light, full of people dancing, and the ceiling was the sky; other halls led out of it, one after the other, every piazza in the town was lit up like day, and each had its own orchestra and ball.

That summer, the thermometer stayed over eighty almost without exception all over Italy. Sartre was writing the sequel to *Les Communistes et la Paix;* he wanted to work, I wanted to go sightseeing: we succeeded in combining our obsessions, but not without considerable discomfort. We would sight-see, wander, walk, eat up the miles until the middle of the afternoon, braving the hottest hours

of the day on foot and by car; then, broken with fatigue, we would retire to our rooms—usually suffocatingly hot—and instead of resting, hurl ourselves at our desks. More than once I had to leave mine to soak my burning, blotchy face in cold water.

On the way back I stayed with my sister in Milan for several days; while there I read Pavese's journal and took it back with me to Paris so we could publish extracts from it in *Les Temps Modernes*.

During our vacation, Lanzmann had been on a trip to Israel; we had written to each other. He returned to Paris two weeks after I did, and our bodies met each other again with joy. We began to build our future by telling each other the past. To define himself, he said first of all: I'm a Jew. I knew the weight of those words; but none of my Jewish friends had ever made me fully understand their meaning. They let their situation as Jews pass without comment—at least in their relations with me. Lanzmann insisted that his be recognized. It was the ruling force of his life.

As a child, he had lived at first in a state of pride: "We are everywhere," his father would tell him proudly as he showed him a map of the world. When, at the age of thirteen, he discovered anti-Semitism, the whole world was shaken, nothing survived intact. He would admit: "Yes, I'm a Jew," and language was immediately abolished, the questioner became a blind, deaf, savage animal; he felt personally to blame for this metamorphosis. At the same time, reduced to the abstract notion, a Jew, he felt expelled from his own being. To such an extent that he no longer knew, in the end, if it was more of a lie to say yes or no. Rejected because of this difference at the age when all children want most to conform, his exile left its mark on him for good. He regained his pride thanks to his father, one of the very first members of the Resistance. He himself started a Resistance organization while still at a lycée in Clermont-Ferrand, and from October 14, 1943 on, fought in the *maquis*. So his experience had presented an image of the Jews not as people resigned, humiliated, persecuted, but as fighters. The six million men, women and children exterminated by the Nazis belonged to a great people not predestined to martyrdom, but the victim of gratuitous barbarism. Weeping with rage at night as he evoked these massacres, by the hate he vowed against the murderers and their accomplices he withdrew again into the exile once forced upon him but now desired of his own free will: he wanted to be a Jew. The names Marx, Freud, and Einstein filled him with pride. He beamed whenever he discovered

that some famous man was a Jew. Even today when people praise the great Soviet physicist Landau without mentioning that he's a Jew, Lanzmann flies into a rage.

Although he had many friends among them, his bitterness toward the *Goyim* never disappeared. "I want to kill, all the time," he told me. I could feel, buried inside him, flexing its muscles, a violence always ready to explode. Sometimes in the morning after some disturbing dream, he would wake up shouting at me: "You're all kapos!" He assailed our world with buffoonery, outrageous behavior, extravagances of speech and manner. At twenty, when he was a senior at the Lycée Louis-le-Grand, he rented a cassock and went around knocking on rich people's doors and collecting money. Yet scandal was only an expedient. He still looked back nostalgically to the days of his childhood, when he was a Jew but all men were brothers. He had been torn apart, the world had been given over to chaos: he tried to make himself whole again and rediscover order in the world. At twenty, he believed in the universality of culture and he had worked zealously to make it his: he had the feeling it didn't quite belong to him. He had put his hopes in the mediating power of truth; but men answered him with their passions and their interests, they remained divided. Neither knowledge nor reasoning could provide an escape from his solitude. Isolated, unjustified, he experienced his own contingency to the point of disgust. He knew that no inner cunning would ever free him from it; his only salvation lay in sustaining himself by some objective necessity. Marxism affected him as a truth no less self-evident than his own existence; it revealed the intelligibility of human conflicts and released him from his subjectivity. Ideologically in agreement with the Communists, recognizing his own dreams in their objectives, he put his trust in them with an optimism that sometimes irritated me, but which was the obverse of a profound pessimism: he needed a vision of a redeemed future to compensate for the laceration he suffered. His Manichaeism astonished me, for he had a subtle, even a cunning, intelligence; he often blamed himself for it, but without being able to keep from relapsing into it. Because he had been dispossessed of everything, he could not bear to be deprived of anything. He had to be able to see his adversaries as the representatives of absolute Evil; the army of Good had to be without defect if it was to restore the lost Paradise. "Why don't you become a member of the Communist Party?" I asked him. He shied away from the idea. Between sympathy, even unconditional

sympathy, and commitment there lies a distance he could never
bridge, because nothing seemed real enough to him, especially not
himself. In his childhood, by forcing him to renounce either his
"Jewishness" or his individuality, the world had stolen his Self: when
he said *I* he always felt like an impostor.

Lacking any frame of reference, he adopted very easily the view-
points of people he respected; but he was also stubborn and willful.
He could find no means inside himself to oppose the voice of his
emotions and desires, or the violence of his imagination; he refused
to try to control them. Indifferent to the usual constraints and con-
ventions, he allowed his sadness to express itself in tears, his feelings
of revulsion in fits of vomiting. Sartre, most of my friends, myself—
all of us were puritans; we kept our reactions under control and
externalized our emotions very little. Lanzmann's spontaneity was
foreign to me. And yet it was by his excesses that he seemed near to
me. Like him, I would make plans with frenzy and follow them
through with maniacal stubbornness. I would weep violently, and
there still lurked within me a sort of nostalgia for my old rages.

A Jew and an eldest son, the responsibilities with which Lanz-
mann had been burdened from childhood on had produced a pre-
cocious maturity in him; sometimes he seemed to be carrying the
weight of a whole ancestral experience on his shoulders: while I was
talking to him, it never occurred to me that he was younger than I.
Yet we were aware that there was seventeen years difference between
us; but the gap did not alarm us. For myself, I needed some sort of
distance if I was to give my heart sincerely, for there could be no
question of trying to duplicate the understanding I had with Sartre.
Algren belonged to another continent, Lanzmann to another gen-
eration; this too was a foreignness that kept a balance in our relation-
ship. His youth doomed me to being only a moment in his life; it
also excused me, in my own eyes, for not being able to give him
today the whole of mine. Not that he asked me for it in any case: he
accepted me as I was, with my past and my present. All the same, the
harmony between us was not achieved all at once. In December, we
spent several days in Holland; along the frozen canals, in the taverns
with their close-drawn curtains where we drank our *advokat*, we
talked. The vacations I took every year with Sartre presented a prob-
lem: I didn't want to give them up; but a separation of two months
would have been painful for both of us. We agreed that Lanzmann
would come every summer and spend ten days or so with myself and

Sartre. As we talked, other sources of uneasiness, our last doubts, were dissipated. When we got back to Paris, we decided to live together. I had loved my solitude, but I did not regret it.

Our life together developed its own pattern. In the morning we worked side by side. He had brought back some notes from Israel that he wanted to work up into an account of his visit. He had been much struck by what he had seen there: in Israel, Jews were not outsiders, they were the people with all the rights; with pride, and with a certain sense of scandal, he had discovered that there were Jewish ships and a Jewish navy, towns, fields, trees that were Jewish too, there were rich Jews and poor Jews. His astonishment had led him to ask himself certain questions about himself. Sartre, to whom he described this experience, advised him to write a book combining an account of Israel with his own story. Lanzmann found the idea attractive; as it turned out, it was not a happy one. At the age of twenty-five he lacked the necessary perspective to write about himself; he began very well, but then came up against obstacles within himself and was forced to stop.

Lanzmann's presence beside me freed me from my age. First, it did away with my anxiety attacks. Two or three times he caught me going through one, and he was so alarmed to see me thus shaken that a command was established in every bone and nerve of my body never to yield to them; I found the idea of dragging him already into the horrors of declining age revolting. And then, his participation revived my interest in everything. For my curiosity had become more temperate. I was living on an earth limited in resources and a prey to terrible and simple ills, and my own finite state—that of my situation, my destiny, my work—restricted my desires; for behind me were the days when I had expected everything in every sphere of life! I still took an interest in what was happening: books, films, painting, theater; but I was more concerned with controlling, deepening, completing my earlier experiences; for Lanzmann, these things were new, and he threw an unexpected light on all of them for me. Thanks to him, a thousand things were restored to me: joys, astonishments, anxieties, laughter and the freshness of the world. After two years in which the universal marasma had coincided for me with the breakup of a love affair and the first warnings of physical decline, I leapt back enthralled into happiness. The war was receding. I immured myself in the gaiety of my private life.

I continued to see Sartre as much as before, but our habits

changed. A few months before I had been awakened by an un-
accustomed noise: someone was tapping lightly on a drum. I switched
on the light. Drops of water were falling from the ceiling onto a
leather armchair. I complained to the concierge, who informed
the agent, who spoke to the owner. And the rain in my room con-
tinued, slowly rotting everything. When Lanzmann lived with me
the furniture and the floor were submerged in books. It was still
possible to work and sleep in the room, but it was no longer a
very pleasant place to live. From then on, to eat and talk and drink, I
moved my headquarters with Sartre to La Palette, on the Boulevard
Montparnasse, or sometimes to Le Falstaff, which reminded us of our
youth. I also went quite often with Lanzmann or Olga to La Bû-
cherie, on the other side of the square; when I arranged to meet
people it was usually there; the place was a meeting place for left-
wing intellectuals; through the bay window you could look out at
Notre-Dame and greenery; there was a phonograph quietly playing
the Brandenburg Concertos. Like myself, Sartre was happiest in the
tiny circle I assembled in the Rue de la Bûcherie for New Year's Eve:
Olga, Bost, Wanda, Michelle, Lanzmann. There was so much under-
stood between us that a smile conveyed as much as a whole oration.
In a group like this, conversation can be the most amusing pastime in
the world; when the complicity we shared is lacking, it becomes hard
work, and often futile as well. I had lost the taste for ephemeral
encounters. Monique Lange offered to take me out to dinner with
Faulkner; I refused. The evening Sartre had dinner at Michelle's
with Picasso and Chaplin, whom I had met in the States, I preferred
to go with Lanzmann to see *Limelight*.

   With spring came a great satisfaction: *The Second Sex* appeared
in America with a success unsoiled by any salacious comment. The
book has always remained dear to me and every time it has been
published in another country, I have been pleased to receive fresh
proof that the scandal it aroused in France was the fault of my read-
ers and not myself.

   Toward the end of March, I went down to Saint-Tropez with
Lanzmann; he took me to see his part of the *maquis;* there were still
great piles of rubble blocking the roads of La Margeride. We joined
Sartre at the Aïoli; Michelle was living with her children on a little
square nearby. Chatting with Sartre on Sennequier's terrace, we
again met Merleau-Ponty and also Brasseur, who had a house at
Gassin. He asked Sartre to do an adaptation of Dumas' *Kean* for

him, and Sarte, who adores melodramas, didn't say no. In the eve-
ning, we would sit by the wood fire in the dining room of the Aïoli:
before long this spruce little hotel was to disappear beneath a layer of
dust, and Mme Clo, so respectable with her white hair, her high-
necked pullover, her discreet makeup, was accused of complicity in a
holdup; I had great difficulty in recognizing her as the old, haggard-
looking woman whose picture appeared in all the newspapers in
1954. I showed Lanzmann Les Maures, Estérel, the coast, the cor-
niches. As we drove we talked about my novel, which I had given
him to read in manuscript; he had an acute and painstaking critical
sense; he gave me some good advice and I learned a lot from his
objections; at first they irritated me, but then I gradually became
aware of the defect that was provoking them. I was taking enormous
trouble over this book. I had reworked it from start to finish since
our Norwegian trip: when Sartre reread it at the end of autumn
1952, he was still not satisfied. Irked by the conventions of the novel,
I had accepted them but had not done so wholeheartedly; it was too
short, too long, scattered; the conversations didn't ring true; I
wanted to show particular individuals, with their certainties and
their doubts, ceaselessly challenged both by others and by themselves,
wavering between clear-sightedness and excessive simplicity, between
prejudice and sincerity; and now, suddenly, instead of creating
people, I seemed to be expounding ideas. Perhaps it really was im-
possible to take writers as heroes, or at any rate impossible for me;
perhaps my resources were not equal to the task. . . . "I'm just go-
ing to shelve the whole thing," I decided. "Keep working at it,"
Sartre told me; but his uneasiness counted more heavily for me than
his encouragement. It was actually Bost and Lanzmann who con-
vinced me to keep going; they were reading it for the first time, and
they were more affected by its positive value than by its weaknesses.
So I went back to work. But there were many times during that last
year of labor when I had to champ hard on the bit when people
asked with polite astonishment: "Aren't you writing any more? Why
doesn't she write any more? It's been a long time since she wrote
anything . . ." And I would feel a stab of jealousy when I caught
sight of the crisp cover of a new novel fresh from the press, and
written by some talented writer with a nimbler pen than mine.

In November, Sartre had published in *Les Temps Modernes* the
second part of his study, *Les Communistes et la Paix*, in which he gave
an account of exactly how far and why he was in agreement with the

Party. He went to Vienna, and on his return gave us a detailed
account of the Congress of the Partisans for Peace. He had spent a
whole evening drinking vodka with the Russians. There were—rela-
tively—only a few Communists there: 20 percent. Many of the dele-
gates had come to the convention without the permission of their
governments; some of them, to get out of Japan and Indochina, had
been forced to make long and devious journeys on foot; others—the
Egyptians particularly—were running the risk of being thrown into
prison when they went back. France, apart from Communists, was
poorly represented; the intellectual Left, which Sartre had hoped to
induce to accompany him, was missing. I went with Lanzmann to the
meeting at the Vel' d'Hiv' where the delegates gave an account of
their experiences; there was a certain piquancy in seeing Sartre and
Duclos sitting next to each other and exchanging smiles. The Com-
munists were surprised as well, I think; the committee member who
was supposed to introduce Sartre hesitated slightly: "We are happy
to have among us Jean-Paul . . ." there was a slight gasp; people
thought he was going to say "David." He recovered himself and
Sartre took the microphone. I was always moved to hear him speak in
public, I suppose because of the distance that the listening crowd cre-
ated between us; one after the other, his sentences landed easily, but to
me each one seemed a precarious miracle. He produced a great deal
of amusement with his mockery of the left-wingers who had been too
frightened to go to Vienna; he took Martinet and Stéphane to task;
the latter was sitting in front of me, I could see him acknowledging
the hits, and from time to time he turned around with a wan smile.

The *Temps Modernes* staff approved of Sartre's political attitude
for the most part; he himself has told[1] how his relations with Mer-
leau-Ponty were altered by it. Many people dissociated themselves
from him, with greater or lesser publicity, either by a profound
and genuine disagreement, or because they found it compromising
to be linked with him. He was rather coldly received at Frei-
burg, where he went to give a lecture. He spoke for three hours.
"I got quite caught up in it; you won't catch me at another!" said the
wife of the director of the French Institute as she came out. Out of
the twelve hundred students who had heard him, barely fifty under-
stood French well enough to follow. "We understood the ideas, but
not the examples," one of them said. Sartre struck them as too close to
Marxism. He paid a visit to Heidegger, perched on his eyrie, and told

---

[1] *Merleau-Ponty Vivant.*

him how sorry he was about the play Gabriel Marcel had just written about him.[1] That was all they talked about, and Sartre left after half an hour. Heidegger was going in for mysticism, Sartre told me; then he added, his eyes wide: "Four thousand students and professors toiling over Heidegger day after day, just think of it!"

He had finally decided to write most of the book devoted to the defense of Henri Martin himself. Some of his friends were a bit worried: hadn't he anything better to do? I had felt that way too, in prehistoric times: before the war. Now, literature was no longer sacred to me; and I knew that when Sartre decided to go in a certain direction it was because he felt it was necessary. "He should finish his novel. It's high time he finished his Ethics. Why does he remain silent? Why did he speak out?" Nothing could be more futile than the criticism and advice with which people inundated me on his behalf. It is impossible to understand from the outside the conditions in which a man's work develops; the person in question knows better than anyone what he needs to do. At that time, Sartre needed to smash a great many things in order to discover others: *"I had read everything; I had to read everything again; I held but one thread in my hand, but Theseus had no more, and it was enough for me too: the inexhaustible and difficult experience of the class struggle. I read everything again. There were still closed doors inside my head, I broke them down, not without an exhausting effort"*[2] He reread Marx, Lenin, Rosa Luxembourg and many others. That was how he prepared for his sequel to *Les Communists et la Paix.* But before that he wrote a long reply to the criticisms Lefort had leveled at him in the pages of *Les Temps Modernes.*

Sartre's new attitudes filled Lanzmann with joy, for politics seemed to him more essential than literature, and I have already mentioned that if he was not a member of the Communist Party, it was only for subjective reasons. When he had read the draft of *The Mandarins,* he had persuaded me to explain more fully the reasons for the distance both Henri and Dubreuilh try to keep between themselves and the Communists; till then, it had seemed to me to need no explanation. I was far from disapproving of what Sartre was doing, but he had not convinced me to follow him because I evaluated his development by referring to his point of departure: I was

---

[1] *La Dimension Florestan,* a painful satire on Heideggerian Existentialism, was not broadcast until the following year. But there had been a public reading of it.
[2] *Merleau-Ponty Vivant.*

afraid that his *rapprochement* with the Communist Party would take him too far from his own truth. Lanzmann was at the other end of the road: every step that Sartre took toward the Communists he called a step in the right direction. Established from the outset and almost by nature at a point where their perspective became his own, he forced me to give explanations when I had been used to asking for them; every day, I was put in the position of having to challenge my most spontaneous reactions, in other words, my oldest prejudices. Little by little, he wore away my resistance, I liquidated my ethical idealism and ended up adopting Sartre's point of view for my own.

All the same, to work with the Communists without renouncing one's own judgment was scarcely any easier—despite the relative relaxation of the French Communist Party—than in 1946. Sartre did not feel concerned with the internal difficulties of the Party, with the expulsion of Marty and of Tillon. But there were things he could not accept: the Prague trials, the anti-Semitism rampant in the U.S.S.R., the articles Hervé was writing in *Ce Soir* against Zionism in Israel, the arrest of the "murderers in white coats." He received visits from Jewish Communists who wanted him to make his position clear. Mauriac, in *Le Figaro,* demanded that he condemn Stalin's attitude toward the Jews, and he replied in *L'Observateur* that he would do so in his own good time. He would soon have been forced into having to quarrel with his new friends, if the course of events had not broken this mounting deadlock. One day, Sartre was to lunch with Aragon; Aragon finally arrived, an hour and a half late, unshaved, completely shattered: Stalin was dead. Malenkov immediately released the doctors who had been accused and took measures to relax the tension in Berlin. For weeks, our little group, like everyone else in the world, was immersed in hypotheses, commentaries and prophecies. Sartre felt strangely relieved! The reconciliation he was hoping for would finally have a chance of success. The article by Péju on the Slansky affair,[1] published in *Les Temps Modernes,* was not attacked by the Communist Party.

The war was still going on in Indochina. Things were beginning to stir in North Africa. After two years of peaceful efforts and disappointed hopes, Bourguiba no longer saw any way of making Tunisia independent other than violence; his arrest[2] provoked riots and a

[1] A large portion of the documentation had been supplied by the Czechoslovakian ambassador.
[2] One hundred and fifty members of the Neo-Destour were arrested with him.

general strike throughout the country; order was restored by scouring Cap Bon, arresting 20,000 people, terrorizing the population and by torture. In December 1952, there was a protest strike in Casablanca after the murder of Ferhat Hached[1]; a deliberately provoked riot and the killing of four or five Europeans enabled M. Boniface to bludgeon the budding Moroccan trade unionism to death; he had five hundred workers massacred. Neo-Destour and Istiqlal were bourgeois parties, but all the same they embodied the desire of Tunisia and Morocco for independence, and Sartre supported them with all the inadequate means at his disposal: going to see people, meetings, *Les Temps Modernes.*

There was one diversion that still kept all of its old allure for me—travel; I had not seen all I wanted to see, and there were many places I wanted to go back to. Lanzmann, for his part, had seen almost nothing of France or the world. Most of our leisure time we spent on excursions, some long, some short.

I think that trees, stones, skies, the colors and sounds of the countryside will never lose their capacity to touch me. I was still as moved as in my youth by a sunset over the sands of the Loire, a red cliff, an apple tree in bloom, a meadow. I loved the gray and pink roads under the endless hedge of plane trees, or the golden rain of the acacia leaves in the fall; I loved the provincial towns, not of course to live in but to pass through and remember, the excitement of the markets in the square at Nemours or Avallon, the quiet streets with their low houses, a rosebush climbing across a stone façade, the murmuring lilacs rising behind a wall; gusts of my childhood would come back to me with the odor of mown hay, plowed fields, brambles, the gurgling of springs. When time was short, we would content ourselves with going out to dine in the countryside near Paris, happy to smell the greenery, to see the lights flowering along the highways, to feel the city's breath as we drove back. We drank new wine on a hillside, red and green stars passed winking over our heads before gliding down on to a glittering plain bristling with red-eyed pylons, and their hum troubled me the way a train whistle across the fields used to. Yes, for a few more years I could take pleasure in the gilded tiles of the roofs in Burgundy, in the granite of the Breton churches, in the stones of the farms of Touraine, in those hidden roads running beside streams greener than their own grassy

[1] The leader of the Tunisian trade union movement, shot down by the Red Hand.

banks, in the garden taverns where we stopped to eat a trout or a fricassee, in the glitter of cars at night, along the asphalt of the Champs-Élysées. Something was secretly undermining this sweetness, these pleasures, this country; but for the moment I was not being obliged to go nosing after it, and I let myself be lulled by the glamour of appearances.

In June we left on our first long trip. Lanzmann was ill, the doctor had prescribed the mountains, and we went to Geneva; but it rained; it was raining all over Switzerland; we wandered around the Italian lakes, then we reached Venice, where Michelle and Sartre were staying. The final outcome of the Rosenberg affair was expected at any moment. It was by then two years since they had been condemned to death, and all that time their lawyers had been fighting to save them. The Supreme Court had just rejected any further stay of execution. But the whole of Europe and the Pope himself were clamoring so loudly for their reprieve that Eisenhower would surely be forced to grant it.

One morning, after spending a few hours on the Lido, Lanzmann and I took a vaporetto back to the Piazza Roma, where we were to join Sartre and Michelle and have lunch with them in Vicenza. We caught sight of a newspaper with the enormous headline: I ROSEN-BERG SONO STATI ASSASSINATI. Sartre and Michelle disembarked a few moments later. Sartre was grim. "We really don't want to go see the theater at Vicenza again," he said, and then added in an angry voice: "We don't feel particularly gay, you know." Lanzmann telephoned to *Libération* and they agreed to publish an article about it by Sartre. He shut himself up in his room and wrote all day; that evening, in the Piazza San Marco, he read us what he had written; no one was particularly taken with it; nor was he. He began over again that night: "The Rosenbergs are dead, and life goes on. That's what you wanted, isn't it?" That was the sentence he telephoned to *Libération* next morning, followed by the rest of the article.

Life was going on. What could one do about it? What could one do? Lanzmann and I talked about the Rosenbergs as we drove on toward Trieste. But we also looked at the sky and the sea, at the world in which they no longer existed.

"If you're going to Yugoslavia, I can get you some dinars," the porter at our hotel in Trieste told us. Go to Yugoslavia? Was it possible? Nothing simpler. In twenty-four hours the Putnik agency had provided us with visas, maps and advice. Armed with two spare

wheels, a jerry-can, candles, oil, planks and various tools, we filled up with gas. "Yugoslavia by car! You're going to have fun!" said the station attendant. We were very excited as we crossed the frontier: almost an Iron Curtain. And it was, in fact, a different world we drove into. Not a vehicle on the road along the sea; the pavement was so full of holes we soon had to edge into the fields; even then it was impossible to do more than twenty-five miles an hour. Night fell, we were dying of hunger by the time we found a hotel in Otocac. "We'll serve you dinner," we were told, "but you'll have to wait for the porter to see about a room." The porter: he couldn't have been a more important character if we'd been in a novel by Kafka. A room? The porter has the key. Gas? Only the porter can start the pump or open the stockroom. Where is he? Never there. Finally he is found. He hasn't got the key; he's gone to get it. He will come back; but when? That evening, we waited patiently in a smoky dining room, chewing meatballs and drinking slivovitz. "There's a French lady here who'd like to speak to you," the man serving us said. A toothless old schoolteacher came and sat down at our table; she knew a prince, whom she was dying to have us meet and who would have plenty to tell us about Tito's extortions; as for herself, her husband was in prison and she had great difficulty earning a living. He had fought as a colonel beside the Germans, and she had lived in Paris, hiding like a little gray mouse, she added. We took a turn around the town, drowned in night and silence, and it looked like a town in a fairy tale, so amazed were we to find ourselves there at all.

The Italian station attendant would have laughed himself silly if he could have followed our progress. Tourists were only just beginning to come back; few hotels, few restaurants, the most frugal of meals; it was hard to find gas. The smallest repair job presented a problem; garages had neither tools nor spare parts; the mechanics just banged about haphazardly with a hammer. We didn't find it funny at all. The country itself had been the poorest in Europe before 1939, and since then it had been ravaged by war. The causes of the general austerity were first its resistance against Fascism, and second its refusal to revive the old system of privileges; for the first time in my life, I did not see opulence side by side with poverty; no one we met showed either arrogance or servility; everyone had the same sense of dignity; and toward us, foreigners as we were, everywhere the same cordiality without reticence; we were asked for help and were offered it with equal naturalness.

We liked what we saw. Around the Plitvice lakes, amid the sound of rustling foliage and waterfalls, children were selling birchbark baskets full of wild strawberries; beautiful blond peasant girls watched us from the roadside as we drove by; I re-experienced a remembered joy: seeing the Mediterranean suddenly appear, from the side of a mountain, and the olive trees terracing down, down toward the infinite blue of the water; steep, full of ravines, bristling with promontories and studded with sparkling islets, the coast was as beautiful as my memories of Greece. We saw Sibenik, Split and its palace; in the churches there were old women mumbling away in front of ikons. Suddenly, we were in the East—Mostar, with its domes and slender minarets; but the temperature there was over 95 degrees, the air was humid, Lanzmann ran a fever and I remembered with remorse the orders his doctor had given us. We decided to hurry back up to Belgrade and return to Switzerland. We stayed a day in Sarajevo; though so close to the Mediterranean, its wide avenues and the heavily furnished hotel belonged to Central Europe; the graceful and dilapidated mosques to the East; and what a strange hodgepodge of women in black kerchiefs, booted peasants, embroidered clothes in the wretched market that evoked a word from before the other war: the Balkans.

To get to Belgrade, we chose the shortest route on our map, which crossed the Sava. Passing through villages and hesitating at crossroads, we asked several times: "Beograd?" The reply was invariably a series of voluble sentences in which the word *autoput* recurred, accompanied by gestures that seemed to be urging us to turn back. While trying to avoid the rabbits that kept leaping into our headlights, Lanzmann asked me: "Do you think this is the right road?" I showed him the map. In the middle of the night we arrived at the edge of a vast stretch of dark water: no bridge. We had to go back the way we had come for 120 miles before getting onto the highway. I took over the wheel from Lanzmann, who was exhausted, and ran over a hare. "Stop and pick it up," he said, "we can give it to someone." It was an enormous hare, and was scarcely bleeding at all.

Dawn was breaking as we drove into Belgrade. We slept, and then went out to have a look at the city, with its massive heart surrounded by big peasant villages; stores, restaurants, streets, people, everything looked poverty-stricken. In the old part of the city, we got out of the car, determined to get rid of the hare, which I

was carrying by its ears. We didn't dare offer it to anyone; but all the same we couldn't just throw it away! Finally we stopped in front of a young couple pushing a baby carriage, and I held the hare out to them saying: "*Autoput.*" They thanked us, laughing.

The following evening we set out again along the deserted *autoput,* which we had all to ourselves except for a few haycarts; a storm of terrifying violence forced us to stop at Brod, a big metallurgical center; there was a dance in progress at the hotel, and the workers of both sexes seemed to be having a good time. The man in charge of the hotel commented on how gay they all were, and then went on to catalogue his country's grievances against the U.S.S.R. Lanzmann knew German, a language many Yugoslavs could also speak. Everyone we talked to hated the U.S.S.R. at that time almost as much as they did the Germans. Among others, I remember a stop in a village where we had two inner tubes repaired. Some road workers invited us to have a drink with them in a shed decorated with paper wreaths and flags; they began to tell stories of the *maquis,* and Lanzmann did the same. For them, too, one of Tito's greatest claims to glory was his break with Stalin.

After stopping for a few hours in Zagreb, then in Ljubljana, we left Yugoslavia; not without regret. Its poverty was extreme; there was a terrible lack of roads, bridges; we had driven over a viaduct that was used not only by cars but by pedestrians and trains as well. But beyond this penury, there was something that touched me, something I had never seen anywhere else: a simple and direct relation between man and man, a community of interest and hopes, fraternity. How rich Italy seemed to us, as soon as we got across the border! Enormous tank-trucks, automobiles, gas stations, an intricate network of roads and railroads, bridges, shops bursting with goods— all these things suddenly seemed like privileges. And with prosperity, we returned once more to hierarchies, distances, barriers.

At last we were back in Switzerland, its snow, its glaciers. We explored every col, every peak accessible by car. After the hazards of our Yugoslavian itineraries, we found it disappointing to drive along heavily frequented roads; crawling up steep and ice-covered roads at night, more than once we squeezed a delicious sense of adventure from our fear. Once we slept nearly 10,000 feet up, at the foot of the Jungfrau, and saw the sun rise on the Eiger. And then we walked: I still could walk. Wearing espadrilles, we would walk for seven hours at a stretch across the glacier snows. Lanzmann was dis-

covering the world of mountains; at Zermatt, he learned by heart all the dramas of the Matterhorn. After a few days in Milan with my sister, we took a look at the Val d'Aosta; on a sign at the edge of a meadow, we read: RESPECT NATURE AND THE RIGHTS OF PROPERTY. Back in Paris, we unpacked our memories and were amazed to find the olive trees of Dalmatia all mixed up with the blue of the glaciers.

I left Paris again almost immediately with Sartre. We spent a month in a hotel in Amsterdam that overlooked the canals; we worked, we visited the museums, explored the town and all of Holland. An exceptionally severe strike had just broken out in France and was paralyzing all the public services, including the Post Office and the Telephones[1]; to keep in touch, Lanzmann and I each took our letters to the air terminals and entrusted them to passengers. Once he tried to soften up a telephone operator by pleading the ardor of his sentiments. "Love is not an emergency," she answered him curtly.

From Amsterdam, Sartre and I drove out to see the Van Goghs in the Kröller-Müller Museum set among woods and fields, we drove along the banks of the Rhine, then of the Moselle. On the terraces of the *Weinstube* we drank scented wine in beautiful thick glasses the color of pale grapes. Sartre showed me the remains of the Stalag where he had been a prisoner, on a hill above Trier. I was struck by the site; but the rusty barbed wire and the few huts that were still standing told me much less than his stories. We crossed Alsace, drove down as far as Basel where I saw the Holbeins and the Klees again.

Lanzmann was supposed to join us there for a few days, as we had arranged, and I awaited his arrival with impatience. I received a telegram: he was in the hospital; he had had an automobile accident just outside Cahors. I was alarmed. I rushed with Sartre to Cahors where Lanzmann was lying, scraped and bruised. It was not as serious as had been feared. He was soon out of bed, and the three of us went touring together around Lot and Limousin; we visited the caves of Lascaux. We drove as far south as Toulouse, revisiting Albi, Cordes, the forest of Grésigne. My vacation with Sartre ended up with a tour of Brittany: it seemed very beautiful to us in those stormy autumn days. But I was anxious. At first I had been afraid that Lanzmann would not be able to accept my relationship with Sartre; now he was taking up so much room in my life that I was beginning to wonder if

1 Provoked by Laniel's decrees aimed at the Post Office workers, it then spread to the railroads and many other industries; some 3 million employees stopped working.

my understanding with Sartre was not going to suffer in consequence. The life Sartre and I led together was no longer quite the same. He had never been so absorbed by his political activity, his writing, all his work; in fact he was overworked. I was profiting from my rediscovered youth; I gave myself to each moment as it came. Of course we would always remain intimate friends, but would our destinies, hitherto intertwined, eventually separate? Later I was reassured. The equilibrium I had achieved, thanks to Lanzmann, to Sartre, to my own vigilance, was durable and endured.

1953 ended well. The deposition of the Sultan was a victory for colonialism, but a precarious one in our opinion. The armistice had finally been signed in Korea; Ho Chi-minh, in an interview given to a Swedish newspaper, the *Expressen,* let it be known that he was ready to negotiate. The riot on June 17th in East Berlin, in the course of which the police had fired on the workers, the fall of Rakosi, and Nagy's abolition of the concentration camps had obliged the Communists to acknowledge certain facts they had been denying up till then; some of them were asking themselves questions; others "gritted their teeth." To sympathizers, the development of the U.S.S.R. brought an unqualified feeling of satisfaction: the work camps and Beria were disappearing; the standard of living of the average Russian would rise, favoring a greater political and intellectual democracy, for light industry was no longer sacrificed to heavy industry; and already there were signs of the "thaw," as Ehrenburg called it in the title of his latest novel. When Malenkov announced that the U.S.S.R. possessed the H-bomb, the likelihood of a world conflict seemed to be removed for some time to come. A "balance of terror" is at least better than terror without any balance. In this context, Adenauer's victory, which portended the creation of a European army, seemed less grave an event than it might have been otherwise.

In a few weeks, and with a great deal of enjoyment, Sartre had made the adaptation of *Kean* Brasseur had asked him for; for once the rehearsals went off without any fuss. I saw *Waiting for Godot.* I am always mistrustful of plays that use symbols to present the human condition in its universal aspect; but I was full of admiration at the way in which Beckett succeeded in captivating us, simply by depicting the indefatigable patience that despite everything, against all odds, keeps our species and each one of us clinging to this earth; I

was one of the actors in the drama, with the author as my partner; as we waited—for what?—he talked, and I listened; with my presence, with his voice, we kept alive a useless and necessary hope.

Hemingway's *The Old Man and the Sea* had just come out in a French translation, and all the critics were lauding it to the skies. Neither my friends nor I liked it. Hemingway knew how to tell a story, but he had overloaded this one with symbols; he had identified himself with the fisherman who carries the Cross on his shoulders, in the falsely simple guise of a fish. I found this senile narcissism irritating. I was not entirely in agreement with Lanzmann about von Salomon's *Fragebogen*. Germany had become the most prosperous country in Europe; Antonina Vallentin, who had just come back from a trip there, told me about her encounters with German Neo-Nazism; despite the "questionnaires," the ex-Nazis and the businessmen who had supported Hitler were regaining the upper hand. I could understand how Salomon's self-justification was being greeted with anger. I recognized how much bad faith there was in his work, and indeed it was apparent in the style itself. But the liveliness of his narratives reawakened my old desire to recount my own memories.

Soon in fact I would have to be asking once more: What shall I write? For at last—and it was a factor that made no small contribution to the gaiety of that fall—I had finished my book. I was worried about the title. I had given up the idea of calling it *The Survivors;* after all, life hadn't actually stopped in 1944. I would have gladly used *The Suspects,* if the word hadn't already been used a few years earlier by Darbon, for the theme of my novel was essentially the ambiguous condition of the writer. Sartre suggested *The Griots:* we rather liked comparing ourselves to those blacksmiths-cum-witch-doctors-cum-poets whom certain African societies honor, fear and despise all at the same time; but it was too esoteric. "Why not *The Mandarins?*" Lanzmann suggested.

The beginning of that winter was a severe one; the Abbé Pierre launched his big charity drive, middle-class ladies eagerly divested their households of a few cast-off garments, everyone felt kind and generous, and the New Year's celebrations were very lively. Our little group gathered at Michelle's. Now that the manuscript of *The Mandarins* had been turned in to Gallimard, and Lanzmann was having a two-week holiday in January, I dreamed of sun. For the time being, Morocco was quiet; Lanzmann wanted to see it and I wanted to see it again; we booked seats on a plane. The day before we were due to

leave, the newspapers carried the headline: Alert in Morocco. It was the beginning of a wave of terrorism and counterterrorism unleashed by the deposition of the Sultan. We changed our plans, and two mornings later we embarked, with the car, for an Algiers that proved to be rainy, full of beggars, men out of work, and despair. Behind this dismal façade, a people in ferment was being organized by militants with stubborn patience, but we were not aware of it then. We made a beeline for the desert. In front of the hotel in Ghardaïa were parked trucks with slogans painted on their sides advertising the purposes of the expedition. "To sell electric cookers and study parasitology across 20,000 miles of Black Africa." An American woman, who was preparing to drive across the Sahara, was polishing up her Willys Overland. Why shouldn't we go on down to El Goléa as well? Lanzmann asked me. The people in the hotel assured him that the Aronde would be in pieces by the time we got there. I suggested we go to Guerrera first. The city rose up, red and resplendent, above the sands; in the square, surrounded by an attentive circle of people, a man carrying a sheep on his back was walking up and down very fast, yelling out words. It was an auction sale; we looked at the people and the streets, walked through the oasis. But to get there and back, what an ordeal! We had to drive along a bumpy, gullied road, switching abruptly from 50 miles an hour to 3; on the way back, night was falling; under a storm sky of terrifying beauty we got stuck in a sand dune; we had a shovel and planks, so Lanzmann managed to get us out; but he gave up the idea of El Goléa.

At Ouargla, the apricot-colored sands and the burnt-almond cliffs that had so moved me eight years before were still exactly the same. Touggourt we disliked; we slept there and couldn't get away quickly enough, despite a sandstorm and the advice heaped on us from all sides. Visibility was less than thirty feet, and at the end of five minutes we found ourselves driving across a wasteland. Each encouraging the other's pigheadedness, we found our way back onto the track and switched on our headlights; a car stopped: a Moslem notable and his chauffeur. "Follow us." Their Citroën plunged on at 60 miles an hour through the thick, white darkness. Lanzmann kept his foot on the accelerator and his eyes riveted to the back of their car. They stopped in a village and we went on, at the same pace—as soon as Lanzmann slowed down, the car would shake and every piece of it begin to bang against the piece next to it—with the certain knowledge that we should be smashed to bits if any obstacle suddenly

appeared in front of us. At last we emerged from the storm, but the wind had drifted sand across the road; at the end of two miles we were stuck. A team of workers servicing a narrow-gauge railroad came to our aid; then we got stuck again. Two vans passed, at less than 6 miles an hour, carrying workers; they got us out of that one. Finally, 50 miles from El Oued, we got stuck for good and all; it was dusk, and very cold; we were going to have a bad night of it. We thanked our stars when we saw a Dodge coming toward us: the stationmaster, his wife, two Moslem drivers. They pulled us out; we got stuck again. Finally we transferred our baggage and ourselves to the Dodge; we locked the car, but refused to let one of the Arab drivers stay and guard it all night.

Next morning the drivers went out to fetch the car. The stationmaster, fearing that if his train weren't used it would be withdrawn from service, wanted us to make use of it the following day in order to get the car back to Biskra. "It will break down," predicted Salem, a young man with a very positive manner who said that for the sum of four thousand francs he was perfectly willing and able to drive it across the desert to Nefta. I had traveled the route myself once in a truck, but could the Aronde get through? No, people told us. As we were wandering, perplexed, through the beautiful, funnel-shaped gardens, we saw Salem approaching; he was in a jeep full of children, and it was leaping from dune to dune like a mountain goat. We turned to each other. "Well, if you don't object, let's try it!" That evening we said good-bye to a very upset stationmaster. His wife, who had not been in Algeria long, was still dazzled; a big house, a vast garden, as many servants as she needed, it was beyond her wildest dreams: "When I write my parents that I drove a hundred miles a day just for fun, they won't believe me!" They were good people, but they objected to Lanzmann's remunerating the two drivers, who were employed at the station. Lanzmann did it all the same, behind their backs; they found out and were offended.

Next morning, all of El-Oued turned out to watch us leave; Salem had let some of the air out of the tires; he started the motor and we moved off, raked by a battery of skeptical looks: "You'll never get through in that thing." We were worried; if anything went wrong, we would have to wait eight days for the next train. Alas! in less than three miles the car was stuck; some peasants helped us get free, but the next time there wouldn't be anyone around, I told myself with consternation. And then, the Aronde began to fly over

the sand; from time to time, as he got to the top of a dune, Salem would put it in reverse so as to attack the summit from another angle, and over we would go. At three that afternoon we were drinking his health in a Moslem café in Nefta, while the other customers came clustering around to gaze at him in admiration. He was lively and intelligent as well as physically adroit; he must have joined the A.L.N. at the first opportunity; what happened to him?

Thanks to him, we had been well received; but a little later, coming back from a stroll through the oasis, the few merchants still standing frozen behind their stalls in the almost deserted square stared at us with hostile eyes; the hotel was closed; a nearby bistro, apparently open, refused to serve us so much as a glass of water. We visited Tataouine, Médenine, Djerba, but felt a veil of hostility cutting us off from the country. Outside Gabès I heard for the first time a phrase that was soon to become familiar: I asked an officer if we could get through to Matmata, I was afraid the road would be too sandy; he gave me a superior smile. "Are you frightened of the fellagha? You don't need to worry; we're always around, they don't try anything with us!" One evening, at dusk, we drove around Cap Bon. We were coming back from Tunis by plane, so we put the car on a boat; a young Tunisian docker read Sartre's name on the car; he called the others: "Hey! Jean-Paul Sartre's car! We'll put it on first one! Say 'thank you' to him for us!" I envied Sartre: on those faces France had doomed to hatred, his mere name could bring forth smiles of friendship.

I began to write again, but halfheartedly. The only project I really cared about now was to resuscitate my childhood and my youth, but I lacked the courage to approach it directly. I took up the threads of some tentative efforts begun and abandoned a long while before, and set to work on a novella about Zaza's death. When I showed it to Sartre after two or three months, he held his nose; I couldn't have agreed more: the story seemed to have no inner necessity and failed to hold the reader's interest. Then there was a period during which I contented myself with reading and correcting, very badly, the proofs of *The Mandarins*.

1954 disappointed many of our hopes; the Berlin Conference having failed, France was preparing to ratify the C.E.D. Supported by America, which, beaten in Korea, at least wanted to keep Indochina from going Communist, France rejected Ho Chi-minh's ad-

vances. On March 13th, the day General Navarre began the battle of Dien Bien Phu, I suffered a distressing experience that was new to me: I felt myself radically cut off from the great mass of my compatriots. Press and radio were predicting that the Vietminh army would be wiped out; not only did I know, from reading the Leftwing and foreign newspapers, that this was untrue, but, together with my friends, I was glad it wasn't true. The war had caused hundreds of thousands of deaths on the Vietminh side, both among the civilian population and in the army, and those deaths affected me more than the casualties of the garrison: 15,000 légionnaires, of whom at least a third were ex-S.S. men. The heroism of the suicide units was more extraordinary than that of Geneviève de Galard and Colonel de Castries, who were indecently exploited by our propaganda services. Bidault used their courage as an argument for refusing to negotiate even a cease-fire long enough to evacuate the wounded. When Dien Bien Phu fell, I knew that the Vietminh had for all practical purposes won its independence, and I was glad of it. For years I had been opposed to the official governments of France; but I had never before been in a position where I found myself rejoicing over a defeat; it was even more shocking than spitting on a victory. The people I passed in the street imagined that a great misfortune had just befallen their country and mine. If they had had any inkling of how pleased I was, they would have thought I deserved to be stood up against a wall and shot.

The ultras and the Army attempted to blame the suffering, the agony, the deaths that occurred at Dien Bien Phu on the civilian population in general and the Left in particular; if Laniel and Pleven got their bottoms kicked, so much the better—at least there were some kicks not going to waste; but after all, it was not the Ministers who had chosen to trap the Expeditionary Force in a "chamber pot." The Army, which was afterward to nurse its rancor with so much self-satisfaction on the memory of this "humiliation," was entirely to blame for the affair. As for the Left, not only had it at all times desired peace, but its newspapers and its politicians had even denounced the dangerous extravagance of the Navarre plan. There was a murderer in the government: Bidault; but his crime was not that of betraying the Army; he had even gone to the point of risking a world war in order to support them. There was no telling what extremities we might be reduced to by the paraphrenia of an army which, refusing to admit its own mistakes, was now returning

to France thirsty for vengeance. Yet, while the Parliament was overthrowing Laniel and Bidault, opposing the departure of a fresh contingent of troops and charging Mendès-France with the task of negotiating a peace, while a majority of the country approved these steps, at the same time a bitter chauvinism, encouraged by those defeated in Indochina, began to infect public opinion. Ulanova was scheduled to dance in Paris; the parachute regiment assumed they would be avenging the defeat of Dien Bien Phu by using threats that so intimidated the authorities that her performance was canceled.

In March, the Americans had exploded a bomb on Bikini which had surpassed even their expectations by its results.[1] Oppenheimer, who had been active in the preparations for this explosion, was nonetheless accused of un-American activities. The witch-hunt showed no signs of slackening; yet American imperialism seemed to be in the best of health; those oppressed by it, and those who attempted to resist it, were immediately crushed. To gain world attention, some Puerto Ricans fired on Congressmen while they were actually sitting in the House: in vain. Arbenz, in Guatemala, had attempted to shake off the yoke of United Fruit; a band of mercenaries, christened an "Army of Liberation," landed and drove him out.

In February, Elsa Triolet asked Sartre to participate in a conference of writers from East and West that was about to prepare the ground for a sort of Round Table at Knokke-le-Zoute; he accepted. Michelle, Lanzmann and I went with him in the car; by day, we went for drives and looked at paintings; in the evening he would tell us how his sessions had gone. The bourgeois intellectuals, Mauriac among others, had refused Elsa Triolet's invitation; the little group of Communists and Communist sympathizers that she had mustered were drawing up an appeal with a view to a much larger meeting. They didn't want to frighten anyone away and therefore had to weigh each word very carefully; Carlo Levi was there, feeling the cold despite his fur hat, Fedin, Anna Seghers and Brecht, charming but throwing the whole conference into an uproar, when the text had been finally settled, by asking in an innocent tone if it wasn't possible to add a protest against the American atomic tests; Fedin and Sartre wisely bypassed his suggestion. The Queen of the Belgians, an old progressive, received the members of this little congress in Brussels. The Russian writers invited Sartre to go to Moscow in May.

---

[1] It claimed a great many victims among Japanese fishermen and also among the customers who bought their fish.

He had overworked the whole year; he was suffering from high blood pressure. His doctor had prescribed a long rest in the country; he did no more than take a few drugs. He scarcely slept for several nights before he left because he had to finish his preface to Cartier-Bresson's book of photographs, *D'une Chine à l'Autre;* he was to stop over in Berlin and take part in a meeting of the Peace Movement, and he was intending to prepare his speech for that on the plane: he was decidedly overdoing things and I was getting worried. He seemed terribly tired. His first letters reassured me a little. In Berlin he had talked about History's universalization and its paradox: one of its aspects was the appearance of weapons capable of demolishing the earth; the other was the intervention in world affairs of countries that had been wholly or partly colonialized, and which, in order to win their independence, were launching national wars against which atomic bombs were powerless.

Now, he assured me, he was recovering from his fatigue. From his Moscow hotel, the National, he could see Red Square covered with flags; they were celebrating the anniversary of the union of the Ukraine with Russia. He watched the procession. "With my own eyes I counted a million men," he wrote. He had been unpleasantly struck by the boorishness of certain foreign diplomats, who sniggered on their grandstand: "Their bad manners would not have been tolerated on the Champs-Élysées on the 14th of July." He visited the University, talked to students and teachers, listened to workers and technicians in a factory discussing the works of Simonov; he went sight-seeing a lot; his interpreter had given him 500 rubles in case he wanted to go out alone, which he did often. He was invited by Simonov to the latter's dacha and subjected to a severe ordeal: a four-hour banquet, twenty toasts in vodka, and at the same time his glass continually refilled with Armenian *vin rosé* and red wine from Georgia. "I am watching him eat," said one of the guests. "He must be a good man, because he eats and drinks sincerely." Sartre felt he owed it to them to remain worthy of this praise all the way to the end. "I managed to keep the use of my senses, but I did partially lose that of my legs," he admitted to me. They put him on the train to Leningrad, which he reached the following morning. He was captivated by the banks of the Neva and all the palaces; but they didn't let him rest. A four-hour drive around the city, a tour of the monuments, an hour off, a four-hour visit to the Palace of Culture. Similar program the next day, followed by an evening at the ballet. He

returned to Moscow, then left by plane for Uzbekistan. After that he was due to accompany Ehrenburg to Stockholm for a Peace Movement meeting and return to Paris on June 21st.

In June, my sister exhibited her recent paintings in a gallery on the Right Bank. Preoccupied with technical problems, she was still keeping her spontaneous gifts too much in check, but some of her things were striking. At the vernissage I met Françoise Sagan, who had come with Jacqueline Audry. I didn't care for her first novel much; later on, I was to like *A Certain Smile* and *Those Without Shadows* better; but she had a delightful way of avoiding the child-prodigy label they had stuck on her.

It was a beautiful summer. I went with Lanzmann to a small hotel on the Lac des Settons; we took a library with us, but as it turned out spent most of our days driving up hill and down dale, looking at châteaux, at abbeys, at churches; the hills were yellow with flowering broom. The day we came back to Paris I found a note from Bost in my pigeonhole at the bottom of the staircase: *Come over and see me at once.* I thought: Something's happened to Sartre. And in fact Ehrenburg had telephoned to d'Astier that morning from Stockholm, asking him to let Sartre's friends know that he had been admitted to a hospital in Moscow; d'Astier had got in touch with Cau, who had passed the message on to Bost. I was alarmed, as I had been on that day in 1940 when I had received the letter from an unknown woman telling me Sartre's new address: *Kranken-revier*. Bost seemed badly shaken too. What exactly was the matter with Sartre? He didn't know. I wanted to talk to Cau; he was at the Sorbonne attending some meeting or other; we went there; d'Astier had said something about blood pressure, Cau told me, it's nothing serious. I wasn't satisfied. I knew already that Sartre was suffering from high blood pressure; had he had an attack? Together with Bost, Olga and Lanzmann, I decided to go to the Soviet Embassy and ask the Cultural Attaché to telephone to Moscow. In the entrance hall we ran into some officials and I explained my request to them; they looked at us with astonishment: "Telephone yourself . . . All you have to do is pick up the receiver and ask for Moscow." The image of the Iron Curtain was still so firmly fixed in our minds at the time that we had some difficulty believing them. We went back to the Rue de la Bûcherie, I asked for Moscow, for the hospital, for Sartre. At the end of three minutes, I was stupefied to hear his voice. "How are you?" I asked anxiously. "I'm very well, thank you," he answered in

polite tones. "How can you be well if you're in the hospital?" "How do you know I'm in the hospital?" He seemed mystified. I explained. He admitted that he'd had a sudden attack of high blood pressure, but it was over and he was returning to Paris. I hung up, but my mind was not at ease; this warning had a completely different meaning from the one in 1940; then, it had been external dangers that were threatening Sartre; suddenly I realized that, like everyone else, he was carrying his own death within him. It was something I had never faced up to; to counter it, I invoked my own disappearance from the world, which, though it filled me with terror, also reassured me; but at that moment I wasn't involved: What did it matter whether or not I was on earth the day he disappeared from it? What did it matter whether I survived him or not?—that day would still come. In twenty years, tomorrow, the threat was still the same: he was going to die. A black enlightenment! Sartre recovered. But something irrevocable had happened; death had closed its hand around me; it was no longer a metaphysical scandal, it was a quality of our arteries; it was no longer a sheath of night around us, it was an intimate presence penetrating my life, changing the taste of things, the quality of the light, my memories, the things I wanted to do: everything.

Sartre returned; apart from the huge ugliness of the new architecture, he liked what he had seen. Above all, he had been interested by the new relations that had been formed between men in the U.S.S.R., and also between people and things; between a writer and his readers, between the workers and their factory. Work, leisure, reading, travel, friendships: all these things had a different meaning there. It seemed to him that Soviet society had to a large extent overcome the solitude that gnaws at ours; the disadvantages attendant on the collective life of the U.S.S.R. seemed to him less regrettable than our individualistic loneliness.

The trip had exhausted him; every day, from early morning till the following dawn, there had been meetings, conversations, visits, journeys, banquets. In Moscow, his program had been spread out over several days and allowed him slightly more respite; elsewhere, the various regional organizations allowed him none. He was supposed to spend 48 hours in Samarkand. "One day with the officials, one day on my own," he had stipulated. They were surprised by this caprice: beauty doesn't cease to be beauty just because there are forty people looking at it at once; it was put down to his bourgeois individualism, but they did finally agree to his request. At the last

moment, the Union of Tashkent Writers shortened the excursion to a single day; there were factories to visit, children's books to look at. "But we'll leave you alone," the interpreter promised. An archaeologist and several of the local notables escorted Sartre through the city; the car stopped in front of palaces and mosques, superb vestiges of the reign of Tamburlaine; everyone got out, the archaeologist delivered an account of each particular building. Then the interpreter spread his arms and shooed everyone away: "And now, Jean-Paul Sartre wishes to be alone." They all moved off, and Sartre was left standing there, waiting until he could decently rejoin them.

The worst ordeals were the moments of relaxation, which were very festive occasions, moreover: banquets and drinking bouts. He was obliged to repeat several times feats similar to those he had accomplished in Simonov's dacha. The evening he was to leave Tashkent, an engineer as strong as three cart horses had challenged him to a vodka duel; his challenger then accompanied him out to the airport, where he sank into a heap on the asphalt, a great moment of triumph for Sartre, who then managed to get to his seat and immediately sank into a leaden sleep. When he woke up, he was in such a bad way that he asked his interpreter to arrange a day's rest when they got to Moscow; as soon as he got out of the plane, he heard his name being called over one of the concourse loudspeakers: Jean-Paul Sartre. . . . It was Simonov, who had telephoned the airport to ask him to lunch. If he had known Russian he would have asked for the lunch to be postponed till the following day, which Simonov would have been quite agreeable to; but neither of his "aides"[1]—apart from his interpreter, he was accompanied on all his trips by a member of the Writers' Union—was willing to take the responsibility of suggesting this change to Simonov. Accordingly, the meal took place that same day; wine again flowed freely and at the end Simonov presented Sartre with a drinking horn of imposing dimensions and brimming with wine: "Empty or full, you shall take it with you"; and Sartre found himself standing there holding it; it was impossible to put it down unless it was empty. Sartre did what was expected of him. After the meal he took a solitary walk along the bank of the Moskova, and he could feel his heart battering against his ribs. It went on pounding so violently during the night and the following morning that he felt unable to attend the meeting with a group of philosophers that had been arranged for him. "But what's the matter with you?" his

[1] In the sense Kafka gives this word in *The Castle*.

interpreter asked. She took his pulse and rushed out of his room to call a doctor, who immediately had Sartre admitted to the hospital. They treated him, he slept, rested, thought he was better. In fact, he wasn't. I invited a few of our closest friends in, and it was visibly a great effort for him to tell us about his adventures. He gave an interview to *Libération;* he rushed through it, and when they offered to let him read what they had taken down, he begged off. He went with Michelle to Italy for a rest and began an autobiography; but he couldn't put two ideas together, he wrote to me. At least he was sleeping an enormous amount and seeing only people he found interesting: he had been received with great friendliness by the Italian Communists. He had an alfresco dinner on the Piazza Trastevere with Togliatti; the restaurant musician proudly showed his Party card to Togliatti and sang some old Roman songs in his honor; a whole crowd gathered, applauding warmly, but some Americans began hissing; the Italians growled back; to prevent a riot they had to leave quickly.

Meanwhile I was traveling in Spain with Lanzmann. A lot of anti-Franquists had been going there without scruples for several years now; so I stifled my own. Except at Tossa, which had been turned into an ugly tourist center, I found little change. Poverty had increased; in certain spots in Barcelona, and almost everywhere in Tarragona, the streets were like sewers, full of famished children, beggars, cripples and sickly-looking prostitutes. The capital was different, we could see that Franco had been taking pains over it; the filthy slum districts I had seen in 1945 had been razed; but where had their inhabitants been relocated? The apartment blocks that had sprouted up on the sites were full of well-off civil servants.

Actually, we had known what was going on in Spain before we went there. If we had come all the same, it was because the country still had ways of reaching us: its past, its soil, its people. I revisited the Prado; I found I now preferred Goya and also Velázquez to El Greco. At Ávila, in the Escorial, in the *cigarrales* of Toledo, in Sevilla, in Granada, I found the same delight I had experienced there in the old days.

Both Lanzmann and I liked to understand, to learn, but we also enjoyed the fugitive emotion to be found in an apparition: a red castle rising on a hill beside a lake; a valley, seen from a high pass, melting away into infinity beneath its veils of mist; a shaft of light suddenly breaking through a cloud and bathing the fields of Old

Castile with an oblique radiance; the sea, far off. And Lanzmann got caught up in my old obsession of combing every detail of the regions through which we passed: coral-colored mountains, swollen, livid plateaus, plains of stubble fired by the setting sun, and that steep and ragged coastline whose terror and splendor Dali has caught so well. The heat held no terrors for us; a burning wind was sweeping the high plains of Andalusia when we visited its hamlets of cave dwellers in a temperature of 90 degrees. We rested on beaches or in deserted creeks, bathing at leisure in the sea and the sun. In the evening we went into the villages and watched the young girls in their pale dresses walking up and down, laughing.

At Lerica it was fiesta; little girls dressed up as grown women in the Andalusian costume—long frilled skirts, fans, mantillas—their lips, cheeks and eyelashes made up, strutted between the shooting galleries, the lottery tents, the carousels, the open-air cafés; fireworks were going off on every street corner. Lanzmann saw his first bull-fight, a bad one, but it moved him nonetheless. Then we headed for the North, which I had never visited; I saw the windows of Léon, the museum in Valladolid, the little ports of the Basque country, Guernica. Finally San Sebastian, and from there we drove straight home.

I found it hard to sort out exactly how I felt now about the Spanish people. Defeat is a disgrace; it is impossible to survive it without compromising with what one hates. I was troubled by what seemed to be a patience no longer illuminated by the slightest hope. As we drove by them in our car, the road workers ought not to have smiled at us. Yet they knew the rich were no friends of theirs, these peasants who never lifted so much as a finger to ask us to stop for them; they looked at us with blank astonishment when we suggested they might like a lift; one old woman even thought we were trying to kidnap her. One evening we picked up a very old man carrying a large sack. "Where are you going?" "Oh . . . the capital!" he answered with a grand gesture; he meant Badajoz, 40 miles away. "That's a long way!" "Oh yes! I would have walked all night." In Sevilla, in the bars of the Alameda, the little prostitutes ought to have regarded us with hostility; but no. One very young girl sat down at our table and begged me; "Take me to Paris; I'm good at washing and ironing, I'm a hard worker, I'll take good care of you. . . ."

A conversation finally made me see it all clearly. In Granada, while we were having dinner at the Alhambra Hotel, Lanzmann,

annoyed with the maître d'hôtel who wouldn't let him take off his
jacket, sounded off against the soldiers and priests who ran the coun-
try; the maître d'hôtel began to laugh: he didn't like them either.
During the civil war he had worked in the hotel in Valencia where
Malraux and Ehrenburg stayed. He reminisced for a minute, then
his voice hardened. "It was you who encouraged us to fight; then you
dropped us; and who paid for it? We did. There were a million
people killed; dead bodies everywhere, on the roads, in the squares.
We're not going to start all over again, never, not at any price." Yes;
these peaceful-looking men had risked their lives for a different fu-
ture; they were the sons, the brothers of the men who had given
theirs; England and France were as responsible for their resignation
as Germany and Italy. Another generation would have to grow up,
less crushed by its memories, before hope could return, before the
struggle could begin again.

By the time I got back to Paris, Mendès-France had signed an
agreement with Vietnam and gone to Tunis for negotiations with the
Tunisian leaders. He had successfully urged the Chamber of Depu-
ties to vote against the C.E.D. Although he had refused the support
of the Communist vote, his policies were those desired by the Left.

Sartre was still in a pretty bad way when we left by car at the end
of August; the first evening, in his hotel room in Strasbourg, he
stayed for a long while just sitting in his chair, hands on his knees,
back bent, eyes blank. We had dinner in a restaurant of *la petite
France*. "Literature is a lot of horseshit," he told me; he sat through
the whole meal emanating a feeling of disgust. Fatigue was making
him see everything in the worst possible light; writing was such an
effort for him that he could no longer see any meaning in it. We
drove through Alsace, the Black Forest, Bavaria. So many ruins! Ulm
had been pounded to pieces, Nuremberg to dust. *Swastikas waved at
every window*. Rothenburg, skillfully restored, took us back twenty
years: In 1934, we had walked along those ramparts, refusing to face
the catastrophe that was almost upon us, unable, even Sartre with his
gift for envisaging disaster, to sense the enormity of what lay ahead.
In the painted streets of Oberammergau, it was difficult to believe
that anything had ever happened. In Munich we found the giant
beer halls still filled with Bavarian gaiety. In 1948, in Berlin, the
distress of the Berliners had softened my bitterness; but I detested
Munich, loudmouthed and cozy, full of strutting profiteers bursting

with delight at the good thing they had made out of their defeat. I have only one pleasant memory of it. One morning, in the middle of the almost dried-up river, two men in evening dress and top hats were staggering about in the water; with their black dress clothes, their bewildered looks, their uncoordinated attempts to get back onto the bank, they were the very embodiment of that grotesque sense of fantasy so peculiar to Germany.

At Salzburg, in a hotel in the old town that mirrored all its age-old graces, Sartre began working again; he was finding himself. We revisited the surrounding countryside, the lakes and mountains, then after a week we headed for Vienna. As a consequence of contracts signed by Nagel without Sartre's assent, a production of *Red Gloves* was in rehearsal there; the Peace Movement warned Sartre of this; he protested, and explained his position to a press conference. At last I saw the Breughels in the museum, the Danube, the Ring, the Prater and the old cafés I had heard so much about; in the evening we would sit down to dinner in medieval-looking cellars in the heart of the city, or in cabarets farther out, at the foot of hills covered with yellow vines.

I had wanted to take another look at Prague; Sartre got us visas without difficulty; the idea of crossing the real Iron Curtain excited my curiosity. It was no mere metaphor; the little grassy road we had followed to an isolated frontier post suddenly ran slap up against a metal grille, flanked by dense and threatening barbed-wire fences; a sentinel was walking nonchalantly back and forth on top of a lookout tower. I sounded the horn. He paid no attention whatever; I sounded the horn again; a soldier came out of the guardroom and examined our passports through the bars; he made a sign to the sentinel who felt in his pockets and threw down a key; the soldier opened the iron grille as though he were a lodge keeper on some large private estate.

It was Sunday; no cars; but lots of people picnicking along the road, in the meadows and under the pines. I drove through country-side and villages, astonished at feeling so immediately at home in a People's Democracy. When we reached Prague, Sartre asked a passerby in German how to get to the hotel we knew was reserved for foreigners; he telephoned to the poet Nezval, who seemed relieved when Sartre told him not to bother to come and see us immediately, for his wife was giving birth just then. We borrowed some money from the porter and walked around the town; it was very moving to

recognize everything again—the avenues, the bridge, the monuments, and also the cafés and restaurants—when in fact nothing was the same. (It was in front of that tavern, in that exact spot, that we had looked over someone's shoulder and read the name Dollfuss and a word beginning with M.) There were neon signs, elegant displays in the shops, an animated crowd, and lots of people in the cafés, which were pretty much like the ones in Vienna. We wandered a long while through the streets and our memories.

The next day, the fat poet Nezval—who loved Paris so much, and used to sit for hours, a beret on his head, on the terrace of the Bonaparte—showed us "the small beer"—the churches, the Jewish cemetery, the museum, the old taverns; some of his friends came with us. We passed a gigantic statue of Stalin; forestalling any comment we might have made, a young woman said sharply: "We don't like it at all." We saw an opera that was mediocre, and several puppet films at a private showing. The most amusing was one exhorting drivers to sobriety; the main character was a charming little stoned motorcyclist who went whizzing past cars and trains and finally smashed himself up trying to go faster than an airplane. We left Prague loaded with gifts: art books, records, lace and crystal. Only one shadow darkened our visit, but it was a big one; we were sight-seeing in a library one day, when for an instant we found ourselves alone with one of the curators; abruptly he whispered: "There are terrible things going on here, you know, these days."

On the way back, we went through a perfunctory customs inspection without difficulty, but on the Austrian side a young Russian soldier refused to let us go on into Austria: we had neglected to ask for permission to drive through the Russian zone. While he was telephoning to his captain, an Austrian soldier engaged Sartre in conversation. "Paris—oh I know Paris well," he said amiably. "I was there in 1943."

Lanzmann came to join us in Vienna. I had never before had the experience of waiting for someone dear to me at an airport. It's a poignant business: the vast, empty sky, the silence, suddenly the tiny whisper up there, the little bird growing larger, approaching, wheeling away again, suddenly hurtling down toward you. We drove into Italy. I suggested we take the Grossglokner Pass and Sartre was indignant: the historic route was the Brenner Pass. As we drove over it, he evoked the pomp of Maximilian's panoplied cavalcade riding down from the dark German forests toward the Roman sun and the

imperial diadem. We rested up from our Central European expedition in Florence and Verona.

Sartre caught a train back from Milan, where I stayed for a short while with my sister. I returned to France with Lanzmann, driving through Genoa and along the coast. Some of my Czech presents had been stolen in Florence one night, when I had left them in the car; I still had some books and records that the customs officers at Menton sniffed at suspiciously; whatever came from Prague was dubious. I explained they were works of art and folk songs. "Prove it!" they replied. I showed them the photographs illustrating one of the books: "You see: they're just landscapes." "Landscapes, there are plenty of those here," said one of the officials, indicating the coastline and the sea with a sweeping gesture. Both books and records were confiscated.

From the first of October on, I was expecting *The Mandarins* to appear in the bookshops any day; *The Second Sex* had taught me a lesson; I could almost hear all the unpleasant gossip in advance. I had put so much of myself into this book that there were moments when my cheeks burned at the idea of indifferent or hostile eyes moving across its pages.

On the way back from Nice to Paris with Lanzmann, I went into a hotel in Grenoble at about midnight; a *Paris-Presse* was lying on the reception desk; I opened it and my eye was immediately caught by an article by Kléber Haedens devoted to *The Mandarins*. To my great surprise—for we didn't see eye to eye on most things—he spoke well of it. When I telephoned Sartre the next day, he told me that a very friendly notice had appeared in *Les Lettres Françaises:* was I going to be greeted with approval from all sides? On the whole, yes. Reversing my expectations, it was the bourgeois critics who found that my novel had a pleasing odor of anti-Communism, while the Communists took it, quite rightly, as an expression of sympathy for them. As for the non-Communist left wing, it was in its name that I had been attempting to speak. Only a few Socialists and the extreme Right attacked me with any venom. Forty thousand copies were sold in the first month.

"They're putting you up for the Goncourt," Jean Cau told me. I was shocked: I was too old. "You'd be foolish to refuse," my friends told me. If I won the prize, the book would reach a really wide public. And I'd earn a lot of money. I had no pressing need of it,

since I had access to Sartre's; but I'd have liked to make my contribution to our common funds. And apart from that, the rain in my room was growing steadily heavier; the Goncourt would enable me to buy an apartment. All right: if they offered it to me, I would accept it.

From what was said at the preliminary discussions, I was told that I had a pretty good chance of winning. Since I had no desire to be swooped down on by a flock of journalists, on the evening before the final deliberations I moved, with Lanzmann, to a lodging procured for me by Suzanne Blum. I waited for the result beside a radio, not without nervousness, for I had been encouraged to make plans I should not be able to abandon without disappointment; at noon I learned that I had won the prize. We had a "family" celebration, consisting of a lunch at Michelle's, during which Sartre presented me with a very appropriate gift—a book on the Goncourts by André Billy which had just been published; the celebration continued with a dinner that evening with Olga, Bost, Scipion and Rolland. I had warned the jury and also Gaston Gallimard that if I were chosen I should not make an appearance either in the Place Gaillon or the Rue Sébastien-Bottin. At thirty-five, in my innocence, I should have enjoyed exhibiting myself; now I found it repugnant. I have neither braggadocio nor indifference enough to offer myself as willing fodder for the curious. Some journalists, sitting on the stairs, vainly besieged a door behind which a cat was meowing, and which was in fact the Bosts'. Two or three days later, some photographers posted themselves in the street to catch me coming out of the Café des Amis; I left through the veterinary clinic, the door of which opened onto another street. The only interview I gave was to *Humanité-Dimanche*. I wanted to make it clear that my novel was not hostile to the Communists and that it had not aroused their enmity.

"If you accepted the prize, you should have played the game," people said to me. I fail to see in what respect the decision of the Goncourt jury can be said to have created an obligation on my part toward the television, the radio and the press, nor why it should have induced me to smile at the camera, answer foolish questions or publish what was better left in a drawer. "The journalists are only doing their job." Agreed; I have nothing against them; some of my best friends are journalists—I just don't like the newspapers they work for. Furthermore, with the best will in the world, or the worst, publicity disfigures those who fall into its hands. In my view, the relations a writer entertains with the truth make it impossible for him to

acquiesce to such treatment; it is quite enough that it should be inflicted on him by force.

The prize brought me a great many letters. A good many readers
automatically buy the book that wins the Goncourt, and to them I
was anything but a satisfying choice; the letters they sent me were
angry, hurt, indignant, moralizing, insulting. I have chosen the following pearl, of Argentine origin (which does slightly tarnish its
orient): "Why must the love scenes in a work of this sort be described in the manner of the *Diary of a Chambermaid* or *The Princess of Cleves?*" People I had known more or less intimately in the
past congratulated me as though on some sort of promotion; this
surprised me, but I had the pleasure of seeing certain ghosts rise up
out of the past: pupils, fellow students, an English teacher at the
Cours Désir. Rouen, Marseilles, the Sorbonne, my childhood itself:
the past suddenly began to fall into place. A great many people I
didn't know also wrote to me, from France, from Poland, from Germany, from Italy. The Portuguese embassy let its displeasure be
known, but students in Lisbon and Coimbra wrote thanking me.
Some young Malgaches sent me a wooden statuette to show how
touched they were at my writing about the repression of 1947. I
believe too fundamentally in death to worry about what will happen
to me after it; in those moments when the dream I dreamed at the
age of twenty—to make myself loved through my books[1]—comes true,
nothing can spoil my pleasure.

My only problems came from the legend, planted and nurtured
by the critics, that I had written an exact and faithful chronicle; this
legend turned my inventions into indiscretions or even into denunciations. Like dreams, novels are often prophetic simply because
they deal with possibilities; thus Camus and Sartre quarreled with
each other two years after I began to recount the avatars and the
breakup of a friendship. Several women wanted to recognize Paule's
story as their own. These coincidences finished off the process by
which my fables became accepted as accredited truths. Did Camus or
Sartre bear false witness as I described Henri doing? people have
asked me. When did I practice psychoanalysis? In one sense, it
pleased me that my story carried such conviction; but it upset me
that people thought me so unscrupulous. One of the secondary char-

---

[1] This is of course a desire common to a great many writers. "I write to be loved,"
Genet has written; and Leiris quoted this phrase in an interview as an expression of
his own feelings.

acters, Sézenac, gave rise to a misunderstanding that I found very unpleasant. He had certain traits reminiscent of Francis Vintenon, whom I mentioned earlier, and whose strange and violent death was attributed to an ex-collaborator; in *The Mandarins*, Sézenac was done away with in a somewhat similar fashion, but by one of his comrades, since I had made the character a double agent guilty of having betrayed some Jews. A woman friend of Vintenon's asked me for an appointment. She thought I had some secret information about him; she had identified the imaginary murderer as one of her friends. She left without my having been able to disabuse her. I'm afraid my book engendered a great many other misunderstandings besides this one, so determined are people to take it as a faithful account of reality.

Bombs, attempted assassinations: the Moroccan nationalists were not going to give up the struggle until the Sultan was reinstated. When the rebellion broke out in the Aurès, I believed that the days of colonialism, at least in North Africa, were numbered. Mendès-France sent reinforcements into Algeria; after him, Edgar Faure refused to negotiate; the Algerian police began imprisoning and torturing people;[1] Soustelle became Governor General and was converted to "integration"; the Army took a solemn oath never to relinquish Algeria; the Poujadist movement, which had come into being eighteen months before, was spreading like wildfire. But the insurrection that had just exploded was an irreversible event, the example of Indochina and the general trend of the world as a whole convinced me of that; it was a conviction confirmed by the Bandoeng Conference, which heralded the imminent decolonization of the entire planet.

The appearance of my street began to change. Leather-jacketed North Africans, looking very well groomed, began to frequent the Café des Amis; all alcohol was forbidden; through the windows I could see the customers sitting down in front of glasses of milk. No more brawls at night. This discipline had been imposed by the F.L.N. militants, who had gained a dominating influence over the Algerian proletariat living in France. The influence of the M.N.A. had greatly declined. In Algeria itself, it represented a harmful dissi-

[1] From January 1955 on, in the *Bloc-Notes* he had been writing since April 1954 for *L'Express*, Mauriac, under the heading *La Question*, denounced the use of torture in Algeria.

dent faction, according to Francis and Colette Jeanson in *L'Algérie Hors la Loi;* the French left wing as a whole was hesitating between the F.L.N. and the M.N.A.; and in any case its position was not clear on any one point; it wanted a "liberal" solution of the conflict: it was a word capable of many interpretations. Sartre and *Les Temps Modernes* joined with Jeanson in demanding independence for the Algerian people, and regarded the latter as embodied by the F.L.N.

The events in North Africa and the fall of Mendès-France brought to a head the opposition between those French people who wanted things changed and those who had an interest in maintaining the status quo. A certain amount of regrouping was going on in the first camp. *L'Express* rallied *La Gauche Nouvelle* to the cause of Mendès-France, who was also supported by Malraux and Mauriac. On December 31st, Mendès-France had persuaded the Assembly to approve the Paris Agreements reviving the Wehrmacht; he defended himself against the accusation of wanting to "abandon" Algeria; his faction was proposing to remodel capitalism and colonialism in order to bring them into line with a new technocracy: really no more than a right-wing policy with a face-lift. The *Nouvelle Gauche,* the idea of which had been launched a year earlier by Bourdet, was more deserving of its name.

It became evident to us that we would have to make distinctions between our real allies and our adversaries in this new "Left." The *Temps Modernes* team took upon itself the task of elucidating the meaning of this now devalued label. Lanzmann made a frontal attack on the question by writing an article on "the left-winger." Others studied and instituted inquiries into more detailed aspects. I approached the problem from the other side, attempting to define the principles professed by the Right today. I had enjoyed unraveling the myths spun around woman through the ages; in this case, too, it was a matter of laying bare the practical truths—the defense of privileges by the privileged—whose crudity is concealed behind systems and nebulous concepts; I had already read a lot, I had swallowed a great deal of nonsense; I now had to gulp down much more. It was boring and irritating work, but I did it joyfully, since all this nonsense was a sign of the ideological collapse of the privileged classes. The economists were sharpening up new theories for the defense of capitalism much less unwieldy than those used by their predecessors; but they no longer knew what ethic, what ideal to invoke as a justification for the combat itself. The conclusion I drew was that their

thought is really no more than a counterthought. The future has proved me right. Through the mouth of Kennedy, of Franco, of Salan, of Malraux, the "Free World" invokes no other reason for its being, no other rule of life than this: to oppose Communism; it is incapable of proposing any positive ideal of life to put in its place. It is a pitiful thing to see the United States Government desperately hunting for themes of propaganda; it cannot hide from the world the fact that the only values being defended by the United States are the interests of America. Even the word Culture has become unusable; against Spender and Denis de Rougemont, the Russian intellectuals would risk insisting on it. Of course there will always be a Thierry Maulnier or two, brandishing a sheaf of threadbare phrases in the face of the future. Such delaying tactics never really delay anything.

In June, Merleau-Ponty, who was becoming very irritated by Sartre's political attitude, published *Les Aventures de la Dialectique,* in which he remodeled his philosophy in the most fantastic manner. He was linked at the time with *La Gauche Nouvelle* and served it by discrediting Sartre's "ultra-bolshevism"; this produced great rejoicings on the extreme Right: ingeniously selecting one of Merleau-Ponty's most unfortunate phrases—in which he confuses need and liberty—Jacques Laurent announced that with these few words he had given Sartrism its death blow. Sartre's ideas were already so ill-understood that it seemed to me deplorable that they should be distorted even further. It was so often forgotten that in *Being and Nothingness* man is not just an abstract point of view, but an embodied presence, so often man's relation with the other was reduced to a matter of the *regard* alone! Gurvitch, in one of his lectures, had recently claimed that the Other, in Sartre's thought, is an "intruder." I wanted to re-establish the truth; Sartre applied the dialectical method in a great many domains; he left the door open for a general theory of dialectical reason; his philosophy was not a philosophy of the subject, etc. The sentences I quoted from his work contradicted, point by point, the allegations Merleau-Ponty had made.

It has been said that it was Sartre's job to reply. There was no compulsion whatever for him to do so; on the other hand, any Sartrian had the right to defend a philosophy that he had made his own. I have also been blamed for the virulence of my reply; but Merleau-Ponty's attack was in its essentials extremely harsh. And he himself did not hold a grudge against me for it, or at least not for long; he was able to accept the existence of purely intellectual anger. And in

any case, though we both felt great friendship for each other, our differences of opinion were often violent; I would often get carried away, and he would smile.

Generally speaking, I take too peremptory a tone in my essays, some people have told me; a more temperate approach would be more convincing. I don't think so. The best way to explode a bag of hot air is not to pat it but to dig one's nails into it. I am not interested in making appeals to people's better natures when I think I've got truth on my side. In my novels, on the other hand, I set great store by nuances and ambiguities. That is because my intentions are not the same. Existence—others have said it and I have already repeated it more than once myself—cannot be reduced to ideas, it cannot be stated in words: it can only be evoked through the medium of an imaginary object; to achieve this, one must recapture the surge of backwash, and the contradictions of life itself. My essays reflect my practical choices and my intellectual certitudes; my novels, the astonishment into which I am thrown both by the whole and by the details of our human condition. They correspond to two different orders of experience which cannot be communicated in the same manner. Both sorts of experience are to me equal in importance and authenticity; I see myself reflected no less in *The Second Sex* than in *The Mandarins,* and vice versa. If I have used two different modes of self-expression, it was because such diversity was for me a necessity.

That winter, we drove down to Marseilles with Lanzmann; despite the devastation and the ugliness of the new buildings, I still liked the place, and he liked it too; it was a pleasure to open my eyes every morning on the sight of the flotilla in the Vieux Port and to see the smooth water turning golden in the evening light. We worked at our articles, we took walks, we talked, and we read the newspapers assiduously. One morning a big front-page headline informed us that Bulganin was replacing Malenkov as Premier of the Soviet Union; Malenkov had retired from the government and Bulganin was to have Khrushchev as his right-hand man. Heavy industry was to have priority over light industry once more. Rakosi had returned to power in Hungary, ousting Nagy. But there was no return to Stalinism. There began to be talk of coexistence. In June, Bulganin and Khrushchev paid a visit to Tito.

None of which prevented the professional anti-Communists from pursuing their extremely fruitful careers in France. They inspired

Sartre to write a farce, *Nékrassov*. It was still not finished when Jean
Meyer began rehearsals, with Vitold in the role of Valéra, the false
Nékrassov; Sartre had difficulty finishing it, because he didn't want
to make his hero into an out-and-out bastard, but he also didn't want
to make him into a convert. After rehearsals had been going on for a
day or two, he brought in the script of a new scene in which he
depicted the terrors of the bourgeoisie in farcical-lyrical style. While
the club of those-to-be-shot was having a lugubrious party at Mme
Bounoumi's, strikers began parading up and down outside the win-
dows, and the hitherto nebulous sense of impending disaster among
the guests slowly turned into wild terror. Simone Berriau went
white: "They'll smash my chairs." Meyer, alarmed, also protested:
"It's much too long!" Valéra, fleeing from the police, was to jump
out of the window among the strikers who then opened his eyes to
the truth. On second thought, this Jadnovian optimism didn't appeal
to Sartre. He cut the riot; the scene immediately lost all its vigor. It
was also shorter; however, the play when finally finished was still
longer than it should have been; the prologue was dropped. Meyer
directed *Nékrassov* without either invention or gaiety, and Sartre has
since regretted not having centered the plot on the newspaper rather
than on Valéra. Which does not keep the play, when performed by
good actors, from being an extremely funny comedy; the terrors, the
ravings, the petty obsessions, the nearsightedness, the slogans and the
fantastic inventions of the anti-Communists—among others the myth
of the "suitcase bomb" lately propagated by Malraux—all of these
had provided Sartre with a series of irresistible effects. The opening-
night audience, made up of critics and society people, was hostile;
they could not help laughing and made up for it afterward by saying
how much they had yawned. But the press could not forgive Sartre
for having dared to ridicule it; it wanted his head. Françoise Giroud
got herself invited to a dress rehearsal and quickly took over the
theater column of *L'Express* from Renée Saurel, who resigned from
the paper; she then tore *Nékrassov* to pieces. All the other news-
papers, or almost all of them, followed suit. A play can weather the
attacks of the critics when it can command the favors of the orches-
tra; this is the case with Anouilh: he appeals to the rich. But *Nékras-
sov* was an attack on precisely those people who assure the box office
of its receipts; the ones who came found the play amusing but made
sure to tell their friends they had been bored stiff. In the name of
culture, the bourgeoisie will swallow a great many affronts; this par-

ticular bone stuck in its throat. *Nékrassov* lasted for only sixty performances.

My articles took up a great deal of my time during that year because of all the reading I had to do for them. I did have some time off all the same. I went for drives with Lanzmann, I went out, I visited friends. I made the acquaintance of Lanzmann's brother Jacques when he came back from America. Stammeringly, he poured into our ears a series of comic adventures in which reality and his own fantasies were freely intermingled. His first book, *La Glace Est Rompue,* gave a picture of Iceland both extravagant and exact; we were sorry that the ambassador was offended by the fragments of it we published in *Les Temps Modernes.* Lanzmann also had a sister, called Evelyne Rey, who belonged to the Centre de l'Ouest theater company; she acted in the provinces for the most part, but the Centre brought their production of *The Three Sisters* to Paris and I saw her work for the first time. Shortly after that she took over the part of Estelle in *Huis Clos* at the Théâtre de l'Athenée. At twenty-two, penniless and inexperienced, she was red-haired, fat, made up like a *femme fatale,* and wore black velvet dresses. Paris improved her taste with amazing rapidity. Within the year, I watched her become blond, slim, fresh-looking and elegant. Evelyne was very funny, which is rare in women, and so pretty that people were amazed by her intelligence. We often went out with her. I liked her very much.

With Lanzmann, I went to the cinema. *Le Sel de la Terre* was a touching story, simply told. I enjoyed Bunuel's variation on *Robinson Crusoe,* and also in Fellini's masterpiece *I Vitelloni.* I had picked up a taste for Westerns from Sartre in the old days. Above all the rest, I preferred Huston's *Treasure of the Sierra Madre,* made from the novel by Traven, the mysterious author of best sellers who lived in Mexico and whose identity no one had ever discovered. But Gary Cooper in *High Noon,* Marilyn Monroe in *River of No Return,* and the violence of *Shane* had also held me breathless. And that was the year I saw Joan Crawford again in *Johnny Guitar,* more beautiful than ever in the luster of her fiftieth year. But most of the time the Americans were now spoiling this sort of film by working the same old political "message" into them all. A hero or heroine, sometimes a child, would have an almost neurotic repugnance toward violence; for an hour and a half, sometimes two, the wickedness of the "bad people" would fail to have any effect on this attitude; suddenly, at

the last moment, to save a friend, a fiancée, a father, the main charac-
ter would kill. The audience then returned home convinced, it was
hoped, of the necessity of the preventive war.

I went to see *Porgy and Bess* delightfully performed by a visiting
American company, and *The Crucible,* very well staged by Rouleau.
*Ping-Pong,* with some of our friends in the cast—Evelyne, Chauffard
—seemed to me Adamov's best play. I don't know how I came to miss
the 1954 production of *Mother Courage* that introduced Brecht to
French audiences; he was revealed to me[1] by *The Caucasian Chalk
Circle,* which the Berliner Ensemble brought to the Sarah-Bernhardt
in June of 1955.

Except for those that informed me about the world I was living
in, few books made a great impression on me. But there was Pavese's
*La Bella Estate,* which offered me all one can ask of a work of fiction:
the re-creation of a world that envelops my own, that belongs to
my own, that takes me into another country and enlightens me,
which leaves its mark on me forever with all the reality of an experi-
ence I have lived through myself. In Leiris' *Fourbis* I found again
those qualities that had riveted me in his *Bifures:* those spirals of
words coiling in on themselves and unrolling again into infinity,
drilling into the abysses of the past and the heart, yet glittering there
in broad daylight, reflecting from image to image toward a secret that
vanishes at the very instant it seems it must appear, the search hav-
ing no other outcome than itself in the slow revolution of its thou-
sand mirrors.

Toward the end of spring, Violette Leduc's *Ravages* appeared,
a tense and violent novel in which the author hurled her experience
down before the public without the slightest complicity; with the
result that the book was found not only shocking but unpleasant as
well, by the Gallimard readers in the first place. The first part re-
lated without compromise—though also without obscenity—the love
affair of two college girls; the Gallimard readers asked that it be
cut. Certain scenes were considered unpublishable, although they
were no more daring than many others that had been printed; it was
just that the erotic object was in this case woman and not man,
which to the Gallimard readers was an outrage. Amputated in this
way, the story lost a great deal of its point without gaining any of
the graces Violette Leduc had deliberately avoided. Nevertheless

[1] *The Threepenny Opera,* which I had seen performed by a French Company in
1930, had given me no real idea of his work.

she had the impression that it was getting off to a good start. We strolled down the walks of the Bagatelle, among the beds of tulips and hyacinths, in the sun, and on the strength of Gallimard's sales figures we dreamed of a success for her. The figures were wrong. There were critics who liked *Ravages* and said so; people still didn't buy it. "I'm a desert that talks to itself," Violette Leduc wrote to me one day. Usually writing that attempts to evoke aridity betrays it, the reader makes his way through a pleasant, dappled landscape; but in Violette Leduc's case, beneath the hard brilliance of the words the desert remained bare, spiky with rocks and thorns. That was her great success; it was also her failure. It threw her into a terrible state of depression.

I wanted very much to visit the U.S.S.R.; but I wanted even more to get a look at China; I had read the report by Belden and all the books that had come out in French on the Chinese Revolution, though there were still only a small number at that time; we had gazed for hours at Cartier-Bresson's book of photographs. All the travelers we met who had been to Peking spoke of it in dazzled tones. When Sartre told me we'd been invited there, I didn't dare believe my ears. In June, as we sat watching an extraordinary performance given by the Peking Opera, I still wasn't sure it was true.

Meanwhile, I took a trip more modest in scope but nevertheless very important for me; the Congress of the Peace Movement was held in Helsinki; my political evolution had led me to a point where I wanted to take some part in that event. I accompanied Sartre. We stopped for a few hours at Stockholm; then our plane rose over a sea so coldly green that I felt it must be solid, like liquid ice. I could make out a scattering of abandoned islets, seeming even more solitary when one house stood on a headland; the islets multiplied, then came a point when I no longer knew if I was flying over waters sprinkled with earth or land punctuated with water; victory went to the land: pines, lakes as elusive as reefs. These inaccessible, invisible, sequestered places were violated by my eyes, and yet my eyes united them too, bestowing on this section of the planet, for a while, an aspect that existed only for me, yet very real all the same. I found it as disturbing as when my eyes in childhood were re-creating the world, as disturbing as that age-old sadness: in a moment, all this will no longer exist for anyone.

I experienced in Helsinki what Sartre had felt in Vienna. In the

vast auditorium hung with decorations and flags, almost every coun-
try in the world was represented; the members of the Committee sat
in tiers; the other members of the Congress sat behind desks pro-
vided with headphones, or else walked up and down the aisles whis-
pering. A variety of costumes: Hindus, Arabs, Roman Catholic
priests, Greek Orthodox prelates. It was moving to see these people
all drawn together by the same hope, often at great risk and personal
danger, from every corner of the earth. I talked to some American
students who had come in secret to Helsinki at the risk of losing their
passports. Sartre introduced me to Maria Rosa Oliver, a beautiful,
paralyzed Argentinian woman who went all over the world in a
wheel chair; she had been forced to go through Chile in order to get
to Finland. I met Nicolas Guillen, the Cuban poet, and Jorge
Amado, the Brazilian writer, whose novels I admired. Once again I
saw Anna Seghers, with her extraordinary blue eyes. During a lunch,
Lukács started a discussion with Sartre on liberty, less ferocious than
the letters they had exchanged the year before, but more fruitful;
Sartre listened politely as Lukács explained that man was condi-
tioned by the age he lives in; he still hadn't finished when it was time
for the afternoon session to begin. I had dinner with Surkov and
Fedin; as we drank Georgian wine on the brink of a night undecided
whether to fall or not, listening under the pale sky to the murmur of
the trees, I remembered the rather doleful curiosity with which, four
years earlier, we had gazed, up beyond the North Cape, at the Rus-
sians' barbed wire and their red-starred sentinels; for us the Iron
Curtain had dissolved; no further embargo, no more exile; the
realms of socialism were now part of our world.

I met Ehrenburg several times. I remembered him as I had seen
him before the war, hirsute and thickset, on the terrace of the Dôme.
Now he was dressed with a casual daring that recalled Montparnasse
in the old days—a pale-green tweed suit, an orange shirt, a woolen
tie; but his body had caved in; under the white, carefully groomed
locks, the face had lengthened. He had a full-bodied voice and his
French was flawless. The only thing about him that made me uncom-
fortable was his self-confidence. He was aware of being the cultural
ambassador of a country that held the future of the world in its
hands; a good Communist can never be in doubt that he is in posses-
sion of the truth: there was nothing surprising in the fact that
Ehrenburg should speak *ex cathedra*. His dogmatism was balanced
by his charm, at once various and acute. He rebuked Sartre, in a

friendly and almost grandfatherly tone, for certain details in an interview that Sartre had given to *Libération* on the subject of the U.S.S.R. He asked him earnestly not to attack the U.S.A. too fiercely when his turn came to speak; conciliation was the order of the day; he had intended to suggest to a certain magazine that it publish certain extracts from *America Day by Day,* but at the moment he didn't think that it would be opportune. He talked to me about *The Mandarins;* in Moscow, all the intellectuals who knew French had read it and discussed it favorably, although the love story had seemed superfluous to them. "However," he added, "we can't see that it's possible to translate your work at the moment." He gave me two reasons for this: first the traditional Russian prudery with regard to literature; secondly, a few years earlier the discussions about the camps would not have worried anyone; people would just have smiled and said: "even our sympathizers are getting mixed up in anti-Communism!" But now, these things were known to be true. The return of those who had been deported was even creating difficult problems; which meant that the reading public would not easily tolerate having a knife turned in the wound. He told us some strange stories about Stalin, the following among others: Stalin was chatting, very informally, with some writers. "There are two ways of being a great writer: painting powerful, tragic frescoes, like Shakespeare, or else describing the tiny details of life in depth, with great precision, like Chekhov." He paused, then said: "If I had been a writer, I should have been a Chekhov." Ehrenburg was making a considerable effort to "thaw" Soviet writing; in his magazine he was trying to create as many contacts with the West as possible; he was a protector of nonofficial painting. With his subtle intelligence, his taste formed by what used to be termed the "avant-garde," he had applied himself to bringing about an effective reconciliation of this acquired liberalism with Soviet orthodoxy; it was a task that had not always been without danger.

I went out, with Sartre or by myself, to look at the town. It was ugly, but lashed by a glorious sea barred with reefs and breakwaters. At its gates, there was an enormous park planted with birches and pines; we had dinner there one evening, all sitting at little tables in a big glass pavilion, and I found it very pleasant chatting first to one little group then to another. Vercors and his wife told me about Peking, the covered market, the imperial palace, and I said to myself: "Only three more months!" We went for a stroll along the paths

with Dominique Desanti and Catherine Varlin Guillen, who had ar-
rived at the end of the meal dying of hunger; at eleven in the eve-
ning it was still light, some festival was being celebrated, and among
the pines we passed bands of Finnish men singing in chorus as they
walked through the park to celebrate one of their heroes and watch
the firework displays. Back in Helsinki, Guillen was dreaming of hot
dogs; but there was not a single café open, not a shop, not even a
street stand. Silence everywhere; the hotel bar was closing; we tried
to buy a bottle to drink up in my room. "It's two minutes past
midnight," one of the hotel employees told us severely. We made do
with water. Guillen fulminated against Nordic puritanism. Another
evening, when Sartre had been delayed, I went to the hotel bar up on
the fifteenth floor. I sat there for a long time in front of a glass of
whisky, watching the sun hanging just at the edge of the horizon, the
coast and its reefs being battered by a tumult of waves, whose foam
slowly faded back into the advancing night. It was beautiful to see,
and I was happy. What Ehrenburg had said about *The Mandarins*
had been a pleasure for me; the American students prophesied a
great success for me in the U.S.A.; I was lucky: while I was writing it,
the cold war had seemed to doom it to failure, now the world thaw
was helping it. After years of fighting against the current, I once more
felt myself borne along on the stream of History; and I wanted to
plunge deeper into it. The example of the men and women I was
moving among here stimulated me. For three years, I had devoted a
great deal of myself to my private life. I regretted nothing. But old
directives began to awaken in me: to be useful in some way.

The sessions of the Congress were not very interesting; there were
orators in abundance; they had not come from the corners of the
earth just to sit and say nothing. But the real work was done in the
subcommittees. The Algerian delegation wanted to have a talk with
the French delegation; Boumendjel presided over the meeting. He
described to us the situation of their country. They called to our
attention the fact that a few days before, the rebellion had entered a
new phase; it was spreading throughout the entire country; the
120,000 French soldiers stationed at that moment on Algerian terri-
tory would be powerless to contain it. We ourselves, they said, can
scarcely control it; tomorrow we won't be able to control it at all.
They urged the French to act immediately in order to break the
vicious circle of repression and rebellion: "Negotiate with us!" Val-
lon and Capitant smiled. "The problem is an economic one; if we

made the necessary reforms, your political demands would no longer have any *raison d'être.*" The Algerians shook their heads. "We'll put the reforms into operation ourselves. Our people wants its freedom." Some of the French delegation supported them. Sartre did not enter the discussion because he was not well enough informed about the problem, but he knew very well that no valid economic reform could be effected within the framework of colonialism.

When we got back to Paris, the vicious circle had not been broken. In the Assembly, an M.R.P. deputy, the Abbé Gau, denounced the methods used by the police in Algeria, which he said were worthy of the Gestapo. He was listened to with half an ear,[1] then a little later a state of emergency was declared. Marshal Juin formed a committee pledged to keep Algeria French at any cost. The fabric of colonialism was cracking everywhere: Bourguiba's triumphal re-entry into Tunis, Lemaigre-Dubreuilh's assassination in Morocco, riots in the Cameroons. But even these proofs did not convince those whose interests lay in ignoring them.

I went back to Spain with Lanzmann. We had decided to see some bullfights. In these days when words cost so little, I can appreciate the value of these trials in which a man engages his body in this hand-to-hand grapple with death. On condition, of course, that he does so of his own free will. In our society, the will of the exploited is never free; and the defects of capitalism have a thousand different repercussions both in the ring and the arena. Given this one reservation—and it is an important one—I find the attacks directed against boxing and bullfighting on moral grounds to be without foundation. The bourgeois moralists are pure spirits, or almost; they pay no at-

---

[1] In February, Vuillaume, Inspector General of the Administration, had been given the task of instituting an inquiry; it was not till much later, when it was published by *Témoignages et Documents,* that I was to see his report of March 22, 1955. He described the different tortures in use by the police and added that they seem to him to be necessary: "*One must have the courage to speak out directly about this delicate problem. In effect, either people take shelter behind the hypocritical attitude that has prevailed up till now and which consists of wanting to remain ignorant of what the police is doing . . . or else they adopt the mock-indignant attitude of someone who is pretending he has been tricked. . . . Now neither of these attitudes is admissible, the first because the veil has been lifted and public opinion alerted, the second because Algeria, particularly in the present circumstances, has need of an especially effective police force. To restore its confidence to the police force and set it back on its feet there is only one remedy: to recognize and condone certain procedures.*" Soustelle did not officially ratify these conclusions but did subscribe to the following, which includes all the others: "*The attempt to establish the limits of personal responsibility is one of extremest difficulty. Furthermore, it is to my mind inopportune.*"

tention to the needs, defections, resources, limits, strength and fragil-
ity of their bodies; they admit them as relevant only in the case of sex
and death. These two words spring immediately to their pens when
they interpret an event in which the body commits itself in its brute
state to an ultimate conflict, without the intermediary of some mech-
anism. If they fling about words like barbaric and sadistic, it is be-
cause they are shocked by the identification of a man with his body.
To the crowd, which accepts this struggle naturally, because it cor-
responds to their inner experience, they attribute "low" and "sus-
pect" instincts. They forget that traditional celebrations are not
susceptible to explanation by individual perversions; as for death, it
is less present in a bullring than on an airstrip. The enthusiasts of the
*corrida* usually irritate me as much as its opponents because they talk
in terms of the same myths as the latter, except that their tone is
ecstatic instead of indignant. These myths did not exist in the
peasant communities where bullfighting was born; they were culti-
vated when the landed aristocracy and their parasites took it over and
used it for their own advantage. If one sweeps such myths away,
despite all the frills and furbelows, the ceremonies, and a whole
literature, the bullfight still retains its original significance: an intel-
ligent animal fights and overcomes an animal that is more powerful
but less mentally skilled. It is precisely because I have a materialist
view of man that such a combat interests me. It has been spoiled by
gimmicks simply because it has become (like boxing) a financial
enterprise whose mainspring is desire for profit. But sometimes the
daring, the sincerity of a bullfighter restores its original purity.

We started off in Barcelona, where we saw Chamaco, idolized by
the Barcelonese although he was still a *novillero*. Then we went to
Pamplona; the *feria* was in progress and bore scarcely any resem-
blance to Hemingway's descriptions. In the squares, in the cafés, in
crowds, in gangs, in brotherhoods, nothing but men, men singing
and dancing heavily and enjoying being with other men. We spent
three afternoons at bullfights; I liked Gijon very much, and that year
he won the golden ear.

We went on to the west coast and stopped at Toja, lured by the
pine groves and the solitude of the immense beaches. But in those
districts Spain had no smile for us. When we walked along the jetties
of the little nearby port, the faces of the fishermen, bent over their
nets, grew hard. In the towns and villages of Asturia, throughout the
mining district, every look we surprised was a reproach; children

threw stones at the car. We preferred this rage to resignation, but we did not find it pleasant to be its target. And we hated all the mystifications even more than we had the year before. Too many fireworks everywhere, imitating gaiety; too many priests patrolling the little towns, thirsty for visions of the life beyond. They swarmed everywhere like insects, those clergymen with velvet hats who have reduced the hatred around them to silence only by force of arms. At Oviedo, as we drove in, a procession was filling the avenues of the town with whining, singsong chants, with orphans, with women in black, with gloomy adolescents in long robes; not a glimmer of light in these faces stupefied by the shabbiest and narrowest sort of devotions. Santiago de Composela, despite its cathedral and the glory of its name, put us to flight: the streets smelled so strongly of holy water and venality. We went through forests whose acorns are used by those who live in them as food; and we wanted to visit the valley of Las Hurdes, disclosed to the world before the war by Buñuel's film. There was one road leading down into it, the only entrance to the valley, and so steep that from below, the wall of rock it clings to like a snake appears impassable. Over a sort of gateway we read: *You are entering the valley of Las Hurdes;* and it seemed to us as though the gates of a world cut off from the world outside were closing behind us. Up in the mountains, I knew that a luxurious monastery had recently been built only a few miles away; that represented the furthest extent of public solicitude. The houses were stables, in which goats, chickens and human cattle all lived pell-mell together; children, adults, all suffering from goiter, all with the same look of animal despair stamped on their faces; and we only saw the bottom of the valley, where at least there is a tiny stream of water and a layer of soil that produces a few plants; but up on the rocky plateaus, water and even earth has to be brought up on the men's backs. It was dark as we drove back; not a light, not a single voice; a few doors stood open to reveal a dark silence in which animals and people lay huddled together; and in our mouths, too, words froze and refused to form.[1]

Salamanca was beautiful: plaza, arcades, stone buildings, statues, all with a classical quality unexpected in Spain. Without stopping, we drove straight on to Valencia through the tumultuous winds of

[1] The scandal was too flagrant. In the last year or two, some superficial remedies have been applied. The road now runs through the valley; electricity has been installed; some schools have been started.

La Mancha dotted with the tall windmills of Don Quixote. The *feria* was beginning; we liked it much better than the one at Pamplona; nothing folksy—the genuine effervescence of a twentieth-century city. We watched the *apartado* on the first morning and then all the *corridas* on the following days. In between we strolled in the Albufera and watched the white sails gliding along among the orange trees of the huerta. There was a water shortage in Valencia for those three days; we drank beer or wine, and took sunbaths till our skins grew sticky. Lanzmann bought a magnificent red and yellow poster of Litri facing a bull, which I pinned up on one of my walls.

Having resisted Andalusia, we reached Huelva; Litri was making a comeback there—once again—to which the press was giving enormous publicity. He was a local boy, and the day of the *corrida* there was a large crowd of men and women gathered at his door waiting with a kind of devotion for him to appear. I have a very vivid memory of that country bullring, crudely whitewashed and dominated by a hill whose colors were those of Africa; among the tawny rocks and eucalyptus trees, people were standing, dressed in brilliantly colored stuffs, and watching. Nothing very interesting happened. Ortega, blond and getting paunchy, was more like a matador in an opera; Bienvenuda was careful not to take too many risks or too much trouble, and Litri, his cheeks as red as those of a Zurbarán madonna, did not quite deserve all the applause he drew from the crowd. Suddenly, as a new bull hurtled into the ring, a young boy leapt over the balustrade, carrying a red handkerchief; faced with the bull, still untaught but intact, he made several daring passes and I could already feel the two horns gouging into my belly; none of the toreros, or any of their teams, made a move. Finally, a policeman reached over the barricade and knocked the kid out; he fell onto the sand and was carried off.

A great eucalyptus woods, a gray plateau planted with umbrella pines, bare sierras; Madrid. We liked it that year, perhaps because we explored it with people who lived there. One night, as we were drinking manzanilla at a counter, beneath the head of a famous bull, one of them, struggling through the barriers of his bad French and our bad Spanish, took a liking to us; he went and woke up his brother who spoke French fluently; in a very old tavern with painted walls, we ate shrimps together, served boiling hot with oil and garlic in earthenware bowls; we talked and drank to the sound of guitars in

the little bars near the Puerta del Sol until dawn; from time to time, a woman or a man, suddenly inspired, would begin to sing or dance. Our friends were lower-middle-class people quite comfortably off; they didn't like the present regime. "Nobody likes it," they assured us; but they did not meddle much with politics. One of them believed fervently in God. "If I didn't," he told us, "I'd kill myself here and now." They didn't let us pay for a single thing we had: "This is our home." The following Sunday, we took them and their wives to see a bullfight out at the Escorial, unfortunately a bad one.

I have already written the story of my journey to China.[1] It was not like my other trips. It was not just a wandering, not an adventure, not a journey made just for the experience, but a field study in which caprice played no part. It was a country fundamentally foreign to me; even with the Yucatán and Guatemala I had been able to establish some common ground because I had already been to Spain. In China there was none. I was able to get to know a little about the work of the writers I met there through English translations that I read at the time; but until then they had not existed for me; and—except for two or three French-literature specialists—neither my own name nor Sartre's meant anything to them; the newspapers explained that Sartre had just written a "Life of Nékrassov,"[2] and the people we talked to frequently expressed a polite interest in this work; then we would move on to gastronomy. This mutual ignorance restricted our conversations even more than the various political constraints. Added to which, Chinese culture—as I have explained at length elsewhere—is essentially a culture of civil servants and courtiers; it had little to say to me. I liked the Opera, the ritual grace of the gestures, the tragic imminence of the music, the slender, birdlike voice. I liked the gray *huntungs* of Peking and its flawless nights set in the splendor of autumn. In the theater sometimes, or occasionally walking along a street, the things I perceived became part of me, I forgot myself. But for the most part I was consciously there, faced with a world which I was struggling to understand and to which I could not find the key.

It was not easy to decipher. I was encountering the Far East for the first time; for the first time I understood fully the meaning of the words underdeveloped country; I saw what poverty meant when it

---

1 *The Long March.*
2 The great nineteenth-century Russian poet.

involved 600 million men; for the first time, I was there watching a people at that hardest of labors: the construction of socialism. These new experiences overlapped and blurred each other; the poverty of the Chinese only appeared to me through the vision of their attempts to overcome it; and it was to that poverty that the constructive efforts of the regime owed their severity; the crowds I was jostled by, their pleasures and their pains were all hidden from me by an exotic veil. All the same, looking, asking, comparing, reading, listening, I did finally experience one fact that emerged clearly from the half-shadows of my perception: the immensity of the victories won in only a few years over the scourges that had once held sway in China—dirt, vermin, infant mortality, epidemics, chronic malnutrition, hunger; the people had clothes and clean housing, and something to eat. Then I saw how very real was the impatient energy with which this nation was building a future for itself. Other points became clear. However incomplete my experience was, I began to think that it might perhaps be interesting to write an account of it.

On the way to China, I had spent only a single day in Moscow, though without anyone or anything spoiling the pleasure of it for me. With Sartre as my guide, I walked through the streets from morning until the moment when the ruby stars are lit on the towers of the Kremlin. We stayed there a week on our way back from Peking. After two months of Chinese poverty, Moscow dazzled me, as New York had once done, coming from the chronic shortages of Europe. It was dark when Simonov came to fetch us from the airport; the University, so ugly by daylight, was glowing with a thousand lights; we had dinner with Simonov and his wife—a well-known actress whom everyone kept staring at—at the Sovietskaia, which turned its dining room into a cabaret at night. What joy to come back to the sort of food and drink one can get high on! There was an orchestra, a floor show, and couples dancing, their cheeks aflame; we were a long way from the phlegmatic teachings of Confucius. Across the city they were building wherever you looked but not with trowels and little baskets of earth: trucks, steamrollers, cranes, bulldozers, there was nothing they didn't have; there were one or two of the old isbas still standing in almost every neighborhood, but bristling with television aerials.

Olga P., our interpreter, took us around without a set program, wherever we felt like going or she had the sudden impulse to take us. She showed us the monastery of Zagorsk, just outside Moscow; the

churches were very beautiful and full of old women mumbling; in
the classrooms, dirty bearded seminarists were leafing through books;
the priests we passed on the walks outside seemed just as unkempt; as
soon as one of the devout old ladies caught sight of one she would
hurl herself at his hand and kiss it gluttonously. But the archiman-
drite who gave us lunch was superb: purple gown, long beautifully
combed hair and long well-groomed beard. "I hope you will excuse
us, today is a day of abstinence," he said, as a novice covered our
plates with caviar; there were enormous photographs of Marx and
Lenin nailed up on the walls. The archimandrite explained to us the
ways in which the Revolution had helped religion: nowadays people
knew that one became a priest by vocation and not for motives of
personal gain. Olga P., who was Jewish, was almost choking with
rage. "I translate," she would say in a stiff voice, and then she would
repeat what the priest had said in a completely flat voice. "I know
we must instruct the people and not rush them," she said as we came
out, taking herself to task, "I know we must respect their beliefs;
but all the same they go too far."

We ran into Carlo Levi. He was delighted by the "dated" quality
of so many things in Moscow: the ruffled curtains, the beaded lamp-
shades, the plush, the acorns, the fringes, the lusters. "It's my child-
hood, it's Turin in 1910," he said. We watched for quite a while as
passersby charitably tried to keep a drunkard leaning against a wall
on his feet: if you fell down and stayed down you were picked up
and locked up until midday, and then you were late for work.

We saw several shows: *The Lower Depths,* staged in the classic
Stanislavsky style;.a comedy by Simonov with his wife acting in it,
and Mayakovsky's *The Bedbug* at the Satirical Theater. Olga P. had
told us the story of the play in great detail and then translated long
bits of it on the spot; the play was helped by a very swift production
done with a very light touch and teeming with invention, also by a
remarkable actor who played the lead in the "alienated" Brechtian
style.[1] During intermission I glanced around the audience and rec-
ognized Elsa Triolet's pretty nose, but the eyes were different and the
hair was red; it was in fact her sister, once Mayakovsky's mistress. She
exchanged a few words with Sartre. "People have called it a play
against Communism," she said very loudly and clearly, "but it's sim-

[1] I have since been informed that Brecht himself saw the show several days after we
did and warmly approved of the art with which the leading actor presented Prissipkin
without identifying with the character.

ply against a certain sort of hygiene." At the end, Prissipkin came to the front of the stage and apostrophized the audience: "Why aren't you all in cages too?" Jumping so swiftly from the imaginary to real life, he put us all in the same boat. Olga P. criticized *The Bedbug* for its didactic character. For us its meaning was quite clear: it is impossible to accept bourgeois society with its defects and excesses; but when one has been formed by it, it is impossible to submit to the "hygiene" demanded by the U.S.S.R. during the early years of socialist construction. The author's suicide seemed to us to confirm this interpretation which, it turned out, was also that of the company and the director. Later, I am told, the play was put on by another company in Moscow which removed all its ambiguities and presented it as a straightforward moral lesson.[1]

I understood why Sartre had ended up in hospital the year before: the Russian writers all enjoyed terrifyingly good health, and it was difficult to avoid their imperious offers of hospitality. A Congress of critics from all regions of the U.S.S.R. was being held in Moscow. Simonov asked Sartre to participate in one of the afternoon sessions; beforehand we would lunch with him and some of his friends from Georgia. "Excellent! But I won't drink," Sartre said. They agreed to that. All the same, there were four bottles of different kinds of vodka on the restaurant table, and ten bottles of wine as well. "Just sample the vodkas," Simonov said, and went on, inexorably, to fill our glasses four times; then we had to drink some wine to go with a barbaric and sumptuous banquet: an enormous quarter of mutton, cooked on a spit and streaming with blood. Simonov and the three other guests told us laughingly that they had been celebrating all night, Muscovites and Georgians challenging each other with glass after glass of vodka and wine; Simonov hadn't slept the night before; he'd started working at five in the morning. They went on till they'd finished every single bottle, without any apparent effect. Olga P., who had done her best to refuse any drink, nevertheless discovered by the time we got to the Congress that she was too tired to translate; my own head was on fire, and I was full of admiration when Sartre managed to get up and talk quite sanely about the role of the critic. There was a debate on the relative amount of space that should be allowed to tractors and men in the peasant novel; I found the discus-

---

[1] Neither the translation that appeared in *Les Temps Modernes,* nor the adaptation staged by Barsacq at the Théâtre de l'Atelier had the slightest success. I conclude that, out of context, *The Bedbug* has remained hermetic to the French public.

sion tedious, but not more so than usual in that sort of argument. I don't imagine that any writer, in the West any more than in the East, has ever learned very much about his job from conferences attended by other writers.

I had to write two articles, give interviews, speak on the radio; I spent my last day in bed, partly, I admit, because I had caught cold, but mainly because I was so exhausted. I spent it reading *The Road to Calvary* by Alexis Tolstoi, enjoying my solitude, and the silence.

# CHAPTER II

WHEN I CAME BACK FROM CHINA, my confidence in history had been restored: the exploited would ultimately conquer in the Maghreb too, and the day of their victory might even be near at hand. On August 20th, at Oued Zem, the Moroccans avenged their brothers massacred by the ultras, by the police, by the Glaoui. On the same day, in the Constantine district, the A.L.N. had shot seventy Europeans.[1] The government had sent troops to North Africa—60,000 men to Algeria alone—but this move had not been allowed to pass without protest. On September 11th, everyone who was available turned out at the Gare de Lyon, and with cries of "Morocco for the Moroccans" prevented the departure of the train. *L'Express* exhorted the youth of the country to obey its government and was immediately inundated with letters of protest. When *Les Temps Modernes* urged the young not to give in, it was with the approval of a large part of the nation. At Rouen, at Courbevoie, and in several other barracks, the soldiers, backed up by the Communist workers, refused to leave, and submitted to orders only by main force.

The left-wing press attempted to strengthen this resistance and mobilize public opinion against the war by trying to print the truth about it; it offered convincing proofs that the A.L.N. was not merely a gang of pirates but a well-disciplined people's army and a political entity. It denounced machine-gunning, bombings, the burning of villages and the use of torture. In November, two articles in *Les Temps Modernes* analyzed and destroyed the myth of integration. A

---

[1] Thirty-five of them at El Halia. The reprisal caused the death of 12,000 men, women and children.

group of intellectuals started an Information Center[1]; a Committee of Intellectuals opposing the prosecution of the war in North Africa was also formed.

In November, the Sultan was to return to Morocco; Tunisia was to be granted "independence with interdependence" in the words of Edgar Faure; the problem of Algeria, a heavily settled colony, was more complicated than that of the two protectorates, but it seemed to us that France could not avoid granting it a new status analogous to those of its neighbors. After the elections of January 2nd—despite the unexpected success of the Poujadists—we believed that the moment for this concession was at hand; the Front Républicain gained a majority of votes and had committed itself to a rapid termination of this war, described by Mollet as "cruel and lunatic." In his inaugural address, given on January 31st, he spoke of the "particular personality of Algeria." From the Socialist benches, Rosenfeld delivered the decisive opinion: "that the fact of Algeria's existence as an independent nation must be recognized."

We were not surprised by the reaction of the Army and the *pieds noirs*—Soustelle's passionate farewells to Algiers, the tomatoes thrown on February 6th, the Committees of Public Safety; Mollet's capitulation, when he replaced Catroux by Lacoste, we did find unexpected. Elected to conclude a peace, he intensified the war. We looked on with stupefaction as the Front Républicain gave him their support and the Communists, on March 12th, voted him special powers. This sudden change of policy was justified by a spate of propaganda that included statements preposterous beyond belief. The population of Algeria, it was said, had a great affection for France. The rebellion there was the result of an "Islamic conspiracy," with Nasser and the Arab League in the role of puppeteers. French deputies in the course of their public duties were forced by Soustelle to applaud a philosophy of history which one normally expects to find only in the novels of Mickey Spillane, in American comic strips and in pulp spy thrillers. The press disseminated it and the public was both delighted with such exciting fare and flattered to be made privy to such very unsecret secrets. The newspapers kept from their readers the true nature of the reprisals by means of lies and omissions. It was known that since "pacification" was not the same thing as war, the A.L.N. was not entitled to the protection of international law; people avoided asking themselves what happened

[1] Which published *Témoignages et Documents*.

to the prisoners that were taken. In April, only *Humanité* carried any mention of the 400 Moslems of Constantine who were beaten and hacked to death or hurled down ravines, all in the course of a single afternoon, by the forces of law and order. Only *L'Observateur* and *Humanité* disclosed the truth behind the tragedy of Rivet.[1] When Lieutenant Maillot went over to the A.L.N. on April 6th, the press showered him with insults without so much as asking what his reasons were. No one even mentioned the living conditions of the North Africans in metropolitan France, the shantytowns of Nanterre, except for two or three left-wing journalists.

And even those the government set about muzzling. Bourdet was arrested, Mandouze suspended, and a search warrant issued against Marrou, who had protested on April 5th in *Le Monde* against collective reprisals, against the concentration camps, and against the use of torture: he had made comparisons with Gurs, Buchenwald and the Gestapo. *Humanité* was seized several times, and André Stil indicted. An attempt was made to disgrace the Left by involving it in a shady "secret information leak"; the Right blamed Bourdet, Stéphane, d'Astier, and Van Chi's negotiations for the loss of Indochina: such traitors should not be left free to stab their mother country in the back a second time. Even so, before settling down to war, the country, which had after all voted for peace, did shy once or twice. In several places there were protests against the departure of recalled conscripts. There were meetings, processions, strikes and walkouts everywhere; petitions circulated, and delegations of constituents asked to see their deputies. The Communists either organized or supported these demonstrations. After the friendly reception given to Mollet and Pineau during their visit to Moscow in June, the Communists became less vociferous, however. Sartre wanted the Peace Movement to condemn the war in Algeria. A Soviet delegate of some importance who happened to be passing through Paris told him that such a motion would be inopportune; he himself wanted a

[1] A policeman was killed at Rivet on May 8th, then two Moslems as a reprisal; then, on May 10th, a European baker. This unleashed a bloody spate of machine-gunning and troops were called in. They surrounded the Moslem district, loaded all the men—about forty—into trucks and shot them. They also picked up and shot some young men from neighboring *mechtas;* after that they set fire to the place; almost all the inhabitants were burned alive except for a handful who managed to escape and begged the soldiers to spare their lives. The rightist papers published a picture of them: "The population of several Arab encampments express their allegiance to France"; Rivert became a small fort, the murdered peasants were referred to as "fellaghas," and this Oradour [French town burned and its population massacred by the Germans, June 10, 1944] was turned into a victory for the French army.

motion passed declaring that the Movement was opposed only to wars of aggression: the French in this case were not aggressors. We thought that the U.S.S.R. was holding back because it was afraid the Maghreb would become part of the American zone of influence. Also, the Communist Party feared it would be cutting itself off from the masses if it appeared to be less nationalistic than the other parties. Officially it expressed its opposition to the government; but it no longer urged all those who could to defy it. It made no effort to combat the racism of the French workers, who considered the 400,000 North Africans settled in France as both intruders doing them out of jobs and as a subproletariat worthy only of contempt.

The electoral campaign had been based on a tissue of ambiguities and rivalries for power; the Front Républicain promised peace while at the same time rejecting the idea of abandoning Algeria, and without mentioning the word independence, which was so unpopular that even we at *Les Temps Modernes,* who both desired it and considered it inevitable, avoided calling it by its real name. If he had not capitulated, would Mollet have succeeded in his negotiations? What is certain is that by the end of June all resistance to the war had ceased. Giving not a thought to what it was going to cost, convinced that "the loss of Algeria" would make them poorer, their mouths full of slogans and clichés—French Empire, French départements, abandonment, selling out, grandeur, honor, dignity—the entire population of the country—workers and employers, farmers and professional people, civilians and soldiers—were caught up in a great tide of chauvinism and racism. If Poujade suddenly lost his importance, it was because everyone in France had become a Poujadist. Our young men were sent without a qualm to the *djebels,* where they consoled themselves by playing soldier at the expense of the *bicots.*[1] We were able to observe, then and for several years to come, in all its dismal splendor, the phenomenon that Sartre calls "recurrence,"[2] each side finding in the conduct—or misconduct—of the other sufficient reason for its own attitude, which serves in its turn as sufficient reason for the actions of the other side. When Mollet had two prisoners guillotined on June 20th and another on July 5th, actions which provoked the Moslems of Algeria to a general strike, no one in France raised so much as an eyebrow.

[1] In March, there were 190,000 men in Algeria; on June 1st, 373,000. The half-million mark was soon reached.
[2] *Critique de la Raison Dialectique.*

We had begun by loathing a few men and a few factions; little by little we were made forcibly aware that all our fellow countrymen were accomplices in this crime and that we were exiles in our own country. There were only a very few of us who did not join in the general chorus. We were accused of demoralizing the nation. We were treated as defeatists—*Those people over there are defeatists, said my father as we passed in front of the Rotonde*—as "the fellaghas of Paris," as anti-French. But for what reason could Sartre and myself—without mentioning the others—be possessed by a mad rage against France? Our childhood, our youth, our language, our culture, our interests—everything bound us to our country. We were not misunderstood there, or hungry, or persecuted in any way. When it has turned out that we were in agreement with its politics and its feelings, we were delighted by such an understanding. There was nothing enviable in our present state of desolation and powerlessness. It was forced on us by evidence we could not ignore.

The A.L.N. now numbered 30,000, and its forces were no longer armed with shotguns but with rifles and automatic weapons; they controlled, as Lacoste himself admitted, one third of Algeria, which meant that the population was on their side. Ferhat Abbas had rejoined the F.L.N. From the mass of the people right up to its leaders, the combat was deepening, intensifying, and in the struggle Algeria's unity as a nation was being forged. Algeria would win. The prolongation of hostilities was in our opinion—as in Mollet's once—"cruel and lunatic," because it meant condemning hundreds of thousands of Algerians to death and torture; on the French side it meant the sacrifice of thousands of young men, the necessity of systematically misleading public opinion, the restriction of liberties, the perversion of ideologies, the decay of a country fed with lies to the point where it had lost all sense of the truth and become alienated, disorganized, passive, ripe for every concession and for the first dictatorship to come along.

We refused to feel indignant about the methods of fighting used by the F.L.N. "We're not fighting against choirboys," was the habitual refrain of the French "paras." Yet when militant Algerians in France liquidated traitors, that was murder. Whereas the Frenchman was proving his virility by slitting throats, torturing prisoners and raping, the Algerian terrorist who did such things was demonstrating his ancestral "Islamic barbarity." In fact, the A.L.N. had no choice; it fought with any means that came to hand. And yet, even among

those who recognized the validity of its aims, there were only a hand-
ful of us who insisted that terrorism and reprisals were inevitably the
two sides of an equation. Partly out of caution, but also with virtuous
sincerity, most people began their denunciations of the use of torture
and machine-gunnings by saying: "Of course we realize that the
other side is guilty of terrible excesses." What excesses? The word
had no meaning when applied to either side. Camus' language had
never sounded hollower than when he demanded pity for the civil-
ians. The conflict was one between two civilian communities; the
enemies of the colonized people were first and foremost the Euro-
pean colonists, the army defending these was only an accessory, and
that army could win the war only by destroying the people from
which the A.L.N. drew its strength; and it was precisely that neces-
sity which far from justifying the army's actions condemned it. The
massacre of a poverty-stricken nation by a rich one (even if it was
carried out without hatred, as was asserted by a young parachutist[1])
is an action that can only turn one's stomach. Our convictions de-
rived from simple common sense; and yet they cut us off from the
rest of the nation and isolated us even among the rest of the Left.

Hervé's *La Révolution et les Fétiches* represented the first at-
tempt made by a French Communist intellectual since the death of
Stalin to criticize the official ideology of the Party. Unfortunately the
work itself was slight and muddled. Hervé was strongly attacked by
orthodox Communists, in particular by Guy Besse, and finally found
himself excommunicated from the Party altogether. In *Les Temps
Modernes,* Sartre dismissed both Hervé and Besse at the same time.
He was very emphatic about how important Marx's thought had
always been for him: *"Men of my age are well aware of this fact:
even more than the two world wars, the all-important thing in their
lives has been a perpetual confrontation with the working class and
with the ideology of the working class which afforded them an irref-
utable vision of the world and of themselves. For us, Marxism is not
merely a philosophy: it is the climate of our ideas, the environment
that nourishes them, it is the movement of what Hegel calls the
Objective Spirit."* But he also deplored the fact that Marxism had
become stagnant; Naville, who thought he had been drawn from
cover, attacked Sartre in *L'Observateur* and Sartre replied. The

---

[1] Perrault: *Les Parachutistes.* In what way is an atrocity less atrocious because it has
been committed without hatred? It seems to me to make the atrocity worse.

Communists let Sartre's article go by without much reaction. One of the editorials in *Les Temps Modernes* blamed them for voting special powers to Mollet; but we remained their allies.

That February it seemed to us that the whole face of the Communist world was about to undergo a great change: Khrushchev announced at the 20th Party Congress that war was not inevitable, that a peaceful withering away of imperialism was possible, followed by a triumph of the working class without an armed struggle; he spoke of each nation's right to determine its own road to socialism. But hope gave way to surprise when his report of February 25th was made public; the brutality of this indictment, its suddenness, its "anecdotage"—all disconcerted us. It was not enough to demolish Stalin; there should have been some analysis of the system that had made his tyranny and his "bloody crimes" possible. Disturbing questions remained unanswered. Was there no risk of a police dictatorship springing up afresh in the service of some new team of rulers? The people who were denouncing the "cult of personality" today had all worked with Stalin. Why had they said nothing? How far did their complicity extend? And how far could they be believed?

No one, either in the U.S.S.R. or elsewhere, has yet given a satisfactory explanation of the Stalin era. On the other hand, the purpose and the meaning of Khrushchev's report were soon apparent. It was a premeditated move. He had wanted to establish the fact that the changes made in the past three years were not merely a chance conglomeration of unconnected events but were to be taken as constituting a sort of revolution, deliberate, coherent and irreversible; he had chosen to demonstrate this by an act rather than by abstract explanation; his condemnation of Stalin had created a definite break between the past and the present; henceforth, the bureaucrats trained under Stalin were to abandon their old ways and adapt themselves to the new order, and if they did not, they would appear unequivocally as an opposing faction.

The rehabilitation of Rajk on March 29th marked the beginnings of de-Stalinization in the People's Democracies. It was to be hoped that it would extend to the Communist Parties of other countries; but the French Communist Party held back. At the end of March, *Humanité* reprinted a *Pravda* article against Stalin; but in their commentaries on the 20th Party Congress, Thorez, Stil, Courtade, Billoux and Wurmser all made it their business to ignore the issue. One or two allusions were made to the "report attributed to

Khrushchev" and during the 14th Congress of the French Communist Party, held at Le Havre, it was not mentioned at all. The Party was not going to become democratic.

However—as in East Germany after 1953—the process of de-Stalinization in Hungary and Poland turned into a revolt against their Stalinist rulers. In Budapest, the Petoefi circle, whose meetings had been encouraged by the regime, suddenly turned against it: Mme Rajk spoke there on June 19th. On June 27th, several thousand intellectuals gathered to rehabilitate some hundreds of journalists who had been condemned as "bourgeois." Tibor Dháry and Tibor Meray attacked the present rulers. They demanded freedom for the press and free access to information. There were cries of: "Down with the government! Long live Imre Nagy!"

In Poznan the following day, thousands of metalworkers went on strike with cries of: "We want bread! Down with Old Guard!"; their immediate target was the food shortages, but they were also protesting against a government that was stifling their freedom without providing them with a decent standard of living. The police fired on the crowds, and forty-eight workers—according to official statements— were killed. The French Communist Party explained away this riot as the result of "provocation" by foreign agents. Courtade denounced what he called "irresponsible Polish rebelliousness." However, only a very few days afterward the Polish government and the official press of the country acknowledged that the demands of the workers were well founded.

After winning the Goncourt, I had bought myself a studio. I had greatly enjoyed furnishing it with Lanzmann's help, and when I came back from China we moved into it. I am very fond of this ground-floor apartment with its high ceiling, so full of light and colors and all the souvenirs of my travels. Through the bay window I look out on an ivy-covered wall and the wide sky; if I go up the inside staircase to the floor above I can look out over the Montparnasse cemetery, low houses and deserted streets; here and there a red bunch of flowers punctuates the gray stones. Perhaps because of this view, but above all because I have always liked things to be settled and decided, when I went to bed for the first time in my new room, I thought: This is the bed I shall die in. I still say it to myself sometimes. It is doubtless here in this workroom that I shall end my days. Even if I actually die elsewhere, it is here that my friends will have to

settle things after my death: go through my papers, throw things away, give away or sell the few objects that belong to me. This room, as it looks now, will survive a little while after I have disappeared. When I look around it, I feel my heart contract sometimes, as if I were seeing here the absence of a dear friend who is never coming back.

But when I lean out of the window on the upper floor, I know nothing of the future; I am completely possessed by the present. I often watch the sunset; then night comes; beneath the leaves along the Rue Froidevaux there is the glow of the sign outside a big *café-tabac* and the traffic lights at the intersection, while the Tour Eiffel ceaselessly sweeps Paris with its long arms of light. In winter, in the early morning when it is still dark, the tall display windows light up, yellow, orange, dark red. But it is in summer, above all, at about five in the morning, that I linger oftenest at the window, breathing in the dawn before I go back to sleep; already there is a premonition of the heavy heat to come hanging in the blue-gray sky; trees cluster above the graves, the ivy climbing up the wall gives off a thick green odor that mingles with the scent of the lime trees flowering in a square nearby, and with the songs of the birds; I am ten years old, I am in the park at Meyrignac; I am thirty, I am setting out for a long walk across the countryside. No; but at least these smells are given to me, this birdsong, this vague hope.

When I returned, my decision to write about China became even stronger. I knew, and I still know, that well-fed Westerners are incapable of putting themselves for a single instant in somebody else's shoes. All the same, I was stupefied by the ignorance that seemed to affect them—or which they seemed to affect. The anti-Communists, having been slightly shaken by the changes inside the U.S.S.R., were now turning to China as the main object of their attacks. They expressed pity for the Chinese because they all have to wear blue,[1] and omitted to mention the fact that until recently three quarters of them had not worn anything at all. Such excessive examples of deliberate misrepresentation spurred me on. And then I remembered the promise I had made myself in Helsinki; by giving the lie to the propaganda issuing from Hong Kong, I should be making myself useful. The austerity of the task did not displease me. It was one that demanded considerable effort on my part. To fill in the gaps in my

[1] This is only true, moreover, in Northern China, where such monotony of dress is traditional.

documentation, I went to libraries and information centers to consult reports, articles, studies, books and statistics devoted to the China of both yesterday and today, without omitting from my reading the accusations of Communist China's enemies. I visited several sinologists who helped me and answered my questions. All this collection of material took some time, and I needed a lot more in which to assimilate all I had found out and to arrive at a synthesis. I have rarely worked so hard so continuously as I did for the whole of that year. I worked at home in the morning and at Sartre's during the afternoon; sometimes I would sit at my worktable in either place for four hours at a stretch without once lifting my head. Sometimes too Sartre would get quite worried because my face turned red: I felt I was on the verge of an attack of congestion and threw myself on his divan for a few moments.

It goes without saying that when *The Long March* was published I was severely taken to task by the anti-Communists; in the United States especially, when the translation came out there, there was a tremendous outcry. What naïveté! they screamed in chorus, those same Americans who were so voraciously swallowing the nonsense served up to them by Allen Dulles. Nevertheless, in the six years since it has been published, several specialists, none of whom can be suspected of Communism—René Dumont, Josué de Castro, Tibor Mende—have confirmed what I said then. China is the only large underdeveloped country that has won the battle against hunger; if it is compared to India, Brazil, etc., this victory seems almost miraculous.

I personally profited from this study a great deal. As I confronted my own civilization with another very different one, I discovered that many traits I had once believed to be common to both were in fact not so at all; simple words like field, peasant, village, town, family did not mean at all the same thing in China as in Europe; and this made me see my own environment in a fresh light. During that period I read *Tristes Tropiques* by Lévi-Strauss, and one of its merits —among many others—in my eyes was to make me see the whole face of the earth again as if for the first time, not because of the extent of his explorations, but simply because of the point of view he adopted; it was the same one I was trying to use to describe Peking and the other places I had been to see. Generally speaking, this journey had swept away all my old touchstones. Until then, despite my wide reading and my few perfunctory glimpses of Mexico and Africa, I had

always taken the prosperity of Europe and the United States as my norm, and the rest of the world had existed only vaguely, somewhere on the horizon. Seeing the masses of China upset my whole idea of our planet; from then on it was the Far East, India, Africa, with their chronic shortage of food, that became the truth of the world, and our Western comfort merely a limited privilege.

*The Long March* could not be as lively a book as *America Day by Day,* and there are some passages in it that are already deadwood. But I do not regret the trouble I took over it; simply by writing it, I acquired a framework of knowledge, certain keys that have helped me to understand other underdeveloped countries.

Sartre was working very hard too. Two years earlier he had published the third part of his essay *Les Communistes et la Paix,* which he had practically given up the idea of finishing. The circumstances which had inspired it were now far in the past; and his relations with the Communists had changed since 1952. The books he had read and his own reflections had brought him to see things from a different point of view. He had been converted to the dialectical method and was attempting to reconcile it with his basic Existentialism. Also, Garaudy had suggested to him that they take a particular topic and use it to compare the usefulness of the Marxist and Existentialist methods; they had decided that they would both make a study of Flaubert and his works, each in his own way. Sartre wrote a long essay crammed with material, but too carelessly put together for him to think of publishing it. He was also still working on his autobiography, searching through the years of his childhood for the reasons which had made him become a writer. Lastly, he was adapting a film scenario, called *Les Sorcières de Salem,* from Arthur Miller's play *The Crucible,* which Raymond Rouleau was to direct.

I did not have much time for holidays that year. All the same, I occasionally allowed myself little vacations. In January, I spent some time with Lanzmann at the *col* of the Kleine Scheidegg. The first morning he could scarcely keep upright on his skis; I had not put mine on for six years; as I heard the gentle crackle of the snow once more, I felt that I had won a little victory over time. We took lessons and made progress, quickly in his case, slowly in mine; but I quivered with pleasure every morning, when I turned my face to the rising sun and felt the sting of the cold on my skin. We went down to Grindelwald; a chair lift hauled us back up over gorges bristling with

black and white pine trees, right up to the peak of the First Run; going up, it was 4 degrees below zero, and our teeth chattered despite the heavy oilskin capes the attendant had wrapped around us; once we were there, we stood in the sun gazing out at a dazzling panorama: the Eiger, the Jungfrau. Soon we were making long expeditions together, broken by halts on the terraces of the chalet-restaurants which smelled of damp wood and orange peel. In the evening, when the little funicular railway had stopped working for the day, the hotel was wrapped in silence and solitude; we would lie down on our beds and read. *The Kingdom of This World* by Alejo Carpentier, about the revolt in Haiti, was a brilliant novel, but not as rich as James' historical account called *Les Jacobins Noirs*. In *The Lost Steppe,* although he subscribed rather unthinkingly to the current myths about primitive life and femininity, Carpentier took me through the virgin forest on the most beautiful journey a book has ever afforded me.

In the spring we took the car to London, which we both liked, despite the austerity of its night life; we also flew to Milan where my sister was having an exhibition of her latest pictures. For a quarter of an hour, in the luminous early light, the pilot circled over the Cervin and Mont Rose: it seemed unfair that we should be able to see without effort this extraordinary landscape for which the Alpine climbers risk their necks. We went for a tour of Brittany: the promontory of Le Raz, Morbihan, Quiberon. A man asked us for a ride; in the car he told us something about himself in a desperate, gravelly voice. He had just come out of prison where he had been confined for vagrancy; he was looking for work, no one would hire him because he had just come out of prison, where he would very soon be put again because he was still a vagrant. We passed two policemen. "If I had been walking, they'd've picked me up," he said. He told us a little about his life: the child of poverty-stricken parents, he had never learned to read nor prepared for any trade. He pointed to the pylons alongside of the road. "One of these days I'll climb up there and touch the wire; then they'll have to do something about me." One often reads in the papers about bums climbing up pylons and electrocuting themselves; that day I understood what lay behind such suicides: creatures so destitute, so utterly alone, that their only way to gain recognition as men is to change themselves into corpses. And the hobo has no hesitation about the way to do it; the pylons are his horizon and his obsession.

I lunched at Ellen and Richard Wright's with my American publisher. He was pleased with the translation of *Les Mandarins*, but apologized for having had to make a few cuts here and there, just a few lines. "In the States, it's all right to talk about sex in a book," he explained, "but not about perversion." The book was a great success in the United States.

I went to see the retrospective exhibition of works by Nicolas de Staël, who had killed himself a year before for reasons to do with his private life, but also, apparently, because in the end painting had not provided him with the certainty he had been seeking; he had followed his talent to most of the dead ends of modern art. At the Palais des Sports I saw the Moscow Circus and Popov; socialist humanism had forced him to express respect for his own species and—although Charlie Chaplin managed it—it is very difficult for a clown to make people laugh without making fun of his fellow men. I went to the opening of *Soledad:* it seemed to me that my friends Colette Audry and Evelyne Rey were both very talented, the first as an author, the second as an actress. The Bochum company did *Lucifer and the Lord* at the Sarah-Bernhardt; Messemer acted the second half much better than Brasseur, but was not so good in the first; unfortunately the other actors were mediocre, the production was expressionist and there were enormous cuts, all of which combined to ruin the performance. However, the press was much more complimentary than for the original production at the Théâtre Antoine; I think the critics must have merely been reflecting the snobbery of the audience, which didn't understand German and because they weren't called upon to understand the play felt free to be enthusiastic about it.

I went to a private screening of Resnais' *Night and Fog.* As we were coming out, Jaeger, a film director I had once known slightly at the Flore, suggested that I do a commentary for a documentary which Mènegos had shot in China; the film was badly put together and spoiled in places by bits of sentimentality and camera tricks, but there was one astonishing sequence: the building of a railroad through sheer mountains, and across the Yangtse-Kiang; they had used a bulldozer, brought over piece by piece in boats, in combination with unbelievably archaic construction techniques of which I had seen examples myself. I agreed to write an accompanying text. I went to the studio several times, and as I ran the reels to and fro on the moviola I realized that I was going to find it a difficult job; my sentences had to follow the rhythm of the shots, they could not say

anything that the images on the screen could say for themselves and yet they must not distract attention from them; Mènegos and Jaeger were eager to reach a wide audience, so I was forbidden to make any political references; they had even gone so far as to cut all the shots that showed portraits of Mao Tse-tung; so I was condemned to fill in the silences with that false poetry which is the trap into which most film commentators fall; I couldn't bring myself to do it. Also the film depicted the hardships and dangers of the work that had been accomplished; it was my task to exalt its heroism. I don't like having to be enthusiastic to order. My literary and moral scruples forced me into a dryness of tone which was doubtless excessive. The director and the producer altered what I had written, made it more flowery. I could never bring myself to go hear it.

In June or thereabouts, *The Fall* by Camus was published. I was angry with him because of his articles in *L'Express;* he had been one of the first to protest against the living conditions of the Algerians in 1945; now the humanist in him had given way to the *pied noir.* All the same, I was upset when I discovered to what extent he had been hurt by the attacks on *The Rebel;* and I was also aware that he had been having a bad time in his private life; his self-confidence had been shaken, he had been through a period of painful self-questioning. I opened this new book of his with a great deal of curiosity. In the first few pages I recognized the same Camus I had known in 1943: his gestures, his voice, his charm, an exact portrait, without any over-emphasis, of a person whose severity was in some secret way softened by his very excessiveness. Camus was at last attaining his old dream: he was filling in the gap between the truth and his public image. He was usually so starchy that I was deeply touched by the simplicity with which he talked about himself now. Then suddenly, this vein of sincerity ran out; he began to gloss over his failures with a series of conventional anecdotes; he switched from the role of penitent to that of judge; he took all the bite out of his confession by putting it too explicitly at the service of his grudges.

One morning, at about nine, we were all gathered in front of the Coupole, Michelle, Sartre, Lanzmann and myself. We were going to Greece. I gazed, with incredulous gaiety bubbling up inside me, at our shiny cars parked at the curb, and pictured them as they would look in ten days, sweeping into Athens covered with dust.

Two days of wandering through Venice, and then we set off for

Belgrade, where we met some Yugoslav intellectuals. One of them, a very old man, asked us fearfully for news of Aragon; he had just served a prison sentence for his loyalty to Stalinism and hardly dared utter the names of his French comrades. Socialism and literature, art and commitment—we discussed all the classic problems; but the writers in Belgrade had one that was peculiar to themselves; most of them had been influenced, in some cases very deeply, by Surrealism, and they wanted to find a way of integrating it with the popular culture of their country. "Now that socialism has been made a reality here," said one novelist very decisively, "everyone is free to write just as he chooses." The others protested. For they made no secret of the fact that the country was beset with great difficulties. Collectivization had not worked, the peasants had gone as far as killing people to prevent its being imposed on them.

As we left Belgrade, we were struck by the poverty of its outer suburbs, and also by the desolation of the villages along the dusty, dilapidated road. We stopped at Skopje, a dismal, dirty Balkan town inhabited by sad-looking peasants and women in black kerchiefs that they pulled right down over their faces. Here too the writers were in a state of perplexity; they were worried by the Surrealist vogue in Belgrade; being Macedonians, they wanted to write for the people of their own province; their language was still crude and unformed; they must make it richer, suppler, mold it until they could use it to say what they wanted to express: the problems of their own time, of their own country. What help could Eluard be to them, or Breton? But could they choose any other point of departure? This simple question seemed to them to verge on the blasphemous. We continued on our way. At the frontier post, we were surprised to see that the customs officers were making the tourists leaving Greece wash their tires and their feet in troughs.

In Greece we noticed immediately that we were regarded without friendliness. Wherever we stopped we had to let it be known pretty quickly that we were French. A year earlier, in July 1955, there had been bombs exploding in Nicosia; the Greeks in Cyprus had been demanding that the island be restored to Greek rule. For a whole year now, Cyprus had been torn by bloody attacks and reprisals. In June, some terrorists had been hanged. The British were well aware of the enmity the Greeks felt for them: we didn't see one Englishman during the whole journey.

Then Salonika, with its glowing green gardens, its glazed tiles, its

basilicas. We left Sartre and Michelle and went on to Athens along difficult roads that wound around the outer bastions of Mount Olympus. The Acropolis, Delphi, Olympia, Mycenae, Epidaurus, Mistra, Delos: I saw everything again except for Santorino. And I went to new places—Cape Sounion, the coast of Euboea, the cyclopean splendor of Tiryns, the feverish wilderness of Morea, where, it is said, fathers still cut off the heads of fallen daughters with their axes; I walked through the beautifully named Malvasia, simmering almost deserted between the dilapidated ramparts that still seemed to defy the pirates. Not a cloud in the sky, and my heart had not rusted. Once or twice we went outside Athens in the evening to drink a glass of whisky at Chez Lapin, with its terrace overhanging the little inlet where the yachts are moored and fronting the sea like a ship's prow; the city's countless glittering lights and the shimmering stars carried me far, far away from everything, away from myself, as it had in the old days. I loved Delphi, the open-air café above the olive groves, where the country people danced in the evening; there was a little three-year-old girl there, spinning and swaying in time to the music, her face made unrecognizable by ecstasy, seemingly quite crazed; we could sense the sea in the distance. The countryside seemed tragically poor; there were women breaking stones along the roads, and peasant women would come out of their houses to beg for alms. Yet in the evening, in the villages, there were bright dresses and laughter.

In Paris I don't have much time to read. When I go away on vacation, I always take a suitcase full of books. In the penumbra of our rooms, or lying on the sandy beaches, I steeped myself that summer in Bénichou's *Morale du Grand Siècle,* Lucien Goldmann's *Hidden God,* and Desanti's study of Spinoza. They were all works that furthered the progress of Marxism by establishing the precise links of a given work with the society from which it emanated. I would have liked to revise all the culture I had ever acquired from this point of view.

We went over to Brindisi by boat and rejoined Sartre in Rome. After we had all spent a few days together in Naples, Amalfi, Paestum, Lanzmann took the train back to Paris.

We were both, Sartre as well as myself, a bit worn out with all the traveling we had done; above all other countries we loved Italy, and above all other cities, Rome; so there we stayed. Since that year—except in 1960, when we were visiting Brazil—Rome is where we have

spent all our summers, with short excursions to Venice, Naples, Capri. Even when its bricks are being scorched by the heat of the *ferragosto,* when the asphalt is melting along the deserted avenues, occasionally punctuated by a solitary, useless policeman in a white helmet, we still feel comfortable there. This great bustling, crowded city still calls to mind the little town founded by Romulus. "They should build cities in the country, the air is much cleaner," goes the old joke; for me, Rome is the country. No factories, no smoke; there is nothing provincial about Rome, but often in the streets, on the piazzas, one feels the harshness, the silence of country villages. The old designation "people," in which all factions were dissolved, really applies to the inhabitants of Rome, who sit in the evening along the Trastevere, on the Campo di Fiori, on the fringes of the old ghetto, at the tables on the wine merchant's terraces in front of a carafe of Frascati; children play around them; calmed by the coolness of the streets, babies sleep on their mothers' knees; through the fragile gaiety hanging in the air, impetuous cries rise up from below. You can hear the popping of the Vespas, but a cricket sings as well. Of course I like those massive cities that press you on all sides, cities where even the trees seemed to have been made by man; but how pleasant it is not to have to leave the bustle of the world and still be able to breathe clean air under an untainted sky, between walls which still retain the color of the earth from which they grew! Rome offers another even rarer opportunity: in Rome you can experience simultaneously today's effervescence and the peace of past ages. There are many ways of dying: falling to dust like Byzantium; being mummified like Venice; or else doing half the one, half the other; museum pieces amid the ashes. Rome endures, her past still lives. People live in the theater of Marcellus, the Piazza Navona is a stadium, the Forum a garden; between the tombs and pine trees, the Appian Way still runs toward Pompeii; and one has never finished discovering it; from the depths of the past something is always appearing as though newly minted in the freshness of each instant: a delight that never palls for me. Classical and baroque, calmly extravagant, Rome combines gentleness with severity; no affectation, no languor, but never harshness or aridity either. And what lightheartedness! The piazzas are irregular, the houses built on a slant. A Roman campanile will have a little bell tower like a wedding cake just next door, and these caprices generate a harmony; gently swelling, delicately receding, even its most monumental esplanades avoid

solemnity; the lines of the buildings—here a cornice, there the coping of a wall—curve in and slowly wheel, avoiding immobility without ever losing their balance. Sometimes they have a severe symmetry of design; but this austerity is tempered by the mellowness of the lines, by the ochres, the time-softened, burned-out terra-cottas that coat them. The travertine is wan, but the Roman light makes it shimmer. Between marble toes, the grass blades sprout. Rome. Artifice and truth melt one into the other. The eye is caught by an eighteenth-century print, flat and white, then it springs to life: it is a church, a staircase, an obelisk. On every side I glimpse theater sets that marvelously deceive the eyes; and then, no, they're not lying, the balustrades, grottoes, terraces and columns are all real. One evening, we looked down a complicated perspective of buildings and saw, as though through the tiny hole of a souvenir penholder, a reproduction of a street in which were walking tiny reproductions of men; what we saw was in fact a street and men quite close to us. Rome. At every bend in the road, at every street corner, at every step, some detail catches my attention: which shall I choose? At the far end of a courtyard, a dark clock face surrounded by greenery, with a double horizontal pendulum, pointed and menacing, like a story by Poe; the stone barrel near the Corso where lovers come to drink; the touching dolphins in front of the Pantheon, pressing themselves against the tritons with their cheeks full of water; and all those little houses, with their own courtyards and gardens, built on the roofs of the big houses. Rome, its shells, its volutes, its conches and its basins: in the evening the light transforms the jets of the fountains into diamond aigrettes, while the stone turns to rippling liquid beneath the streaming reflections of the dappled water; in the velvet of the night sky, the roofs glow with the colors of dying suns, bordering flower beds of stars; on the Capitol the scent of pines and cypress trees makes me long for immortality. Rome: a place where what we must call beauty is the most ordinary thing in the world.

We used to drink our coffee every morning in the piazza in front of the Pantheon, among the street vendors in their felt hats, carrying on their trade and making deals as though they were at a country fair; smalltime smugglers keeping an eye on the stocks of American cigarettes stuck under the mudguards of the cars in front of the Hotel Senato. We would read and discuss the day's newspapers, then go back home to work. At about two, we'd set off on an expedition around one of the seven hills or out into the countryside. I spent

some pretty appalling afternoons that year; my room, in a hotel on
the Piazza Montecitorio, overlooked a little courtyard being refaced
by a team of masons wearing their traditional headgear of old news-
papers; my window was barred by their scaffolding; I was slaving
away, trying to finish my book on China, and every now and then I
was choked by the *afa*. In the evening, the heat would abate; we
would eat dinner in various places, quite often on the Piazza Navona
or the Piazza San Ignazio, and then we'd decide where to go and have
a drink. We rather liked the Piazza del Popolo, but at Rosatti's, the
Flore of Rome, we met journalists, who demanded interviews, and
all sorts of people who bothered us. Sometimes we sat in a little bar
at the foot of the Capitol; I always felt that at any moment the
bronze warrior sitting in the middle of the piazza, lit up as though
for a ball, would put his spurs to his horse and come galloping down
the staircase. Our favorite spot was—and still is—the Piazza Sant'
Eustacchio, facing the church with its dreamy stag's head; late into
the night the cars move past, luxurious or modest, families, couples,
gangs stopping at the counter to gulp down cups of what is supposed
to be the best coffee in Rome; often the women stay in the cars and
let the men get out to argue and laugh among themselves; a horribly
depressing old man came around trying to sell little dolls that pissed,
and every ten minutes he would refill them with dismal concentra-
tion, though no one ever bought any. Here, and in many other spots
where we could watch the night people of Rome leading their
strange lives, we would sit for hours, drinking and talking. Sartre was
less confident about the future than he had once been, more severe
about the past, and sometimes everything looked dark to him; he
would lament the fact—as Camus once had, though in a different
sense—that it was impossible for a writer to re-create the truth; one
tells truths, and that's better than nothing, but they are fragmentary,
insubstantial, mutilated by a thousand and one restrictions. When
we talked together we made it our particular endeavor to go as far as
it was humanly possible in the search for truth, to consider it from
every aspect, to abandon ourselves unstintingly to the pleasures of
argument, of extravagance, of blasphemy; it was our way of deciding
where we stood, and also a way of blowing off steam, a game, a
purification.

A committee of left-wing writers invited us to a dinner in the
Via Margutta. The president, Repacci, white-haired, pink-cheeked,
clear-eyed, confessed to me that he amazed himself by the rapidity of

his pen: he could knock off two novels in a single week. Sartre was seated next to an eighty-year-old lady novelist, Mme Sybille, still very beautiful and once rather famous, about fifty years ago; she had every right to believe she was still young considering the grace deployed by the Italians—who can be coarse, but in an altogether different way from Frenchmen—in paying court to her; even a formal banquet doesn't stifle their imagination, and I wasn't bored at all. In fact the dinner we were invited to by Alba de Cespedès I found very entertaining indeed; like her friend Paula Massini, she combined the usual salty Italian malice with a caustic and very feminine turn of phrase; together they lacerated for us the underside of Roman literary life. Visconti was there, intelligent and lively, demonstrating his conversational brilliance; and a young man who, going over to Visconti and Sartre, asked nonchalantly: "You both know all about the film world. Why is it that directors are always so stupid?"

From time to time we saw Carlo Levi, Moravia, Guttuso the Communist painter and Alicata. Part of Rome's charm was that the unity of the Left had never been broken since our first trip there after the war in 1946. What Sartre had tried to bring about in France he could see here in reality. Almost all the intellectuals were in sympathy with the Communists, and the Communists had remained faithful to their humanist traditions. This alliance with the Communist Party, so austere in France, found expression here in warm and openhearted discussions. Sartre responded very strongly to this friendly atmosphere. And also, in Italy there was no flourishing anti-Communist movement; besides which, they were lucky enough not to have any colonies; the people you passed in the street were not, like people in the streets of Paris, like us, accomplices in mass murders and torture.

Thanks to the liberal attitude of the Italian Communist Party and its fortunate situation, there are some very good Left-wing newspapers in Italy that reach a very wide public; reading them is one of our pleasures. We pay close attention to the smaller news items—the whole of Italy is reflected in them. For several days the press was kept in copy by the tragicomedy of Terrazzano. Two brothers, inmates of the gloomy asylum of Aversat, near Naples, were granted a leave of absence for good conduct. They managed, without much difficulty, to buy submachine guns and explosives, then took over the school at Terrazzano and demanded two hundred million lire in exchange for the lives of the ninety schoolchildren and three women teachers

whom they had captured and tied up; they also demanded a radio, a television set and food. Their requests were granted; the money was brought in a truck; but they were afraid of a trap and wouldn't come out; for six hours they continued to threaten the crowd outside and the children inside, while the police, the town officials and a priest tried to reason with them. They killed a young workman who tried to get in through a window. Finally, with the help of one of the teachers, who had managed to untie herself, the police rounded them up.

In *Unità* and *Paese Sera* we followed the Poznan trial that had begun in September. Contrary to normal usage, the police did not "prepare" the trial. The accused had counsels who defended them and witnesses who gave evidence in their defense. The galleries applauded when the rulers of the country were vilified. They were supported by riots and demonstrations. The people demanded the reinstatement of Gomulka, who had been imprisoned in 1948 by the Stalinists and since rehabilitated. The government made considerable concessions; the prisoners on trial were given very indulgent sentences. In October, the masses demanded that Poland become autonomous, and that as a first step the Soviet troops under Rokossovsky be withdrawn; they asked for worker-management to be introduced in industry, that the hasty and badly executed collectivization that had been introduced be slowed down, and that the country be "democratized." On October 19th, the eighth Plenum was inaugurated; Gomulka, who had been named a member of the Central Committee, immediately demanded the exclusion of all pro-Soviet leaders and Rokossovsky's recall.

Theatrically, Khrushchev, Molotov, Zukov, Mikoyan and Kaganovitch suddenly flew to Warsaw; they opposed the departure of Rokossovsky; Russian tanks began to advance on Warsaw; Gomulka called up Polish troops and armed the workers. There were clashes, the beginnings of riots. Suddenly, Khrushchev and his men flew back. What had happened? Whatever it was, Gomulka was now First Secretary of the Polish Communist Party, and Poland was already on the road to de-Stalinization.

In Hungary, Rakosi had left the government. On October 6th, an enormous crowd followed Rajk's funeral cortege. On the 14th, Nagy was reinstated as a member of the Party. On the 23rd, the students of the country decided to celebrate the victory in Poland with a demonstration.

What a shock when we bought *France-Soir* at a kiosk in the Piazza
Colonna on October 24th and read the headline: REVOLUTION IN
HUNGARY. SOVIET ARMY AND AIR FORCE ATTACK REBELS. In fact,
the Air Force had not been involved. But this did not make the
events as described in *Paese Sera* any less distressing: 300,000 people
had paraded through Budapest demanding the return of Nagy, polit-
ical independence from the U.S.S.R., and even in some cases seces-
sion from the Warsaw Pact. The A.V.O. had fired on the crowd.
Soviet tanks, rushed into Budapest, had fired too; there were at least
350 dead and thousands of wounded. When Nagy seized power the
following morning, the Russians and the rebels were already at grips,
and the crowd was lynching members of the A.V.O.

That evening we had dinner at the Fontanella with Guttuso and
his wife; he took us on to Chez Georges near the Via Veneto, where a
guitarist was playing old Roman songs. Nervously, we repeated what
had happened again and again, without understanding what it all
meant. Confronting an unpopular, or even a hated regime, rebelling
against excessively harsh living conditions, de-Stalinization had un-
leashed an explosion of nationalist and vengeful feelings, just as it
had in Poznan; as in Poznan, the police had fired on the crowd; but
why had Russian tanks been so quick to intervene, thereby giving
the lie to the promises of the 20th Party Congress, violating the
principle of nonintervention, covering the U.S.S.R. with the taint of
a crime that would convict it in the eyes of the world of being an
imperialist power and an oppressor? Shattered though he was, Gut-
tuso could still not envisage breaking the innumerable bonds attach-
ing him to his party; he fought back his despair with words, gulping
glasses of whisky that brought the tears to his eyes. Sartre, who was
almost as committed as Guttuso by the efforts he had made to reach
an agreement with the Communists, defended himself in much the
same way. We thought too about the Left in France, which at that
moment needed more than ever to keep its ranks tightly closed—we
had just heard about the idiotic capture of Ben Bella—and which
would be completely and finally split apart by this unjustifiable trag-
edy. The appearance of Anna Magnani made a diversion; she sat
down at our table and sang a few songs very quietly, accompanied by
the guitarist. Then we returned to our perplexities. There were mo-
ments when I felt like parodying Dos Passos: "Sartre emptied his
glass of whisky and said agitatedly that the U.S.S.R. was Socialism's
last chance and had betrayed it. 'We could neither approve of this

intervention nor condemn the U.S.S.R.,' said Guttuso. He ordered another drink and the tears came to his eyes." But this humor was shattered in an instant at the thought of the real anguish which at that moment, as we well knew, was holding millions of men in its grip.

*Paese Sera* and *Unità* printed extremely impartial comments on the facts. In Turin, one day when one of the issues of *Unità* defended the Russian intervention—the local editions varied from place to place—a group of workers forced their way into the office and protested. We were able to derive some comfort from the honesty of the Italian Communists. And the situation looked as though it might evolve in the direction of agreements similar to those that had been reached in Poland. Nagy proclaimed an amnesty; workers' councils and revolutionary committees were formed throughout the country; he promised, and obtained, the withdrawal of the Russian troops stationed in Budapest. When I left Sartre at Milan, where I was to stay with my sister for a short while, we were feeling better about things. But with Cardinal Mindszenty out of prison and talking on the radio, the demands of the rebels and the concessions made by Nagy, our anxiety revived. Nagy announced that the old parties were to be reconstituted and that there were to be free elections; despite a visit from Mikoyan and Suslov, he repudiated the Warsaw Pact and insisted on Hungary's remaining neutral; the hunt for members of the A.V.O. was still going on, and "refugees from the interior" were beginning to appear; the situation had reached the point where socialism was in danger. Russian tanks surrounded Budapest. On November 3rd, A. Koethly, a Socialist, and members of the various other parties became members of the government, which now included only three remaining Communists: Nagy, Kádár and Malester.

The following afternoon, Lanzmann having come down by plane to meet me, we left Milan in the car, spending the night at Susa; it was drizzling; we bought the newspapers and sat shivering in a dismal café to read them. Moscow was accusing Nagy of having chosen "the Fascist path"; the Russians had attacked Budapest and bombarded the Cespel factories. We chewed anxiously on this news all evening. We were worried about what was going on in Egypt, too. The whole summer, ever since the nationalization of the Suez Canal, there had been a violent propaganda campaign against Nasser in England and France. On October 30th, Mollet and Eden had deliv-

ered an ultimatum. Mollet had been urging on the Israeli Army against him and, strongly supported by the French Air Force, it had just won the battle of the Sinai desert. Despite the opposition of the rest of the world, an Anglo-French landing was expected at any moment.

The following morning we drove out of Italy over the Montgenèvre Pass; between a bright blue sky and the glowing russet of the land below, the snow sparkled in sheets of joy; Budapest and Cairo were a long way off; we talked about them; but all that seemed real to me was the splendor of the mountains under the sun. Then we went into an inn and ordered lunch. The owner was laughing as he talked to some of the other customers, and slapping himself on the thigh: "Oh they caught them all right—in midair, like a lot of butterflies!" Immediately I understood what it meant to be back in France: I had fallen into a cesspool. By giving the order to shoot down that Moroccan plane, Max Lejeune and Lacoste had deliberately sabotaged the possibility of a negotiation. On the international level, France had chosen the solitary and shameful path from which it was never to deviate again. And without gaining anything by it, for in Algeria new leaders were already taking over. There had been anti-French riots in Tunis; in Meknès, some Europeans had been massacred. But the innkeeper and his customers, and so many millions of others besides, all thought it was very, very funny; the phrase was so French, so witty. "Like butterflies!" they said again and again. And the calm splendor of the autumn was forced to give way to their hilarity. I felt the war inside me again, all wars, all the things that divide us, that tear the world apart.

When I got to Paris, the country was expressing public indignation at the new "national humiliation" that had just been inflicted on it. On November 5th, English and French paratroopers had landed in Egypt; on the 6th, under pressure from the U.N., from the United States, from Khrushchev, from the British Labour Party, they had left again. In fact, in the privacy of their homes, what really concerned my fellow countrymen was the gas rationing that the blockade of the Canal entailed.

On his return from Italy, Sartre was disgusted by the French Communist newspapers. Referring to the events in Hungary, *Libération* used the phrase "Fascist putsch," André Stil called the workers of Budapest "the dregs of the fallen classes," and Yves Moreau labeled them "Versaillais." In an interview in *L'Express,* Sartre ex-

pressed his unqualified condemnation of the Soviet aggression; he
said that he was "regretfully but completely" breaking off all rela-
tions with his friends in the Soviet Union, and even more definitively
with those responsible for the policies of the French Communist
Party. He had made such efforts, for such a long time, to reach some
sort of agreement with them and keep it intact! Nevertheless he did
not hesitate for an instant: the Russian intervention had to be de-
nounced in the name of that very socialism it was claiming to defend.
I joined with him and some other writers in signing a protest against
the Russian intervention that was published by *L'Observateur*. After
a few days of fighting, the rebellion was stamped out; but the Hun-
garian workers went on a long strike in protest against this "return to
order." We were infuriated by the lies printed in *Humanité*, accord-
ing to which the members of the A.V.O. who had been lynched were
workers murdered by Fascists. But from another point of view we
could not help but wonder at the generous internationalism of our
French chauvinists: because Russian tanks had fired on the Hungar-
ian workers, they demanded that the French Communist Party
should be suppressed. These purehearted lovers of justice—their
hands dripping with Algerian blood—delivered themselves of the
highest-sounding phrases on the subject of a people's right to self-
determination; to strengthen this argument, they set fire to the
headquarters of the Communist Party and led an attack on the offices
of *Humanité*. Budapest: what a godsend for the reactionaries! Their
old weapons had been blunted by the changes inside the Soviet
Union and by the events in Poland that October; now they had a
brand-new one handed to them on a platter; they are still using it.
When Malraux is asked if he has no regrets about betraying *Man's
Fate*, he answers: Budapest. Written, spoken, all through that year
the interminable dialogue went on: "What about Suez?—Well, what
about Budapest?" You were forbidden to speak out against the Suez
landing unless you had shouted equally loudly about the Russian
tanks. The Thierry Maulniers were very disappointed that Sartre
had in fact shouted, and they congratulated him on his adroitness
with very sick-looking smiles on their faces.

The events in Hungary, disguised and interpreted in so many
different ways, seemed to us to be less and less easy to disentangle the
more we heard about them. The Hungarian workers were certainly
not "Versaillais"; but when Radio Free Europe broadcast encourage-
ment to the rebels there was no doubt that the Right had been

counting on nothing less than a counterrevolution. Was this the case? And if so, since we believed that socialism, even a distorted, impure form of socialism, was the only hope of mankind today, how should we judge the Soviet reply?

I remember one long evening we spent, among others, discussing this problem at Fejtö's; his wife was there, Sartre, Martinet, Lanzmann, the Polish Ambassador, and a Polish journalist on *Tribuna-Ludu* who had actually been present during the insurrection. Fejtö had already written a book and an incredible number of articles on the subject; he was so exhausted, his wife told us, that she had been forced to give him injections to keep him going. The Polish journalist was of the opinion that initially the insurrection was a unanimous expression of the people's discontent; he didn't believe for an instant that there had been any émigrés, National Socialists, or Fascists playing roles of any importance. But he did think that without the second Russian intervention, the slide toward the Right which began between the 23rd and the 31st of the month would have led to civil war; if Hungary had rallied to the Western bloc, there would have been such violent repercussions in the satellite countries that a world war would have broken out. Fejtö, who was savagely anti-Soviet, admitted that the reactionary forces had tried to keep the rebellion going for their own profit, especially in the western part of the country; yes, there was a threat of civil war and the victory of socialism was not certain. Then should the Russians have risked its being defeated? the Pole insisted. Sartre's reply—which he developed later in *Le Fantôme de Staline*—was that the refusal to face this test automatically implied the choice of a certain political standpoint: that of the blocs and the cold war, in short a Stalinist standpoint. Hungary, all the Communist Parties and the Soviet Union itself would pay dearly for this decision on the part of the Russians; better to have allowed free elections than to do this violence to a whole people.

The Communist press dug itself in behind its barrage of lies; André Stil's "smile of Budapest" stuck in a good many throats. Several of the Party's intellectuals expressed their disapproval more or less discreetly. Rolland was excluded; Claude Roy, Morgan, Vailland received warnings. There was a violent altercation within the headquarters of the C.N.E., of which Sartre was a member, between Aragon and Louis de Villefosse who then left the Committee, taking several sympathizers with him; Vercors and Sartre decided it was preferable to stay; but they were very dissatisfied with the text of the

declaration that Aragon finally produced for signature. Fearing a general hostility, the C.N.E. canceled its annual sale. The Committee of Intellectuals was shaken by violent disputes; certain members, some ex-Communists in particular, wanted to railroad through a motion containing a radical condemnation of the U.S.S.R.; it would have been tantamount to throwing all the Communist members off the Committee. Others thought that for us, as Frenchmen, peace in Algeria still remained the primary objective and that we shouldn't allow ourselves to be disunited. This was the position held by most of my friends, and Lanzmann defended it.

Nagy, who had taken refuge in the Yugoslav Embassy, was kidnapped by the police. We heard news of fresh arrests. The writers of the Soviet Union sent a letter to the writers of France deploring the attitude taken by the latter and defending the attitude of the U.S.S.R.; the signers of our original protest replied with a new declaration quite as unequivocal as the first but giving the reasons for our attitude in more detail and also leaving a door open: *"We are prepared to meet you in a country of your choice in order to continue this discussion."* Sartre, Claude Roy and Vercors intervened at the C.N.E. on behalf of the Hungarian journalists who had been condemned to death. This time Aragon was in agreement with them.

In January *Les Temps Modernes* published a special issue on Hungary that had been almost entirely produced between the time of the 20th Congress and the events of October. In *Le Fantôme de Staline,* Sartre explained his position in the matter: *"True political action must necessarily contain an implicit moral evaluation of itself."* This was the basis of his criticism of the Soviet Union's relations with the satellite countries and of his disapproval of the Russian interventions. Nevertheless, he reaffirmed his adherence to socialism as embodied in the U.S.S.R., despite the errors of its leaders. Budapest had been a heavy blow to him. But, in the final analysis, he had at least been able to test on this occasion the line of conduct he had laid down for himself: to side with the U.S.S.R., and to count on no one but himself to maintain his own point of view.

He did not fall back into solitude, he was not reconverted into an enemy of the people. Coming after the 20th Congress and the events of October in Poland, Budapest forced the Communist intellectuals to ask themselves certain questions. Many "sealed their lips" and refused to yield an inch. But many others felt that their very deepest beliefs had been jeopardized. "When I think of my articles on Hun-

gary!" said one woman I knew who was a Communist sympathizer. "How could I have painted such a rosy picture? Though of course, that was under Nagy!" Certain militant Communists noisily reproached themselves for having insisted on the guilt of Rajk and Slansky. Others, like Hélène Parmelin, while refusing to indulge in what she called a "mental strip-tease," a form of entertainment the anti-Communists could watch with a jubilant sense of their own virtue, nevertheless did reawaken their critical faculties; several groups were formed with the intention of remaining within the Communist Party, but without accepting all its orders. *La Tribune de Discussions,* founded in the spring of 1956 by some militant Parisian workers dissatisfied with the attribution of special powers to the government, won the support of a certain number of intellectuals. In December, others started *L'Étincelle,* which in April was to be amalgamated with *La Tribune.* What they wanted was not to *revise* Marxism from the outside, but to *change* it, for far from having surmounted them, they were finding themselves caught inside the various Socialist contradictions. Sartre had never ceased to demand a living Marxism; discussions between him and the Communist opposition grew more and more frequent; he had many with the Polish intellectuals as well. Polish-Soviet agreements were signed in Moscow on the Leninist basis of equality of rights; the Stalinists were removed from power, a large number of militants were rehabilitated, and the unions were encouraged in their defense of the workers' interests. The Congress of Writers expressed its condemnation of Socialist Realism. Gomulka was attempting to allow liberty its rightful place, without weakening socialism. Sartre's independent attitude toward the Communist Party meant that to the writers of Poland his words seemed specially intended for them. In November we were invited to the Polish Embassy; there we met Jan Kott and Lissowski, who asked Sartre to write an article for a magazine he was running. Sartre's plays were put on in Warsaw, and *Les Temps Modernes* on its side devoted an issue to Poland.

Even with the orthodox Communists, even with the Soviet Union, our bridges were not burned. Sartre had broken with the French Communist Party but not with the C.N.E. and not with the Peace Movement. He found that *The Respectful Prostitute* was still being performed in Moscow; it was put on in Czechoslovakia and even, a little later, in Hungary. Toward the spring of 1957, he twice met Ehrenburg, and, although neither man changed his position,

they were able to carry on a very cordial conversation. Shrewd and faithful to the spirit of the 20th Congress, the Russians had decided not to alienate the sympathizers who had refused to accept Budapest; Vercors, one of those who had protested, received an invitation from them in 1957. It was a new and important development, the discovery that one could attack the U.S.S.R. on a specific point without being considered a traitor. This moderate attitude allowed us to work side by side with the French Communist Party on the issue that was most burning for us all: Algeria.

# CHAPTER III

IT WAS NOT OF MY OWN FREE WILL, nor with any lightness of heart, that I allowed the war in Algeria to invade my thoughts, my sleep, my every mood. Camus' advice—hang on to your own happiness, no matter what—was exactly suited to my temperament. There had been Indochina, Madagascar, Cap Bon, Casablanca: I had always managed to regain my serenity. After the capture of Ben Bella and the Suez crisis, it was destroyed. The government was going to persist with this war. Algeria would win its independence; but not for a long time. At that moment, when I could not even glimpse the end of it all, the truth behind the restoration of peace in Algeria was finally brought into the light of day. Recalled conscripts had talked; information flowed in: conversations, letters written to myself or to friends, the reports of foreign journalists, more or less secret accounts distributed by small groups. We didn't know everything, but we knew a lot, too much. My own situation with regard to my country, to the world, to myself, was completely altered by it all.

I am an intellectual, I take words and the truth to be of value; every day I had to undergo an endlessly repeated onslaught of lies spewed from every mouth. Generals and colonels explained that they were waging a magnanimous, even a revolutionary war. We were treated to a spectacle fit only for a circus freak show: an army that thinks! The *pieds noirs* were clamoring for integration when the mere idea of a single University was enough to make them recoil in horror. They declared that aside from a few ringleaders, the population liked them. Yet during the "rat hunt" that followed Frogier's funeral, they made no attempt to distinguish between the *good* Mos-

lems, *their* Moslems, and the others; they lynched anyone they could lay their hands on. The press had become a lie factory. It would not breathe a word of the mass graves that had to be dug for the victims of Fechoz and Castille,[1] but shrieked blue murder at the assassinations that began the battle of Algiers. The paras surrounded the Casbah, the wave of terrorism was brought to a halt; we were not told by what means. The newspapers were afraid not only of seizure and legal proceedings but also of a drop in circulation; they simply printed what their readers wanted to hear.

For, provided it was properly costumed for them, the people of France were prepared to accept this war with a light heart. I was not at all upset when the ultras demonstrated on the Champs-Élysées; they demanded that we fight "to the very end," and that the Left be outlawed; as they went by, they smashed the windows of the tourist agency underneath the offices of *L'Express*. They were just ultras. What did appall me was to see the vast majority of the French people turn chauvinist and to realize the depth of their racist attitude. Bost and Jacques Lanzmann—who had taken my old room in the Rue de la Bûcherie—told me how the police treated the neighborhood Algerians; there were searches, raids and manhunts every day; they beat them up, and overturned the vendors' carts in the open-air market. No one made any protest, far from it; the people there—who had never had so much as a finger laid on them by a North African—congratulated themselves on being "protected." I was even more stupefied and saddened when I learned with what docility the young soldiers sent to Algeria became accomplices in the methods of pacification.

My natural inclination to torture myself was so slight that when Lanzmann gave me the *Dossier Müller* to read, my first reaction was just to put it out of sight. Today, in this grim December of 1961, like most of my fellow creatures I suppose, I am suffering from a sort of tetanus of the imagination. I read Boudot's statement in the Lindon trial: *"One evening, I saw some men coming up to my table with leaden faces; they were members of the engineering corps who had just buried alive four fellaghas between the ages of twenty and seventy-five. The old one had been the last to die. He was so afraid, they told me, . . . that the sweat from his body rose like steam in*

---

[1] The plastic bomb placed in the Casbah by Fechoz in July killed 53 persons and wounded innumerable others. On August 6th, Castille left another one, only slightly less murderous, there.

*the night air. They died gradually as the bulldozer threw the earth on top of them."* Then I read Leuliette's statement: *"These prisoners had been hung by their feet. I saw them in the morning, and in the evening they were still there. Their faces were quite black, and they were still alive. I should also like to instance the use of electric current. It was when the genital area was affected that the victims cried out most. It was also used on the inside of the mouth."* I read this and moved on to another article. That, perhaps, is the final stage of demoralization for a nation: one gets used to it.

But in 1957, the broken bones, the burns on the faces, on the genitals, the torn-out nails, the impalements, the cries of pain, the convulsions, they reached me, all right. Müller had publicly related his experiences while serving as a soldier in Algeria, and his courage had earned him his death from a French bullet; it was our duty to read it and make it as widely known as possible. But I had to force myself. There were many other accounts of the same kind to inflict on myself. For every one we published in *Les Temps Modernes,* we received ten. Some appeared in *Esprit* as well. Whole battalions were looting, burning, raping, massacring. Torture was being used as the normal and indispensable method of obtaining information; it was not a matter of "incidents," of isolated excesses, this was a system. In this war a whole people had risen against us, and every individual member of that people was a suspect. The only way to stop the atrocities was to stop the war.

My compatriots did not want to know anything about all this. In the spring of 1957, the truth was already available, and if they had greeted it with as much zeal as they had the revelations about the Soviet work camps, then nothing could have prevented its being brought to the eyes of the world. The plot to hide it succeeded only because the whole country was an accomplice to it. The ones who did speak were not listened to, the others shouted louder to drown them out, and if people did hear a few rumors in spite of themselves, then they went about forgetting them as fast as possible. Pierre-Henri Simon's book *Sur la Torture,* which introduced the public to the *Dossier Müller,* was repeatedly discussed in the columns of *Le Monde* and *L'Express,* which are not, after all, secret publications. The entire left-wing press reviewed the collection called *Les Rappelés Témoignent,* and Sartre wrote an article about it called *"Vous Êtes Formidables"* in *Les Temps Modernes;* the authors of these accounts were mostly seminarists and priests, certainly not people in

the pay of Nasser or Moscow; in any case, no one accused them of
lying; people simply stopped their ears; nor was Servan-Schreiber,
who had been recalled a few months earlier to serve as a lieutenant
in Algeria, in the pay of the Arab League or the U.S.S.R. His eye-
witness account, which appeared first in *L'Express* and later in book
form, received an even greater degree of publicity when an official
inquiry was instituted against him. Despite his respect for the Estab-
lishment and military tradition, even though he readily swallowed
the mystique of the "black commandos," the crimes he described
should have had some effect on public opinion: Arabs shot down "for
the fun of it," prisoners brutally murdered, villages burned, mass ex-
ecutions, etc. No one turned a hair.

Murderers with bazookas were allowed to go where they liked.
Yveton, who had placed a bomb in an empty factory after taking
every precaution to avoid killing anyone, was guillotined. Why had
this Frenchman taken up the cause of the Algerian people? Why
were doctors, lawyers, teachers and priests in Algeria helping the
F.L.N.? People said, "Oh, they're traitors," and felt that was answer
enough. The public was told about the "suicide" of Larbi Ben
Mihidi, who was found hanged from one of the bars of his window,
bound hand and foot. After the "suicide" of Boumendjel, who had
been kept in solitary confinement and tortured by the paras for
several weeks and then thrown off a roof, Capitant, a professor of
law at the University of Paris, stopped his lectures as a protest; his
gesture caused violent repercussions. On March 29th, General de La
Bollardière caused a sensation: he asked to be relieved of his com-
mand because he disapproved of the methods the French Army was
using. The case of Djamila Bouhired was reported both throughout
France and abroad. The Left's campaign against the use of torture
must have been a matter of public knowledge, since the government
was sufficiently worried by it to set up a "Safeguard Committee" to
protect itself.

I had been labeled, along with several others, anti-French. I be-
came so. I could no longer bear my fellow citizens. When I dined out
with Lanzmann or Sartre, we hid away in a corner; even so, we could
not get away from their voices; amid the malicious gossip about Mar-
garet, Coccinelle, Brigitte Bardot, Sagan, Princess Grace, we would
suddenly hear a sentence that made us want to run for the door. I
went with Lanzmann to Les Trois Baudets, where Vian was singing.
In one of the sketches the actors unfolded newspapers: rebel units

destroyed, a *mechta* captured. I read: Rivet, Oradour; and the laugh-
ter of the audience filled me with loathing. Another evening we went
to hear Greco sing at the Olympia. A *pied noir* stood on the stage
and told stories about the *"bicots";* my palms were wet with shame.
At the cinema we had to swallow newsreels showing the fine work the
French were doing in Algeria. We stopped going out. Just having a
coffee at a counter or going into a bakery became an ordeal. We
heard things like: "It's all because the Americans want our oil," or:
"Why don't they just put all they've got into it and get it over with?"
Outside the cafés, the customers would spread *L'Aurore* or *Paris-
Presse* on their tables, and I knew what was going on in their heads:
the same thing that was there in the paper; I couldn't sit down near
them any more. I had liked crowds once; now even the streets were
hostile to me, I felt as dispossessed as I had when the Occupation
began.

It was even worse, because, whether I wanted to be or not, I was
an accomplice of these people I couldn't bear to be in the same street
with. That was what I could least forgive. Or else they should have
trained me from childhood to be an S.S., a para, instead of giving me
a Christian, democratic humanist conscience: a conscience. I needed
my self-esteem to go on living, and I was seeing myself through the
eyes of women who had been raped twenty times, of men with
broken bones, of crazed children: a Frenchwoman.

My sister and her husband had come back to live in Paris. He was
a Socialist and defended Mollet's policies. "All the same, we've put a
stop to the terrorism in Algiers," he told me. I knew—only partially,
but already enough for my peace of mind—what this mock peace had
cost. "After all, these cases of torture are only exceptions," was an-
other thing he told me. When he said such things I would fly into fits
of rage I tried to repress. But whenever I said good-bye to him, I
could tell from the pounding of my heart, the weight on the back of
my neck, the buzzing in my ears, that the tension inside me had
mounted.

I wanted to stop being an accomplice in this war, but how? I
could talk in meetings or write articles; but I would only have been
saying the same things as Sartre less well than he was saying them. I
would have felt ridiculous following him like a shadow at the silent
demonstration he took part in with Mauriac. Today,[1] however little
it might affect the outcome, I could only throw all my weight into

[1] Winter, 1961.

the struggle. In those days, I still wanted to feel that an effort would not be in vain before I was willing to make it.

We knew Francis Jeanson very well. He had visited Sartre in 1946 with the manuscript of *La Morale de Sartre*. During the war he had crossed the Spanish frontier to join the Free French; he had been captured and put in a concentration camp. He was released after several months, but the life there had ruined his health, and in Algeria he had been obliged to accept an office job. He became friendly with many Moslems. After the Liberation he had gone back to Algeria quite often and followed events there very closely; this was how he had been able to write *L'Algérie hors la Loi*. He was a contributor to *Les Temps Modernes* and its manager for four years. In 1955 Éditions Seuil had published his *Sartre par Lui-même*. There were very few people who understood Sartre's thought as well as Jeanson. After Budapest he had blamed Sartre for what he considered too intransigent an attitude, and relations between us had been cold since then. Mutual friends informed us about his work with the F.L.N. Neither Lanzmann, Sartre, nor myself were yet ready to follow him. In Algeria there was only one choice, Fascism or the F.L.N. In France, we thought, it was different. It seemed to us that the Left had nothing to teach the Algerians, and that *El Moudjahid* was quite right to put them in their place. But we still believed that it was possible to work for their independence by legal means. Knowing Jeanson as we did, we were sure he had not committed himself in such a way without mature consideration; there was no doubt that he must have had very good reasons. I shied away from the idea all the same. I had met two people who were working with him,[1] and they had shocked me by the flippancy of their chatter; I wondered whether clandestine action might not be a way of getting rid of guilt. Perhaps those who had taken this path already nursed a desire to cut themselves off from the French nation, bound up with feelings of resentment and unresolved hostilities?[2] I defended myself against the doubts their choice aroused in me by the absurd maneuver I so much detest of attributing it to a psychological rationalization on their part, without asking myself if my own distrust was not

[1] They soon stopped doing so, moreover.

[2] Jeanson's reply to these doubts was unexceptionable: "When we undertook the action we are being blamed for, none of us lacked work, we all loved our respective professions, and none of us was considered mediocre in our exercise of them. Nor could we possibly have been ignorant of the fact that France was the only country in which we had a chance of feeling completely at home and of finding work that would suit our various aptitudes."

dictated by subjective motives. I had not understood that Jeanson was not rejecting his status as a Frenchman by helping the F.L.N. Even if I had been more lucid in my appraisal of what he was doing, the fact remained that participation would have meant going over to the traitors' camp in the eyes of the country as a whole; something inside me—timidity, vestiges of mistaken beliefs—still prevented me from contemplating such a thing.

In October 1956, my essay on China completed, I set out to tell the story of my childhood. It was an old project. I had tried to write about Zaza several times, in novels and short stories. I had attributed my own desire to write about myself to the character of Henri in *The Mandarins*. On the two or three occasions I had allowed myself to be interviewed I had always been disappointed: I would have liked to ask the questions as well as give the answers:

*I have always had the secret fantasy that my life was being recorded, down to the tiniest detail, on some giant tape recorder, and that the day would come when I should play back the whole of my past. I am almost fifty, it is too late to cheat: soon everything will sink into the abyss. My life can only be recorded in a general way, on paper and by my own hand; so I shall make a book of it. When I was fifteen I wanted people to read my biography and find it touching and strange; all my ambitions to become "a well-known author" were directed to this end. Since then I have often thought of writing it myself. I have long been a stranger to the exaltation this dream once aroused in me; but the desire to make it a reality has always remained in my heart . . .*

*. . . I spent the first twenty years of my life in a big village that stretched from the Lion de Belfort to the Rue Jacob, from the Boulevard Saint-Germain to the Boulevard Raspail: I still live there. From my worktable I look out and watch a group of schoolgirls walking across the Place Saint-Germain-des-Prés: one of them used to be me. She walks home just as the first streetlamps come on; she will sit down in front of a blank sheet of paper, she will make marks on it just as I am doing on this sheet now. There have been wars and journeys, and deaths and faces; nothing has changed. In the mirror, I should see a different picture, but there is no mirror; there wasn't then. There are moments when I don't quite know whether I am a child playing at being a grown-up or an aging woman remembering her childhood.*

*No. I do know; I am myself, today. The little girl whose future has become my past no longer exists. There are times when I want to believe that I still carry her inside me, that it is possible to tear her free from the wrappings of my memory, smooth her worn eyelashes, and sit her down beside me just as she used to be. It isn't possible. She has disappeared without leaving even a tiny skeleton to remind me that she did once exist. How am I to call her back from this oblivion?*

For eighteen months, sometimes up, sometimes down, through difficulties, through joys, I kept at this work of resurrection: of creation, for it made as many demands on my powers of imagination and reflection as it did on my memory.

Sartre meanwhile, at Lissowski's instigation, was examining the relation between Existentialism and Marxism; he wrote an essay which later became *The Question of Method.* Once under way, he began the work he entitled *Critique de la Raison Dialectique.* He had been pondering the subject for years, but had felt that his ideas were not yet ripe; he had needed some external stimulus before being able to take the plunge. At the same time, a publisher asked him for a study of a painter to be published as one of a series of art books; Sartre had always loved Tintoretto; even before the war, and increasingly since 1946, he had been interested by the Venetian master's conception of space and time. He decided to devote a long essay to the subject.

My *Memoirs* absorbed me less totally than my study of China; I read more. My friends lent me various books by Americans concerned with analyzing the society of their own country, all of which tended toward the same conclusions: Riesman's *The Lonely Crowd,* the essays of Wright Mills, Whyte's *The Organization Man,* Spectorsky's *The Exurbanites.* They described both the causes and the consequences of the conformism that had so disappointed me in 1947, and which had become even more pronounced. America, having become essentially a consumer society, had passed from the inner-directed society of the Puritan era to the other-directed stage in which the individual is governed not by his own judgment but by the behavior of other members of society; these books gave an account of the startling ways in which the morals, education, life style, science and feelings of the nation had been transformed. This country, once so passionate about individualism and still scornfully calling the Chinese "a nation of ants," had itself become a nation of sheep;

repressing originality, both in itself and in others, rejecting criticism, measuring value by success, it left open no road to freedom except that of anarchic revolt; this explains the corruption of its youth, their refuge in drug-taking and their imbecile outbreaks of violence. Of course, there were still men in America who were using their eyes to see with: these books themselves, other similar ones and certain films were proof of that. There were a few literary magazines, a few almost secret political newsletters that still dared oppose public opinion. But most of the left-wing newspapers had disappeared. *The Nation* and *New Republic* preserved only the narrowest margin of intellectual independence. The *New Yorker* had become as much a part of the Establishment as *Partisan Review.*

My aversion to America had not diminished since the Korean war. The government was fighting segregation more or less vigorously; a large part of the country was rejecting it outright, and the industrialization of the South doomed it to eventual extinction. Yet it had provoked several appalling scandals during the past few years: the execution of MacGee; the lynching of Emmet Till, accused at the age of fourteen, without proof, of having raped a white woman, and the acquittal of his murderers; the violence inflicted in Alabama on colored students who attempted to mix with whites; even without these outbreaks I knew what the implications were, and that they had not changed. As for the anti-Communist fanaticism of the Americans, it had never been more virulent. Purges, trials, inquisitions, witch-hunts—the very principles of democracy had been rejected. Algren had seen his passport taken away simply because he had belonged to the Rosenberg Committee. In foreign affairs, America was using its dollars to support, against the demands of its own people, men it had bought who, furthermore, were often more concerned with their own interests and served the Americans very badly. If voices were raised against this policy, they must have been effectively silenced: I never heard one.

What then had happened to the writers I had liked and who were still living? And what did I think of them today? Reading them with a fresh eye, discussing them with Lanzmann, I revised many of my earlier judgments. The early novels of Wright, Steinbeck, Dos Passos and Faulkner still kept the merits, however unequal, I had previously seen in them. But we were no longer politically in agreement with Wright, who had become openly anti-Communist; he no longer seemed interested in writing. Steinbeck had foundered in patriotism

and foolishness; Dos Passos' talent had dried up ever since he had rallied to Western values: instead of a world of verminous depths, determined to mask its own putrefaction by words and gestures, he was now describing only the diseased, hardened skin. In *A Fable,* Faulkner too, though on the surface it was just the story of the Unknown Soldier, was in fact retelling the Passion of Christ; as if we needed that again! *Intruder in the Dust* showed that racism in the South often conceals nuances and values incomprehensible to Northerners blinded by a simplistic rationalism. In 1956, Faulkner had said in an interview that the South should be left to settle the Negro problem in its own way; he openly declared himself on the side of the whites, even if it meant going out into the street and shooting Negroes. As for Hemingway, I still admired some of his short stories, but *A Farewell to Arms* and *The Sun Also Rises* disappointed me on a second reading. He had done a great deal to further the technique of the novel, but now that the freshness of his innovations had faded, the tricks and the shallowness of his characters had become only too apparent. Even more important, I discovered that his conception of life was antipathetic to me. His individualism implied a deliberate complicity with capitalist injustice; it was the individualism of a dilettante rich enough to finance costly hunting and fishing expeditions and treating his guides, his servants, the natives he encountered, with ingenuous paternalism. Lanzmann pointed out the taint of racism in *The Sun Also Rises;* a novel is a microcosm: if the only coward in it is a Jew, the only Jew a coward, an inclusive if not a universal relation is established between these two terms. Apart from which, the implication of the complicity Hemingway invites us to feel with him at every turn of his plots is that we too are aware of being, like himself, Aryan, male, endowed with wealth and leisure, and experiencing our body only in confrontations with sex and death. He speaks as one Seigneur to another. The geniality of the style may mislead, but it is no coincidence that the Right has woven him so many laurel wreaths; it is the world of the privileged that he has described and exalted.

I was not very familiar with the younger writers. I had liked the work of Carson McCullers very much, and met her once in Paris, ravaged by drink, puffy, almost paralyzed; it appeared she was no longer writing. I had also glimpsed Truman Capote once at the Wrights', lying on a divan in pale-blue velvet pants; he had talent, but didn't seem to do much with it. People had praised Salinger's

*Catcher in the Rye* rather too much; I found it little more than promising. And unfortunately poetry was beyond me; I didn't know the language well enough to judge for myself, and I mistrusted translations. In short, in writing as in other things, I could find nothing in America that could touch me, except perhaps for its past. It aroused the same bitter feeling of disapppointment as France itself. I still retained vivid and grateful memories of its landscapes, its cities, its great spaces, its crowds and its smells; I liked its swift, swarming language, informal, vigorous, and so well suited to catch the very movement of life; I thought with affection of my American friends who had given me so much pleasure by their cordiality, by the openness of their laughter and their sudden humor. But I knew that if I were to go back to New York or Chicago, the air I breathed there would be, like that of Paris, polluted.

The best moments of that year were the two weeks I spent at Davos with Lanzmann. There I had rediscovered the pleasures of sun and snow, and experienced the relief of not having to listen to French people talking. In the early summer I once more felt the joy of leaving this country, where a Socialist government was suppressing celebrations on the 14th of July. I went with Lanzmann to the south of Italy. The roads were better than in 1952, the hotels more comfortable; the cities had all grown larger, and many had managed to do so with elegance. But the country seemed to be as poor as ever; around the Gulf of Tarento a few empty gestures had been made toward agrarian reform; there were cottages, each named after one saint or another, sticking up in the middle of the marshes which had been parceled out among the peasants; they had no water or fertilizers, so nothing grew. We passed *braccianti* on the village squares, and the life of the provinces hadn't changed since Fellini had portrayed it in *I Vitelloni;* drinking *grappa* at about eleven one evening on a deserted street in Cantazaro, we watched a scene that was a faithful evocation of the spirit of his film: some young men were running along after a *topolino,* they caught it, shook it, stuffed up the exhaust with paper, it started up again, the plug shot out to the sound of laughs that sounded more like yawns; the *topolino* turned around, the whole thing began over again. Over and over again. We got tired first.

We went on down toward Sicily; one evening, as we came around a bend in the road, it appeared in front of us in the fading dusk,

speckled with lights and fringed with mist; we stopped; another car drew up behind us. "Looking at the view?" asked the driver. "Me too. Every time I pass this way I stop and look at it." He was a policeman. He made a sweeping gesture with his hand and said emphatically: "It's the second most beautiful view in the world." "Oh?" I said. "And which is the most beautiful?" He hesitated. "That I don't know." I visited Sicily again; I saw Ragusa, sullen and prosperous, its baroque beauties girdled by a zone of very pretty new apartment houses. We fled from Lipari, where the water was black with oil and infested with French tourists. After a stop at Cape Palinuro, which Darina Silone had pointed out to me years before, we drove back up to Rome. We took with us a Yugoslav refugee who hitched a ride as we were leaving Eboli; he had been given several days' leave from the Italian camp where he had been interned with other stateless Yugoslavs so that he could look for work, but he was penniless, and if he was late getting back to camp he risked penalties: another instance of the almost inextricable situations I have so often encountered along the road.

I stayed in Rome with Sartre for over a month. Our Communist friends kept their distance and we saw very few people, but I was very happy at the Hôtel d'Angleterre, just off the Piazza di Spagna, and I worked well. Sartre wanted a rest after the *Critique*. He had been to Venice to take another look at the Tintorettos, and began writing about them. He also did a preface for *The Traitor* by Gorz.[1]

I felt I should like to spend two or three weeks breathing a less citified air than that of Rome. Sartre suggested we go to Capri. The Roman newspapers were saying that Naples was being ravaged by an epidemic of Asian flu; but Capri is not Naples, and the epidemic would undoubtedly move north. We set out. In Capri, we read in the Neapolitan newspapers that the Asian flu was ravaging Rome. Each city delighted in exaggerating the disaster that had befallen the other.

I had been afraid that Capri would be flooded by tourists and snobs; as it turned out, they all descended on the same places at exactly the same times—as they do in Venice, or Florence, as they do everywhere. We had no difficulty avoiding them. We stayed in an uninviting hotel right in the center of the town; but since it was in a

1 Ten years after our meeting in Geneva, Gorz, who was then living in Paris, had brought Sartre a philosophical work, intelligent but too obviously derivative of *Being and Nothingness*. After that he had written an essay about himself which was excellent.

district where no car could penetrate we enjoyed both solitude and silence. We walked along the sea, we gazed at the Faraglioni, which gave Sartre as much pleasure as Giacometti's sculptures; we passed above the lurid red villa Malaparte had left in his will to the writers of the Chinese People's Republic, who were finding it rather an embarrassment; sometimes we climbed up as far as the palace of Tiberius; generally we stopped lower down in some deserted open-air café, or else we lunched off a cake or a sandwich with a glass of white wine, while we sat and watched the sun on the rocks and the sea. When he was writing *Le Dernier Touriste,* Sartre had done research on all these places; he also knew a great many anecdotes and bits of gossip about life on Capri. I persuaded him to let himself be hauled up with me by chair lift from Anacapri to the top of Monte Solaro; his delight in the charms and glories of this ascent was rather less than mine, but he took great satisfaction in being able to take in the subtle lines of the whole island at a glance.

To drink our coffee in the morning, and every evening after dinner, we went and sat on a terrace of the *Salotto,* either before the *Führungen* invaded it or after they had evacuated it. After midnight, there would only be a scattering of people left at the bottom of the staircase that looked as noble and remote as a set for a play; alone, in couples, in groups, people would walk up or down it, stop at the top of the steps, sit down on them, or melt away into the darkness beyond.[1] They seemed to be acting in some mysterious and very beautiful play; their gestures, their poses, the colors of their clothes, among which we recognized the same pink Tintoretto used in his paintings, all seemed preordained and inevitable; and in a flash the illusion, so long forgotten, lived again: our life was as rich, as rigorous, as the stories people tell. Sartre talked to me about his book. He was working slowly, carefully, shaping each sentence; there were some I said to myself over and over again with delight, in the velvety silence of the night. In Capri that summer, the stones were as beautiful as statues, and words sometimes shimmered with light.

My sister was no longer living in Milan; we stayed there only one day, waiting for Lanzmann to join us. We went over the Tenda Pass to Nice, and from there to Aix where we spent the night. As we were driving under the starry sky, we glimpsed the coppery flash of a meteor: the Sputnik! The newspapers next day confirmed that it had in fact passed over that exact spot at that time. We thought with

[1] A brightly lit store has now ruined this décor.

friendship of this ephemeral little companion in space, and we gazed with new eyes at the old moon on which men might land within our lifetime. Against all expectations, the first satellite had been launched by the U.S.S.R.; that pleased us no end. The enemies of socialism were always trying to prove that it had failed by pointing out Russia's industrial and technical backwardness; this would give them the lie with a vengeance! The Americans talked about a "scientific Pearl Harbor." This achievement gave the Russians a military superiority on which we congratulated ourselves: if the country which has the least interest in starting a war has the greatest likelihood of winning it, then so much the better for peace. The "anti-Party" faction had been superseded; the spirit of the 20th Congress was taking root. Our hopes for peaceful coexistence were to become even stronger in April, when Moscow announced the Russian suspension of nuclear tests.

Revolts against American imperialism were brewing all over South America. There was a great deal of talk about the Cuban rebels when they walked into the entrance hall of a hotel two days before the Havana Grand Prix, kidnapped the famous racing driver Fangio, and released him after the race. Their leader, Castro, a lawyer exiled to Mexico by Batista, had returned with a few comrades in a boat. He was described as being a sort of bearded Robin Hood. The little guerrilla army under his command included some women members, a fact which caused a good many sniggers among the French bourgeoisie; apparently he could count on support from the Cuban population, from students and intellectuals among others; but it was difficult to believe him when he announced that he would shortly overthrow Batista by strikes, riots and open fighting.

The French Left was finding it difficult to recover from Budapest. The severity of the penalties inflicted on the rebels—Tibor Dáry, among others, was sentenced to nine years in prison—outraged the non-Communists, while the Party continued to assert its solidarity with Kádár. *L'Étincelle* was discontinued. Vercors, who had been a zealous supporter of the Party, explained in a rather funny little book called *P.P.C.* that he had had enough of being used to dress up the set and was now making his final exit. Even more serious than these dissensions among the intellectuals was the political apathy of the proletariat. At the end of October, after the success of the gas and electricity workers' strike, the C.G.T. and the C.F.T.C. launched

others. At Saint-Nazaire, strikes broke out with such violence that a worker was killed and the journalist Gatti was wounded. The Renault workers struck, as did the Civil Service and the teaching profession. But the very fact that these movements were launched at the height of a governmental crisis proved that they were apolitical. Neither the parties nor the unions linked them in a struggle against the Algerian war. Nevertheless, the Right became extremely uneasy; there was talk of conspiracies. *L'Express* created regional Forums as weapons against the threat of Fascism.

Lacoste's "last quarter of an hour" had been going on for over a year, and the methods of pacification being used were exactly the same as at the beginning. Telling some friends about the contents of an issue of *Les Temps Modernes,* Daniel, a contributor to *L'Express,* ended by saying: "And then of course there's the usual torture ration." It was monotonous, certainly: electric goads, immersions, hangings, burnings, rapes, funnels, stakes, nails torn out, bones broken; always the same boring program. But we saw no reason to change our tune until the Army and the police changed theirs.

A university graduate called Audin had been arrested in Algeria on June 1st; he had not been heard of since. The staff of the Lycée Jules-Ferry had demanded an inquiry; in vain. Early in December, one of his friends defended his thesis in mathematics at the Sorbonne; the event was actually a funeral attended by a great number of professors and writers.

Even the readers of *Figaro* were kept informed of cases of arbitrary arrest, disappearances and torture, by Martin-Chauffier.[1] After weeks of continual postponements, the report of the Safeguard Committee appeared in *Le Monde.* The Committee spokesman began: *Acts which in other times and in normal circumstances might appear exorbitant, are perfectly legal in Algeria."* So there was, of course, no need to denounce them. The report limited itself to stating the facts, which, even when covered by this "exorbitant" legality, nonetheless seemed excessive. They were shocking enough and numerous enough to create a scandal. *Le Monde* was severely criticized for having printed the report; the events themselves seemed to be of little interest for the reading public.

On December 10th, the trial of Ben Saddok began. Several months earlier, at an exit of the Colombes stadium, he had shot Ali

[1] He had made an investigation in the name of the International Commission Against Concentration Camps.

Chehka, the former vice-president of the Algerian Assembly and one of the most notable Moslem Collaborators. Pierre Stibbe, his lawyer, called several left-wing intellectuals as witnesses for the defense, among them Sartre. Sartre was very much moved as we made our way to the Palais de Justice; in conferences and meetings, words may sometimes be taken lightly enough, but that day a man's life was at stake. If Sartre helped save his life, in a few years' time there would be an amnesty to make him a free man again; the difference between life and death sentences was therefore much greater than in ordinary trials. Hence the anxiety of the witnesses, since each of them could assume that his testimony might well be the deciding factor in the jury's decision.

Sartre was sequestered with the others, out of earshot of the pre-liminary arguments. I took a seat on the crowded benches beside some young lawyers. Mme Ali Chehkal, draped in mourning veils and sitting just beneath the judge's bench, represented the case for the prosecution. I looked at the young, open-faced man in the dock. Acts analogous to the one he had committed had been acclaimed dur-ing the Resistance as heroic deeds; yet the people of France were now going to make him pay for his, perhaps with his life.

Some of Saddok's comrades spoke about his qualities as a man, as a worker, as a friend; his aging parents wept. After that, teachers, writers, a priest, a general and some journalists got up to explain how Saddok's action was caused by the conditions of life imposed on his fellow Algerians; and they described those conditions. "So that's it!" said two of the young lawyers sitting near me, in bitter tones, "We're the ones they're putting on trial. They're saying that what-ever happens to us in Algeria is just a fair exchange!" The prosecu-tion had called Soustelle. He appeared, in black tortoiseshell specta-cles and an overcoat that made him look like a big manufacturer; without looking at anyone, he launched precipitately into a eulogy of the dead politician. After that, a young girl with artificial legs came forward, supported by some of her relations; she had been a victim of the bomb-throwing at the Casino de la Corniche.[1] She began to shout in a jerky, strident voice: "There's been enough horror! You don't know what we go through! There's been enough bloodshed! No more blood! No more blood!" This melodrama had been re-hearsed by the prosecution as part of its case against Saddok, but the embarrassment it caused had rather the opposite effect. Émile Kahn,

---

[1] Subsequently transformed into a torture center.

old, frail, his hair completely white, staggered to his feet, demanding on behalf of the League of the Rights of Man, of which he was the president, that the great number of extenuating circumstances involved in Saddok's case be taken into account. A pastor read a letter from his son, who had been recalled and sent to Algeria; the youth told how he had seen a territorial unit—in other words, *pieds noirs* —torturing an old Arab man; supported by a few friends, he had been forced to threaten them with arms before he could succeed in wresting their victim from them. This narrative—hanging, beatings, torture—was read out in stony silence; not one gasp of surprise or disgust: everyone knew already. My heart froze inside me as I once again faced this truth: everyone knew and didn't give a damn, or else approved.

Sartre was one of the last to be heard. He did not betray how nervous he was, except perhaps at one point when he was speaking with formal deference of the dead man and referred to him as Ali Jackal. Comparing his own attitude to Ben Saddok's, he explained that young men could not be expected to display the same patience as their elders because all they knew of France was a bloodstained face. He went on to emphasize the fact that Saddok's action was a political murder and must not be treated as a terrorist attack. He made a great effort to speak in terms that would not shock the court, and the court in its turn seemed relieved by this moderation.

Massignon gave his evidence after Sartre, then Germaine Tillon; France, she pointed out, had forced the youth of Algeria into hatred. A teacher there had assigned the following subject to his class of ten-year-old Moslems for an essay: "What would you do if you were invisible?" She herself had read some of their compositions; every single student had given the same answer, expressed in different specific fantasies: "I would kill all the French people."

I left the court. In the corridor, General Tubert was thundering against the French in Algeria. All the witnesses were praising the impartiality of the president of the court and the freedom he had allowed them. There were harsh comments on Camus' absence. His voice would have carried added weight because he had just been awarded the Nobel Prize. Stibbe had asked him to do no more than read aloud a passage from one of his recent essays in which he condemned the death penalty; he had refused to appear in the witness box or even to send a written message to the court. Several witnesses

had quoted him in their pleas to the judge for clemency, though with a slight touch of sarcasm in some cases.

I ate dinner at La Palette with Sartre and Lanzmann. Would Saddok lose his head or not? We were full of anxiety. To release the accumulated tensions of the day, Sartre drank some whisky. He hadn't been able to drink for some time, and he grew still more agitated; before long, he had fallen into a fit of angry depression. "To think that I stood there and eulogized Chehkal! and spoke against terrorism: as if I was against terrorism! All to please the Poujadists on the jury! Just think of it!" His rage and frustration brought tears to his eyes. "To go through all that for a few Poujadists!" he repeated. I was frightened by the violence of his emotion: it was caused by more than his disgust at the concessions he had made in court; his nerves had already been stretched to breaking point for weeks, for months.

The newspapers next morning made depressing reading. They carried reports of what the witnesses had said, and without realizing it had drawn up an excellent indictment of the war; the reading public was going to get the truth at last in this unexpected manner. But every paper was violently against Saddok. "What a nice-looking boy he is, Chehkal's murderer!" read one of the headlines. The press generally accused the witnesses of having cast a stigma on the fair name of France that only the blade of the guillotine could remove. We were afraid that the jury would be influenced by these articles.

It was with great relief that we learned the verdict that evening. Life imprisonment; but the prison gates would be opened when the war was over. We were happy for Saddok first of all, but it was also a comfort to find that there were still men in France capable of judging an Algerian according to their conscience.

In Algeria, such notions no longer existed. Scapegoats were chosen simply by chance: six Moslems confessed under torture to the murder of Frogier; one was picked out for execution, and although there was no proof against him, Coty refused to pardon him.

Toward the end of January 1958, Maître Bruguier asked me to testify to the good character of Jacqueline Guerroudj, who had been one of my best pupils at Rouen. She had gone as a teacher to Algeria, where she had married a Moslem teacher and with him become a member of the urban groups of the A.L.N.; she had passed on to Yveton the bomb that he had placed in the headquarters of the E.G.A. Both of them, along with Taleb, one of those accused with

them, were condemned to death in December 1957. The Left started a campaign to save them, and I helped as best I could. We managed to win a remission of their sentence. But Taleb, convicted only of having prepared the explosives and denying all participation in this particular attack, was beheaded.

The bombing of Sakiet upset a large section of the French Right. Oradours were committed every day, as one corporal put it;[1] but smashing up a Tunisian village was a mistake. In an attempt to justify it, the newsreel *Actualités* inserted a piece of film showing A.L.N. soldiers stationed in Tunisia: another mistake; in uniform and well disciplined, they constituted an army, not just a gang of malefactors.

It was being said that Massu, a pious and scrupulous man, had insisted on sampling the electrodes himself. His verdict: "Very rough; but a brave man could take it." A book appeared to remind us all of the intolerable truth about torture: *The Question* by Henri Alleg. Sartre reviewed it in an article called "A Victory," which was published by *L'Express* and bitterly criticized. The book nevertheless sold tens of thousands of copies and was translated all over the world.

The use of torture was by now such a well-established fact that even the Church had been forced to make a pronouncement on its legality. Many priests rejected it, both in word and deed, but there were also chaplains on hand to encourage the *corps d'élite*; as for the bishops, most of them carried tolerance pretty far, and not one of them risked raising his voice in reprobation. Among the laity, what a deafening silence of consent! I was revolted by Camus' refusal to speak. He could no longer argue, as he had done during the war in Indochina, that he didn't want to play the Communists' game; so he just mumbled something about the problem not being understood in France. When he went to Stockholm to receive his Nobel Prize, he betrayed himself even further. He boasted of the freedom of the press in France: that week *L'Express, L'Observateur and France-Nouvelle* were all seized. In front of an enormous audience, he declared: "I love Justice; but I will fight for my mother before Justice," which amounted to saying that he was on the side of the *pieds noirs*. The fraud lay in the fact that he posed at the same time as a man above

---

[1] Quoted in 1957 by a recalled conscript; in August 1956, a corporal of the 2nd B.E.P. had told him: "If there's ever another Nuremberg trial we'll all be condemned: we have an Oradour every day."

the battle, thus providing a warning for those who wanted to reconcile this war and its methods with bourgeois humanism. For, as Senator Rogier was to say a year later, in all seriousness: *Our country . . . needs to color all its actions with a universal and humanitarian ideal.* And there my fellow countrymen were, indeed, all trying as hard as they could to preserve that ideal while they were trampling it underfoot. Every evening, a sentimental audience wept over the past misfortunes of little Anne Frank; but all the children in agony, dying, going mad at that moment in a supposedly French country was something they preferred to ignore. If you had attempted to stir up pity for them, you would have been accused of lowering the nation's morale.

This hypocrisy, this indifference, this country, my own self, were no longer bearable to me. All those people in the streets, in open agreement or battered into a stupid submission—they were all murderers, all guilty. Myself as well. "I'm French." The words scalded my throat like an admission of hideous deformity. For millions of men and women, old men and children, I was just one of the people who were torturing them, burning them, machine-gunning them, slashing their throats, starving them; I deserved their hatred because I could still sleep, write, enjoy a walk or a book. The only moments of which I was not ashamed were those in which I couldn't do any of those things, the moments when I would rather have been blind than go on reading the book in front of me, deaf than hearing what people were saying, dead than knowing what we all knew. I felt that I was suffering from one of those diseases whose most serious symptom is the lack of pain.

Sometimes, some parachutists would appear in the afternoon and set up a sort of stall in front of Saint-Germain-des-Prés. I could never bring myself to go up to it. I never knew exactly what they were up to; in any case, it was some sort of propaganda. As I sat at my desk I could hear the sound of military music; they gave talks and made collections, and I think they showed photographs, carefully selected ones, of their campaigns. I could feel the familiar lump forming in my throat, the old impotent, raging disgust: exactly the same symptoms the sight of an S.S. man had always produced. French uniforms were having the same effect on me that swastikas once did. I looked at those boys in their camouflaged battle uniforms, smiling and parading with bronzed faces and clean hands: those hands . . . People stopped to watch, interested, curious, friendly. Yes, I was living in an

occupied city, and I loathed the occupiers even more fiercely than I had those others in the forties, because of all the ties that bound me to them.

Sartre protected himself by working furiously at his *Critique de la Raison Dialectique*. It was not a case of writing as he ordinarily did, pausing to think and make corrections, tearing up a page, starting again; for hours at a stretch he raced across sheet after sheet without rereading them, as though absorbed by ideas that his pen, even at that speed, couldn't keep up with; to maintain this pace I could hear him crunching corydrame capsules, of which he managed to get through a tube a day. At the end of the afternoon he would be exhausted; all his powers of concentration would suddenly relax, his gestures would become vague, and quite often he would get his words all mixed up. We spent our evenings in my apartment; as soon as he drank a glass of whisky the alcohol would go straight to his head. "That's enough," I'd say to him; but for him it was not enough; against my will I would hand him a second glass; then he'd ask for a third; two years before he'd have needed a great deal more; but now he lost control of his movements and his speech very quickly, and I would say again: "That's enough." Two or three times I flew into violent tempers, I smashed a glass on the tiled floor of the kitchen. But I found it too exhausting to quarrel with him. And I knew he needed something to help him relax, in other words something to destroy himself a little. Usually I didn't protest strongly until the fourth glass. If he was swaying when he left, I blamed myself. I was almost as worried about him as I had been during those agonizing weeks in the summer of 1954.

I was hoping that the snow would do something to raise my spirits, but the two weeks I spent at Courchevel disappointed me. Two years before, I had felt rejuvenated when I put on my skis again; now I could tell I was getting old because I could make no progress. Lanzmann rarely accompanied me to the slopes; he was writing an article for *Les Temps Modernes* about the curé of Uruffe. It was an astonishing story: a priest murdering the woman he had got with child, slitting her open so he could baptize the fetus, sounding the alarm, denouncing the crime and helping his parishioners look for the murderer. The trial had been even more astonishing; Lanzmann's piece exposed its true meaning with great point and clarity: "The Reason of the Church" demanded at one and the same time that the priest should be neither understood nor punished. So the

curé saved his head while the two murderers of Saint-Cloud, no less deserving of clemency—two half-retarded boys who had spent their childhoods in orphanages—were condemned to death.[1] The other people at our hotel found it quite natural that they should go to the guillotine; I couldn't help overhearing what they said at mealtimes. This was the main reason why our stay there was not very pleasant: we were still in France. In Paris, I managed to avoid the horrors of the French bourgeoisie I suddenly found myself swamped by here. The couple who complained about no longer being allowed to beat the Negroes in the Congo were Belgians; but the French people felt for them in their affliction. When Lanzmann and I wanted to go away for a few days in April, we picked England: the south coast, Cornwall. The only Frenchmen I felt any sympathy for as a group were the young people; some left-wing students asked me to give a talk on the novel at the Sorbonne and I accepted. I had been living such a retired life that when I walked into the lecture hall it was a shock to realize, from the welcome they gave me, that they knew who I was. This expression of friendship warmed my heart, something it badly needed.

[1] One of them was reprieved.

# CHAPTER IV

THE BOMBING OF SAKIET HAD PRO-
voked the intervention of the English and American good offices;
there was talk of a diplomatic Dien Bien Phu; the Army began
to protest very loudly that it would not allow such a thing. People
began to talk about De Gaulle's returning to office. It was useless to
count on the police being able to maintain order within the
Republic. A certain number of cops having been shot in Paris by Al-
gerians—not by chance in the majority of cases, but as isolated re-
prisals—the police staged a mass demonstration in front of the Cham-
ber of Deputies on March 13th. The Dides network had set up nuclei
within the force, which as a result was sympathetic to Fascism. When
the Left began to hold increasing numbers of forums and meetings
after the fall of Gaillard, brought down by Soustelle and Bidault on
April 15th, the "patriots" who came to smash the faces of the speak-
ers were therefore assured of police protection. It seemed impossible
to arrive at any combination of Ministers that would stand together
as a government, and De Gaulle's name was heard more and more
often on everyone's lips. On May 6th, Pflimlin was mentioned, but
he was unable to form a government without the votes of the Inde-
pendents and they could not reach a decision.

The F.L.N. had to a large extent absorbed the M.N.A. and won a
spectacular number of adherents to its cause.[1] It was insisting that
the conventions of international law be applied to the A.L.N. When
the French Government sent two Algerian fighters to the guillotine,
three French prisoners were shot. The city of Algiers decided to
demonstrate against these reprisals on May 13th.

[1] On April 18th, nine Algerian soccer players from the national French team, ten
Algerian N.C.O.s from Saint-Maixent, and the Grand Mufti Lakdam left for Tunis.

That evening, I was in my apartment with Lanzmann when Pouillon, the recording secretary of the Assembly, telephoned. The demonstration in the Forum had developed into an insurrection; the crowd, led by Lagaillarde, had seized the Gouvernement Général; Massu was now president of a Committee of Public Safety; in short, with the support of the Army, Algeria was cutting itself off from France in order to remain French. Other telephone calls followed— journalist friends giving us the latest news. Pouillon called again to tell us that the Chamber of Deputies had been quite firm in its reaction; it had voted Pflimlin in by 280 votes against 120, the Communists having abstained on principle. I went to bed feeling reassured. The following morning there was a rumor that when the colonels had heard about last night's vote in the Chamber they had panicked; one of them was supposed to have said, "It's all fucked up!" Pflimlin severed all communications between Algeria and France; against such a blockade the seditious faction would not be able to hold out a week. On May 14th, none of the people I knew was particularly uneasy. Lanzmann had been invited to visit North Korea with a delegation of other extreme-left journalists: he had wondered during the night if the trip would be canceled; now he didn't think it would.

The following day we learnt that during the morning Salan had stood in the Forum and cried: "Vive De Gaulle!" Pflimlin restored communications with Algeria and took no further action. The day after that, the newspapers described the masquerade that had been organized in Algiers and throughout the country in the name of fraternization.

The evening I went to the Sarah-Bernhardt theater to hear Brecht's *Trial of Lucullus,* a grim attack on war and generals, the audience nearly brought the roof down with its applause; but it was entirely composed of left-wing intellectuals who had already been isolated in their own country for a long time. The Communists professed to be optimistic. Lanzmann represented Sartre at the Committee of Resistance Against Fascism; every time they met, Raymond Guyot would say: "To start with, we should congratulate ourselves. Committees are being formed everywhere . . . the situation is excellent . . ." But on the 19th, the general strike launched by the unions collapsed. That same day De Gaulle gave a press conference; Lanzmann told us about it as we ate dinner in the Rue de la Bûcherie with Bost and his wife; he had recognized all the old R.P.F.

faces in the crush. While insisting on an exceptional method of investiture, De Gaulle had made it understood that he wanted to be called to office legally by the country. There were society women listening in ecstasy; Mauriac was swooning with joy. Bourdet asked De Gaulle if he didn't think he was playing into the hands of the various factions. "Your world is not my world," was the gist of De Gaulle's reply. He was going to pull it off, Lanzmann had no doubt on that score; our bourgeois democrats would much rather put themselves in the hands of a dictator than revive the Popular Front. Bost didn't want to believe it; they bet a bottle of whisky on it.

Some Americans who landed at Orly refused to leave the plane because they imagined Paris to be in the throes of a bloody revolution; we laughed, but it didn't really seem all that funny. Everything was happening so quietly it felt like a funeral. The country allowed itself to be persuaded that there were only two alternatives: De Gaulle or the paras. The Army was Gaullist, the police Fascist; Moch had suggested the mobilization of civilian militias. But the one thing the Right and the Socialists were worried about, as the paras got ready to advance on Paris, was to avoid *"le coup de Prague."* The "appeal" De Gaulle sent Mollet on the 19th was couched in such blunt terms that it shocked the recipient himself; then he prevailed on himself to answer it. As for the apathy of the proletariat, it had to be interpreted as consent; without De Gaulle, the working class would no doubt have shaken itself awake, but his government between 1945 and 1947 had been no worse than those that had succeeded it; he still retained his prestige as a liberator, and since he was not venal he passed for honest. Thanks to him, Algiers would triumph.

What on May 13th had seemed impossible appeared inevitable by the 23rd. The *pieds noirs* and the Army had won. Everything was going to be settled without any struggle. It was so easy to see it all coming that the delegation with which Lanzmann was going to Korea decided not to delay their departure. He himself would have liked to stay, but couldn't stand out against the others. I went with him to Honfleur, which we both loved, and we spent two days there. Pointing at the little meadows full of flowering apple trees, he said in a desolate voice: "Even the grass won't be the same color any more." What upset us most was the sudden vision of what France had gradually become: politically apathetic, inert, ready to hand itself over to the men who wanted to fight the war to the bitter end.

I drove Lanzmann to Orly on the morning of May 25th. During the afternoon, news came through of the uprising in Corsica. These were upsetting, uncertain days, for me as for so many others. I had stopped working. *Memoirs of a Dutiful Daughter* had been given to Gallimard in March. I hesitated to go on with them. My state of idleness and the general anxiety led me, as in September 1940, to start writing my diary again. I also began it again to a large extent so that I could show it later to Lanzmann, with whom it was almost impossible to correspond. I shall transcribe it here, as I have done before.

## May 26th

Strange days, in which we listen hour after hour to the radio and INF. 1, and buy every edition of the newspapers. Yesterday, Pentecost Sunday, 800,000 Parisians left the city, the streets were quite empty; it was heavy, but not hot, with a gray sky. From Sartre's window you could see the fire engines, bright red, their long ladders on top, rushing along the Boulevard Saint-Germain. A great many police cars on patrol. The new Algiers Committee (Massu, Sid-Cara, Soustelle) announced on Saturday: "De Gaulle or Death." They have sent Arrighi to Corsica, but they also declare they have severed all relations with Corsica.

Lanzmann left the day before yesterday for Korea. Telegram from Moscow, where he is to spend three days.

Talks with Sartre in the evening about my book while we ate at La Palette. He reminded me how happy we used to be at Rouen, in the anonymity of youth (I can still see the Brasserie Paul where I used to correct my pupils' work). Mustn't falsify this period when I write about it.

Icy weather today. The wind is shaking the ivy on the cemetery wall and getting into the studio around all the window frames. The work I'm starting will take me three or four years, which is a rather frightening thought. Better start by getting all the material together.

Yes, for another whole day, all of Pentecost Monday—Paris was as deserted as yesterday, newspapers censored, foreign papers forbidden—the same muted atmosphere of disaster. It's rained, and there was a big thunderstorm. Lunch at La Palette with Nazim Hikmet. Seventeen years of prison, and now he has to lie down twelve hours every day because of his heart. Very charming. He told me how a

year after he came out of prison there were two attempts to murder him (with cars, in the narrow streets of Istanbul). And then they tried to make him do military service on the Russian frontier: he was fifty. The doctor, a major, said to him: "Half an hour standing in the sun and you're a dead man. But I shall have to give you a certificate of health." So then he escaped, across the Bosporus in a tiny motorboat on a stormy night—when it was calm the straits were too well guarded. He wanted to reach Bulgaria, but it was impossible with a high sea running. He passed a Rumanian cargo ship, he began to circle it, shouting his name. They saluted him, they waved handkerchiefs, but they didn't stop. He followed and went on circling them in the height of the storm; after two hours they stopped, but without picking him up. His motor stalled, he thought he was done for. At last they hauled him aboard; they had been telephoning to Bucharest for instructions. Exhausted, half dead, he staggered into the officers' cabin; there was an enormous photograph of him with the caption: SAVE NAZIM HIKMET. The most ironical part, he added, was that he had already been at liberty for over a year.

Lanzmann telephoned from Moscow. It was seven here, nine there, and night was just coming down over the Moskova. So near, so far. Some young fellows had come up to him at the entrance to his hotel and murmured in English: "Business?" They wanted to get clothes from him in exchange for girls. He was feeling completely at sea, very worried about events, which he could only learn about through the Moscow correspondent of *Humanité*.

Found it difficult to work. We're waiting, though we don't know for what. Spent the evening with Sartre and Bost. Speculated about events.

### Tuesday May 27th

Lunch with Sartre at the Coupole. The C.G.T. had given orders to go on strike. The F.O. and C.F.T.C. weren't following their lead, but all the same we were expecting something from them. Nothing; buses and métro still working. In the taxi, on the radio, end of De Gaulle's statement. Yes, it's "the last quarter of an hour" as Duverger puts it. The driver: "Well that's it! Now they've got him in it, along with taking all our money, and sending those kids to get killed in Algeria." He was furious with the "cocos" because they voted the government special powers and then a tribute to the Army; they're

just making jackasses of everyone: "Look how their so-called strike is going!" Doubtless some sort of Leftist, ready to accept De Gaulle out of anger. What self-deception! Everything will be managed very gently, then they'll get tough afterward. Just a country that's given up; and it's been going on so long one feels only disgust. How stale defeat tastes! An impression of living "historic" moments, but not in the same acute, agonizing way as in June 1940; days of deceit, slimy, like the ones Guillemin describes. We're sloshing through the messy materials of some book by a future Guillemin.

Last night there were terrible black things, twisted like vine shoots, falling out of the sky; one landed beside me, it was an enormous python, and my fear stopped me from running away. A sort of police car was going by, I leapt inside; they were hunting the snakes, which had already been falling on the country for hours—a strange country made up of jungles and worn-down roads. But the only memorable sight was the vision of those great, apocalyptic shapes above my head, still falling.

Telephone calls all day, as on the night of May 13th. And my young friend in Marseilles writes me almost every morning. We all feel the need to talk, even if we have nothing to say.

Péju has just called (at six o'clock) to tell me that Pflimlin left Coty looking very disturbed, that De Gaulle has left Colombey, he's on his way back. No strike anywhere, except among the miners in the north. De Gaulle said tonight that if he hasn't been given power within the next forty-eight hours, he will seize it. The Army is for him. In Toulouse, they asked the military commandant to guarantee order in the town (because of the demonstration expected this evening) and he refused.

Sartre is working on his play; and I'm trying to interest myself in my past. On our way to Honfleur, Lanzmann told me: "Even the grass won't be the same color any more." I look out at the Place Saint-Germain and I think: It won't be the same city any more.

Radio at half past seven: still hope perhaps.

### Wednesday 28th

Spent yesterday evening with Leiris and his wife. Listened to the radio with them; impossible to get Radio Luxembourg, could hear only French national stations. Night session of Parliament. Pflimlin made them vote on the law to change the Constitution. Remembered

the time I listened to the radio with them when the Germans were retreating into Belgium.

This morning, glorious weather. Found out what was happening. Pflimlin got a majority of 400 votes against a little more than 100, the Independents have left the government, he has resigned, but without creating "*la vacance de pouvoir.*" Coty has announced that a new government will be formed by this evening.

There is supposed to be a huge demonstration this afternoon; we are going to it.

### Friday May 30th

I can't write anything except this diary, and I don't really want to write that, but I've got to kill time somehow. Wednesday, lunch at La Palette with Claude Roy, who has asked to be reinstated as a member of the Communist Party and no doubt will be. He quoted something De Gaulle said about Malraux which is all over Paris: "He blamed me for going all the way to the Rubicon just to do some fresh-water fishing, and now that I've crossed it he's off fishing in the lagoon." Malraux has in fact been away in Venice all this time, lecturing on art; but he came back the evening before last and is expecting, according to Florence, to be made Minister of Information and Culture.

We went by taxi—on Wednesday—at quarter of six in the evening, to the Reuilly-Diderot métro station. Long procession on the left-hand sidewalk; Communists, obviously so, carrying placards: LONG LIVE THE REPUBLIC. We were expecting the Committee of the Sixième at the station, but the C.N.E. had chosen it for *their* meeting place as well. The métro began disgorging a whole heap of people we knew: Pontalis, Chapsal, Chauffard, the Adamovs, the Pozners, Anne Philipe, Tzara, Gégé with his family and the people from his studio, my sister. Everyone was amazed to see such a huge crowd there; each of us had been afraid that the demonstration would be a flop. The Place de la Nation was black with people. We walked behind the banner of the "Beaux-Arts," only to find ourselves suddenly behind the "Rights of Man," then somewhere vaguely in between. We saw old Republicans in a state of jubilation, feeling fifty years younger because of it all; they jumped up in the air to see over the heads of the crowd, and when they saw how long the procession was their faces beamed. People were perched on the traffic

signs down the middle of the streets, climbing on the shoulders of
friends and waving approval; the procession was endless in either
direction. Along the sidewalks, a great many people were applaud-
ing and shouting with us; they were in fact demonstrating. A gay
crowd, and a well-behaved crowd, obeying orders. There were a few
cries of: "Long live the Republic," but the favorite was: "No Fascists
in France"; there was a lot of "Hang Massu hang Soustelle"; some:
"Down with De Gaulle," though not shouted very loudly. The
slogans: "De Gaulle in the museum—the paras in the factories" were
a big success. (Was this discretion the result of a sense of law and
order, or the respect for De Gaulle that S.L. was talking about yes-
terday? In any case, when someone began to shout "Hang De
Gaulle," they always shut him up.) We sang the *Marseillaise* and the
*Chant du Départ*. Sartre sang with all his might. There were two tall,
good-looking boys, each with a pretty girl on his arm, who never
stopped yelling the whole time. People were staring out of windows,
and many of them expressed sympathy; children applauded. Over
the Berceau Doré, three very old ladies in white wigs, leaning on
faded gold cushions, saluted us with regal gestures as we passed. The
lights went on changing from red to green, even though all traffic
had been stopped. However, from time to time the procession would
get jammed; we stopped, then set off again. In front of the police
station, the cops stood motionless, impassive, and the crowd turned
toward them aggressively with cries of: "Hang Massu!" It was a heart-
warming, moving, unanimous procession. There were men who had
been deported walking along in striped uniforms, and invalids and
cripples in cars. The arrival at the Place de la République was dis-
appointing; nothing had been arranged beforehand. There were
people who had climbed up on the plinth and were waving flags, but
no orders had been given; we began to disperse. There were some
shouts of "To the Place de la Concorde!" but no one made a move; it
would have been impossible to get through in any case. There wasn't
a single cop on the route, but both ends were guarded by C.R.S. cars.
The crowd was not in a fighting mood. What was surprising was the
spirit that had swept everyone along: even the least politically
minded sort of people from *Le Village* had come. But some of us
couldn't help remarking that people in general seemed too good-
humored, they seemed quite happy to shout and sing, but not at all
determined to act. And the evening before, the strike had failed; the
F.O. and the C.F.T.C. congratulated themselves the next day on

having demonstrated "independently of the C.G.T." There will certainly be no general strike. Bost, Olga and the Apteckmans went up to the second floor of the Hôtel Moderne, where some American journalists were working, with the help of a great deal of whisky; the view from up there was very striking, they say. However, down in the dining room on the ground floor, there were some English-women drinking soup with complete indifference. Apparently Mendès was acclaimed in the Place de la Nation, but after he arrived, when all the groups were dispersing, some Fascists tried to attack him. They didn't have much luck.

We went back to Sartre's apartment, feeling moved, and with a glimmer of hope in our hearts. We immediately heard bad news: the parachutists had landed (a rumor that's been going around for four days); neither the Army nor the C.R.S. will support the Government; De Gaulle had left Colombey and Coty was to call him to the Élysée during the night. Sartre had an engagement for the evening, and I couldn't bear being on my own; I went to join the Bosts and Apteckman in a restaurant on the Rue Stanislas. We went back to the cars we'd left in the Rue du Faubourg-Saint-Honoré and prowled around the Élysée Palace, which was all lit up; it was nearly midnight; the people who had come in great numbers to watch during the evening were beginning to disperse; we could hear chants of: "Massu in Paris! The Paras in Paris!" It was a handful of distinguished-looking forty-year-olds (I forgot to say that there has been a joyful recovery on the Stock Exchange, and that the napoleon has gone down 70 francs). The cops headed them off very politely. Regiments of C.R.S. men in their dark cars, or standing in the street, pistols in hand, had cordoned it all off; if they had been Gardes Républicains one would have felt protected, but in the circumstances they inspired fear more than anything else. They were letting the crowd move by—pedestrians and cars. Barbara Apteckman tried her charm on them and they answered back good-humoredly. She asked them: "What are you waiting for?" "De Gaulle; but we've been here two hours and he still hasn't arrived." Others said: "We've been sent from Bordeaux, they treat us like shit here." And others: "We're waiting to fight." There was a vast procession of elegant cars crawling along because of the bottleneck. "Where are you going?" "To see De Gaulle." A taxi from Chez Maxim's, very old-fashioned, with a very chic old driver and Maxim's crest on the door; inside, a man in evening dress and a superb woman in a red dress, covered

with jewels. They were like film extras: that little typical and unexpected touch in a film shot ten years later. A car drove out of the Élysée; it looked as though it was over and De Gaulle hadn't turned up. We drove past the Chamber and went for a drink in the Bûcherie. It was full of people who had demonstrated that afternoon, all of whom were expressing astonishment at the size of the turnout. But no one knew what was happening at the moment, and the Bosts' radio was broken. I called Péju. The parachutists had definitely not landed, and the Socialists were standing firm against De Gaulle. In fact, he went back to Colombey during the night. Apteckman was as convinced as I that the Socialists would betray us. The next day (yesterday, Thursday) was a strangely sad morning. It was marvelous weather, I went out to read the newspapers, birds singing in the squares, chestnut blossoms falling. Sat on the terrace of a café, on the corner of the Avenue d'Orléans. *Le Figaro* criticized the demonstration. *Humanité* announced that there had been 500,000 demonstrators, which disappointed me because I thought there had *really* been 500,000. *L'Express*, ready to scuttle itself, with Mauriac shamefully at the helm. Went home, unable to read through the papers properly, or write, or do anything. I was tied in knots with anxiety. The trash cans were overflowing with garbage along the sidewalks because the collectors were on strike.

And that day the betrayal began. The letter from Auriol to De Gaulle was published: if De Gaulle would promise to cut himself off from Algiers, then sixty-nine Socialists had declared that they would vote for him, "in order to avoid civil war." Lunched at the Puillons'. It was there we heard Coty's message to the two Chambers; he threatened to resign if De Gaulle was not put in office. That evening De Gaulle came back. He called the leaders of all the "national" groups together at the Élysée. During the night, he went back to Colombey yet again. There's going to be one more day of machinations, and then the trick will have been played: slick scenario, perfect execution.

At lunch, Pouillon talked very amusingly about parliamentary customs and rites. Lévi-Strauss was there, taciturn as ever. He asked in an amazed tone of voice: "But why does De Gaulle find mankind so despicable?" which was charming, because he always affects to be much more interested in the fauna and flora of the countries he goes to than in their inhabitants; but in fact he is a humanist, and there is nothing he finds more repugnant than the idea of "greatness."

At Sartre's at five in the afternoon: papers, radio, anger. He goes on working all the same.

Evening with Olga. She asked Bost to join us at the Coupole. A young left-wing journalist who came with him refused to believe that De Gaulle could have been involved in any sort of plot. He began to speculate about his "character," which just set my nerves on edge. Got home in a state of violent exasperation.

*Saturday May 31st*

I'm calm again, I don't know why; perhaps because Sartre has decided to stop taking corydrame, is making himself sleep and be calm, and it's contagious. And above all, because it's all settled, the game is lost and, as Tristan Bernard said after he was arrested, we've got nothing to fear now, we can start to hope. De Gaulle's investiture will take place this evening without any doubt. At least the S.F.I.O. will make a show of protest. The teachers' strike, supported by the pupils' parents, was a success yesterday in the primary and technical schools, and half successful in the secondary schools. There will still be considerable opposition forces, and they're bound to make themselves felt in one way or another.

There were incidents in Saint-Germain-des-Prés on Thursday evening. Evelyne was there. Some elegant cars were going up toward the Champs-Élysées; there was a traffic jam. They began to sound their horns: "Algeria for the French!" The cafés all emptied out into the street, the "villagers" all came out, and since there happened to be some cobblestones in front of the church, they picked some up and threw them at the cars. Evelyne got into Robert's car with him and they followed. Around the Élysée, the ladies in their evening dresses, their long kid gloves and their jewels, were fraternizing with the helmeted C.R.S. men.

Even people we know are giving in. Z. the other day: "After all, at least De Gaulle is one better than Massu." And X. explained to me today that if the Socialists refused to vote for De Gaulle it would mean civil war. He's waiting for De Gaulle to get together with Mendès-France and revolutionize the economy. His wife, when we were left alone, said to me: "You understand how it is; we need to think that Jean [her husband] won't be forced to resign."

Sartre had lunch with Cocteau, who was in disagreement with the appeal the Academy had sent to De Gaulle.

Press conference at the Lutétia on use of torture. Only moderate applause when Mauriac announced that he was a Gaullist. Big attendance. Not many journalists, actually, but five hundred intellectuals.

At the moment I'm doing much more reading than writing. In *Critique*, an interesting article on operational research. If a computer has to work out the "optimum answer" in a case such as the following: the shortest route to visit twenty American cities, it would take it two hundred and fifty thousand years. Whereas man takes "shortcuts"; each man has to deal with others who also decide things by "shortcuts." So we do everything at a level where the "optimum answer" doesn't exist.

Lanzmann arrives in Korea today. Curious situation.

As I was coming back along the Rue Blomet yesterday, at about three in the afternoon, I saw some groups of young men wandering about on the Boulevard Pasteur. "The cops chased them away, but they're coming back," the taxi driver told me. They were right-wingers trying to get the classes at the Lycée Buffon going again. The taxi driver: "I've finished with strikes myself. Got the message. You don't work, so the others get it all. It's not worth it. . . . What's going to happen? Well it's not going to be any worse than what we've had already." (That's what one hears people saying everywhere: at least things will change, they can't get worse.) However, he had one footnote to add, on the subject of De Gaulle: "It's all his fault, all this. All he needed to do in 1945 was chuck out all the Jews." I laughed out loud at that, so he ended up: "I don't know what it all means. No idea at all. No one else has either. And I've got a son in Algeria!"

INF. 1 has announced that there were other demonstrations along the Champs-Élysée last night, with car horns and "Vive De Gaulle." Then counterdemonstrators shouted: "No Fascism in France." Riot; several people seriously wounded; the Communists got the best of it.

This morning I read all the weeklies through again quietly, and all the passages on De Gaulle in Werth. The business of the postcards sent to Colombey is farcical. Certainly nothing of the "great figure" about him.

Lunch and quiet day with Sartre. Still incapable of working, but tried to read Lacouture's *Le Maroc à l'Épreuve*. The radio announced that De Gaulle's investiture would be tomorrow: the Social-

ists haven't reached an agreement among themselves (77 for, 74 against; in the Chamber, about 40 for and 50 against, Guy Mollet possibly resigning); they will vote individually. De Gaulle has climbed down a step; he's going to make a personal appearance in the Chamber, and he'll allow himself to be photographed. The government is expected to be very right-wing, but without anyone from Algiers. They must be worried in Algiers, despite the demonstration yesterday evening.

As I was leaving Sartre's, I met Evelyne, Jacques, Lestienne and Bénichou. They were going up to the Champs-Élysées, where a lot more action was expected. The little Fascists were already in Saint-Germain with their newspapers and their placards; police everywhere. There were obviously going to be some heads broken.

Evelyne is on permanent duty on the Committee of the 6ième and goes out rioting every night. An intense longing to be young again cut through me, a desire to go to the Champs-Élysées, driven by a genuine youthful impulse, with her gang. Perhaps I might even have done it if I hadn't had a date with Violette Leduc. I went home. It's eight in the evening, and all my anxiety has come back. I'll take her out to Saint-Germain in any case, I can't stay shut up here this evening—the last one of the Republic. The committees expect to stage demonstrations tomorrow, but it's all still vague, and that just adds to the tension.

Question number one: What will De Gaulle do in Algeria?

A strange evening; V.L. arrived and threw herself into my arms: "Chantal is dead!" And then I was swamped with all the goings-on in the house where she lives: the hermit on the third floor she took rice pudding to, who received her in his underpants, then got dressed, put on his tie, went out onto the landing to deliver "political" speeches and finally got sent to the asylum at Villejuif by the concierge; Chantal, a girl of fifteen with enormous quantities of hair and three holes in her heart, who lay on the operating table for twenty-six hours and died that morning without a drop of blood left in her. V.L. poured out all these sinister tales which didn't concern me and stopped my thinking about the things that did. We ate dinner at the Bûcherie, where I saw Claude Roy, and then went for a drink in Saint-Germain. People everywhere, not a single empty chair on the terrace of the Deux Magots; we found a place outside the Royal and stayed there almost two hours just looking, without saying a word. We looked at the women's extravagant dresses, the infinity of faces,

and above all the cars, the cars coming and going, packed with arrogant women and delighted men. Every now and then a police car or a little patrol van. Nothing to put your finger on except, half an hour past midnight, this enormous crush of automobiles, like traffic coming back into the city after a weekend or afternoon traffic on a busy weekday. Riveted to my chair, beside V.L., I felt quite empty, possessed entirely by this beautiful evening without a sky (the lights devoured it) in which, after all, nothing was really happening any more, because everything was over, but which formed a setting nevertheless, with its shining automobiles, its ladies and gentlemen riding the streets in triumph, where something hideous was taking off its mask.

### Sunday June 1st

Didn't sleep much; am astonished by the civic classicism of my dreams: they were drowning a naked woman, half flesh, half statue, who was the Republic. Investiture this afternoon. A young woman rang the bell and handed me my committee invitation (the 14th), for 3:45 P.M.

Telegram from Lanzmann. He's arrived at Pyongyang.

### Monday June 2nd

Not a spare minute yesterday to write about what was happening. The committee telephoned. It was V. who called, and when I said : "Speaking," he still sounded incredulous: "Mlle de Beauvoir herself?" "Yes, yes." "In person?" "Of course." Sartre tells me it's just Communist distrust. V. told me what the committee had decided: we had to go and lay flowers at the foot of the statue of the Republic. I asked if I was to join the committee of the 14th Arrondissement; and what about Sartre? V. hesitated, he didn't know, he told me to go to headquarters but to walk with the 14th group as well, and he asked me to pass on the order because they had been forbidden all communiqués and hadn't been able to distribute pamphlets. It all seemed very badly organized to me.

I had to meet Rolland at the Deux Magots because he wants to publish a small extract from my *Memoirs* in *L'Observateur*, together with a short interview. He had got his orders from the Communists: get to Sèvres-Babylone with a car to help block the road (?). Went up

to see Sartre; from the window I could see Bost talking to Evelyne, in a flowered skirt and pink jumper with a pink scarf on her head, looking ravishing. She sweeps up the headquarters of the 6ième every evening; she had spent the morning running around the police stations with Reggiani trying to get out a girl who'd been arrested for distributing pamphlets; they hadn't found her. She suggested we join the committee of the 6ième which was to meet at half past three at Sèvres Croix-Rouge.

We left at 3:25; passed Adamov and some others who were "part of the act." Got into the car, in which Olga and Evelyne were already waiting for us. I bought some blue and white irises and some red gladioli in the Rue Jacob; who would have thought, seeing us twenty years before, that one day we'd be going to lay red, white and blue bouquets at the feet of the statue of the Republic! There were a great many demonstrators with placards and flags at the Sèvres Croix-Rouge crossroads, some of them scattered, some in a tight group. A car passed and sounded its horn: *"Al-gé-rie-fran-çaise!"* We rushed the car; the driver zigzagged his way through, sneering at our shouts. There were cries of: "Down with De Gaulle!" and the customers on the terrace of the Lutétia replied with "Long live De Gaulle!" Argument. The Desantis and some others said we should go to the Place de la République; however, the Communist instructions were different; the procession moved up the Boulevard Raspail chanting slogans. Since we were part of the "Anti-Fascist Committee," we got back in the car and moved on toward the Place de la République; I was rather glad about this, because I had the impression that the procession was going to run into trouble (which is what happened—it was rather a bloody fight in fact). We left the car and the flowers in the Boulevard Voltaire. At a quarter of four, not many people, but cops everywhere, an army of them—helmeted squads on foot, cars packed; the statue was cordoned off, impossible to get near it. It was very hot and very sultry; we went around the square; a lot of people, but scattered, perplexed; some of the women carrying bouquets (we saw lots in the streets that morning, but for another reason: it was Mother's Day). Near a métro entrance, a woman had given way to hysteria and was shrieking. We sat down on a terrace; Apteckman and his wife were passing and they came and sat with us; a lot of the customers were like us, just waiting; the old lady sitting next to us had a bouquet. Apteckman went to see how things were going and came back at a run: we could get through. Bost ran to get our flow-

ers, but he took too long and we joined the procession without him, moving across the square in little groups under police control; a little girl carrying a bunch of daisies came and handed one to each of us. We laid them in front of the statue and went and stood on the sidewalk; there was beginning to be quite a crowd; behind us stood rows of flower stalls, put up, or anyway increased in number, for the occasion. The crowd sang the *Marseillaise* and shouted: "The police are with us." Some boys in leather jackets were hurriedly buying peonies or hydrangeas and carrying them solemnly across the square; there was a marvelous old man—long yellow beard, pince-nez, ecstatic smile on his face—who looked like a believer walking back from Communion. They were still shouting: "Republican Police. De Gaulle to the Museum!" Suddenly, everyone began to run. In the rush, an invalid fell down, some men stopped to pick him up. Evelyne tried to get behind the grille gates of a cinema, but they chased her out; the concierges were closing the main gates of the apartment houses (as they did when Paris was liberated). We took a cross street back to the Boulevard and looked for the car which Bost must have moved somewhere else (that's why he took so long) to leave everything clear for the C.R.S. cars. It was about four-thirty. We drove back through the square, and it was quiet again. (It was ten minutes later, I think, that Georges Arnaud got his arm broken by a blow from a truncheon and the blood started flowing.) There was a rumor that there were demonstrations in Belleville, so we started up toward the Buttes-Chaumont. How green and gay it is there, with such pretty streets and sudden wide vistas out over Paris, blue in the distance! It was a quiet Sunday, people taking the air on benches, children playing, little girls walking in procession to Communion. And then, in the Avenue Ménilmontant, we ran into a procession; we got out of the car and joined it; they were Communists, men from the neighborhood cells; they wound up and down the streets where I used to go once to do "social fieldwork"; they shouted up to the people in the windows: "All Republicans down with us!" Sartre gave the same full-throated rendition of the *Marseillaise* that I'd heard on Wednesday; he was there, not as a member of a delegation, nor even as the writer Jean-Paul Sartre, but just as an unknown citizen; he no longer cared what people thought, he felt at home in this crowd, he who had always had such difficulty accepting elites, and felt so ill at ease being part of them. We got back onto the Avenue; as we passed the terrace of a café packed with North Africans, the demonstrators

shouted: "Peace in Algeria!" The Algerians scarcely smiled. A woman said quietly: "There aren't many of them demonstrating." "And quite right too, it'd be too big a risk; they're always the ones who get it, with things like this," the woman next to her answered, sympathetically. People began to pick up stones along a stretch of the street that was being repaired; but another procession, with placards and flags, came marching to meet them and put a stop to that; there were parleys; the leaders urged the crowds to disperse. Had they come from the Place de la République? When we went through it once more in the car, it was quiet; but this time, as well as the cops, there were Red Cross orderlies in helmets, stationed at the street corners.

We listened to the latest news in Mme Mancy's room. There had been riots in a lot of places; at the city gates and at the exits from the big railroad stations, the C.R.S. were stopping people coming into Paris (mostly members of Communist cells); this hadn't prevented meetings in the Place de la Trinité and near the Bastille though; or in other places. Good speeches by Mendès and Mitterand, both declaring: "We will not yield to blackmail"; more than half the Socialists, 50 out of 90, are going to vote *No*. The counting begins at seven-thirty.

Evelyne called; Jacques had been picked up on Saturday evening on the Champs-Élysées, and sent to Beaujon; he had spent the night wandering through the corridors and yards, and the day without anything to eat because he went on a hunger strike; his fellow prisoners were Fascists, and they'd been fighting each other with stones. They were beginning to release the prisoners, but only in little groups. Jacques had been let out at nine in the evening. (Evelyne quoted a charming thing that Lestienne had said; he was complaining about Palle. "Palle is a Gaullist and keeps on spouting Gaullist propaganda at me; it's quite sickening, because he knows I'm a right-winger underneath it all and that it's only too easy to influence me!")

Spent the evening with Sartre, first at La Palette, then here at my place. Hope (vague) that the Left may pull itself together, and intense curiosity about Algeria. Malraux talked to De Gaulle for three hours on Saturday; no doubt that he's to be Minister of Information.

As for personal matters: Sartre saw Huston and Suzanne Flon on Saturday; it's agreed that he will do the film on Freud.

At about eleven, the storm that had been threatening all day

finally broke. Flashes of lightning all around a helicopter glowing with red lights, the police helicopter that was flying over Paris during the procession on Wednesday, and still keeping watch on us; the Eiffel Tower floodlit; they call it its "robe of light"; I liked it better dark, with those beautiful rubies glowing around its head. Rain bucketing down, tremendous wind, not very propitious weather for any demonstrations of enthusiasm, and the fact is, nobody's tried to start any. The investiture tonight was as dreary as that of any old Président du Conseil. Nevertheless, my head is ready to burst; the apprehension has all gone, but I'm so tense I've been taking sarpagnan.

This morning I read Herbart's *La Ligne de Force,* in which there are some very malicious but very funny passages on Gide, and a nice little anecdote about Aragon.

I gave Rolland some pages of my *Memoirs;* lunch with J., the American student, who staggered me with her wildly misconceived opinions about Gaullism. She told me about her childhood: a horrific membrane over one eye, a childish, dominating, hysterical Jewish mother, complexes everywhere. An operation at the age of nineteen made her bad eye look normal again, and she contends that Sartre and I taught her through our books that one is marked by one's past but not determined by it. From that time on she was saved. She wants to make me a present of her private diary in eighteen manuscript volumes. She is haunted by the atomic bomb, and can't understand why people in France worry about it so little. She has written to Oppenheimer. She showed me a brochure about the four Americans who went by boat across the Pacific and wouldn't move from the area where the next test was to take place; they soon found themselves in prison. Her dream is to get a boat crammed with people of all nationalities to do the same thing; then the U.S.A. couldn't just put them all in prison. Or else she wants to offer herself as a martyr on whom they can do experiments to find out the results of the explosions. It's typically American, this naïve idealism projected on a world scale (Gary Davis). She's not a fool, however; far from it. Perhaps she'll move out of this phase when she has a profession and some solid ground beneath her feet.

Spent the day with Sartre, reading newspapers and taking notes. He lunched with S.-S. and Giroud. They had a referendum at *L'Express* ten days ago; everyone was decidedly opposed to De Gaulle except F., from sheer despair, and, of course, Jean Daniel.

None of the Algerian faction in the government; nor any demonstrations of enthusiasm in Algiers. They're terrified they've been betrayed. Beuve-Méry has capitulated entirely. The last issue of *L'Express* is much more accurate than the one before. The most stubborn of them all, the one who's really standing firm, is Bourdet. His reply to Sirius (Beuve-Méry) in *Le Monde* was really excellent. In any case, there's a split inside *Le Monde;* some of the contributors are holding out. *France-Soir* is beginning to turn its coat; today they started a series of extracts from De Gaulle's *Memoirs.*

We were saying yesterday evening with Sartre: "The intellectual can be in agreement with a regime; but—except in underdeveloped countries which are short of trained people—he should never agree to fill a technical function as Malraux is doing. Even if he supports the government, he should remain a latent source of opposition and criticism, in other words, he should judge policies, not execute them. Even so, he will find a thousand problems confronting him; but his role must not become confused with that of the rulers; this division of labor is infinitely desirable."

## *Tuesday June 3rd*

After the tension, depression. I was so little inclined to put my nose out of the door this morning that I slept until half past twelve. The weather still muggy and cold. Yesterday evening with Sartre and Bost. Lunch today with Sartre, Pontalis and Chapsal. Waited for them at the Falstaff; at the next table, a young gentleman looking like a rather superior civil servant[1] was chatting to a beastly woman: "All the same, Mendès did applaud De Gaulle . . . No, X. doesn't want a Popular Front; that means he can be brought around . . . Try to convince your group . . . That's unfortunate; apparently Lazareff is basically anti-Gaullist . . ." When Sartre came in they whispered: "There's Sartre," and then left after a little while. We were just beginning to eat when there was a telephone call for Sartre: "Monsieur Sartre, I felt I must tell you that the General is getting ready to make peace in Algeria, that he's not going to have you arrested, and that we regret the attitudes you have adopted in the pages of *L'Express.*" Very polite; he wanted to *bring Sartre around!*

[1] Possibly he was a small-time con man. In 1963, he bumped into Sartre again in the Falstaff. "It's going to start getting tough now," he warned him.

I don't find it amusing any more, jotting down these little things. But I'm too down to write. Or am I down because I'm not writing? We leave next week for Italy; that makes these last days feel even more provisional and contingent. I find it difficult to get interested in my past; I don't really know what to do.

A very good article in *Saturday Review,* with my photograph on the cover. But *Time* and *The New York Times* don't like it at all. What annoys them is that I should speak well of China when I'm not a Communist.

To describe the demonstrations on Wednesday and Sunday as a "detotalized totality" would be a real literary challenge; Sartre managed it up to a point in *The Reprieve.* It seems to me a much more interesting way to attempt things than what they are calling *"alitera-ture."*

Sartre was telling Pontalis just now that whenever he tries to think of a subject for a play an immense void forms inside his head; then, at a certain moment, he hears the words "The Four Horsemen of the Apocalypse" echoing inside it. It's the title of a novel by Blasco Ibañez that he read when he was young. He is also having trouble getting back to work. He's taking corydrame again. "I'm not sad," he told me, "but I'm asleep. It's like a morgue."

### Thursday June 5th

I don't know what it was that drove me to such a pitch of exasper-ation yesterday evening; probably irritation at seeing all those news-papers and hearing all those people wondering what "he" is going to say, going around in circles trying to interpret his silences. Also hear-ing him, against a background of all that shouting in Algiers, with his aging voice and his enigmatic grandiloquence. And thinking that they'll all start trying to decipher the oracle yet again, insisting at all costs on squeezing some drop of hope from his words, when in fact everything is settled now, immutably: years of war and massacres and torture.

Yesterday morning I went to the dentist. L., a Communist and a Jew, was as lugubrious as myself. He said that he found the vigor, the optimism of the Communists insupportable; just because half the Socialists had voted with them they thought they'd won. As for his patients, some of them were saying things like: "Oh come on, De Gaulle isn't going to send you to a concentration camp." "I

know." "Well then, what does it all matter to *you?*" Lunch with Bianca, still very taken up by her committees. She said she had met some groups of parachutists on the street in civilian clothes. (It ties up with a piece of news censored from *L'Express* but revealed today: Lagaillarde had landed with six men at a nearby airfield to try to contact the parachutists stationed near Paris. They were nevertheless politely shipped back to Algeria.) She also told me that in Passy and in Neuilly, "urban militias" of a sort are being formed, with block leaders, etc., much the same as under the Occupation.

Spent the afternoon at Sartre's, vainly attempting to think about my book. I too found myself wondering: What is De Gaulle going to say? Now, I know. He has given his blessing to the "renovation" and "fraternization" of which Algeria has given us such an example, and he hopes these things will spread all through France itself. Soustelle never leaves his side. Then, in the Forum, he paid tribute to Algiers, to the Army, and without actually using the word integration, said that Moslems must become "Frenchmen in the full sense of the word"; he mentioned a "single university." Algiers is disappointed because this is still not Fascist enough for them, and because *real* integration would put them up the creek. In spite of all our suspicions, we were still amazed that he should have taken over Algiers and their policies so completely. At least it makes everything quite clear. All evening at La Palette we talked about nothing else. I blamed myself for not having tried to do more. Sartre pointed out exactly what I had always told myself: that I can't very well go around mimicking him all the time; our names are so closely linked we're almost thought of as only one person. All the same, when I come back from Italy I'll try to commit myself more actively. I should find the present situation less intolerable if I had been more energetic and militant. When I got home, feeling very nervous and humiliated in a way, as well as angry, I found an absolutely insane letter from Y. about Gorz's book *The Traitor* and Sartre's article in *L'Express;* it was a flood of anti-Semitism. I was seized by a fit of anger against the world in general that kept me in a state of near suffocation for an hour before I finally managed to drug myself to sleep.

I slept badly and woke up with my nerves in knots. There was a letter from the "Ministry of National Defense," signed by a Mme de _____, asking me to write some articles for *Bellone,* a magazine intended for the "Women's Armed Forces," of which she enclosed a

copy. Were they going to make advances to us, on top of everything else? Went to buy the newspapers and read them in the café on the corner (the corner of the Avenue d'Orléans). *L'Observateur* still very good, *L'Express* had some good bits and some wishy-washy articles. Both were guarded. They were waiting to see what De Gaulle was really up to in Algeria; they said we must regroup against him "even if . . ."; today everything is clear, and I suppose that Bourdet is, in Mauriac's famous phrase, "agreeably disappointed." Abbas, Tunis, Rabat, are all categorical: De Gaulle's offers are unacceptable. Only that nut Amrouche gives a military salute in *Le Monde:* "I take you at your word, *mon Général.*" We are also informed that there are now more than three hundred and fifty Committees of Public Safety in France. With all this encouragement from De Gaulle, the hatches will soon be well battened down. Sartre says that there is nothing we can do—he and I—for the moment. So, off we go to rest a bit, we can work when we come back.

Lunch with Reggiani and his wife. Sartre told them about his play, which he wants to have put on in October; after October it might not get put on at all.

I bought myself a dress as a distraction, but it only took five minutes and didn't distract me in the slightest. The brackish taste of defeat.

I really don't understand why I'm as upset as I am. The country will end up Fascist, and then, whether it's jail or exile, things will go badly for Sartre; but it's not fear that's got hold of me. I haven't reached that stage yet, unless I'm beyond it. What I find physically intolerable is being forced to be an accomplice of drumbeaters, incendiaries, torturers and mass murderers; it's my country all this is happening to, and I used to love it; and without chauvinism or jingoism, it's pretty difficult to be against one's own country. Even the countryside, the sky over Paris, the Eiffel Tower, are poisoned for me.

This morning, as I was reading on the corner of the avenue, two cart vendors—they were selling cherries—both North Africans, suddenly went for one another. How they fought! All the same there were two passers-by in leather jackets—not middle-class people, of course—who hurried over to try to separate them. It wasn't too easy, because one of them had got his teeth firmly fixed in the other's shoulder through his check shirt. Then a cop strolled up, swinging

his truncheon and smiling; but it was all over, he missed his chance of clouting anyone.

*Friday June 6th*

This morning, for no particular reason, something inside me had loosened; I felt relaxed. Card from L. in Irkutsk; he found Siberia enchanting. How well I remember those little airfields with their ruffled curtains! I took the car out to Fontainebleau and back to see how things went; it's all right—I'm in good working order and so is the car. I can't wait to start.

Joan left all eighteen volumes of her diary with the concierge. It's interesting, despite all the rubbish, because she has revealed herself completely. Generally speaking, I find personal diaries fascinating, and this one is quite extraordinary, one really does take a dive straight into someone else's life, another frame of reference, and in a sense that's the severest test of all: while I'm reading it, she's the absolute subject, not me any more.

De Gaulle is still on his tour of Algeria, obviously displeased. In Oran, they yelled: "Soustelle! Soustelle!" and he said: "Stop, I beg you." He evidently doesn't like this Fascism, which will try to go further than he wants. He may be playing into their hands. But enough of this commenting and prophesying and interpreting. I will just make a note of the fact that the press is lukewarm about the whole thing. The fact is, this "comeback" hasn't produced much enthusiasm on either side.

*Saturday June 7th*

Almost two weeks without working, and yet I felt so impatient to begin on the morning of the 25th. But you can't expect to work well in a state of anxiety, especially when it's a question of invention, getting yourself started. Letter from Joan this morning; listening to De Gaulle speak has put her off him; a purely sentimental reaction, but shared by a great many other people. He has a Fascist style when he speaks, military, grandiloquent; it makes a lot of things clear when you hear it. Interesting letter from A.B.[1] He talks about how frightened the Moslems are in the little villages; they're avoiding him because to be seen with him would be compromising; terrible

---

[1] A soldier in Algeria.

pressures are being used to create the mock fraternization; the arrests still go on underneath it all, and the murders.

I must answer letters; gray, dull morning.

### Sunday June 8th

Finished with the radio three times a day, INF. 1, every edition of the newspapers. Things will move slowly for the next few days. At Mostaganem, on Friday evening, De Gaulle finally came out with the words "French Algeria"; but the "left-wing Gaullists" insist on the fact that he avoids saying "integration." For a man of "character," he has proved to be singularly accommodating; for after all—without mentioning the other things—in Algiers they put the two Ministers accompanying him under house arrest; and instead of insisting that they should appear at all the various functions during the next few days, he accepted the snub. Obviously he's prepared to bow and scrape if he has to.

I'm still wading through Joan's extraordinary diary, wallowing in it. I find it touching, because she's read me as though I were part of her own life, because many of her criticisms are very much to the point, because she defends me with so much warmth all the time, and often with intelligence. But even here I'm blasé; ten years ago it would have had quite an effect; now, I find it quite pleasant, but troubling too. I ought to be writing new books, better ones, I ought to be proving my worth afresh, proving that I really deserve to exist like that for other people. And I'm hovering between two projects without being able to decide.

### Tuesday June 10th

Malraux said to S.-S., who repeated it directly to Sartre: "We have received completely reliable information about fraternization: it is a reality." When mythomania is blown up into a political system, things are becoming serious. He made a short speech about French "generosity" so farfetched that even Clavel protested in *Combat*. Bost is on the Cinema Vigilance Committee and is furious because they're so cautious: ten out of the fifteen members are Communists. Sartre says it's simply a question of getting into position and that the committees can't really do anything until the referendum comes up.

Dinner on Sunday with Suzanne Flon, nice, and Huston; he has

that American attractiveness, despite a big sty on his eye. We talked a lot about Freud, a virgin until he was married at the age of twenty-seven, and a completely faithful husband. Huston had the idea for this film after shooting a documentary on battle neuroses; the film turned out so antimilitaristic that it was suppressed.

*Wednesday June 11th*

Since I had the evening free yesterday I called Joan and asked her to come over. It gives my heart a slight pang to think that she spent five years wanting to see me, was tenacious and clever enough to succeed in doing so, and now all that success amounts to is these three rather everyday conversations. At this point, having read her diary, I wanted to talk to her about herself. How unhappy she had been! What a beautiful little "private hell" she had built for herself with that curious and very American mixture of freedom and taboos. And what a solid foundation it had: her appallingly cruel deformity and her tortured relationship with a mother at once pretty, famous and completely off the rails ever since her husband—a calm, attractive man—had left her and gone off to the other end of the earth. Joan, with her membrane-covered eye, her crooked teeth, afflicted by tics and shyness, spent a lonely and haunted childhood entirely in her shadow. At sixteen, there was an idyll with Bodenheim, a poet famous in the twenties, by then a half-mad, impotent alcoholic; he used to grope her in parks. The mother, informed of what was happening by a policewoman, wrote him a letter, purporting to come from a professional boxer, in which she threatened to beat him up. He explained to Joan that he had to break with her because he had piles and a hernia; and also because he had been mixed up in so many affairs with minors that he might be jailed if it happened again; or at the very least there would be a scandal, and then his publisher wouldn't reprint any of his books. He died five years later, caught in bed with a fairly attractive woman by her jealous husband, who stabbed Bodenheim in the heart, strangled his wife and ended his days in a lunatic asylum. The whole of Greenwich Village went to Bodenheim's funeral, but not one person followed the wife's coffin. After that, Joan's story was one long series of more or less sordid affairs and unfortunate passions. She spent two years at Yale: more unfortunate passions. Although she was a brilliant student, people shied away from her because she was so vehement and excitable, as

well as being mixed up with Communists and Trotskyites. Finally she came to Paris. That was how she had managed to be at my lecture, interrupt me and then write to me. We had dinner at the Falstaff. A half-crazed woman selling flowers came in singing and writhed about on the floor, to the great amusement of the customers. I advised Joan to go back to America, to stop keeping a diary, to think about something besides herself, and to read instead of talk. I also advised her to write, it seems to me that she could: something does "come across," and strongly, in that extravagant diary of hers. She doesn't dare; she wants to work in a factory so she can be "close to the working classes." But I think writing is the only way she's going to find of defeating her solitude. She had on a black velvet dress with a rather pretty blue brooch, she'd had her bangs curled. "I'm not *ugly,* I'm just *plain,*" she told me. She's going back to America in August. I'll be surprised if she does decide to become a writer.

Stopped in at Gallimard's this morning. Chatted for an hour and a half with Jacques Lanzmann at the Deux Magots. He told me about his trip to Mexico, Cuba, Haiti and San Domingo. He assured me that in Santiago de Cuba he had seen men hanged by the balls, and a tiger that was given the corpses to eat. But he's a poet. Every day the Batista-controlled newspapers publish pictures of the people he's had tortured and killed: more than a hundred each day. It made Claude Julien sick, and he'd been tortured himself during the Resistance. They found a way of getting out into the *maquis,* hoping to do a story on Castro and the rebel army. They were arrested an hour before they were due to leave. They had the bright idea of saying to the general (who is not averse to castrating prisoners with his own hands): "We have had problems similar to yours in Algeria, so we thought we'd come and see how you coped with them." Thanks to his papers, Julien was able to get back to Havana, whereas Jacques was put on a plane to Haiti.

Yesterday evening, the Committee of Public Safety in Algiers delivered itself of an incendiary declaration. Did Salan approve it or not? After some hesitation, De Gaulle finally decided to say that he was displeased.

Corrected my proofs and took notes at Sartre's. He's as happy as I am about starting for Venice. It's impossible for me to start work till I'm settled there. I had the impulse three weeks ago, but it suddenly stopped short.

Jules Moch (*En Retard d'une Guerre*) divides the history of destruction into epochs: individual, artisan, small-scale, large-scale, and quasi-universal. Why am I (Sartre is the same) so little affected by the atomic threat? Perhaps because we can do absolutely nothing about it; all one can do is think about it, an idle occupation, especially when the problems in Algeria are so real and urgent, and concern us so directly.

### Friday June 13th

Very friendly letter from a twenty-year-old girl student. At the moment, everything seems to be encouraging me to be narcissistic: Joan's diary, heaps of friendly letters, Gennari's book about me, my own memories as I go through my *Memoirs,* correcting proof. It has all made me decide to go on with my autobiography; Sartre said again that in any case I've already gone far enough for the attempt to be legitimate. I'll get down to it in Italy then. Usual contingent days before a departure; errands, mail, enormous bundles of proofs to correct. I've borrowed Monique Nathan's *Virginia Woolf* from V. Leduc; now that I've read her *Diary of a Writer* I wanted to have another look at the extraordinary faces of this woman—what a lonely face!

Malraux and his "psychological shock"; complete insanity.

### Monday June 16th—Milan

Suddenly, a completely new viewpoint: holiday. I woke up on Saturday at 6:30 in the morning, and what was stopping me from leaving right then? I left. To dive back into solitude, into freedom, as in the days of my. walking tours—what rejuvenation! A beautiful morning. I know that road through the Morvan by heart, it's signposted with my memories. . . . Annecy too is a memory, from further back; after twenty years, I still recognized its canal, the streets with their arcades, the little restaurants at the edge of the water. I ate dinner in the old town and drank a Scotch on the lake as I read Hlasko's *Eighth Day of the Week.* I love starting off early in the morning, before the curtain rises. Pretty road, still deserted, along the side of the lake, and gradually the villages filled up with people in their Sunday clothes. On the Little Saint Bernard, there was snow, and even some skiers slalom-racing. Seeing the snow and the moun-

tain scenery made me a little nostalgic, because all that is lost forever now: the long walks, ten or twelve hours, between six and nine thousand feet or even higher, sleeping in tents or barns—I loved it all so much. Lunch at Saint-Vincent. "How are things in France?" my hostess asked me. "It depends which side you're on. It depends whether you like generals or not," I answered. To take advantage of the sun, I stopped in a meadow where I had a superb landscape on every side of me, a dilapidated castle far away on my right, another off on the left, and buried in the high grass I finished Hlasko's book: a lot of vodka, very little love, because there was nowhere to go indoors and make love, a general atmosphere of sarcasm produced by the author's dissatisfaction with the world and with himself as well; cleverly written, but nothing more. I drove through a few more little towns bubbling with Sunday spirits and paved with yellow pebbles, then came the Autostrada and the Piazza della Scala.

Six in the evening. I had absolutely nothing to do, which was rather disconcerting but pleasant too. I drank two gin fizzes in the hotel bar; they're still as good as ever. I remember the same bar in 1946, how luxurious it seemed to me! That was a real second youth, even more head-turning than the first. I was thinking of those past days as I wandered out into the streets of Milan, tepid, idle, almost empty: Sunday evening. All the Italian women were wearing shirt dresses, some made for them, some off the rack, all, in my opinion, regrettable. New skyscrapers, new blocks of apartments—things change quickly in Italy. The Autostrada had changed since the year before, with that enormous bridge that joins it to the city.

Sartre arrived this morning at half past eight; we read the newspapers in the Café della Scala. Marvelous Italy! One slips into the atmosphere immediately. All Milan is talking about a great artistic drama: a madman, who calls himself "an anachronic painter," yesterday morning at the Brera attacked Raphael's "Marriage of the Virgin" with a hammer. One of the guards managed to keep the destruction from becoming total, but traces of the "sacrilege" will always remain, a fact which has apparently thrown the entire world into a state of consternation. There isn't much about France in today's papers, but at the hairdresser's I found an issue of *Oggi* with a very amusing article called "The Gaullist's Ten Commandments"; it drew a parallel between the present events in France and those in Italy during 1922; it's our turn to have a taste of Fascism, and they

find it rather entertaining. The Left is laughing too, but they're worried; a right-wing dictatorship in France is a serious danger for Italy too.

This morning we wandered around Milan, then lunched with the Mondadoris at the Ristorante della Scala. He has scarcely changed in twelve years, still looks like a swashbuckling pirate; she's blond now, but still has the same smile, the same unaffected manner, the same charm. He's begun writing poems, *engagé* poems, because he's left-wing. We talked about Hemingway. M. said that at Cortina, he was still drinking as usual, but that he was in a state of terror about his liver, his heart, and the idea that drink might kill him. One day, after a meal, he got hiccups. He called his doctor in a state of panic. "You must use the elevator," the doctor told him. So H. went up and down, up and down, six times, supported on one side by the doctor and on the other by Mondadori. The hiccups stopped. He pulled down his green eyeshield, and went off to bed.

We went to see the exhibition of ancient Lombard art; nothing particularly good in it, except for a big altarpiece. Sartre got annoyed: "It's all military art! This is the sort of painting you get when a country is ruled by soldiers!" (Mondadori said, with slightly ironical sympathy: "For twenty years now, we've had neither art nor literature. . . .")

We ate dinner at dusk in the Piazza del Duomo, relaxed, relieved at having escaped from France. Sartre said that he hadn't felt so calm for a long time.

*Tuesday 17th—Venice*

All the same, I still have bad dreams; I'm eager to wake up in the morning.

We left a little before ten in the morning; blue-gray sky, sunny, damp weather: North Italy. Lunch in Padua. We took our coffee in a café reputed to be the largest in the world. I bought a newspaper. On the front page: Nagy shot, also Malester and two others. "We mustn't buy any more newspapers!" said Sartre, his calm suddenly shattered.

Venice; for the tenth time, or is it the twelfth? Pleasantly familiar. "Canal closed—work in progress." We turned off down canals we'd never seen before, so narrow it was almost impossible to pass. Charming rooms at the Cavaletto. Sartre ordered "three teas," and settled down to work. Festy has sent me some proofs; I went to the

Piazza San Marco, but there was too much music; I made myself comfortable on the bank of the canal and corrected forty pages; now I've come back here. The sky is pale with a slight wash of pink, there is a faint murmur coming up from the gondola moorings and the quays. I must get back to work tomorrow or I'll begin to droop and pine.

*Wednesday June 18th*

The big headlines of the Italian newspapers read: LE MANI SPORCHE. No one talks about anything except the execution of Nagy and Malester. Why? We discuss it endlessly without reaching any conclusion. It's sinister as far as France is concerned because the Communists are going to be even more isolated, the Left more demoralized, and Gaullism strengthened. The counterdemonstrators won't be feeling so enthusiastic today. And just when Sartre was trying to forget politics for a few days!

Long letter from Lanzmann; he was dazzled by Siberia, and the Koreans got him drunk on ginseng. He heard about De Gaulle's investiture on the Okinawa radio.

*Friday June 20th*

I'm very pleased with my room, with the ripples of light and shade moving across the ceiling and the *battie-becco* of the gondoliers. But until this morning I've been working badly, done nothing but read, and been tired. This morning I decided to take the plunge. I ought to make myself write ten pages of rough draft every day. Then at the end of the vacation I'd have something to work on, a nice bundle of "rubbish" I might then make something of. There are so many memories to be assembled that I can't see any other way of going about it. I've read *She Came to Stay* from cover to cover and made notes of what I thought about it now. I discovered things in it that I've said again almost word for word in my *Memoirs,* and others which recur in *The Mandarins.* Yes—and there's nothing discouraging in the fact—no writer ever writes anything except *his* books.

We went to see San Rocco again, and the church there and the Accadèmia. I compared what I saw with what Sartre had to say last year about Tintoretto.

Apparently almost nothing happened on June 18th, except for a few brawls with the Fascists in Ajaccio, Pau, Marseilles.

### Saturday June 21st

Received some letters. One of them from a Roman woman, married, mother of two grown children, once an opponent of Fascism and now a member of the Communist Party, in despair over Nagy's execution and wondering what point there is in living: nothing to do, powerless to affect the world by her actions. There are so many people who write to me and say: "It's terrible to be a woman!" I wasn't wrong when I wrote *The Second Sex,* in fact I was even more right than I thought at the time. A series of extracts from the letters I have received since that book came out would make a very moving document.

Yesterday, at the Correr Museum, we saw an Antonello da Messina, not particularly good, but certainly concrete proof of what Sartre had told me: that he was the link between Vivarini and Giorgione's "Tempest," and even more definitely between Bellini's first and second styles. Our tastes haven't really changed much in twenty-five years; I still experience the same astonished admiration in front of the Cosimo Turas and remember my surprise when I first came upon them years ago.

We're settling down into a rhythm here. Up at 9:30, long breakfast with the newspapers in the Piazza San Marco. Work till 2:30. A snack. Sight-seeing or a museum. Work from five till nine. Dinner. A Scotch at Harry's Bar. A last Scotch at midnight on the Piazza, when it's finally free of all the musicians, the tourists, the pigeons, and despite the chairs on the café terraces regains the tragic beauty Tintoretto captured in his "Abduction of Saint Mark."

Yesterday afternoon I corrected an enormous bundle of proofs sent by Festy; for once one of my books is giving me pleasure to reread. Unless I'm mistaken, it should be a success with young girls who are having problems with their family and religion, and aren't yet liberated enough to liberate themselves. Also, I think I've really got my new book started at last.

Newspapers from Paris. In his *Bloc-Notes,* Mauriac has reached the stage of eulogizing Guy Mollet! Letters from Paris. The meeting of the Committee of the 6th Arrondissement, at which Regiani read out Sartre's piece, was a success on June 17th; more particularly,

there was an ovation for Sartre after the first few sentences, and an
even bigger one at the end. (There were almost seven hundred
people there, at the Sociétés Savantes' hall.) Henri Lefebvre has
been excluded from the Party for a year because he joined the "Club
de Gauche."

How pretty it was, as we sat in the Piazza San Marco last night,
that single *oeil-de-boeuf* lit up under the eaves, amid the vast ex-
panse of all those flat façades, and that man's silhouette inside it. He
was just looking; it was as though he were unable to tear himself away
from the sight of the Piazza at night. Suddenly the light went out, so
unexpectedly that Sartre and I both said together: "Oh! It was like a
shooting star."

### Sunday June 22nd

Yes, I think I'm off to a good start, and for at least two years. In
one sense it makes me feel secure. That good little schoolgirl is still
there inside me, worrying if I "sit doing nothing" for a week or two.
A trip is a kind of activity, so I can give myself up to it without guilt.
But in Paris I was just drifting, and I blamed myself for that. All the
same, I haven't been completely wasting my time. Apart from writ-
ing this diary and correcting my proofs, I've amassed material for
my book, reread my old novels and letters, jotted down some memo-
ries. I think I really will get through my ten pages a day now.
There's something disheartening about doing it all so messily, but I
can't afford to hold myself back by *writing* a single page before I've
got the whole canvas blocked out. This is the way I worked on *Amer-
ica Day by Day;* though not on the *Memoirs*—those I wrote in little
sections.

### Tuesday June 24th

On Sunday afternoon we went out toward the Arsenal; there was
a crowd on the Fundamenta Nuova, but no tourists; they were Ital-
ians who had come to watch the regatta. Boats, canoes, gondolas,
packed with people, clustering around great posts with green decora-
tions painted around the top. Everywhere in the green lagoon—ex-
actly the same green as the trees—there were processions of gondolas,
and gondoliers, dressed in dazzling white, bent over their poles, their
buttocks modeled just as one sees them in the pictures of Carpaccio.

A few russet or purplish sails; two or three yachts in the distance. We left before the regatta began. The streets were so peaceful: the provinces. Then little by little—rather like cars on the road as one approaches a big town—there were more and more people walking, suddenly we were in a crowd, the *Führungen*, peasants in Tyrolean hats, real rustics straight off their mountains (one of them with an enormous red beard), fat German women in transparent dresses and straw hats, and then we were back in the Piazza San Marco; the pigeons, the photographers, the city.

After dinner at La Fenice, where the owner insisted on taking us on a tour of the kitchen, we went to Harry's Bar. As we came out, two Italian men accosted Sartre very graciously. They invited us to go and have a drink at Ciro's. "Turn to the left; with Sartre, one must always go left," they said as they showed us the way. One of them was a tiny sculptor; the other, a man of about forty, with a curiously mobile, rather shifty face, said he was a "scientist"; he works with microbes and runs a laboratory. "Me, I'm just someone whose job it is to make people piss"; he's called "Charming" he informed us. He once read *The Wall* and found it so good he doesn't want to read anything else Sartre has written. Like many Italians, he enjoys playing on words; he uses a nice expression that I didn't know: *faire du casino* (make a disturbance, a row). They bought us Venetian white wine while they talked on charmingly about Venice, how it manages to be so provincial and still support a large working-class population. "No one works so hard as the Venetians," he assured us. "Besides, there are 300,000 of them in Milan." We finished the evening on the dance floor of the Martini Tavern, almost deserted because by then it was two in the morning.

They arranged to meet us at eleven the following evening in Harry's. By then, we said to each other: "It's going to be a hell of a bore; for one thing we had a few drinks in us last night; and also they're bound to bring other people along." We weren't wrong there, but it turned out quite differently from what we expected.

"Charming" was eating with a dark-haired man at a round table; he came over to us. "He's an American, a ghastly bore, who's just arrived from New York." He was in fact an Italian who had a business in America, but he was from Genoa, and the Genoese, C. explained, are not Italians. The "American" spoke not a word of French; the conversation began badly; enter an Italian woman, blond, heavy but with beautiful pale eyes, very much made up, more

or less dotty about the "American"; she didn't speak French either. They were all making fun of her because a burglar had recently tied his boat up alongside her house, slipped in through a window and stolen all her brassieres and panties. "The tools of her trade," said C., who has a touch of the pederast's misogyny about him (he is obsessed with pederasty). He suggested animatedly that we should go and have a drink at a very beautiful new hotel on the Giudecca, where his friend wanted to check in; we agreed, and got into the hotel's private launch; it was charming crossing the canal on a beautiful night, starry for once, with an orange crescent of moon that looked as though it had been stuck up there just for the tourists; in the distance, we could see the lights of the Lido, bright yellow, and the Doges' Palace floating away. The hotel had a garden going right down to the lagoon, really lovely. But we wandered about uncertainly in the enormous vestibules; the barman had "shut up shop" we were told by the porter. The "American" went up to pick a room and we sat down to wait for him. The sculptor telephoned; we set off again, and as we stepped out of the launch once more, Sartre and I agreed that we felt like people in one of Pavese's stories: all these enthusiastic schemes perpetually falling flat. The sculptor was waiting for us with some of his friends; we went out onto the Campo della Fenice, where there is a pleasant café set in the middle of greenery. C. ordered us some strange drinks: a concoction of mint and grappa, a Venetian speciality consumed by the Venetian worker, or so he claimed, at five in the morning, and mixtures of pernod and whisky. I stuck to straight grappa. Poor Sartre had by now become prey to a short young man with starry eyes who worked in films; he had collaborated on the scenario of *Le Amice;* he said to me: "You're famous here, people in Venice adore *The Mandarins,"* and C. asked me: "Was that you, *The Mandarins?"* Though he hadn't in fact read it. "Yes, now I think of it, one might expect you to be a writer," he said, looking perplexed. Things seemed to have turned formal, the charm was broken. We said good night and went off in the direction of our usual hangout, a tavern on the little Piazza dei Leoni off Saint Mark's. The big Piazza was deserted; a red-haired woman was sobbing and screaming; she had one hand wrapped in gauze and was making a scene with two well-dressed characters who were obviously plain-clothes policemen; she was lying prostrate under one of the arcades; suddenly she left off weeping, leapt up after the two men and began protesting with wild gestures; all the neighborhood

whores came out of the shadows to see what was going on. Finally the redhead moved off, grumbling to herself. We sat down in front of two Scotches. A man came running out of a nearby café—quite well-dressed, middle-aged, Italian—followed by a waiter who was hitting him; the customer suddenly turned, seized a chair and brandished it; the waiter knocked him down. A tremendous outcry from the on-lookers: "No!" and they all rushed over to pull them apart. We were agreeably affected by this reaction; in France, people wouldn't have felt this impulse to interfere, they would have let them go on till they drew blood. The waiter was led back to his café; the customer walked off; two minutes later he was back, accompanied by two guards carrying sabers. We went and joined the group of idlers in front of the café (all Italians, because it was late). The waiter got irritated, he asked them to move on, saying in French: "If you had any education, you wouldn't stand around." "Are you telling me I'm uneducated?" Sartre asked. The discussion looked as though it might become ugly, but the café owner, annoyed now, made the waiter go inside. A tall, dark-haired prostitute shouted after him in Italian: "He's French and you've insulted him; that's not good manners!" We went back to our table. The Italian who'd been knocked down came over to the counter of our tavern and drank a coffee with an arrogant but chastened expression; he went away again. Two cleanly dressed bums with beautiful white hair and sharp faces helped the waiter of the nearby café take in his chairs while they listened to his account of the affair; he gave them a few coins; they divided them up and disappeared nonchalantly into the night. We left too, and sud-denly found ourselves surrounded by three or four café waiters, among them the protagonist of the recent drama. He wanted to ex-plain matters to Sartre; but the tone he took was so aggressive that the quarrel seemed more likely to be resumed than settled. "That customer comes and makes trouble for us every single night," said one of the waiters in defense of his colleague. The latter insisted: "I wasn't attacking you, I was talking generally, to everybody." "But they were all Italians, and you spoke in French," Sartre answered with a smile. They all laughed, and the waiter held out his hand with a smile. "True. All right. I apologize." The whole of this affair was conducted in a style quite peculiar to Italy.

Rain today, Venice melting in mist, the churches and palazzos deliquescing. A few gondoliers have swathed themselves in black capes.

De Gaulle is still negotiating Mollet's visit to Algeria; he wants a reassurance that he won't be forced to leave him behind in the cloak-room. Under pressure from Algiers, one of the radio reporters has been sacked and the staff in general has been overhauled; Delannoy is leaving, Nocher is back. More and more, Algiers is giving the orders.

### Wednesday June 25th

The *Corriere della Sera* found Malraux's press conference very amusing. Photographers, television cameras, big production number; Malraux spoke in the tones of some mystical preacher, and the four hundred journalists expressed surprise. Not many facts, said the Italian correspondent, but everyone learned a good deal about "the psychological and choreographic style of the regime." Malraux wants to make another Tennessee Valley out of Algeria, and send the three French Nobel Prize winners to investigate the prisons. As Sartre says: "We've fallen out of cowardice into the symbol."

### Thursday June 26th

Letter from Lanzmann, admiration mixed with irritation. He says the Koreans are extraordinarily likable, but that the official optimism there is worse than in China.

Legal proceedings have been instituted against *L'Observateur* and *L'Express*. At least we know where we are now as far as freedom of the press is concerned. And anyway, a comparison with the Italian newspapers makes it clear how much the French press censors itself, it's been castrated. The articles they're being prosecuted for are about Algeria, of course; among other things, there was an interview with an F.L.N. leader. However, Algiers is fuming; Malraux's press conference has infuriated them.

### Monday June 30th

We revisited Torcello and saw the Carpaccios at San Giorgio again; we went up the campanile and the bells rang out in our ears. We visited the Biennale: a very bad Braque exhibition, a very lovely one of Wols; interesting sculptures by Pevsner. And we've had some

charming evenings; to avoid meeting people, we've migrated from Harry's Bar to Ciro's, where a German pianist plays lovely old tunes. I was amused by two young Americans who sat side by side for hours on end without opening their mouths, but with their eyes perpetually starry and smiles on their lips, as though they just couldn't get over the fact that they're alive, that they're Americans, and that the rest of the world exists. A big, pasty Belgian decided, without knowing who he was, to make a portrait of Sartre; it was pitiful. He had just arrived from Brussels in the company of a homosexual count obviously a victim of one of those terrible love agonies homosexuals suffer from so often: dark, empty eyes, haunted by some distant image; great difficulty in regaining his presence of mind when the other man spoke to him.

This evening, our last, we went to Harry's to say good-bye to "Charming" and the sculptor. They were drinking white wine with a rich Swedish arms manufacturer and his wife. He touched my heart because he had bought *The Mandarins* and spent a whole night reading 137 pages of it; he told me enthusiastically that he thought it was "even better than *Gone With the Wind.*" He said: "Naturally, I'm a snob; what else have I got?" He gestured toward the Swedish woman. "She loathes *The Mandarins.*" Then she, not at all embarrassed: "Yes, there's too much politics in it; I loathe politics." Then she added graciously: "Besides, I'm a conservative. I have a husband, an official lover and a great deal of money; so of course I'm conservative." Then, with a slightly worried air, to the arms manufacturer: "I do have a great deal of money, don't I?" He shook his head and she laughed. "No! Then I'm ruined." She attacked C.: "You're such a pig." To which he replied with animation: "Yes, but such a human one!"

*Tuesday July 1st*

Left Venice. But first we breakfasted on the Rialto, on the Grand Canal, and read the papers. De Gaulle has set out with Mollet for the Algerian "front." The business of the Perpignan teacher who killed one of his pupils seems quite clear. Perpignan is full of "Africans" from Morocco and Tunisia; they are completely Fascist and have formed a sort of "Committee of Public Safety" against the teachers who went on strike in May and against all left-wing teachers in general. The Amiels were left-wing, and life was systematically made im-

possible for them; in class by constant riots, at home by fireworks in their letter box; they had seriously threatened to kill him. A few days beforehand, when some pupils came to make trouble in front of his house, he had fired over their heads. This time, the rumpus outside his windows had been even worse than usual; he had fired on them. And now the teachers are brawling among themselves in the school courtyard, Fascists against anti-Fascists. Bianca had been telling me about the tension, even in Paris, between pupils and teachers in the "high-class" *lycées* like Pasteur, Janson, etc.

Stopped at Ferrara. Arrived at Ravenna at six. It's pleasant in the falling dusk, but there's nothing noisier than these little Italian towns with their motorbikes and their scooters. It's already six years since I was last here, driving for the first time on a long journey, just having met Lanzmann.

### Wednesday July 2nd

How beautiful Spoleto is, with its streets all ramps and stairways, and paved with little pebbles. There are big lanterns hung from black façades and so much shadow that the spiders think they're in a barn and spin immense webs between the telegraph wires. Our hotel overlooks a little square paved with irregularly shaped stones, surrounded with greenery, with a little fountain sobbing in the middle, just like a private garden. The scent of lime trees in bloom mingles with a vague odor of leatherwork and incense. All around are the dry hills, the blue distances of Italy.

I haven't been to look at the Ravenna mosaics again, I didn't particularly want to and I no longer feel I have a duty to perform; on trips, I only do what I feel like doing now. I enjoyed revisiting Urbino where we lunched and drank coffee under the arcades. The waiter asked Sartre: "Are you French? Are you a writer? Are you Jean-Paul Sartre?" He claimed he recognized him "from the newspapers." But a few moments later three young Italian teachers came over and asked Sartre for his autograph; it was they who had discovered his presence.

In Spoleto, Alleg's *La Tortura* is on sale. There are posters on the walls: De Gaulle, *il dittatore,* Mollet, *il traditore,* Pflimlin, *il codardo.* And the caption: THIS IS WHAT ANTICOMMUNISM LEADS TO: FASCISM . . . BEWARE OF THE POPE! Marvelous blue sky and the pleasure of coming back to Italy again: Venice isn't Italy.

In the evening, I walked with Sartre through the streets smelling of lime-flower tea. The big lanterns were all lit up.

## Friday July 4th

Yesterday we saw the streets, the Duomo and the superb bridge with its tall arches stretching across a narrow and rather shallow valley. Why this bridge? In front of the hotel, the waiters were putting out tables and lamps, they were painting the barricades violet for some celebration or other. We left for Rome. We could see Saint Peter's and the Monte Mario from twelve miles away.

It was raining and the afternoon was not very enjoyable, despite the pleasure of staying in the Piazza Rotonda at the Hotel Senato. When I nap for an hour in the afternoon, I am always seized by panic just before I wake up: we're going to be seventy years old, and then we'll die, it's a fact, it's certain, it's not just a nightmare! It's as though waking life were a too-rosy dream with death hidden in the misty distance, and in sleep I reach the truth, the heart of the matter.

Today is very beautiful, very blue, I feel the happiness of being in Rome for a long time take hold of me again, and the desire to write. And I write. A long letter from Lanzmann, torn between his love for the Koreans and the irritation of having to travel as part of a delegation.

De Gaulle is coming back from Algeria. He did not receive the Committee of Public Safety; they are furious in Algiers. But the ambiguity persists, the symbols, the disputes of terminology. There's an article in *Le Littéraire* by Mauriac, in which he exalts De Gaulle and talks with rancorous affection about Malraux, who has fallen in love with power and been given a "ministry to nibble at."

Sartre is happy in Rome and is enjoying the play he's settled down to. I still haven't read any of it. Evidently Simone Berriau is going crazy in Paris waiting for it.

When I feel the desire to write these days, I get on with my book; when the desire leaves me, even this diary bores me. I don't know if I'm really giving it a chance.

## Tuesday July 8th

Huge headlines in the newspapers: SOUSTELLE REPLACES MALRAUX.

The Socialists are rallying more and more. Mollet still hasn't given an inch.

No, I really haven't anything to say at the moment in this diary. Rome is empty of tourists, not too hot, blue, ideal. Same daily rhythm as last year. At about ten, long breakfast out in the Piazza, still full of rustics in floppy hats; work till two or three; we eat a sandwich on a terrace and go for a little walk. Work again till five. We dine at Pancracio's, with spaghetti *à la carbonara* and some Barolo. And then we drink a little bit too much whisky in the Piazza Santi Apostoli or the Piazza del Popolo. And it's all so familiar, so happy, that there's no need for words.

*Friday July 11th*

And perhaps there are other reasons, too, for my not having anything to say. Yes, Rome is a happy place, and my work, though it's a bit sickening, interests me, and Sartre's is difficult but it absorbs him. Only there's France. As we drank our last Scotch in the Via Francesco Crispi, watching the hostesses at the neighboring dance hall (and the very funny girl, all in pink and very feminine one evening, and the next day in jeans and fascinated by Sartre's shoes), we admitted to each other that our hearts were not light. We put on a show of living a humdrum, peaceful life, but nothing really tastes quite right.

Beautiful storm yesterday over Rome, and in the evening the Via Veneto was still wet and almost deserted. I don't like Fellini all that much; but it's impossible not to see the Via Veneto through the shots of *Cabiria*.

Florence wrote in a friendly way in *Le Monde* about the extracts in *Les Temps Modernes* from *Memoirs of a Dutiful Daughter*. I do so hope that people will like the book, and it would help me in writing the next one.

The Socialists have asked De Gaulle to do away with the Algeria Committees; as the *Corriere della Sera* put it, it's very significant and of no importance whatever. Silence, resignation throughout the French press. *L'Express* and *L'Observateur* both call attention despairingly to this sickening apathy, and the scarcely veiled, quiet, inevitable rising tide of all the things we hate.

*Sunday July 13th*

"Before the invention of window glass, it was impossible to be a genius outside those regions where the olive tree grows." That is the sort of observation I find enchanting. I read Sauvy's things with passion; now I am reading Fourastié's, which amuse me a great deal. Though he irritates me too, with his *Mme Express-Technocrat* side. Frightening vision of technocratic man; the other side of his optimism is "the Organization Man." These tertiary towns in which Le Corbusier, Francastel, Fourastié, etc., want to make people live are actually "suburbs"; American residential districts. They give me the shudders. Space, light, air, order—fair enough; but what do they mean by "harmony"? Doesn't "man" (which man?) need aggressiveness in his environment as much as calm, doesn't he need resistance, the unexpected, and to feel when he looks about him that the world is not just a big kitchen garden? Must we really choose between hovels and high-status subdivisions?

What a beautiful day! We lunched at the Tor del Carbone off the Appian Way. Cypresses, umbrella pines and bricks under a pale sky, and that endless road, for even in a car the eye still takes its measure as it was when you traveled it on horseback or on foot to far-off Pompeii: straight between the straight cypresses, it suggests a flat and limitless country to the mind. I loved it today with almost the same intensity of feeling as at twenty-five.

This evening, people in Paris are going to dance, with the most magnificent fireworks, the biggest orchestras that have been seen for years. And last year was a mockery: a Socialist government forbidding the 14th of July balls. But this "national renascence" that's being celebrated tomorrow is sickening. I used to love our Fourteenth of Julys so much. I'm glad I'm not in Paris. I'd have been grinding my teeth every night.

Amusingly enough, across the narrow street, my bathroom window frames my neighbor's window opposite exactly, while his forms a frame for his television screen; he is sitting alone on a chair, and I can see perfectly what he is watching. This evening, a woman in a spotted dress is meditating, alone, against the white background; then she says a word and there's applause. It's one of the *lascia-raddopia* programs we're always reading such impassioned accounts of in the newspapers; in Italy it's really a national sport.

The storm has cleared the air; it's had a similar effect on me, too.

I feel relaxed now for no good reason. So much the worse for the Fourteenth of July balls; just now I was in the Piazza Navona, there was the dark blue sky of the Roman night over the dark-red houses, with the *oeil-de-boeuf* windows lit up, and all the people strolling about—a moment of perfection. Tonight, once more, life sinks its teeth into my heart.

*Tuesday July 15th*

From now on the Fourteenth of July will also be a day of national celebration for Irak: revolution in Baghdad! Which smashes the Baghdad Pact to pieces, Irak supporting the "Arab Republic," Nasser in the seventh heaven, and the rebels in Beirut likewise. I imagine the F.L.N. is jubilant about it, too.

Meanwhile, there's been a parade on the Champs-Élysées. De Gaulle didn't watch it because he would have had to take third place in the stand: still that acute sense of *grandeur!* Malraux delivered an address in the Place de l'Hôtel-de Ville, but the "people of Paris" he was purportedly speaking to were in fact Moslem and French soldiers under orders to be there. One interesting incident. Several young Algerian soldiers, brought to Paris by force as a symbol of fraternization, as they passed the stand, instead of saluting Coty, pulled green and white banners out from under their shirts and waved them defiantly. That night the Algerians killed eleven people, six of them Moslem collaborators.

Another long letter from Lanzmann. There isn't a single man in Korea who isn't either a widower or an orphan, he writes; many of them weep as they tell their story. The Americans completely destroyed towns and villages just for the fun of it, and the Koreans hate them for it. They figure in all the plays and all the films there as villains with cardboard noses, and the booing that greets their appearances is by no means a mere convention. He watched a parade that was much more rigid and military than the one in China on October 1st, according to Gatti who saw both. They are still tense with the feeling of the war; it is the peculiar feature of the country, this perpetual background of war.

Sartre was seeing people yesterday evening. I went to the movies, a bad American film about the crimes committed in the name of journalism. There was a trailer for *Paths of Glory.* It seems to be rather good and I scarcely have the courage to go see it. The present

is bad enough without going and making myself ill watching the horrors of the 1914–18 war and all that military beastliness. As Georges Bataille used to say: "I have my schedule for suffering."

While lunching with Sartre, met the Merleau-Pontys, very lively and gay on their way to Naples. A little Italian girl, very shy, planted herself firmly in front of our table and began showering me with compliments; which is always enjoyable. (How enjoyable? etc. That's one of the points I must go into in my next book.)

If I were like the famous writer in Fourastié's book who couldn't work because of the noise two children made with their roller skates, I should be in a very bad way indeed. This piazza is the noisiest in Rome: scooters, motorbikes, cars braking savagely with loud squeals, horns blaring despite its being forbidden, clanging scaffolding, shouts, the lot. But it doesn't bother me. The women in Rome all look terrible in their shift dresses, which are even more of an eyesore along the Via Veneto in the evening than they are on the housewives around here in the morning. The big dress designers have given their homosexual sadism full rein, from the look of it.

I'm reading Jones' book on Freud; what's astonishing is the curious mixture of conscience and frivolity, naïveté and sagacity in this "adventurer." He and his cocaine were fundamentally responsible for the death of at least one man, and the story of Fliess is horrible. Freud had "guilt feelings," but he was guilty. Admirable story about Breuer. He was treating Anna O. (or rather, as Camille would say, "she was treating herself with him," for it was she who discovered the *catharsis*). He fell in love with her without admitting it to himself, but his wife became aware of what was happening. He decided to call a halt to the treatment and informed Anna, who was in any case almost cured, that he intended to do so; the evening of the break, a telephone call revealed that she had suffered a complete relapse; she was hysterically miming a childbirth. Breuer understood what this meant, got his hat, fled to Venice with his wife and got her with child—a daughter who killed herself sixty years later in New York. Meanwhile Anna became the first social worker in Europe; she saved numbers of Jewish children during the pogroms just after 1900.

## Wednesday July 16th

On May 25th I set to work on this book with a light heart; now I'm having difficulty with it and beginning to have doubts; perhaps

it's because of the heat—95°; and I dashed off four hundred pages of appallingly sloppy stuff without stopping; that takes the pleasure out of it. I'll go on for another month, dragging material out of my head and stockpiling it, then when I get back to Paris, I'll just have to use it somehow to revive a little interest in myself, a little enthusiasm. I still don't begin to know what the tone of the book is going to be like, or how it'll be planned.

According to *Paese Sera*, the Americans have invaded Lebanon; "landed" in Lebanon is the word the *Messagero* uses. Nuances.

The young Moslems with the F.LN. banners have been apprehended; there were four of them apparently. According to *Le Monde*, they shouted: "Down with French Algeria." The French have killed Bellounis,[1] who was accused of having shot four hundred of his men; the Italian newspapers say the French have killed Bellounis *and* the four hundred men.

Jones doesn't explain very well what Freud's own particular neurosis was, nor how he got rid of it. Perhaps the fact that Freud's daughter is still alive embarrasses him, but there are certain questions he doesn't ask: Freud's relationship with his wife, for example. It's easy enough to say that they were "excellent"; but Freud's depressions and migraines are either directly linked to his domestic life or they are not. Which? After all, he was an extremely vital man; witness his passionate love of travel. Monogamous, all right; but why, exactly? Jones avoids the question. On the other hand, what he does describe in great detail, and very well, is Freud's work, so different from that of both the philosopher and the scientist. The most moving moment is the one where he discovers his mistake about hysteria. He had believed that all his women patients had been "seduced" by their fathers and expounded this theory to his colleagues, despite general reprobation on their part; then he reflected that there could hardly be so many incestuous fathers, that his own had not been, even though his two sisters displayed symptoms of hysterical disorders; he realized that his patients had invented it all. What a slap in the face! What a shock! It was only after a terrible struggle that he mustered the courage to continue practicing, and he scarcely earned any money at all for a long while afterward. And yet he wrote to Fliess that he had a feeling it was a victory rather than a defeat; this unanimous lie appeared to him pregnant with meaning, and opened

---

[1] Bellounis had made overtures to France on behalf of the M.N.A. and organized a "Popular Army of Liberation" in opposition to the A.L.N.

a new path. And it was in fact the starting point of his discovery of infantile sexuality. "I am an adventurer, a conquistador, and not a scientist," he used to say, regretfully sometimes. It is moving to watch these concepts that have become so scholastic, mechanical—transference for example—reveal themselves in such vital experiences. The first time one of his women patients flung her arms around Freud's neck, he remembered the story of Breuer and suddenly sensed the existence of the transference principle. In one of his letters he gives a ravishing description of the Piazza Colonna and of the Italians; he was staying at the Hotel Milano. His face, in his photographs, grew more and more intense as he advanced in years, and also more and more closed, and above all sad.

Joan fights against her tendency to idolize people by searching out the weaknesses in her "heroes"; but if, on the contrary, one starts by taking a "hero" as a man, then one begins to admire him for what he has gone on to do despite his weaknesses.

I have read through this diary and found it entertaining. I ought to go on with it, but I'm taking more trouble over it. Everything that "goes without saying" has been passed over in silence; for example, our reactions after Nagy's execution.

Why are there some things I want so much to say and others I want to bury? Because they are too precious (sacred perhaps) to be written about. As though death alone, only oblivion, could suffice for certain realities.

If only I could write when I'm drunk; or be more excited when I write! There ought to be a way of combining the two!

Rain, Roman rain; it's beautiful outside the shutters, at midnight, with the grumbling thunder and all that noise of water. Storms are becoming to Rome. I have opened my shutters; the sky is full of waterfalls, from the dome of the Pantheon, from the roofs, from the gutters. There are three black silhouettes, tiny, motionless, with their shirts making white splashes, under the sudden immensity of the Pantheon colonnades; now they are moving, walking calmly across the black and white porch while the water and the lightning rage around them. It's a beautiful sight. The street is becoming a torrent, a piece of paper is caught up in an eddy of wind, hovers, and is flattened against a wall. When the lightning flashes, it scatters strings of brilliants along the pavement. A powerful smell of the earth, suddenly, in this city of stone. The cars leave wakes behind them like boats. But suddenly there are no more cars, and the electric

lights in the street have just gone off. There are people trying to leave the Sacristy; the waiter has opened an umbrella and there is the roar of the taxi starting up. And all the time, the men still there, alone, calm and unaccountable, tiny figures hardly moving, black and white against the black and white of the paving stones.

The storm dies down. A street sign lights up again: PIZZERIA. Last rumblings. A pink and blue man goes running by. It is one in the morning.

### Friday July 17th

I always have this feeling when I begin a new book, that it's a gigantic, impossible undertaking. I forget the way work is done, how one gets from the first shapeless jottings to the final draft; I always feel that this time it's not coming off, that I'm not going to make it. And then, in one way or another, the book gets written; it's just a matter of time.

### Sunday August 17th—Paris

Well, there's no doubt that I have a happy disposition. I enjoyed my vacation, but it's a pleasure all the same to find myself back in Paris, sitting in front of my desk, in this room invaded at the moment by all the souvenirs of the Far East that Lanzmann has scattered over the coverless divans. It's the first time in six years that I haven't spent the summer holidays with him, because of Korea. But I'm getting old. My desire to rush about all over the world has become decidedly blunted, the desire to work has increased. I begin to feel the sense of urgency Sartre has inside him all the time. How hot it was in Italy! My arms stuck to the table, and the words got gummed up inside the cells of my brain. I couldn't get them down into my pen. Here it's cool, almost too cool, and I've got at least eleven straight months of work ahead of me; it's going to seem long, but at the moment the thought encourages me. And Lanzmann tells me that people like the extracts from my *Memoirs* already published—that encourages me too.

It was because of the heat that I stopped keeping this diary for a month. It has to be written quickly, with a gaiety that keeps the hand skipping across the page. I was able to make myself work—I got through some sixty pages, which for me is a lot—but that drained me

of the impulse to do anything else. This is my first morning back in Paris, and I'm starting it again.

Perhaps it was also the fact that there wasn't very much to say on Capri. This year we had delightful rooms in the Hotel de la Pineta I discovered the year before when I was living in the smoke from the kitchens of the Palma. There was a vast tiled room that looked cool, although it wasn't, a big terrace with deck chairs and tables; you could see the sea, pine trees, Monte Soláro, and for a whole week there was the most beautiful moonlight. I liked the crowing of the cocks in the morning. The island was full of the good smell of Mediterranean scrub, but there was an oversweet scent of crushed strawberries lurking in some spots. Breakfast with Sartre at the *Salotto,* the newspapers, work from eleven-thirty to three or thereabouts, walk in the heat of the day, with a stop for something to eat; at the Metromania they had a delicious cake that brought back my childhood, and what a beautiful view! Work again till nine, and long evenings watching the people in the piazza, as we drank our Scotch. The five-and-dime-store aspect of the place had unfortunately been accentuated by the lamps hung up over the *Salotto.*

Was it because we were less lighthearted this year that we were more sensitive to the weaknesses of Capri? We were perpetually disheartened by the situation in France, which has fallen into such a state of apathy that I don't feel I even want to talk about it any more. And then, the previous year Sartre had been happily writing about Tintoretto, whereas at the moment his play is getting off to a slow start; he's not in the mood to write "fiction" these days. He's only doing it because he's contracted to.

We saw the Clouzots briefly, and had dinner twice with Moravia, very amusing, relaxed, friendly; instead of discussing general ideas, he talked about himself, about Italy, and talked very well. Speaking about his accident, he admitted with disarming candor: "Ah! I have accidents all the time, I drive very badly, I'm too nervous and I like to go fast; once, coming from Spoleto to Rome, the road was empty and I never went less than eighty-five the whole way, it was all right that time; but if it hadn't been . . ." In Rome he had once mistaken reverse for first and squashed two peasant women up against a wall; two days before he had almost crashed into a truck while driving a Cadillac belonging to a princess, and he braked so sharply that the car caught fire "inside the wheels." He agrees that Carlo Levi is more careful: "But he has to get help from the attendant to get out

of a parking lot; he can't manage reverse. And he never goes over twenty-five miles an hour."[1] He's very funny when you get him on to the subject of his colleagues. He says that all the writers from the provinces have *one* thing to say, about their own region, something local, and after that they've got nothing left; whereas he has the whole of Rome (which is to say Italy, and mankind). The speed at which he works! He writes for two or three hours in the morning, never more, and he produces two short stories a month and a novel every two or three years! We talked to him about his early works. He told us a little about his life, in snatches, with much grace. He had a bone disease from the age of nine until he was sixteen, had hardly any schooling, wrote *The Time of Indifference* at twenty; it had a success in Italy greater than any book had had for a long time, and greater than any was to have since. For six years he felt empty; he wrote nothing. Then he wrote *Wheel of Fortune;* this second novel was not given *one line* of criticism in Italy because of Fascism: it was decadent literature, and one thing led to another until he was first forbidden to sign his newspaper articles and then to write them at all. He had inherited money, so he traveled abroad to escape Fascism: China, France, America. He spent several years on Capri with his wife, Elsa Morante. He talks about her with affection and respect, and considers her books to be the best contemporary Italian novels being written, but he seemed extremely alarmed when I said I'd like to meet her. It irritates him that she surrounds herself entirely with homosexuals. He claims that 80 percent of the men in Rome have slept with other men. He talks about them almost enviously because their sexual adventures are so easily come by, and because they have such a gleeful gluttony for them; he quoted a remark made by P., one of Elsa Morante's friends: "How many people are there on the earth?" "More than two billion." "That means there are more than a billion men I'll never sleep with!" He also tells charming stories about the Church, like all Italians. There was a Pope who had a real ambition to be saint, a canonized saint; the Cardinals prayed for him: "May the Lord open the eyes of Our Holy Father—or else close them."

[1] A little later, in Rome, Carlo Levi told Sartre: "Moravia? But you know he has many more accidents than he says. He has them every day. Only little ones, of course. They don't put them in the newspapers. It's his psychomotor mechanism that doesn't work properly, the connection between his head and his arm. He doesn't know what he's doing, he tries to shift into first and finds himself shooting off in reverse."

The pleasure of writing for the pleasure of writing; I am just writing whatever comes into my head. When we came back to our hotel, no matter what time it was, there was always one little pale waiter, fifteen years old, with a woman customer putting his apron straight for him one day; he was always there, morning and night. One day I asked him: "Don't you ever sleep?" "Sometimes," he answered, without bitterness, without irony, in an absolutely matter-of-fact tone, as the English say. The next day I asked him: "How long did you sleep last night?" "Four hours." "And during the day?" "An hour." "That's not much." "That's life, Madame." I suppose he was content just eating well and being properly dressed: he was one of the privileged. Possibly even more heartbreaking was the waiter in a striped sweat shirt at the Capranica; the third evening we went there, he said to Sartre stammeringly: "Factory? Me work . . ." He wanted to get work in a factory in France. He didn't like the job he was doing. "Business not lovely tonight," he said to us once very sadly; business was never lovely for him, except once, when he lit up suddenly: "Oh! Tonight the check is lovely!"

There was Lanzmann's lightning trip to see us: six hundred million Chinese, without counting the Koreans, suddenly invading the little island of Capri. I went with him to Naples where the civil airport was guarded by an army of American soldiers because it was covered with United States fighter planes in transit to Lebanon. Then the return with Sartre along the new Naples-Rome Corniche; the pines and the Etruscan green of the Domitiana gave us both the feeling, at exactly the same moment, that we had suddenly been transported straight back to classical times. An evening in Rome with Merleau-Ponty, whom we bumped into near the Pantheon. Then Pisa. The Pisanos in the museum—the dancing woman without a head, and the woman hiding behind her dress; it was as though the marble had been immersed in a volcano, matter is tragic, and movement astounding.

Return with Sartre as far as Pisa, where he is meeting Michele. Inferno of the Pisa-Genoa road. And on the morning of August 15th, on the "truck route" to Turin, hell again. Then the pleasure of driving, especially yesterday, Bourg to Paris in five and a half hours.

Sign of old age: distress at all leave-takings, all separations. And the sadness of memories, because I'm aware they're condemned to death.

*Wednesday August 24th*

Work. For two afternoons at the Bibliothèque Nationale I have
been steeping myself in old copies of the N.R.F. and *Marianne*. It's
amazing finding oneself back *before* events that now make up the
past. I want more and more to write about old age. Envy of the youth
of today, so much ahead of us at their age, and partly thanks to us.
How undernourished we must have been! How rudimentary every-
thing we were told about philosophy, economics, etc. An impres-
sion (unjust) that mankind wasted a great deal of time at my expense.
And it's hard to keep the future as a dimension in one's life when
one already feels one's been buried by those who are coming *after*.

The night before last, the F.L.N. committed a spectacular series
of acts of violence in metropolitan France: gas storage tanks set
alight in Marseilles, cops killed in Paris. De Gaulle was booed in
Dakar and Guinea. I am reading Duverger and Sternberg's *Le Con-
flit du Siècle*, which is as entertaining as a thriller. First fine day after
all the rain and cold; it's warm, golden, rather autumnal and sump-
tuous.

The Committee of Resistance against Fascism is getting up a big
counterdemonstration for September 4th; how will it go off? Lanz-
mann is doing a lot for it and tells me that the preparatory campaign
is being very well organized. He has spoken at many meetings, in
Paris and in the provinces.

*Monday September 1st*

Telephone call from Sartre. He's seen Servan-Schreiber in Rome.
He's doing three articles for *L'Express* which will appear on the
11th, 18th and 25th.

*Thursday September 4th*

There's a vaguely sinister feeling about this morning, Sartre still
in Italy, Lanzmann not back yet from Montargis where he spoke
yesterday evening, Paris seems empty. The workmen bang so loud on
the wall that it's impossible to sleep after eight and difficult to work;
anyway I'm too nervous. Pale blue sky with yellow clouds above the
yellowing trees; it's fall now among the graves in the cemetery of
Montparnasse. I feel panicky about this afternoon. No, not fear

(though there may be some of that too), apprehensive because it may be a failure; I dread having to swallow a whole hour of that sickening ceremony without there being anything to show for it. Yes, they're bringing Pétain back to life; a hundred picked workers will be awarded the Légion d'Honneur, and Malraux will explain that De Gaulle has taken up the left-wing challenge and that he will dare to speak in the Place de la République. I went through it the day before yesterday evening with Lanzmann. It's been arranged in such a way—with stands which will be packed with guests, cops, veterans, etc.—that the public will be miles away and won't even be able to hear us. Yesterday it was announced that the local authorities have forbidden the carrying of placards. At the Committee they have given us yellow papers with a NO at the top; we're to bring them out when De Gaulle appears. Instructions vary from committee to committee, though. Evelyne's isn't coming till five instead of four, and they're going to unroll their banners right away, which is idiotic. Everyone's just hoping we'll be able to improvise something when the moment comes. But whatever happens, there are going to be so many cops among the crowd (even *Paris-Presse* has admitted this, with a smile), that I don't think there's a chance of doing much against these farcical displays, these masquerades that turn my stomach.

A tiny young lady rang my bell two days ago in order to "contact" me. So I went to my neighborhood committee yesterday evening. It was pitiful and touching. I made the mistake of getting there at nine: no one. The concierge handed me a key after a lot of grumbling, but I preferred to wait on one of the benches. After half an hour a young woman arrived and led me into a big, empty studio at the other end of the courtyard. Other women began to arrive, little by little; there were eight of us finally, and not a single man. Muddled discussion; still, I admire their dedication, they didn't go home till midnight, and three of them offered to stick up posters and distribute pamphlets between six and seven in the morning; and they have children, and a career. Very mild evening, lots of people and neon signs in the streets.

The North Africans are no longer allowed to go out at night. At Athis-Mons the cops fired at some Italians because they thought they were North Africans.

*September 9th*

I was wrong, on the morning of September 4th, when I envisaged a complete fiasco. At one, in the Place Saint-Germain-des-Près, I ran into Genet, we fell on each other's necks and went to have lunch on a café terrace. He talked with great enthusiasm about Greece and Homer, and very well about Rembrandt; there had been some extracts from his *Rembrandt* in *L'Express,* but cut—what he said was really much better. He too remakes the man in his own image when he says that he changed from pride to goodness because he wanted there to be nothing separating him from the world; anyway it's a beautiful idea. He said some nice things about the bits of my *Memoirs* he'd read: "They give you more density." Then he launched into a passionate apologia for F.L.N. terrorism, but my attempts to get him to go to the Place de la République were in vain.

Bost decided to wear his Croix de Guerre and Lanzmann sported his Resistance medal. We went together, and arrived shortly before four at the barriers in the Rue Turbigo separating the guests from the general public; the cops were there, checking invitation cards. Seeing the way they'd set up the barriers, we both immediately thought: "It's a police trap." We went back up toward the Lycée Turgot, where I was supposed to meet the others. Nobody there; all along the sidewalk buses full of C.R.S. men, ugly women got up to the nines walking in front of them brandishing their passes roguishly; they were feeling very important.

I realized that the others wouldn't be able to get to the Lycée because the street had been made into a blind alley by the blockade, so I got out of it myself. Three hundred yards farther down there was already a first cordon of police. L. had gone to join the leaders of the Resistance Committee[1] at Saint-Maur; I waited for the Sixth Committee at the Réaumur métro station, where Evelyne had told me they were supposed to meet. And I did in fact see Evelyne, the Adamovs, etc., arriving. By then, people were flowing in, in groups, in crowds, in masses. We took hope again; we formed a group near the Arts-et-Métiers métro station, right next to the first police barrier. A man who wanted to get by insulted them; they hit him and the crowd yelled, showering them with little pieces of paper: NO. The courage of some of the demonstrators took my breath away. Someone said nonchalantly: "They're going to charge, they're put-

[1] Which was coordinating all the neighborhood committees.

ting on their gloves," and we backed away a little, so that we'd be able to get into the cross streets. People were still arriving, *en masse,* but they all got a shock when they saw the tremendous barricades. Adamov grew irritable and said: "Let's try somewhere else!" I myself thought we should stay there, not scatter about but keep opposite the stands, as many of us as possible. I think I was right too, except that we'd have got truncheons on our heads; Adamov's impatience saved us from that. We began to wend our way around the Place de la République, vainly searching for a way to get closer in. There was a rumor that some groups had gone off to the Place de la Nation, but I persuaded mine to go back and demonstrate opposite the stands, near the Arts-et-Métiers station. We passed other processions, going where? They didn't know. We told each other: "You can't get through there." "Not back there either." Finally we ended up in the Rue de Bretagne and people got out their little banners and posters and placards and balloons with the word NO on them, and there was a lot of applause. There were cries of "Down with De Gaulle," shouted out syllable by syllable as though we were at a sporting event, and Adamov said angrily: "It's all too gay, this isn't how we should be behaving." Clusters of balloons rose up into the sky just above the stands, and there were NOs floating in midair. We had run into Scipion and Lanzmann's father; they had just been in the Rue Turbigo; the people there had been allowed to get into the street in fairly large numbers and then discovered they were caught like rats in a trap. They began to demonstrate when Berthoin started his speech, to such good effect that no one could hear him; whereupon the police went into action, from behind, from the front, there was no way out, the crowd was savagely punished by their truncheons. While Scipion was telling us all this, Adamov got thirsty and we all went into a bistro; suddenly, outside, there was a stampede; the police were charging. (One charge had already been started earlier, and we had taken refuge under the main gate of an apartment building; the concierge let everyone come in who wanted to, saying: "If *they* turn up, close the door.") Two blood-spattered women came into the bistro, one calm, the other screaming, really knocked out of her senses, and they made her lie down on one of the banquettes in the back room. One blond woman had blood streaming through her hair; there were men with blood on them going past in the street. Evelyne shed one or two tears of emotion, and someone said sternly: "You're not going to faint!" We went out and began demonstrating

again. There was a market all along the Rue de Bretagne, and the tradespeople appeared to be on our side. The crowd was very likeable—hard, excited, and gay; it was the liveliest demonstration I've ever taken part in. Not legal like the big funeral procession of the Republic, nor hesitant like the Sunday of the investiture; it was serious and for some, dangerous. V.'s wife was very pale when they arrived at five, green at 5:15, vomiting at 5:30; her husband was holding her against a wall and coaxing her. "She's ill," a friend said; and another corrected him: "She's scared." And then added, by way of a complete explanation: "She's always like that." I asked why she didn't stay at home. "Ah! Then she gets such a bad conscience about it, it makes her even sicker than being scared does." They left her in a café in the Rue des Archives.

At about 7:30 we decided to get out of it. Lanzmann's father took us in his car; we went back through the Arts-et-Métiers intersection. The ground was littered with NOs; along the Rue Beaubourg, some of the cobbles had been torn up; there were groups of people arguing along the Boulevards. We went to Bost's. He had been demonstrating with Serge. We all had dinner at Marie-Claire's, telling each other about the events of the day and tearing apart Germaine Tillon's article, which Bost, Lanzmann and I thought was disgusting.

Ignominy of the press the next day. All the same, Le Figaro's "hundreds of demonstrators" was going a bit too far. The Prefecture announced that there had been 150,000 people present; there were 6,000 invited guests, 4,000 sightseers, foreigners or even mystified Gaullists; therefore there had been 140,000 of us. (When I called Sartre to give him the figures he was disappointed; in Rome, the newspapers had been talking about the 250,000 demonstrators.) Shots had been fired in the Rue Beaubourg; four people wounded. Humanité and Libération gave accounts that coincided exactly with the one Lanzmann had written for the Committee of Resistance newspaper; the sad thing is that no one reads them, except those already on their side. All the same, despite all its efforts to slant things, a few truths emerged in France-Soir; there were the letters published in Le Monde the following day, and the tone of Paris-Presse was scarcely triumphant. They admitted that there was a certain "contact" which did not materialize between De Gaulle and the public. We heard his speech at Marie-Claire's—not live, but retransmitted half an hour after the event, so that they had time to filter out the background of Nos; the voice and the speech of a far from hale-

and-hearty old man. The real gem of the day, recounted by a great number of newspapers: "Six Swedish journalists were brutally beaten with truncheons, taken to the police station, and given another going over. Their protests finally got through to their Embassy; as they released them the police said: "We apologize, we thought you were Dutch." Another journalist said: "I'm an American"; one of the police blacked his eye and said in English: "Go home!"

M. was one of the invited guests; even up there, everyone didn't applaud, and the Nos sounded terrifically loud; the foreign diplomats couldn't take their eyes off the truncheon-work going on at the end of the street. During De Gaulle's speech people kept turning their heads to look at the crowd, and from time to time the whisper went around: "They've broken through the barriers." Whereupon all the gentlemen up there had the same reflex; they loosened their belts in order to use them as weapons. Basic misrepresentation by the newsreels, the radio and the television. Nevertheless, De Gaulle has given up the idea of his big propaganda tour; when he leaves here on the 28th it will be to visit only a few towns, and even then he will limit himself to making contact with the "official bodies."

On the subject of propaganda, here is one detail among others. I found another internal revenue summons waiting for me at home. I wrote to the tax inspector: "Very well, fix a day." He answered: "If you pay in November, there will be no summons." And then I learned that the internal revenue offices had been given a "confidential" warning not to insist too brutally on taxes being paid, and not to seize any goods. A matter of soft-soaping the taxpayer.

### Sunday September 14th

A sumptuous autumn. Yesterday, at about 8:30 in the morning, I had the impression I was back in Peking. There was the same golden softness in the sky and in the air, and there I was waiting for a car to take me to a boring meeting; it was a conference of Protestant teachers at Bièvre; I had accepted their invitation because of the referendum, hoping to drag a few Nos out of them. It was lovely, the old bulbous manor house sitting in the middle of its undulating grounds. The audience seemed very pleasant; a lot of pastors, among them Mathiot, who had just spent six months in jail for helping an F.L.N. member get to Switzerland. I spoke about commitment among the

intelligentsia; we discussed it a bit, and they seemed to agree with me. But the ride home in the car was a letdown; one white-haired woman thought as I did, but the two others, a psychiatrist and a woman doctor, were afraid of parachutists and Communists. They said that De Gaulle was, after all, De Gaulle; that on the Left there was no one but Mendès, and he has such an unpleasant personality! All these people suffocating themselves like this by sticking their own heads in the sand are not Fascists; but they are so terrified of Communism!

In the evening, Lanzmann took me to dinner at the Vanne Rouge. When I got back to Paris I was so sleepy and so nervous at the same time that I couldn't even face a drink at the Dôme, so I went home to bed. I still feel tense this morning. Is it going to be like May all over again? The idea frightens me. I'm frightened of staying tense like this till the 28th. And after that? I can't imagine October this year.

I'm eager to keep this diary again now, partly because any other work is so difficult while I'm in this state of tension. The meeting of the "Liaison Committee" of the 14th Arrondissement on Friday evening was pleasant and friendly. I decided to walk to the Rue du Château; it gave me a gentle poetic feeling, walking along the Rue Froidevaux, passing the Hôtel Mistral and the Trois Mousquetaires. I've been diving back into my past so much recently that at the moment it's a dimension of my life. The little room, which must be a C.G.T. headquarters, was packed. Jusquin asked me to sit up with the committee. I was next to Francotte, a Senator, ex-Municipal Councillor and a Communist, looking very much the cunning old left-wing politician. He said to me: "Ah! *The Mandarins!* That was good. . . ." And then, laughing: "It's exactly the same situation, the same problem: with us or against us. . . ." I answered: "Yes, and the same solution; we're *obliged* to work with you." To which he replied, in an inimitable tone: "What can you expect, the fact is we trip up sometimes, we make mistakes. Who doesn't? But by and large, we're in the right." Jusquin outlined the situation, not bad, but my God! why all this optimism? Why say "The victory of the Nos is assured" when the problem is to know whether there will be just slightly more Nos than Communist votes? They asked me to do some articles for the little local paper, and I also agreed to go see some students at the Cité Universitaire. Then someone passed me a note: "How pleasant to see you again, etc." It was from Françoise

d'Eaubonne, whom I hadn't seen for a long time. I took her off with me to the Trois Mousquetaires, where I had a bite to eat. She had been working for *Travail et Culture,* but there had been political dissensions and she left. She still writes for *Europe* and is a reader for Julliard.

Sartre will be back tomorrow; he told me on the phone that he's pretty tired. The article he sent—I helped S.-S. cut it—gives the same impression; he wasn't inspired. But he had to write it.

Excellent speech by Mendès-France. Lanzmann was at the conference; also, curiously enough, Genet. Evidently Mauriac looked touched, but that didn't prevent him from repeating in his *Bloc-Notes,* like some old dotard: "All the same, there is De Gaulle; there is De Gaulle." He accuses himself—only too truthfully I'm afraid, for his sake—of having sought all his life for the deplorable sort of isolation you get in a sleeping car.

*September 16th*

I met Sartre yesterday in the rain at the Gare de Lyon, and then we spent the day chatting. He's very tired. I'm still being "militant": writing posters, lectures, articles. Lanzmann is completely taken up by the electoral campaign. During his lecture at Montargis, before two hundred and fifty teachers, he spoke of "the rape of conscience." Z., a Communist, said to him: "You shouldn't have used that word; there were women present."

*Wednesday September 23rd*

Up till this morning, it's been like a madhouse all around me. Sartre got a liver infection on Sunday, just as he was due to begin working on his next article for *L'Express.* He was so worn out, so feverish and weak-headed on Sunday afternoon that it looked as though it would be impossible for him to write it; and since he'd been irritated at the slight dullness of his first article, the idea that this one might be the same infuriated him. He worked for twenty-eight hours at a stretch, without sleep and almost without a break; he slept a little on Sunday night, but when I left him harassed, at eleven on Monday evening, he started working on it again and went on till eleven the next morning; by that afternoon he gave the impression

of being deaf and blind; I wondered how he could possibly hold up through the meeting. And it appears he spoke very well. He didn't go to bed until half an hour past midnight. Meanwhile, on Monday evening, I went to see Lanzmann and found him completely absorbed in his article about China, which he spent all that night and the following day completing—and which is very good. I was spending that same Monday evening making cuts in Sartre's article, an ungrateful task, and pretty tiring when it's got to be done fast. *L'Express* has just been delivered at Sartre's, finally. The article is really very good indeed, and the joints aren't too obvious.

I don't know if it's exhaustion or irritation, but my constant state of tension, which I feel especially in the back of the neck, the eyes, the ears, the temples, makes work difficult. I've written the articles I promised; it's insane how the tiniest paragraph takes me ages to write. Still, for better or worse, I've started revising my book, beginning with Chapter One.

Yesterday a Trappist rang at my door: Pierre Mabille. He was bringing me some of Zaza's notebooks to help me complete my *Memoirs*. Nothing very interesting; her letters say everything.

Lunch this morning with Baudiou, the boy from the École Normale. He talked to me about the Socialist Party, about the paras "occupying" Toulouse on the 14th of July; they pushed everyone off the sidewalks, ordered drinks in the cafés, refused to pay, and forced the girls to dance with them. The officers were shouting at them through loudspeakers: "That's it, boys, make them dance, you're all worth more than these civilian pimps." But it didn't have the effect of anti-Gaullist propaganda; on the contrary, people thought: De Gaulle will protect us from this sort of thing. Baudiou told me that his father was in serious danger on May 27th, when the Tunisia-Morocco veterans, of whom there are a great many in Toulouse, tried to stage a nationalist *putsch*. We talked about Algeria, of course. And about the referendum. He is extremely pessimistic.

Everybody is waiting for Sunday: 60 percent? 70 percent? We're putting our money on 65 to 68 percent; probably 68. After that comes the election campaign, which seems to be getting off to a bad start.

The various tortures are all thriving more than ever, even in Metropolitan France. The police and the North Africans have machine-gun fights every day.

*Saturday September 27th*

Yes, it does me good to get out of my shell a bit. I had often regretted living so pent up all last year. I enjoyed yesterday evening very much. Not that I got the same little personal satisfaction out of it that I felt when I gave my lecture at the Sorbonne, before six hundred people who'd come just to hear me and gave me such a warm reception; but I too am "a true democrat," and that's the sort of contact that moves me most, when one gets the benefit of a collective sympathy.

I prepared a few words of introduction in a bistro in the Rue d'Alésia, then I went on into the school. About two thousand four hundred people, half of them suffocating in the heat of the hall, the other half shivering out in the courtyard. "The finest meeting of the whole campaign," said Stibbe. Jusquin piously claimed that only a third of them were Communists; but even reversing the proportions, one-third non-Communists rubbing elbows with the Communists wasn't so bad. Beneath the dais, some old gentlemen—one bearded, some bald—very agitated. There was a U.F.D. meeting in the Mairie of the XIVième Arrondissement a few hundred yards away, and they hadn't been warned that ours was taking place; individually, no one could have cared less, but one must have consideration for the feelings of others, etc. In short, it was decided to exchange delegations. Then my co-president stood up to speak, I said a few words, and the speakers came up one by one: Madaule, Gisèle Halimi, very persuasive; she spoke unrhetorically, in a conversational tone, but passionately, with smiling intensity and tiny gestures. She had been at a meeting in Toulouse the evening before, had spent the day on a train, was going the next day to ask the President of the Republic for a favor; she has children and a career that must take a toll of her nerves and her heart: yet another of the superactive young women to whom I take off my hat. We got on well together and exchanged addresses. After that, Yves Robert did a charming act, supported by Danièle Delorme, fresh as a flower in a smart yellow suit; we ought to use "theatre folk" more; he made everyone laugh a lot. An amazing speech from a lawyer who until recently had been a left-wing Gaullist, well-groomed, impeccable, "the man-most-likely" type, fundamentally different from everyone else there, and juggling with incomprehensible words; he told how at the meeting on Thursday in the Salle Pleyel the applause had been so wild that it had drowned

Soustelle's speech; they had shouted: "Death to the Communists!" and Soustelle had egged them on. "They'll kill him!" someone had shouted. (People were interrupting as though it were a Victorian melodrama with cries of "Yes! No! Bravo!" It was all very appealing.) The lawyer finished up with a great rhetorical gesture. "I saw that meeting, and now I look at this one; and I have chosen!" He was acclaimed, everyone present feeling that they had been chosen personally. Next came d'Astier, a classic performance; a Communist, reading (as they always do) a long treatise without skipping a single word and without a single inflection; then Stibbe, who gave a detailed commentary on the Constitution. All the other speakers were sweating; when he gave me his hand, it was like ice. There was one farcical incident: a U.F.D. delegate from the other meeting made a speech heavily underlining the divergencies between the U.F.D. and the group he was addressing; but he "was made happy by the thought of these parallel existences that were going to converge in a unanimous No." While the co-president was asking for money, it was announced that Bourdet was in the hall: ovation. "Let him speak!" But he refused to do so. He had just come from the U.F.D. meeting, which apparently only ninety-three people had attended. I very much enjoyed watching the faces of the people there, and their reactions. There was one very poor-looking woman, almost a female bum, who had brought two kids with her: a little dark girl with a Modigliani face under her black pudding-basin of hair; and a little boy of ten who laughed and clapped and seemed passionately interested in everything that went on.

As we came out, students, very nice people, and a blind man with his wife. He had read *The Mandarins* in Braille, he runs a Braille library, had put out a Braille anthology which was honored by the Académie, and wanted me to be a patron of his magazine for blind poets; he already has Fernand Gregh and Duhamel! I got out of it. In the big brasserie, I joined up with C. Chonez, Françoise d'Eaubonne, Renée Saurel. At a nearby table were Hélène Parmelin, O. Wormser, Pignon; at another table were the U.F.D. group: Stibbe, Bourdet, Halimi. We sent each other delegations from table to table; it was all very gay, and I stayed till 1:30 in the morning. Everyone spoke very highly of Sartre's article.

Today, work; the first chapter is taking shape. It's not impossible that the whole book will be finished in two years.

Tuesday, the books have been sent out from Gallimard's. I re-

member the feeling of dread when *The Mandarins* came out; I had put so much of myself into those pages, and I couldn't help thinking of all those eyes moving across them. This time it's different, I can keep myself more aloof; the critics and readers don't bother me. But I do feel uneasy—almost remorseful—when I think of all the people I've brought into it and who'll be furious.

A beautiful fall, warm, golden, shady and sunny; but people are beginning to come to blows all over France.

Latest conversation with a taxi driver; he observed that Paris is full this Saturday because of the voting. "And how will they vote?" I asked. "Come now, little lady, that goes without saying; for honesty . . . He's honest, that man, you know; if he wasn't, you can imagine what the parties would have said about him. . . . No, I can't see him being a dictator; and what if he was? After this, we'll be electing our deputies, we'll have our say too. . . . Anyway, it's got to change, hasn't it, and it can't be any worse than it was before. . . . You've got to have a bit of faith."

### Sunday September 28th

Referendum.

### Monday September 29th

Well! Now we know what defeat tastes like, and it's bitter, on the whole. It was a beautiful day, golden, clear, people went to vote with a smile, the polling stations seemed to be almost empty, despite the enormous number of people who voted, doubtless because it was all so well organized. I voted in the morning, lunched with my sister, went with Sartre to the Rue Mabillon; the polling officer smiled and said to him: "There were some photographers round this morning asking what time you were going to vote." We went for a walk, without much enthusiasm, then sat out on a terrace near Saint-Michel. We felt useless, empty; but there was no great anxiety, the government, the Communists and our own common sense told us that a figure of between 62 and 68 percent was a more or less foregone conclusion. We ran into Boubal; he said with conviction: "Ah! The Occupation, those were the good old days!" and he lamented the fact that all one ever sees in the Flore these days is queers. After that we worked, then had dinner at La Palette. Sartre was still rather

tired. I extorted a promise from him to go see his doctor. Lanzmann turned up at about midnight, already overwhelmed by the impending disaster, but trying not to show it too much, because Sartre is always accusing him of being pessimistic. The results already announced filled us with dismay: more than 80 percent. Sartre went off to get some sleep. We visited *France-Soir,* humming with activity. All the provinces were in, except Marseilles, and they made it more than 80 percent. We went home, in complete gloom, and began the same merry-go-round of phone calls as on May 13th. First Péju, who had piles of detailed and very upsetting figures. At *Humanité,* Lanzmann got through to T. and asked: "The Communists must have betrayed us; how is it possible?" and T. answered somberly: "Read your friend Sartre's article." I began to cry, I'd never have believed it could affect me so much; I still feel like crying this morning. It's rather dreadful to be against a whole country, your own country; you feel as though you're already an exile. We called L.'s father; he told us that all the rightists were out gloating on the Champs-Élysées. It's almost as hard to bear as the disappointment of the people on our side. There was a moment of false hope; according to *Europe I,* the last count made it only 72 percent. But it was an error—77 percent of Paris voted yes. A large section of them, an enormous section, don't know what they're doing, people like my taxi driver the other day: Well, things have got to change, we'll just have to hope. Only what they've done is irrevocable; how many years before they realize that there's no hope in that direction? And when they do? On the telephone, Lanzmann asked an Information operator how he had voted: Yes. "You were wrong," Lanzmann said. While I was waiting to be connected to someone who was out, I too asked: "Are you happy with the results?" "Why do you ask that?" came the uneasy reply. "I just wanted to know." "I've already had someone jumping down my throat just a moment ago." "Because you voted Yes?" "Yes." "Ah! Well, it *is* a pity you did, isn't it?" I replied as I hung up. He wasn't sure he was in the right; but all the same, it was another Yes.

Nightmares the whole night. I feel as though I've been put through a grinder.

When I bought *France-Soir* and *Libération,* then opened them in the Place Denfert-Rochereau, it made me think of the war, when I opened the papers and burst into tears: "The Germans have marched into Belgium." This time I was prepared; but I felt almost the same distress. How gloomy *Libération* was! *Humanité* too, ap-

parently, but there weren't any tears left. I telephoned: Sartre wasn't expecting this. I can feel death in my heart.

It was my *département*, the Corrèze, that voted the best! That impoverished country of wasteland and chestnut trees was already radical when I was a child.

The horror people have of Parlement; Sartre points out in his article that people think of the deputies as "loafers" who just hamstring the executive all the time with a series of mutinies. Then there are other things as well. To begin with, the stink of old scandals still clings: Panama, Oustric, Stavisky; there hasn't been one during the Fourth Republic (the piasters affair was something else again), but people still have the idea that the Chamber is choc-a-bloc with Freemasonry, backstage intrigue, bribery, and they feel they're always being stabbed in the back. The heart of the matter is that *they don't want to be governed by their equals;* they have too low an opinion of them, because they have too low an opinion of themselves and of their next-door neighbors. It's "human" to like money and watch out for one's own interests. But if one is human like everybody else, then one is not capable of governing everyone else. So people demand the nonhuman, the superhuman, the Great Man who will be "honest" because he's "above that sort of thing."

It's a sinister defeat because it's not merely the defeat of a party or of an idea, but a repudiation by 80 percent of the French people of all that we had believed in and wanted for France. A repudiation of themselves, an enormous collective suicide.

### Wednesday October 1st

A day overcast by the referendum and Sartre's illness; he has a bad head, but won't go and see the doctor before Saturday, which worries me. I have nightmares and then feel uneasy all day long.

Last night I had dinner with Han Suyin, who is enchanting. I met her at the Pont-Royal: light-colored suit, tall, slender, her face hardly Asiatic at all, beautiful for her forty years. Her daughter, by a Chinese father, is distinctly Asiatic-looking; she doesn't know a word of French and must have been very bored. We had dinner at Chez Beulemans. Han Suyin is interesting. She decided at a very early age to accept her condition as a half-caste; she chose not to choose. She feels as much a Westerner as an Oriental, she says, but her heart belongs entirely to Asia. She lives in Singapore, and devotes every

day, from nine in the morning till five in the afternoon, to her Chinese patients (she's a practicing gynecologist); then she drives back to her house and writes. Since 1952, she's visited China every year; she has enormous admiration for the Chinese leaders: they're Saints, she says. She told me that in Singapore and even in Canton, despite the new regime, there are still communities of women (about thirty thousand in Canton) who are officially recognized as Lesbians; they marry within the community and adopt children. They may leave the community and marry a man. In that case they cut their hair. They have their tutelary goddess, ceremonies, etc. She says that Chinese puritanism is really stifling, that in the beginning the Russians caused a scandal because they tried to flirt with the Chinese girls. She thinks that for at least five years it will go on being difficult for Chinese intellectuals.

### Thursday October 2nd

Dark days. *L'Express* makes depressing reading; an issue full of resigned defeat and distractions. *L'Observateur* puts up a better show. Sartre had lunch with Simone Berriau. I'm grateful to her for frightening him; he's going to the doctor in a moment, and I'll accompany him. Qualified satisfaction: she threatened him with hemiplegia and infarctus; he seems terribly tired; he stuffs himself with Optalidon, belladénal and corydrame, one after the other; he has attacks of vertigo and incessant headaches.

Lunch at the Coupole with Gisèle Halimi. In the course of the conversation she told me about her life. Oh, how much there is still to be done about the condition of women! She told me about the Philippeville trial. There wasn't a single hotelkeeper there who would give her or her colleagues a room; the lawyers in the town had to give them lodgings in their own homes. The chief of police had asked for nine death sentences; the bench pronounced fourteen, which is to say one for each of the accused (who had been picked at random after the riot and were doubtless all innocent), except one decoy. The trial has in any case been disallowed, there's going to be a retrial in Algiers any day now.

### Monday October 6th

Sartre saw the doctor. He's a little better now, although he still gets headaches.

It's been raining so much that all the trees along the Paris avenues still have green leaves. It scarcely seems like autumn at all.

The future has no face. We feel unemployed, useless, abashed.

## Tuesday October *14th*

These really are days of horror. It was like this in the plane that had lost an engine six hours out of Shannon: constant fear, with brief respites followed by a fresh onslaught of fear. It's the same with Sartre. Now and then he seems better; then, like yesterday, he stumbles over words, has difficulty walking, his handwriting and his spelling are appalling, and I am appalled. The left ventricle is tired, the doctor says. He needs a real rest, which is just what he won't take. Our death is inside us, but not like the pit in the fruit, like the meaning of our life; inside us, but a stranger to us, an enemy, a thing of fear. Nothing else counts. My book, the criticisms, the letters I get, the people who talk to me about it, everything that would otherwise have given me pleasure, rendered utterly void. I haven't even the strength to go on with this diary.

## Tuesday October *21st*

Days of horror. Especially Saturday, when I went to the doctor's. Sunday, yesterday, one long suffocating nightmare!

## Tuesday October *28th*

Coming out of the nightmare, the illness. I must be already benumbed by old age to be able to bear it.

I think I'm going to stop keeping this diary.

And, in fact, I did stop keeping it. I put the pages in a folder, and wrote on it, impulsively: *Diary of a defeat*. And I never touched it again.

What happened during those days of horror was that Sartre had just missed having a heart attack. He had been putting his health to a terrible test for a long time, not so much because of the exhaustion his desire to make "full use" of himself was inflicting on him as because of the tension he had set up inside himself. To think against oneself is all very well—it has fertile results—but in the long run it

tears one to pieces; by forcibly smashing a way through to new ideas
he had also done damage to his nerves. Once before, writing *The
Psychology of Imagination* had got him into a very bad state; to
complete the *Critique de la Raison Dialectique* had required a con-
siderably more violent effort. But it was the defeat of the Left, above
all, and De Gaulle's accession to power that had really stunned him.
In Rome, stuffing himself with corydrame the whole time, he had
worked on a play; I knew the general outline of it, and at Pisa,
before I said good-bye to him there, he had shown me the first act.
Outside, it was a hundred degrees, but he had regulated the air
conditioner in his room until it was like being inside a glacier. I
shivered as I sat reading a text that was full of promises but didn't
keep one of them. "It's like Sudermann," I told him. He agreed. He
would begin again, but he needed time, and as usual he had made a
lot of rash commitments. The fear of spoiling a work that was enor-
mously important to him also aggravated his state of excitement and
irritability. Finally, when he got back to Paris, a serious liver infec-
tion flared up. The twenty-eight hours of uninterrupted work, fol-
lowed by the evening meeting, all of which I had noted in my diary,
finally finished him off. Shattered by continual headaches, stumbling
over his words in a thick voice, handwriting and spelling completely
out of control, he began to suffer from vertigo and lose his sense of
balance. While lunching with Simone Berriau he very carefully put
his glass down an inch from the table; she immediately picked up
the telephone and made an appointment for him with Professor
Moreau. Waiting for him in a nearby bistro, I fully expected to see
him come out of the doctor's office on a stretcher. He walked out, and
showed me the prescription: certain drugs, no drinking, no smoking,
rest. He more or less obeyed, but went on working. The headaches
persisted. He had once been so lively, so decisive, and now he walked
along with his neck stiff, his limbs leaden, his face puffy and fixed,
speech and gestures completely unsure. His mood too was unusual: a
dopey calm, punctuated by acute fits of anger. The doctor must have
been struck by his apathetic expression, because he promised him
straightaway: "I can restore your aggressiveness." Yet when I saw him
tense at his desk, his pen scratching wildly across the paper, his eyes
heavy with sleep, and told him: "Take a rest," he answered me more
violently than I ever remembered. Sometimes he gave in. "All right,
five minutes," he would say. He would lie down, exhausted, and
sleep two or three hours. "He's tired today," his mother said to me

one afternoon when I got back to his apartment ahead of him. "Are you tired?" I asked him when he came in. "Of course not," he said, sitting down at his desk. I persisted. "I assure you I feel perfectly all right"; he smiled: "Everyone has his own distillations. . . ." "What d'you mean?" "You know perfectly well: the thickets of the heart." And he began drawing unnamable things on a piece of paper. I pretended to work, expecting to see him collapse at any moment. He had an appointment the next morning with a woman friend; I succeeded in making him write a *pneu* to call it off; he made four tries before he managed to write it, and when she received it she burst into tears: the words were all on top of each other, distorted, incoherent. I went to see the doctor. "I won't try to conceal from you," he said, "that when I saw him coming into my surgery I thought: That man is going to have a heart attack." He added: "He is a very emotional man. He has overworked himself intellectually, but even more so emotionally. He must have moral calm. Let him work a bit if he insists, but he mustn't try racing against the clock. If he does, I don't give him six months." Moral calm in France today! I went straight to Simone Berriau; she agreed to put off *The Condemned of Altona* until the following fall. I hadn't informed Sartre of these visits; when I did tell him a few hours afterward, he listened with an indifferent smile; I'd rather he'd flown into a rage. For a while he only worked a very little at a time; then, slowly, he began to get better. The most painful part for me during this crisis was the solitude his illness condemned me to; I couldn't share my worries with him because he was the object of them. The scars left by the memory of those days have never left me, especially of the one when "the thickets of the heart" first threw their mysterious shadow between us. Death had become an intimate presence to me in 1954, but henceforth it possessed me.

This subjection had a name: old age. Toward the middle of November we had dinner at La Palette with Leiris and his wife; since the last time we'd met him he had swallowed a fatal dose of barbiturates and been saved only by a very difficult operation and then a long course of treatment. We talked about sleeping pills, drugs, sedatives, and the anti-depressants Leiris was taking; I asked him what effect they had exactly. "Well, they de-depress you." Then, when I asked him to be more precise: "It means you know everything's just as awful as it was before; only you're not depressed." As he was sitting there with Sartre thrashing out the differences between

tranquillizers and anti-depressants, I thought: Well that's it, we're on the other side now, we're old. A little while later, chatting with Herbaud, a very old friend, I said that, basically, there was nothing else for us to look forward to except our own death or the deaths of those close to us. Who'll go first? Who'll see the others out? Those were the questions I was asking now when I thought about the future. "Now, now," he said to me, "we haven't reached that stage yet; you've always been too old for your years." And yet, I wasn't wrong. . . .

The last thread that kept me from my true state snapped: Lanzmann and I drifted apart. It was natural, it was inevitable and even, on reflection, desirable for both of us; but the moment for reflection had not yet come. The action of time has always disconcerted me, I regard everything as definitive, so that the business of separation was difficult for me; for him, too, though the initiative had been his. I wasn't sure that we would manage to salvage the past, and it meant too much to me for the idea of giving it up not to be odious. It was with a heavy heart that I reached the end of that intolerable year.

# CHAPTER V

EVER SINCE MAY, GREAT GUSTS OF words had been sweeping across France; the simple syllable "lies" was inadequate to describe them; they were *lecta,* without any positive or negative relation to reality, rumors engendered in the air by human breath. There were teams of specialists to interpret them. They produced the translation "generous offer" for the phrase "peace for the brave," which to the Algerians meant capitulation.

The press went into hiding. The elections were a farce in Algeria, and in France a victory for the U.N.R. who, with the obligatory Moslem candidates also elected, formed a bloc of two hundred and sixty Gaullist deputies. The Communists lost ground. Many people who had up till then been left-wing opted for what they called "realism." One particularly striking case was that of the Unionist Serge Mallet who, early in 1958, had talked very intelligently to Sartre about the new tactics the employers were using and the difficulties they were creating for the unions; at that time he was searching for a means, within the framework of the class struggle, of overcoming them. The long essay in which he repeated these explanations in print had amazed Sartre by its clumsiness; Mallet lost no time in correcting this error. He wrote some excellent articles for *Les Temps Modernes* and several other left-wing newspapers in which he analyzed neo-capitalism and described the present working conditions of agricultural and factory workers. I made his acquaintance at the Coupole at the time of the referendum, and he surprised me. He knew from a completely reliable source that an emissary from De Gaulle was in Tunis at that moment conducting negotiations; the peace would be signed within two days. I saw him again a few weeks

later; he described the maneuvers being used by the young employers to split up the working class, he criticized the trade unionists for clinging to outdated attitudes, and I realized that beneath a pretense of adapting the working class avant-garde to the new methods of neo-capitalism he was really subscribing to collaboration between the classes. He was rallying to the economic theory that had become the new regime's perpetual refrain. *Les Temps Modernes* accepted no more of his articles on economic theory.

The result of the referendum had severed the last threads linking me to my country. There were to be no more trips through France. Tavant, Saint-Savin, and other places I had never seen no longer held any attraction for me; the present was even spoiling the past for me. From that time on I lived through the pride of our autumns in humiliation, and the sweetness of summer in bitterness. Sometimes I still feel a catch in my throat at a landscape's sudden grace, but it is the memory of a love betrayed, it is like a smile that lies. Every night when I went to bed, I was afraid of sleep, afraid of the nightmares twisting through it, and when I woke up I was cold.

"The time of battles is over," De Gaulle announced at Touggourt. But they had never been more serious. Challe achieved several military successes, he smashed the *katiba*. But his psychological warfare failed, he did not win over the population. In the early spring of 1959, a new and as yet little-known aspect of this war of extermination was revealed to us: the prison camps. It was learned that from November 1957 on, the so-called "redistribution" program had begun to assume increasingly large proportions. Since the A.L.N.—despite official propaganda—existed among the population "like a fish in water," the only thing to do was remove the water: empty the *mechta* and the *douars,* scorch the earth and herd the peasants together, under the control of the army, behind barbed wire. This principle was applied on a grand scale. On March 12, 1958, *Le Monde* made a fleeting allusion to the existence of these camps. In April, the Secretary General of Catholic Aid, Mgr Rodhain, led an inquiry into the matter and then, on August 11th, published certain of its findings in *La Croix:* "I discovered that there were more than a million human beings involved, generally women and children. . . . A notable proportion, particularly among the children, suffer from hunger. I have seen these things and bear witness to them." He estimated the numbers of the "redistributed" at more than 1,500,-

ooo.[1] Some of them, as he had seen with his own eyes, had been reduced to eating grass. Tuberculosis was rampant. The people there were in such bad physical condition that even drugs did not affect them any more. On April 15th, an even more appalling report was made public, this one addressed officially to M. Delouvrier on his request. From this it emerged that more than a million redistributed peasants were living in "extremely precarious" conditions.[2] On an average, 550 out of every thousand inmates were children, and one of those 550 was dying every two days; since many of the women and old men were also unable to withstand the conditions, it may be estimated that these camps killed more than a million people in three years.[3]

Delouvrier forbade the creation of further centers. He was ignored, and the numbers of the "redistributed" only increased. In July, Pierre Macaigne published in *Le Figaro* an account of his visit to the Bessombourg camp: "Crammed together in unbroken wretchedness, fifteen to a tent since 1957, this human flotsam lies tangled in

[1] This is also the figure arrived at by Paillat—*Dossier Secret de l'Algérie*—who is generally little moved by the misfortunes of Moslem populations: "From May 1958 to July 1960, the number of displaced persons rose from 460,00 to 1,513,000. Their number is still increasing." The paragraph heading "The Piteous Horror of the Redistribution Centers" and the material following it make it quite clear that he is referring to the camps. And he too emphasizes, on the strength of a report by General Parlange, their "deplorable material conditions."

[2] The report stated: "Any displacement of populations entails an appreciable, *and in some cases a total*, curtailment of the material resources of those involved." These people were obliged to leave behind their goats, their chickens and their meager land, they were losing at least a third of their resources; the more fortunate among them sometimes managed to get a new piece of land to cultivate, but since there were very few adult males among them—all in the *maquis*, in prison, or dead—those that did could not possibly provide for the needs of the women, children and old people composing almost the entire population of the redistribution centers. In fact, these 1,500,000 displaced persons were living on relief of staggering inadequacy. "The sanitary situation is almost everywhere *deplorable.* . . . When a group of displaced persons reaches the thousand mark, approximately one child dies every two days." The sanitary situation, the writers of the report continued, is an outcome of the standard of living: "In one of the most tragic cases we encountered, a medical report specifies that the physiological condition of the population is such that drugs no longer affect them." And under the heading "standard of living" it states: "It is in this realm that the situation of these displaced persons is at its most tragic, the sanitary situation being only a consequence of it. . . . The almost total absence of domestic animals is a characteristic common to all the redistribution centers; this means that milk, eggs and meat are of necessity excluded from the diet of those living in them. . . . The rations distributed by way of relief are extremely meager; in one of the cases we observed, they were limited to 24 lbs. of barley per adult, per month, which is not much when there are young children as well. The most serious lack in this matter is the total absence of regularity in these distributions. . . . Means of existence must at all costs be provided for these people if the experiment is not to end in disaster." The redistribution centers very rarely numbered less than 1,000 and sometimes as many as 6,000.

[3] This was also the figure given by the Algerians.

an indescribable state. There are 1,800 children living at Bessom-
bourg. . . . At the moment, the whole population is fed entirely on
semolina. Each person receives about 4 ounces of semolina a day.
. . . Milk is given out twice a week: one pint per child. . . . No
rations of fat have been distributed for eight months. No rations of
chick-peas for a year. . . . No ration of soap for a year. . . . "

From young soldiers and from journalists who had been in Tuni-
sia and met Algerians torn from camps near the frontier, I discovered
further details: systematic, organized rapes—the men were taken out
of the camp or herded into a corner while the soldiers went in and
performed; dogs set on old men for diversion; torture. But these
reports as they stood should have been enough to disturb people.
Mgr Feltin, Pastor Boegner, both spoke about them with indigna-
tion; scarcely anyone listened. The press kept quiet. The French Red
Cross, which the International Red Cross had been asking to do
something about these displaced persons for two years, still took no
action. Whereas when the floods in Madagascar left 100,000 home-
less, the government, anxious to demonstrate the advantages the is-
land gained from its adherence to the French Commonwealth,
launched a relief campaign, and the French people rushed to prove
how *"formidable"* they were.[1] It is always nicer to get emotional
about a natural cataclysm than about crimes to which we are
accomplices.

There were other sorts of camps: internment camps, transit
camps and selection camps, in which men were imprisoned by arbi-
trary decisions of the police or the army; they were then tortured,
physically and psychologically, till they went mad or, in many cases,
died. Abdallah S. described in *L'Express* how between beatings and
tortures he was forced to deny the F.L.N. and tell them how much he
loved France, in words straight from the heart. There were camps of
this sort in France; Larzac—once this had been the name of a plateau
I used to rush gaily over in my youth, on foot, or on my bicycle; now
it was a name for hell. The people living in the vicinity were aware
of this, despite the precautions that had been taken. The entire
French people were aware that camps had been set up on their own
soil similar to the ones in Siberia they had once denounced with such
a hue and cry; no one protested now. Camus did not raise the slight-

[1] At the beginning of his report, Mgr Rodhain remarked: "A natural disaster in
Madagascar and a man-made disaster in Algeria. . . . In the first case, 100,000 left
homeless, in the second, a million refugees. . . . The public is passionately concerned
about Madagascar. . . . For the refugees in Algeria, no one will lift a finger."

est objection—Camus, who had been so disgusted only shortly before by the indifference of the French working class to the Russian camps.

As for the use of torture, in about March 1958, De Gaulle, after continual requests for a public condemnation, coolly announced from on high that torture was a product of the "system" and would disappear with it. "The use of torture has ceased," Malraux had assured the nation after May 13th. In fact, it had spread to France itself. In October, in his defense of the priests being tried at Lyons for having helped the F.L.N., Cardinal Gerher invoked the tortures to which Moslems were being subjected in the police stations of the city. An Algerian being "interrogated" in a Versailles police station hanged himself from the bars of his cell. *Témoignage Chrétien* and *Les Temps Modernes* published the complaints of the Algerian students so savagely "questioned" by the D.S.T. in December. In February, during the trial of the Algerians who had shot at Soustelle, one of the accused pointed to one of the police officers packing the court, Commissioner Beloeil: "That man tortured me." The Commissioner disappeared from sight and was not questioned. In Algeria, the use of torture was an accepted fact. "There was a time," Gisèle Halimi told me, "when if I said: 'My client's admissions were extracted from him by torture,' the President of the Court would hammer on the table and say: 'That is an insult to the French Army.' Now, he simply says: 'I accept them, nevertheless, as true.' " Thirty young priests, shattered by their experiences in Algeria, wrote to their bishops, and a military chaplain publicly condemned the use of torture. But the legal reforms which in March made secret hearings legal, made the isolation and ill-treatment of prisoners even easier. In June, the students who had been tortured in December—Boumaza, Khebaïli, Souami, Fancis, Belhadj—spoke out. They brought action against M. Wybot who had been present in person at several of the interrogations. The book was seized and the affair hushed up.

In March a meeting protesting the use of torture was to be held at the Mutualité; I was in the middle of preparing my protest when the Commissioner of Police for our district came around to warn me that the meeting had been forbidden. He was most polite about it; then he pointed to a strip of black crepe on his lapel. "I lost a son in Algeria, Madame." "It is in all our interests to make an end of this war," I replied. His voice became threatening. "There's only one thing I want, and that's to go down there and finish off a few of them myself." I shouldn't have liked to have him "question" me. There

was a press conference that evening. Later, we managed to organize two or three meetings. A great many people turned out at the Montparnasse cemetery to attend the burial of Ouled Aoudia, killed by a policeman shortly before the trial of the Algerian students arrested for having re-established the U.G.E.M.A., in whose defense he was to appear. At the end of the academic year, a "fortnight of action for peace in Algeria" was organized. These demonstrations were not entirely useless, but so inadequate that a growing number of young people and adults were opting for illegal action.

After the whip-cracking of June 1956, there was no further open and collective opposition to the war among young people. There were more or less secret committees of young people still protesting, but in words only. In September 1958, I received the first mimeographed, anonymous issue of a publication called *Vérité pour* . . . which limited itself at first to economic and political analyses, but very quickly began to preach desertion and support of the F.L.N. It was run by Francis Jeanson, who was thus attempting to overcome a difficulty: "that of making public a means of action that should theoretically remain underground."[1] It was at this time, too, that the Young Resistance Movement was started.

My friends and I had very different opinions now on the subject of supporting the F.L.N. We had seen Jeanson again and been convinced by the reasons he gave that his movement was politically justified. The French Left could not now resume its former revolutionary attitude except in collaboration with the F.L.N. "You are stabbing French soldiers in the back," he had been told. This accusation reminded me of the sophistry of the Germans when they accused the *maquisards* of preventing the return of prisoners. It was the professional military men and the government that were killing the youth of France by prolonging the war. The lives of Moslems were of no less importance in my eyes than those of my fellow countrymen; the enormous disproportion between the French losses and the number of their adversaries they had massacred revealed this emphasis on the shedding of French blood to be no more than a sickening piece of blackmail.[2] Since the Left had completely failed in its attempt to carry on the struggle within the limits of legality, if one wanted to remain faithful to one's anticolonialist convictions and free oneself of

[1] *Notre Guerre* by Francis Jeanson.
[2] Jeanson later revealed that his connections with the Fédération de France had in fact enabled him, on several occasions, to influence it and to save French lives.

all complicity with this war, then underground action remained the only possible course. I admired those who took part in such action. But to do so demanded total commitment, and it would have been cheating to pretend that I was capable of such a thing. I am not a woman of action; my reason for living is writing; to sacrifice that I would have had to believe myself indispensable in some other field. Such was not by any means the case. I contented myself with giving what help I could when I was asked for it; certain of my friends did more.

Malraux was dropping Labiche and Feydeau from the Comédie-Française repertory; he cast a veil of high-sounding speeches over the machinations of the Philips Corporation which had had the idea, to the great despair of the Greeks, of exploiting the commercial resources of the Acropolis by presenting a *Son et Lumière* performance there. "Not since the Nazis set foot on the Acropolis have we experienced such a humiliation," we read next day in a Greek newspaper, and a conservative one at that. France's degradation continued. The University was crying out for financial help, and the government was preparing to subsidize private schools. The anti-Sovietism of the middle classes persisted. The Soviet scientists announced when they launched the first Lunik that it would pass close to the moon; the newspapers insinuated that they had intended to hit it and failed. The Pasternak affair was a godsend. It is true that the Union of Soviet Writers showed itself in a clumsy and sectarian light by insulting and expelling Pasternak; but he was after all allowed to live in peace in his *dacha,* and the Swedish Academicians were being intentionally provocative when they conferred their prize on a Russian novel that expressed a rather cool attitude toward Communism and which they considered as counterrevolutionary; they were forcing the Soviet Writers Union, which until then had turned a blind eye, to act in some way. Pasternak is a very great poet, but I could not get through *Doctor Zhivago.* Reading it taught me nothing about a world to which the author seemed to have made himself deliberately blind and deaf, and then he enveloped it in a mist in which even he himself melted away. To swallow these lumps of solidified fog, the middle classes must have been sustained by a fanaticism of no mean power. The same fanaticism later inspired them with a no less far-fetched passion for Tibet, about which they knew nothing whatever except that it had rebelled against Chinese domination; the Dalai

Lama immediately became the embodiment of liberty and Western values. If there was one thing they hated more than the U.S.S.R., it was China. On his return from Peking, Lanzmann had told me a great deal about the Chinese experiments with communes; apparently the success of these had varied greatly according to different regions and conditions, but it was an interesting attempt to decentralize industry and link it more closely with agriculture. In France, it was accused of destroying the family as well as of crushing individuality, and only its difficulties were publicized.

I greeted the Pope's death with a certain amount of pleasure, as well as that of John Foster Dulles. The Cyprus incident was settled to the advantage of the Cypriots. But the most astonishing revolutionary victory was the one brought off in Cuba by the rebels of the Sierra Maestra. As winter began, they marched westward from their mountains, Batista fled, Castro's brother led his troops into a Havana mad with joy, and Fidel was received there in triumph on January 9th. In the cellars of the city, in the surrounding countryside, tremendous mass graves were unearthed: more than twenty thousand people had been tortured and shot, whole villages had been pounded to pieces by the air force. The people demanded reprisals; to satisfy them and keep them within bounds, Castro instituted a public trial that resulted in roughly two hundred and twenty death sentences. The French newspapers presented this inevitable purge as a crime. *Match* published photographs of the condemned men kissing their wives and children, but without, needless to say, showing any pictures of the bodies of their victims, without saying how many there had been, without even mentioning them. Castro was well received by Washington; but when he began to put his agrarian reforms into effect and they discovered that their Robin Hood was in fact an out-and-out revolutionary, the Americans—who had fried the Rosenbergs when they were accused of espionage in peacetime—waxed indignant because he had sent some war criminals to the firing squad. Castro had the whole Cuban population behind him; when he handed in his resignation in July, as a means of settling his conflict with Urrutia, the President of the Republic, a million peasants flowed into Havana. Striking their machetes together, producing a deafening din, they demanded that he remain at the head of the country and that Urrutia go instead—which he did. He was replaced by Dorticós.

During my vacation I had decided, as I said, to go on with my autobiography; I continued to waver in this determination for a long

time; it seemed to me presumptuous to talk so much about myself.
Sartre encouraged me. I asked everyone I met whether they agreed;
they did. My question became increasingly pointless as the book
progressed. I compared my recollections with Sartre's, with Olga's,
with Bost's; I went to the Bibliothèque Nationale to get my life back
into its historical frame. For hours on end, reading old newspapers, I
became involved in a present heavy with the uncertainty of its future
and already become a past left far behind; it was disconcerting.
Sometimes I became so absorbed in my task that time fell away from
under me. As I came out of the library courtyard, unchanged since I
was twenty, I no longer knew what year I was walking into. I looked
through the evening paper with the feeling that the next day's issue
was already on the shelves, within arm's reach.

I was spurred on by the success of my *Memoirs* which, once
Sartre was out of danger, affected me more intimately than the re-
ception of any of my other books. In the morning when I got up, and
when I came home to go to bed, there were always letters on the floor
inside my door to drag me out of my depressions. Ghosts rose up out
of the past, some annoyed, some kindly; school friends I'd treated
rather sharply smiled at the awkwardness of their youth; friends I'd
written about sympathetically got angry. Some ex-pupils of the Cours
Désir approved of the picture I had painted of our education; others
protested. One lady threatened me with court proceedings. The
Mabille family were grateful to me for having made Zaza live again.
They sent me details about her death that I did not know, and also
about her parents' relations with Pradelle, whose reticence I under-
stood much better as a consequence. It was romantic, this discovery
of my past brought about by my writing an account of it. As I reread
Zaza's letters and notebooks, I was plunged back into it once more.
And it was as though she had died a second time. Never again did she
come back to see me in my dreams. Generally speaking, since it has
been published and read, the story of my childhood and youth has
detached itself from me entirely.

In October, the *Temps Modernes* staff got together for a lunch at
Lipp's to celebrate the return of Pouillon, who had spent the sum-
mer near Lake Chad among the Corbos on an ethnographical expe-
dition. He had been quite insensitive to the heat and was bothered
only by the flies that covered him from head to foot every time he
washed in front of his tent. He had been quite happy eating the
lump of millet that they kneaded for him every morning. His sole
occupation was talking to the natives all day with the help of an

interpreter. It seemed to me that if I had been in his place I should have died of boredom. "Every morning," I told him, "I'd have been panic-stricken wondering: What am I going to do until this evening?" "In that case, never go there!" he answered vehemently. Unfortunately he hadn't been able to collect much information; the life of the Corbos is extremely rude. "They've lost the bow," Pouillon explained, "they had it, and now they've lost it. It's worse than never having discovered it; you can never discover it a second time!" The neighboring tribes used them; but what's the good? they said. Given these conditions, there was no modern invention capable of dazzling them; automobiles, airplanes: what's the good? Occasionally they would kill birds with stones and eat them. They owned cattle, but the pastures where they were turned out to graze were so far off that they were scarcely more than an imaginary form of wealth. The women did the work of cultivating the land, so naturally all the men were polygamous except one idiot, a bachelor who lived on charity, and an old man better off than the others who explained to Pouillon: "I don't need to have more than one wife; I'm rich." Their traditions appeared to be as rudimentary as their way of life; to perpetuate them would have required an intelligent old man and a curious child. This conjuncture did not occur very often; many had fallen into oblivion. They lived without religion and without rites, or almost. Pouillon's voice was vibrant with enthusiasm as he talked. These people escaped want by rejecting all wants; they had nothing, yet they lacked nothing. We were afraid he was going to become a naturalized Corbo.

Outside the circle of my intimates, I only enjoyed talking with people when we could be alone, since we could often get through the small-talk stage very quickly then; I was sorry I had never managed to do so in the course of my rare meetings with Françoise Sagan. I very much liked the light touch of her humor, her determination not to be fooled by anyone and not to strike attitudes; every time I left her, I said to myself that next time we must have a real talk together; and then the next time we didn't—I'm not quite sure why. Since her conversation makes its points by way of ellipses, allusions, implications and unfinished sentences, I always felt it would be pedantic of me to finish mine, but I just couldn't get used to breaking them off halfway through, and always wound up unable to think of anything to say. I found her intimidating, as I do children and adolescents and everyone who uses language differently from me. I suppose she felt

ill at ease with me too. One summer evening we happened to meet on the terrace of a café on the Boulevard Montparnasse; we exchanged a few words; as usual she was very charming and funny and I would have enjoyed nothing more than just staying there with her. But she told me immediately that there were some friends waiting for us at the Epi Club. Jacques Chazot was there, Paola de Saint-Just, Nicole Berger and a few others. Sagan drank in silence. Chazot told a lot of Marie-Chantal stories, and I was astonished to think that there had been a time when nothing could have been more normal than to find myself sitting in a nightclub with a glass of Scotch in front of me—I felt so out of place! Though it's true that I was surrounded by a group of strangers, and that they had no more idea what I was doing there with them than I had.

I read a little. Aragon's *Holy Week* bored me almost as much as *Doctor Zhivago;* once I got the point he was making, and realized the virtuosity with which he was doing it, I could see no reason to go on with this scholarly allegory; I like Aragon's voice direct and uncluttered, as it comes through sometimes in *Le Roman Inachevé,* and in *Elsa;* I found him moving when he was talking about his youth and his visions, his ambitions, the ashes left by fame, life passing and killing as it goes. Though *Zazie* won such an enormous public, I had liked other books by Queneau better, from *Chiendent* to *Saint-Glinglin*. But I plunged with great enjoyment into the intricacies of *Lolita*. With disquieting humor, Nabokov was disputing the transparent rationalizations about sex, about the emotions, about the individual, so necessary to the Organization World. Despite the pretentious clumsiness of the prologue and his failure to sustain the end, I was gripped by the story. De Rougemont, who writes idiotically about Europe but not at all badly about sex, has praised Nabokov for having discovered a new embodiment of the idea of love-as-fatality, love-as-curse; and it is true that in our age of Coccinelle and sentimental ballads, love doesn't seem to entail damnation for anyone any more; whereas, from the very first moment that he sets eyes on Lolita, Humbert Humbert is in hell. With *La Révocation de l'Édit de Nantes,* Klossovski had written, in incomparable style, a novel of deep and baroque eroticism. Usually in erotic books the characters are reduced to a single dimension; their debauches are inadequate to restore life to bodies the author has cut off from the real world, and thereby drained of their life's blood. But Klossovski's heroine, a much-honored Radical-Socialist member of Parliament, really lived;

when he led her into dungeons worthy of Eugene Sue and delivered her up to flagellations, one believed in her masochistic jubilation. The treatment he doled out to those who put their trust in heaven was no better than that reserved for those who laughed in its face; in each case, the distortions of their sexuality demonstrated the inability of today's bourgeoisie to assume their bodies, and thus to be men.

It was generally during the afternoon, before working, that I read. In bed at night I occasionally glanced through one of the advance copies of novels that had been sent to me; at the end of ten minutes my light would be off. One evening it didn't go off. The book was by an unknown woman, and it began without any great fuss; a nice young girl met a mixed-up boy, she saved him from suicide, they were going to love each other: banal enough, only this wasn't. Disturbing, equivocal, their love forced the reader of *Warrior's Rest* to question the nature of love itself. This unschooled young girl spoke like a woman rich with experience, and in a tone of voice that held me right up to the last page, despite a certain number of slack passages. It's a rare pleasure, being struck unexpectedly by a book that no one has even mentioned to you. Christiane Rochefort: who was she? I only found out a short while later, when the verdict of the public had sustained my own.

The complete version of *Ivan the Terrible* was shown in Paris. The first part was a little stilted; the second, unfettered, lyric, epic, inspired, perhaps outstripped anything I had ever seen on a screen. The Central Committee having condemned it, in September 1946, Eisenstein wrote to Stalin, who received him and then sat through the film in the Kremlin projection room; Stalin remained impassive throughout, or so Ehrenburg had told us, and then left without a word. Eisenstein had been given official permission to shoot a third section which was to be amalgamated with the second; but he was already very ill and died two years later.

For a long time Bost had been singing the praises of a new film which he had seen at a private screening and which broke with the usual pattern of French films: *Le Beau Serge*. As soon as it was released, I went to see it. The actors were all unknowns, and it depicted a village in the central part of France with such fidelity that the images on the screen seemed to me like memories; Chabrol told the story of its inhabitants' narrow lives, their shortcomings, without ever seeming to look down on them. In *The Cousins*, this gift for compassion and for presenting the truth in all its freshness was no longer in evidence, but here again the tone was original. In *The*

*Four Hundred Blows,* Truffaut portrayed the world of grown-ups rather badly, but that of childhood extremely well. The "New Wave" directors were always operating on too meager a budget to be able to use the costly production methods of their elders; this helped them shake off a lot of the dust that had settled.

In about May, Lanzmann took me one evening to watch Josephine Baker rehearsing at the Olympia; actors in street clothes were walking through sets that were only half up and bumping into other half-naked actors in imitation classical garb; I greatly enjoyed the disorder, the frenzy of the technicians, the bad temper of those in charge, the unexpected effects produced by this conjuncture of sumptuous artifice with the routine of everyday life. But as I recalled the Josephine of my youth, I kept repeating to myself that line of Aragon's: "What's happened? Life . . ." Baker managed with a heroism that compelled one's admiration; but that only made it seem all the more indecent to watch her. I could detect in her face the disease that was gnawing at mine.

Shortly after that—exactly ten years after the doctors had told him: "You've got another ten years"—Boris Vian died of anger and a heart attack during a private screening of his film *I'll Spit on Your Graves.* I learned the news one afternoon when I arrived at Sartre's and picked up *Le Monde.* I had seen him for the last time at Les Trois Baudets. We'd taken a drink together; he had scarcely changed since the first time we talked. I had been very fond of him. Yet it was only several days later, coming across a picture in *Match* of a bier covered with a piece of cloth, that I realized: it's Vian under there. And I understood that if nothing in me revolted at that, it was because I was already used to the idea of my own death.

I spent a month in Rome with Sartre. He was much better, he was well. He was finishing his play. He had rewritten the first act and gone on to write the next few scenes, which were all I could possibly have wished. One evening he gave me the manuscript of the last act, which I read in the little Piazza Sant' Eustacchio: a family council had been called to judge Franz; each of them explained his or her point of view, then we got back to Sudermann. When one of Sartre's works disappoints me, I always try at first to put myself in the wrong, and then I get angry as I go on and find myself more and more in the right. I was in a very bad temper indeed when he rejoined me and I had to tell him how let down I felt. He wasn't particularly disturbed. His first idea had been for a dialogue between the father and the son,

and he wasn't even sure why he'd changed it. So he went back to that idea, and this time the scene seemed to me to be the best one in a play I rated above any of the others he had written.

He in his turn gave me some stern criticisms of the first draft of my book. I have already said that when Sartre is not satisfied with what I've done, he doesn't mince words either. I would have to do it all over again. But finally he added that it was going to be more interesting, for his taste, than the *Memoirs,* and I went back to work with renewed pleasure. In the hottest part of the day, lying on my bed, I read Métraux's *Le Vaudou, Hopi Sun,* the amazing autobiography of an Indian that describes his double commitment to American civilization and to the traditional life of an Indian village; in *The Planetarium* I revisited the world of Nathalie Sarraute's lower-middle-class paranoiacs. And I rediscovered Rousseau's *Confessions.*

Sartre left me in Milan; I was to meet Lanzmann there a week later. I went to stay at Bellagio, a little intimidated at the prospect of being alone with myself for so long, since I'd got out of the habit. The days seemed too short. I had my breakfast at the edge of the lake, leafing through the Italian newspapers; I worked in front of my open window, enchanted by the calm landscape of hills and water before me; in the afternoon I read Massin's *Mozart,* which I had wrested from Sartre before he even finished it. He had found it excellent; it was a book so rich and so passionately written that I had difficulty tearing myself away from it and getting back to work. I was delighted to plunge back into it after dinner, as I sat drinking grappa on the terrace. Then I would walk in the moonlight. I spent ten days at Menton with Lanzmann. He read my manuscript and gave me some good advice. Our lives were moving apart, but the past had been preserved intact in our friendship. When I had first known him, I was not yet ripe for old age; he hid its approach from me. Now I had found it already established inside me. I still had the strength to hate it, but no longer to despair.

During the summer, Malraux made a public-relations tour of Brazil. They confronted him with the political attitude taken by Sartre; Malraux accused him, in public addresses, of never having resisted the Germans, and even of having collaborated, to the extent of allowing his plays to be put on during the Occupation. A Minister of Culture insulting one of his country's writers while in a foreign

country—that was something quite new. He also claimed that during his three months as Minister of Information the use of torture had been suspended; as people pointed out, that wasn't being very nice to M. Frey.

In about July, the Red Cross announced that an increasing number of Moslems were disappearing as Audin had "disappeared." Vergés and Zavrian had established themselves in Aletti on August 10th in order to give a hearing to the Algerian women whose husbands, sons and brothers had vanished in this way; they came in droves. Though expelled, the two lawyers still had time to collect a hundred and seventy-five statements, which appeared in *Les Temps Modernes* in October, as well as in *L'Express*. No bodies, therefore no proofs, was the answer of those people to whose advantage it was to deny these murders. *La France Catholique* explained in one and the same breath that no one could affirm that Audin had been tortured and strangled because no one had been there to witness it, and that the tortures suffered by Alleg could hardly have been much of an ordeal since he had lived to tell the tale. When the trade unionist Aïssat Idir died in the hospital in August as a result of burns, an inquiry was started. Interned in the camp of Bitraria he had awakened one January night to discover his pallet in flames. Despite the insistant protests published for once by the press, and in particular by *Le Monde*, it was decided that he had set himself on fire, through negligence.

On September 16th, De Gaulle came out with the word "self-determination," in November he agreed to include the G.P.R.A. among "those with a right to be heard"; Fascist plots and regroupings multiplied; meanwhile the restorers of peace in Algeria continued to devastate the land and decimate the population. An official army communiqué showed that 334,542 Moslems had been confined in redistribution camps between June and September.[1] In Novem-

---

[1] In *Réforme*, on November 14, 1959, Pastor Beaumont published some travel notes made between October 14th and 29th: "In many of the redistribution centers the average ration, counted in calories, is only a quarter or a third of the *minimum* necessary to sustain life." The number of those interned in the centers had increased by 30 percent since March, and the camps would certainly not be suppressed before the end of the war. The people in them were getting an average of about 5 ounces of hard wheat, or 700 calories, per day per capita, but in one of the cases he encountered the daily ration was as low as 3 ounces or 400 calories. In another extreme case, at the Michel farm, 500 out of 1,000 had died. In a "normal" camp, Pastor Beaumont had seen with his own eyes children dead and dying of hunger: "Children with tibias and fibulas covered by no more than skin, children in the last stages of rickets, children with malaria for whom there was no quinine, and who lay shivering on the bare ground without even a covering over them."

ber, there appeared in *L'Express* an eyewitness account by Farrugia,
an ex-deportee, of the internment camp at Berrouaghia[1] which
was indisputably nothing but an extermination camp. There were
others like it. Between October 15th and November 27th, the
International Red Cross made surveys of the redistribution, selec-
tion, internment and transit camps, which it then collated to form
a general survey of about three hundred pages, incorporating
eighty-two reports; they were so shocking from the French point
of view that after negotiations with the government the Red
Cross released only a few extracts, from which *Le Monde* then
published certain conclusions. But the complete text was circulated
under cover. *L'Observateur* reminded its readers of the circumspec-
tion with which the International Red Cross had spoken of the Nazi
camps. Their investigators had not seen the gas chambers with their
own eyes; the camp officers had assured them that the parcels sent to
the internees were faithfully distributed, etc. It was obvious that
everything had been done to fool them in this case as well, and they
had more or less acquiesced. Nevertheless, even though I was inured
to these things, it was only with difficulty that I forced myself to read
their report through to the end.

In December, *Témoignage Chrétien* and then *Le Monde* made
public the report of a priest, a reserve officer, on the instructions
given in August 1958 at the "Training Center for Subversive War-
fare" at the Jeanne-d'-Arc camp: "Captain L. gave us five points of
which I have a precise record, together with the objections and the
replies to them: 1) Torture must be kept clean; 2) it must not be
carried out in front of young soldiers; 3) it must not be carried out
in the presence of those with sadistic tendencies; 4) it must be car-
ried out by an officer or some responsible person; 5) above all, it
must be humane, which means that it must cease as soon as the
prisoner has talked; and even more important, it must leave no trace.
Given these conditions—was the conclusion—you have the right to
use water and electricity."

This report passed more or less unnoticed. The French people
were by then drifting in a state of indifference in which the words
knowledge and ignorance were more or less equivalent, a state in
which even the most startling revelation made no impression on

[1] He confirmed the account given of it in July by *El Moudjahid;* there were 2,500
prisoners there: men considered particularly dangerous and "intellectuals." They were
being treated with brutality, tortured, beaten up, murdered; many went mad; many
killed themselves.

them. The Audin Committee proved that Audin had been strangled to death. But wind of it scarcely reached the general public, and they had no desire to find out more.

After the days of the barricades, De Gaulle had the bill for plenary powers voted through. The atmosphere became more unbreathable every day. On street corners, in front of police stations, you saw the cops standing, submachine guns in hand, eyes constantly alert; if you went up to them at night to ask the way, they leveled their weapons at you. On New Year's Eve, one of them killed a boy of seventeen in Gennevilliers as he was going home from a dance. Once Bost was driving home very fast at about two in the morning when he was chased and stopped by a police car. He had to show his papers; profession: journalist. "An intellectual!" said one of the policemen with hate in his voice. While he kept his submachine gun trained on Bost, the others went through the trunk. You couldn't go a hundred yards along a street without seeing North Africans being loaded into a police truck. As I passed the Préfecture, I saw one lying on a stretcher covered in blood. One Sunday, I drove with Lanzmann along the Rue de la Chapelle. There were cops, snug in their bulletproof vests, Sten guns in their hands, searching some men they'd lined up against a wall with their hands in the air: Algerians, shaved, well groomed, wearing their best clothes. It was Sunday for them too; the hands delved into their pockets and came out brandishing their pitiful personal belongings: a pack of cigarettes, a handkerchief. I gave up going out in Paris.

Yet it was certain that Algeria would obtain its independence; all Africa agreed about that. When Guinea had the courage to reply No to the referendum on September 28, 1958, France broke off relations; she did not break off relations with the other nations which, a year later, made as if to follow the same path.[1] In an attempt to prevent a revolution in the Congo and safeguard its own economic interests, Belgium was decolonizing as fast as it could. The last of the English colonies had received assurances of their imminent emancipation. In Monrovia, during the summer, the young African nations had made a demonstration of their solidarity with Algeria.

Things in the rest of the world seemed less gloomy than in France. The tension between the blocs still subsisted on certain points, especially in West Germany, where a fanatical anti-Com-

[1] The truth is, that with the exception of Mali, they didn't really attack colonialist exploitation, and the genuine revolutionaries had to continue the struggle. In the Cameroons it was, and still is, a bloody one.

munism was now being supplemented by a renaissance of anti-Semitism; swastikas appeared on the synagogues on Christmas Eve. But Khrushchev's trip to Washington and the one Eisenhower was to make to Moscow were events without precedent. Lunik 2 and Lunik 3 confirmed Russia's superiority in space; that was a guarantee of peace.

In much the same way as airline passengers involved in an accident are advised to get straight into another plane, old Mirande had urged Sartre, after the failure of *Nékrassov:* "Write another play right away; if you don't, you've had it, you'll never dare to again." Although he'd let several years elapse, Sartre had dared to. I liked *The Condemned of Altona* so much that it revived my old illusions: a work, perfectly brought off, transfigures and justifies the life of its author; yet Sartre, possibly because of the circumstances in the midst of which he began work on it, never felt any great liking for this play. Vera Korène put it on at the Théâtre de la Renaissance and, once back in Paris, I watched almost all the rehearsals, often delighted, often disappointed. My pleasure was unalloyed on the afternoon when Reggiani, after going through it again and again, correcting himself with subtle severity at each attempt, taped the monologue at the end, which I found so beautiful; it was reassuring to realize that not one of those intonations could ever, now, be changed again. For the actors varied. I wasn't entirely satisfied with the scenery and the costumes, and, for a change, the play went on too long. I helped Sartre make a few cuts and encouraged him in refusing to make others demanded by the management. Vera Korène and Simone Berriau, who was associated with the production, prophesied disaster; cabals, scenes, tantrums—I was used to all that. But this time there was something serious at stake. I had never seen Sartre so anxious about the reception his work was going to get. Once, between two work sessions, we were striding out along the boulevard under a stony sky, and I felt his uneasiness infecting me. "Even if it's a bomb, you'll still have written your best play," I told him; perhaps, but what a disaster for the actors who would have blown their whole season on it! And it would disgust Sartre with the theater for good. I thought of all the enemies who had been announcing for years that Sartre was finished and would rush around with glee to bury him. Spiteful rumors had already begun to circulate when the first performance had to be postponed because the technicians and actors

weren't ready. But it opened at last. Standing at the back of the orchestra, I studied the invited audience; it was stifling in the badly ventilated auditorium; that wasn't going to help anyone follow a play of such rich and difficult content. Yes, I was sure Reggiani had been wrong not to muss up that far too handsome uniform. Suddenly other imperfections began to hit me in the eye. More moved than ever by the public unveiling of a work that affected me personally to the very marrow of my bones, dripping with sweat, clutched by panic, I hung onto a pillar, expecting to faint at any moment. At the final curtain the applause was so loud that I knew we had won. All the same, I was nervous when the curtain rose a few evenings later before the sullen audience of the first public performance. I went for a walk with Sartre along the boulevard. There was an apartment house on fire, we stopped to watch the firemen fight the blaze. Back at the theater, I stood in one of the boxes, then another, watching the play in snatches and noticing that, as always happens, the company was acting less well than on the previous evenings. During intermission, Vera Korène and her friends went off into a chorus of lamentation about the length of the play; that did nothing to boost the morale of the actors, who were already half dead with nerves. After the final curtain, the dressing rooms, the staircases, the corridors back stage, were inundated with everyone's friends. They liked the play, but complained about not being able to hear very well and being too hot. My nerves were in shreds by the time I got up to the second floor of the Falstaff, where Sartre was giving a supper for the company and his close friends. We were all worried. Sartre had resigned himself to making more cuts, but reluctantly, and I could sense his inner torment. He downed a drink, two drinks; once it had never occurred to me to count; the more he used to drink the funnier he became, but that was in the old days; he poured himself a third, I tried to stop him, he laughed and took no notice; my head was suddenly filled with memories of the winter before—the distillations, the thickets in his heart—and what with the Scotch inside me as well, I was suddenly seized by such a feeling of panic that I burst into tears; immediately, Sartre put down his glass. Amid the general excitement the incident passed almost unnoticed.

Sartre cut or deleted some of the scenes, reducing the playing time by about half an hour. And without having read almost any of the reviews he flew off to Ireland, where Huston was waiting for him to bring the Freud scenario. As soon as I woke up on Thursday, I

went out to buy the dailies and weeklies and glanced through them, sitting in the sun on a café terrace: it was a beautiful October morning. Almost all the critics agreed with me in placing *The Condemned of Altona* above all Sartre's other plays. I sent him a cable immediately, and the reviews.

By the time Sartre came back ten days later, the play's success was assured. He gave me a lighthearted account of his stay in Ireland. Huston had greeted him on the threshold of his house dressed in a red tuxedo; it was an enormous building, still unfinished, crammed with a costly and bizarre assortment of *objets d'art,* surrounded by grounds so vast that it took hours to cross them on foot. In the morning, Huston would go prancing about them on horseback, sometimes falling off. He would invite all sorts of people out there and then suddenly go off and leave them, in the middle of a conversation, which Sartre would struggle vainly to keep going. Sartre had been forced in this way to entertain an Anglican bishop, a maharajah and an eminent authority on fox hunting, none of whom spoke French. During the day he was always occupied by discussions with Reinhart and Huston, so he didn't see much of Ireland, but he had been taken with its funereal charm. He was finding the profession of scenario writer an ungrateful one.

I too made my first attempt in that field. Cayatte suggested that I work with him on a film about divorce; I hadn't the slightest desire to write about "the problems of the couple," but I knew a lot about them. I had received so many letters, heard so many case histories; the idea of making use of all this material in a scenario was a tempting one. Two things bothered me. First, the cinema does not leave room for the same frankness as the printed page; impossible to refer to the Algerian war, and consequently to locate my main characters in their true social situation; but their story, detached in this way from its background, no longer seemed real in my eyes: could I succeed in interesting myself in it? Second, Cayatte wanted the woman's and the man's differing versions of the conflict that divided them to be presented in two separately narrated episodes. I objected that the life of any couple is a story with two faces, but not two distinct stories. He insisted, but when he read my script admitted that this binary form was ruining it. I amalgamated the two sections. It would have been better to start again from scratch, but I had already got caught up with my characters and with the situations I had involved them in; my imagination was no longer free. Before

long, I realized that, despite our mutual goodwill, there was a misunderstanding between Cayatte and myself; I think he had approached me because I am generally thought of as having a taste for "problem novels," whereas, as I have already said, I don't like them at all. In my scenario I was at pains not to prove anything whatever, all the sequences were ambiguous, the links between them varied and fluid. Was Cayatte right or wrong in finding it confused? It also lacked, according to him, the necessary "gimmick" that surprises an audience and guarantees success; I would have preferred to capture the audience by less obvious methods, by the underlying tone, by a style, as Bresson did, for example, in *Les Dames du Bois de Boulogne*, with its intense austerity of effect. But after all, I had no complaints; Cayatte knew what he wanted, and it wasn't what I was giving him. I understood perfectly why he decided not to go on with it.

During the few weeks I was busy was the scenario, I did not stop reworking my book. Spurred on by the favorable comments, and even more by the criticisms I received from Sartre and Bost and Lanzmann, I cut, amplified, corrected, tore up, began again, pondered, made decisions. For me, it's a privileged interval, the period when I finally escape the vertigo of the blank page and haven't yet bogged down in the minutiae of the final draft. I was also spending hours reading and rereading the manuscript of the *Critique de la Raison Dialectique;* I groped my way along many dark tunnels, but when I emerged I was often transported by a feeling of pleasure that made me feel twenty years younger. *Altona* and the *Critique* redeemed all the marasmas, all the fears of the previous autumn. Through Sartre, and on my own account too, the adventure of writing regained its exalting taste.

To spend hours, months, years, talking to people one doesn't know—a strange activity. Luckily, chance makes me a little present from time to time. In the summer of 1955, I walked into a bookshop in Bayonne. "There's one book I really like," a young woman was just saying, "it's hard, it's peculiar, but I like it: *The Mandarins.*" It gives me pleasure to see flesh-and-blood readers who really like me. I also rather like getting to see the ones who loathe me. There was another summer when I was lunching with Lanzmann in a hotel in the Pyrenées; some Spanish people and a Frenchwoman married to a certain Carlo were dining at a nearby table; she talked about her

domestic life: "I've got a chauffeur, and it's so convenient for getting the children out." She was depressive and narcissistic; going on to analyze the subtle reactions of her heart, she said: "I only like what's completely the opposite of myself." Then her voice rose. "A mad-woman, she's abnormal, a disgusting book . . ." She was talking about *The Second Sex*, and me. We left the restaurant first, and as we got back into the car I gave the waiter a signed postcard with the words: "To Madame Carlo, who has the good taste to like only what is completely the opposite of herself."

Ever since *The Second Sex*, I have received a great many letters. Some are merely tiresome: autograph hunters, snobs, gossips, busy-bodies. Some are insulting; that doesn't worry me. The invectives of an anti-Semite who wittily signs himself Merdocu, Rumanian Jew, or of a *pied noir* who accuses me of coprophagia and describes my banquets, can only divert me. The ones from a "French Algerian" lieutenant who wanted to see me stood up against a wall and riddled with bullets simply confirm my opinions about the military pro-fession. And there are other letters, envious, sharp-tongued, angry, that help me understand the resistance aroused by my books. The majority of my correspondents tell me of their fellow feelings, confide their difficulties, ask for advice or explanations; they encour-age me and sometimes enrich my experience. During the Algerian war, young soldiers who felt the need to talk to someone shared their lives with me. I am often asked to read manuscripts. I always accept.

Among the people who wish to make my acquaintance, many are simply inconsiderate. "I'd like to talk to you to find out what you think about women," was how one young woman phrased her re-quest. "Read *The Second Sex*." "I haven't time to read." "I haven't time to talk." But I'm always happy to meet students of either sex. Many of them know both Sartre's books and my own very well and want to discuss and elucidate particular points; to see them is there-fore not merely doing them a service but also an opportunity for me to find out what young people are thinking, what they know, what they want, how they live. The acquaintance of young girls whose lives have not yet become settled is a great comfort to me. Once, when I was expecting to greet someone who sounded, from her letters, like an oppressed wife and mother, I was agreeably surprised to see a beautiful twenty-year-old blond girl walk into my studio. A French Canadian who found no stimulus in her family, her en-

vironment, her country, she had pursued her education as far
as possible and then won a scholarship to study theater direction
in Paris. Her letters of reference, her beauty and her intelligence
soon enabled her to make her way in the Paris theater world; she
attended several courses; she watched rehearsals, going every day to
those for *Tête d'Or*. She used to tell me about them; nothing
escaped her lively and critical eye. Her own difficult personal
problems never kept her from being ardently interested in those
that affected the world at large. I missed her when she went back
to Canada. Though very different, Jacqueline O. had also succeeded
in wrenching herself free from a stifling background and overcom-
ing serious personal distress; twenty years old, a schoolteacher in
Switzerland, she was studying for a diploma, writing short stories
feverishly, reporting for newspapers, working actively for Social-
ism, and for votes and independence for women; dark-haired and
plump, her long green or purple nails and exaggeratedly large
earrings made a curious contrast with the calmness and maturity
of her manner. Later, she was to quit Europe and as a professor
move to Mali, where she is quite happy.

I also felt great friendship for a young man from Marseilles who
had been writing me comradely letters for some years. After a diffi-
cult adolescence, he had been a sailor, then a busboy in a London
restaurant, and I don't know what else. "I'm a classic misfit," he told
me modestly, the first time he came to see me. He had a closed face,
but when he managed one of his awkward smiles he looked like a
little boy. He was against society, against adults, against everything.
He arranged matters so that he could earn a living and at the same
time continue his education and pass his exams. From his original
tentative anarchism he progressed to an extreme and even dangerous
state of commitment. He often took me severely to task. When *The
Long March* came out—a much less vigorous book than *America Day
by Day*—he asked me uneasily, making a downward, slithering ges-
ture with his hand: "Are you going to keep on like this?"

It is mostly young women who come to see me. Many have
reached the age of thirty and feel trapped in a situation—husband,
child, work—which they have helped to create, though in a way de-
spite themselves; some of them manage better than others in such
situations. Often they try to write. They discuss their problems with
me. Some of them make extravagant confessions. I saw Mme C. two
or three times about a manuscript of mediocre quality she had sent

me; she was about thirty, married, comfortably off, with two children, and she described her marital difficulties to me. She was frigid; her husband was consoling himself with her best friend, Denise, and the two went off on car-hopping orgies together. "Why? What do you get out of it?" she had asked Denise. "An extraordinary feeling of complicity; and afterward, tenderness," Denise had answered. One morning Mme C. telephoned me; she had to see me, right away. She rang my bell that afternoon, came in and began her story. Unable to contain her curiosity about the complicity and the tenderness, she had gone with her husband and Denise in a car to the Avenue des Acacias in the Bois de Boulogne, where the participants do their car hopping. C. decided on two little cars filled with nothing but men. "Well, you won't have the time to be bored, my dears," he said to the women, leading two men into the apartment, followed by four others: mechanics, garage hands, delighted by this piece of good luck. Everyone drank a lot. The husband contented himself with looking on. As soon as the guests had departed, he went over to Denise and began murmuring endearments to her; the tenderness was for her! Despair, scene; Denise left. "You've spoiled everything," C. shouted at his wife, rushing out and slamming the door. She ran after him, he got into his car, she got into hers, they both drove off, one behind the other, at top speed. In the middle of Les Halles, he stopped short and she drove into the back of his car. She'd left her license and insurance at home; the police kept her at the station until her husband brought them. They went back home and were immediately disturbed by two of their nocturnal visitors in an ugly mood: one of the four others had taken their wallets. Exhausted, she lay down on her bed, thinking over all her trials and tribulations. "And suddenly," she told me, "I felt something I'd never experienced before. . . ."

Why had she insisted on letting me in on all this? At all events, it provided me with a curious glimpse of Parisian morals. One evening, Olga, Bost, Lanzmann and myself drove to the Avenue des Acacias. Cars were cruising slowly up and down, passing, waiting, smiles were exchanged. The social hierarchy was respected. Posh cars followed posh cars; little cars formed groups of their own. We got in on the act too, and soon we had a 403 and an Aronde tagging along behind us. Bost accelerated fiercely and we shook them off, aware that we had violated all the rules of polite behavior. As for Mme C., she has slipped out of my life.

Every writer who is at all well-known receives crank letters from

nuts. I should be doing no service either to them or to myself by replying; I refrain from doing so. But sometimes they are insistent. One morning, in Rome, I received a cable—in English—from Philadelphia: "Trying vainly to reach you for two weeks. Will telephone Tuesday noon. Love. Lucy." Apparently this person knew me, knew me well even; who was it? The voice on the telephone spoke to me quite intimately; but in English, and over such a distance, I could scarcely make out what was said. "Excuse me," I said, "but when did we meet? I can't place you. . . ." There was a long silence. "You can't place me!" She hung up. I was a bit upset, imagining that Lucy, whoever she was, had met someone in Paris pretending to be me. She telephoned again during the afternoon. "Madame de Beauvoir," she said in a distant voice, "I shall be in Paris on December 17th and I'd like to talk to you about Existentialism." "Gladly," I answered and hung up; I had realized what it was all about. I found out later that to get my address Lucy had telephoned first to my American publisher, and then, at their suggestion, to Ellen Wright in Paris. Letters began arriving—three or four a week. Lucy owned an antique shop, she was going to sell out so that she could come and live with me, she was buying a new topcoat, she described my joy when I would open my door to welcome her! "There is a misunderstanding," I wrote her on several occasions. Then I would receive a cable or a formal letter: "Would you be kind enough to grant me an interview so that we can discuss *The Ethics of Ambiguity*." Meanwhile, I was advised that the customs office was holding certain packages on which I was supposed to pay duty: a bust of Nefertiti, an "engagement ring" worth 50,000 francs. I had them returned to the sender. Once more I wrote: "Do not come." Whereupon Lucy telephoned Ellen Wright: "Should I come or not?" "No," Ellen said. I received a final letter: "I have sold my shop, I am penniless, and now you reject me! You have taught me a lesson, but I am a bad student; I haven't understood it. I cannot even blame you for anything, you have been so careful to protect yourself." A month later, a parcel from Philadelphia was delivered; it had been very carefully wrapped, and contained a single chair rung.

In 1958, in our opposition to the Algerian war and to Fascist threats, we had drawn much closer to the French Communists. Sartre had intervened in the Peace Movement with his request that it should fight for Algerian independence as it had fought for that of Vietnam.

In April, he had gone with Servan-Schreiber to meet some Communists at the Hôtel Moderne with a view to creating anti-Fascist committees. From May on, we had fought side by side. Through Guttuso, whom he had met again in the spring of 1958, Sartre had renewed his contact with the Italian Communists. In 1959, Aragon had passed on an invitation to him from Orlova, who was playing Lizzie in *The Respectful Prostitute,* and her husband Alexandrov. He didn't think he could accept, but when the Soviet Embassy asked us to dinner, we went. Maurois and Aragon, who were preparing to write parallel histories of the U.S.A. and the U.S.S.R., were there; also Elsa Triolet, Claude Gallimard and his wife, the Julliards, and Dutourd, who avoided shaking our hands, thus sparing us his. I found myself beside Vinogradov, who was beaming with joy because Khrushchev was due to visit Paris very shortly; on my other side was Leonid Leonov; I had read *The Badgers* twenty years before, but Leonov spoke scarcely any French. He did manage to tell me: "Philosophy's finished. . . . Einstein's equation makes all philosophy useless." Elsa Triolet sat opposite me, between the ambassador and Sartre; her hair had gone gray, her eyes had stayed very blue, and her pretty smile contrasted sharply with the bitter expression of her face. As we were talking about discoveries for rejuvenating the old and prolonging life, she said abruptly: "Oh no! It lasts long enough already; I'm nearly through it now, don't make me go back again." Camus had told me in 1946 that she and I had one characteristic in common: the horror of growing old. One day, talking about the beginning of *Le Cheval Roux*—in which the narrator has been so appallingly disfigured by an atomic explosion that she wears a stocking over her head to hide her face—Sartre had asked Elsa Triolet how she had had the courage to imagine herself with this scarecrow face. "I only had to look in a mirror," she replied. At the time, I said to myself: "But she's wrong. An old woman isn't the same as an ugly woman. She's just an old woman." In the eyes of others, yes; but for oneself, once past a certain stage, the looking glass reflects a disfigured face. Now I understood her. After dinner, I found myself in a corner of the drawing room with Maurois. I was hoping he would talk to me about Virginia Woolf, whom he had known; but the conversation didn't "take."

In October, Lanzmann told me about a book he'd only glanced through, but which seemed to him very good: *The Last of the Just.* After so many real-life stories, after Poliakoff's *Le IIIe Reich et les*

*Juifs,* what could a work of fiction possibly say? I opened the book one evening, and could not stop reading it all night. When the book subsequently became so famous and so widely discussed, I rebutted many of the criticisms that were leveled at it. Nevertheless, I did have some reservations to make on a second reading: some crudities in the writing; a religiosity still apparent beneath all the skillful camouflage. Perhaps, too, the book's authenticity is tainted by a little too much ingenuity; but after all, that is what literature is, as Cocteau says: *un cri écrit,* a written cry.

Lanzmann made Schwartz-Bart's acquaintance, and he invited us over together one Sunday afternoon. Schwartz-Bart was dressed like a worker, but it was the head and face of an intellectual that emerged from his turtleneck sweater; he had restless eyes, a sensitive, mobile mouth, and spoke very volubly in such a whispering voice it was difficult to catch what he said. Although completely indifferent to worldly values, money, honors, privileges, fame, he made no attempt to seem annoyed by the interest he had aroused. "At the moment I'm not working, so the interviews and all that don't bother me; it's just part of the trade." He had spent four years writing his book as well as he could; it seemed to him logical that he should now do his best to make sure people read it. Nevertheless, he had reacted vigorously to the importunity of certain journalists. He was no lamb ready for the slaughter; if he professed nonviolence, it was, it seemed to me, because it seemed to him to be the most appropriate and effective weapon at the time—which doesn't mean that he wasn't quite sincere about it. He believed in human nature, and he believed that it was good; he wanted society to be content with what he called "the human minimum" instead of running after progress; in short, his inclinations were far more toward the saintly ideal than toward that of the revolutionary. Lanzmann and I disagreed with him on these points, but he was a difficult person to argue with. Being spontaneous and warmhearted, he gave at first an impression of openness and relaxation; then one realized that by adjusting his ideas so exactly to his emotions, he had constructed an almost unassailable system of defenses for himself; for him, to shift from any position by so much as an inch would have entailed a total demolition and a total reconstruction of his whole attitude to the world. We noticed afterward that he had in fact told us nothing he did not subsequently repeat to the press and television; that was natural enough, but it belied the illusion of sharing his secret confidences which his ease of

manner created. Even reduced to a rather official version, the story of his early life was fascinating; he had a very quick mind, and a charm that combined gentleness and pride, sharpness and patience, sincerity and reticence; instead of the two hours I had expected to be with him, I stayed six. The next time I saw Schwartz-Bart was once again with Lanzmann, at the Coupole; the success of his book, which the juries of the Goncourt and the Fémina were fighting over, had annoyed several little-known writers who regarded Judaism as their province; they had persuaded Parinaud, who wanted the honor of the Goncourt for a writer in his own circle, to write an article which, thanks to the comments Bernard Franck made on it in *L'Observateur*, was soon the laughingstock of Paris. Schwartz-Bart was accused of some harmless enough errors and also, a more serious matter, of plagiarism; there was in fact, in the first part of his novel, a passage of about ten lines that very closely resembled a similar passage in an old chronicle. There was nothing to make such a fuss about. This first section was in any case a pastiche; to imitate the style of a text one has to steep oneself in it; certain sentences fix themselves in one's mind, to such an extent that one ends up by thinking they are one's own. I had experienced the same thing myself when I was writing *All Men Are Mortal*. But as I had already divined, if Schwartz-Bart took such pains to protect himself, it was because he was vulnerable; this intrigue had upset him badly. He sat across from me, quivering with calm. "It's all over, I've decided not to worry about it any more," he told me. "I spent the night thinking it all over quietly. The prize I don't care about; as for money, I've already earned quite enough. It's losing my reputation that's so terrible, but I'll get it back. I'll disappear for four years; I'll come back with a new book; and they'll see that I really am a writer." We assured him that the Goncourt jury wouldn't be taken in by the plot, and that none of his readers had any doubts about his being the real author of his book. He scarcely listened. "I prefer to expect the worst; that's how I do things; I imagine exactly what it will be like, I accept it and then I stop worrying about what's going to happen."

After the Goncourt, announced prematurely to the fury of the ladies of the Fémina, I invited Lanzmann and Schwartz-Bart over. I was flabbergasted when I saw him come in and almost began to laugh. He had disguised himself in a long green raincoat, a green hat with a turned-down brim, and dark glasses. "I'm being hounded," he said wildly. "People come up to me in cafés and ask for autographs, they

call me Monsieur Schwartz-Bart. Monsieur! Can you imagine!" He
was sincerely frightened by the realization that celebrity limits you
and cuts you off from others. And he was disturbed by the obligations
it was imposing on him; he received so many letters! Confidences,
confessions, thanks, complaints, requests, pleas; apparently he felt he
ought to pay a personal visit to everyone who wrote him; he thought
of himself as accountable in the eyes of the entire Jewish community.
I thought there was a hint of self-satisfaction in his panic, and I felt
the impulse to assure him that in a few months' time he would be
able to walk along the street in perfect peace. But no one, after all,
can pass so quickly from obscurity to fame, from poverty to riches,
without being disturbed by the process. What was he to do with the
millions of francs that were suddenly showering down on him? There
were people around him who needed a helping hand, but no more
than that, and there weren't many of them. As for himself, there was
nothing he wanted. Did he need to buy an apartment? Obviously
not. A car? He wouldn't know how to drive it. "I have no dreams,"
he told us; he paused. "Yes, one little one: a motorbike to ride out
into the country on Sundays." Then he added with a half-smile:
"And you can get around so easily on a motorbike; they're very
convenient." We suggested a phonograph and some records. He only
wanted three records: "I could listen to the Seventh Symphony for-
ever; I don't see how I'd get any more out of buying fifty records."
He had a sincere antipathy to luxury and enormous scruples with
regard to money, for he always thought of the price of anything in
terms of a worker's salary; he had taken a taxi to get to my studio—
that represented two hours' work for a laborer. I understood this
attitude, because as soon as I made any money it had presented me
with problems I have never solved. He also talked about his future
plans—a novel on the situation of the Negro; sensitive to the oppres-
sion women suffer, he was going to take a Negro woman as his main
character. I wondered if he would be able to bring her to life as
convincingly as he had done with Ernie. In any case, he was leaving
for Martinique.

I didn't see him until a year later, when he came back to sign the
Manifesto of the 121. He hadn't yielded at all to the blandishments
of fame and money, though using the latter seemed to come to him
more naturally, and asceticism was no longer his ideal, either for
himself or for humanity in general. His friends in Martinique had
converted him to a belief in revolution by violence; he had utterly

approved of the first chapter of *Les Damnés de la Terre,* published
by *Les Temps Modernes,* in which Fanon demonstrated that the
oppressed have no other way of attaining their rightful status as
human beings. Schwartz-Bart was inwardly freer than before, more
open and, it seemed to me, had his feet more firmly planted on the
ground. These changes were proof that he was putting the truths of
reality before his own opinions, risk before the comfort of certainty.

I was alone in Sartre's apartment one January afternoon when
the telephone rang. "Camus has just been killed in a car crash,"
Lanzmann told me. He was coming back from the South of France
with a friend, the car had smashed into a plane tree, and he was
killed instantly. I put down the receiver, my throat tight, my lips
trembling. "I'm not going to start crying," I said to myself, "he
didn't mean anything to me any more." I stood there, leaning against
the window, watching night come down over Saint-Germain-des-
Prés, incapable of calming myself or of giving way to real grief.
Sartre was upset as well, and we spent the whole evening with Bost
talking about Camus. Before getting to bed I swallowed some bella-
dénal pills; I hadn't taken any since Sartre's recovery, I ought to have
gone to sleep; I remained completely wide awake. I got up, threw on
the first clothes I found, and set out walking through the night. It
wasn't the fifty-year-old man who'd just died I was mourning; not
that just man without justice, so arrogant and touchy behind his
stern mask, who had been struck out of my heart when he gave his
approval to the crimes of France; it was the companion of our hope-
ful years, whose open face laughed and smiled so easily, the young,
ambitious writer, wild to enjoy life, its pleasures, its triumphs, and
comradeship, friendship, love and happiness. Death had brought him
back to life; for him, time no longer existed, yesterday had no more
truth now than the day before; Camus as I had loved him emerged
from the night about me, in the same instant recovered and painfully
lost. Every time a man dies, a child dies too, and an adolescent and a
young man as well; everyone weeps for the one who was dear to him.
A fine, cold rain was falling; along the Avenue d'Orléans, there were
bums sleeping in the doorways, hunched up in another world. Every-
thing tore at my heart: this poverty, this unhappiness, this city, the
world, and life, and death.

When I woke up, I thought: He can't see this morning. It wasn't
the first time I'd said that to myself; but every time is the first time.

Cayatte came over, I remember, and we talked about the scenario; the conversation was just a pretense; far from having left the world, Camus, by the violence of the event that had struck him down, had become the center of it and I could no longer see anything except through his dead eyes. I had gone over to the other side where there is nothing, and realized, with a dumb pain, how everything still continued to exist though I was no longer there; all day I teetered on the edge of that impossible experience: touching the other side of my own non-being.

That evening I had planned to go see *Citizen Kane* again; I got to the theater too early and sat down in the café opposite, in the Avenue de l'Opéra. There were people reading newspapers, quite indifferent to the big headline on the front page and the photograph that was blinding me. I thought of the woman who loved Camus, of her agony at encountering that face on every street corner, a public face that must seem to belong to everyone else now as much as to her, a face that could no longer speak and tell her it wasn't so. What a refinement of torture, I thought, one's secret despair proclaimed and trumpeted to the wind at every street corner. Michel Gallimard had been badly injured; he used to come to our celebrations in 1944 and 1945; he too died. Vian, Camus, Michel: the series of deaths had begun, it would go on till it reached mine, inevitably too soon, or too late.

That winter I explored again a realm that I had left unvisited for a long time: music. I had given away my phonograph, I didn't go to concerts any more. My young Canadian friend, who used to go to those given by the Domaine Musical, urged me to go hear one; it was very near Sartre's apartment, at the Odéon, and she promised to get the tickets. I was afraid of not understanding anything. But Sartre was curious enough to have a try. As it turned out, we felt completely lost. Why were they sniggering? Why were they clapping? Wahl, Merleau-Ponty and Lefèvre-Pontalis, all of whom we saw in the intermission, couldn't make head nor tail of it either, but that didn't seem to bother them at all. Sartre felt piqued at finding himself out of things. I bought a hi-fi and some records, adding to my collection every month. Sartre helped me pick out the tone rows, identify the structures. We spent a whole winter on Webern; I found his music as dense as a sculpture by Giacometti: not an ounce of superfluous flesh, not one unnecessary note. I worked my way backward into the past;

every kind of music interested me. I spent all my free time near my turntable. Two or three evenings a week, I would settle down on my divan with a glass of Scotch and listen for three or four hours. I still do it quite often. Music has assumed much greater importance for me than at any other period in my life.

I wondered why. No doubt the main reason is a material one: the existence of the long playing record, the quality of the recordings. The old seventy-eights were difficult to keep in order and handle; you couldn't concentrate on the music and give yourself up to it at the same time because it was cut up into such little pieces. Today, the ends of the sides almost always coincide with the natural divisions of the music and are therefore geared to the natural rhythm of one's attention. There are a great many works available, which means that one can put together extremely rich and varied concerts for oneself. Circumstances too played a part. I very rarely go to the movies or to the theater any more, I stay in. Of course I could read; but when the evening comes, I feel I've had enough words, my mind is swimming with them; I feel worn out by this world of ours and books are no escape from it. Novels do invent other worlds, but they're very similar to this one, and usually more insipid. Music takes me into another universe, ruled by necessity and composed of a substance, sound, which I find physically agreeable. It is a universe of innocence —at least it was until the nineteenth century—because man is absent from it; when I listen to Lassus or Pergolesi, even the idea of evil no longer seems to exist. And then I was so ignorant about music. It brought me something that the other arts no longer afford me: the shock of great works that are completely unknown to me. I discovered Monteverdi, Schütz, Perotinus, Machaut, Josquin, Victoria. I learned to appreciate better the composers I was already familiar with. My books are piled helter-skelter on their shelves, they don't mean anything to me; but I love looking at my multicolored record sleeves, austere or gay, concealing such tumults and harmonies beneath their glossy surfaces. During these past few years, it has been through music that art has mingled familiarly with my everyday life, inspired me with violent emotions, permitted me to experience its power and its truth, as well as its limits and its hoaxes.

Often, on Sunday walks with Sartre along the banks of the Seine, behind the Pantheon, in Ménilmontant, we would lament the way in which age had blunted our curiosity; for we were being offered splendid opportunities to travel. When he was passing through Paris,

Franqui, the editor of the largest newspaper in Cuba, *Revolución*, came round to see me with a few friends, one of whom spoke French. Hair and moustache black, very Spanish, he told me authoritatively that it was our duty to take a look with our own eyes at a revolution actually in progress. We felt great sympathy with Castro; yet Franqui's offer to us—for Sartre had met him too—left us almost indifferent. Some Brazilians invited us to visit their country the following summer, and our reaction was just as halfhearted. "I wonder," Sartre said to me, "whether it's not just physical exhaustion that stops us, rather than moral fatigue." This explanation appeared to him to be truer and more optimistic than the other, and certainly the fear that he would overtax himself kept a firm rein on my desires. There was another reason for our apathy: the war in Algeria was blocking our horizon. Yet the rest of the world did still exist, and we had no right to be completely uninterested in it. What Franqui said was true: Cuba's experiment did concern us. A visit to Brazil would enlighten us about the problems of underdeveloped countries; Amado and other leftists there wanted us to come because they hoped that by giving lectures and writing articles, Sartre might be useful to them. To remain deaf to these invitations, to anesthetize our curiosity, to brood in impotence over the misfortunes of our own country, was a sort of resignation from life. Sartre was the first to decide that we should shake ourselves out of our inertia.

When we took off, halfway through February, relations between Cuba and the United States were strained, and the American ambassador had returned to Washington. The Spanish ambassador had also left Havana, having forced his way, dead drunk, into the television studios there, because, according to him, they were insulting Franco. The bonds between Cuba and the U.S.S.R. were strengthening; Mikoyan had just paid Castro an official visit. It was a fine February morning; I watched the precise outlines, the clear-cut colors of a geographical map unroll beneath me; as in my atlas, the Gironde fanned out its muddy waters from Bordeaux to the green-tinted ocean; the snow-covered Pyrenees sloped gently down to a sea already hinting at spring; soon, quite suddenly, we were in Madrid, hitherto so far away. Sartre, who hadn't set foot there for thirty years, got no joy out of seeing it again. At about three in the afternoon all the shops were shut, it was raining, the few people we saw in the streets seemed badly dressed and dismal-looking. "There's a pleasure in imagining what's going on inside those people's heads," he said as

we sat drinking manzanilla in a café on the Gran Vía. The next day he went to look at the Goyas and Velásquezes in the Prado. And then we left for Havana. In the plane we deciphered as much as we could of some Cuban newspapers and then dropped off into fitful sleep. When I awoke, I looked out and saw another, different sea, islands, then the coast and a green plain with palm trees sticking up out of it.

The bewilderment of our arrival: temples still throbbing, ears humming, the sun beating down, bouquets, compliments, questions all jumbled together ("What do you think of the Cuban Revolution?" one journalist asked Sartre. "That's what I've come to find out," he answered), and all those strange new faces. An automobile drove us along a wide road between palm trees and huge flowers; as we went, someone gave me a running commentary on the places we passed, the monuments, but I scarcely heard any of it, I could only see the wildness of the sea on my left; I was sleepy, I was hot, I wanted a shower, then there I was sitting at a second-floor window, looking out over a gray stone square facing a very beautiful church, holding a daiquiri as voluptuous as in Sartre's descriptions, and the voices still explaining and asking questions. They even began to grow in number when, after a short respite, we went to have lunch in a restaurant which was a deluxe imitation of a rustic *bohío*. A few days later I knew I would be able to put names to these smiles, to decide which I liked and which I didn't, but at that moment I could make no distinctions between all these mouths interrogating me about abstract painting, Algeria, the commitment of French writers, of American writers, and Existentialism. I should have delighted in all this noise and fuss, if only I could have shaken off the burden of fatigue that had been made so much heavier by all the hours we had lost in flight.

Next day my weariness had gone. After Madrid, after Paris, the gaiety of the place exploded like a miracle under the blue sky, in the gentle darkness of the night. Sartre has explained at length in his account of our visit what advantages their revolution afforded the Cuban people. To watch the struggle of six million men against oppression, hunger, slums, unemployment, and illiteracy, to understand the mechanisms of the struggle and discover its significance was a passionately interesting experience. The discussions, the visits, the briefing sessions very rarely took a formal turn; our guides and our interpreter, Arcocha, very quickly became our friends; after a few initial moments of stiffness, our three-day trip with Castro was spent

in an atmosphere of familiarity. Striking out with him into the warmth of the crowds, we experienced a joy we had not known for a long time. I liked the simple, expansive Cuban landscapes. The pale-green of the sugarcane harmonized perfectly with the deep green of the palm fronds at the top of their smooth silver stems; one of my biggest shocks was seeing cows grazing at the foot of these trees whose image had always been linked for me with that of the desert. I liked Santiago with its black crowds and Trinidad, austerely embalmed in its colonial past, yet fresh too with all the exuberance of its flowers. I loved Havana. Vedado, where our hotel was, displayed all the seductions of a rich capitalist city: wide avenues, long American automobiles, elegant skyscrapers and, in the evening, brilliant displays of neon signs. The windows of my room overlooked a park that extended down to the sea; in the distance I could see old Havana, the headland battered furiously by tall waves. I would drink my very black, almost bitter coffee with Sartre in the morning, eat some tender, succulent pineapple and then, while he was writing a preface for Nizan's *Aden-Arabie* which Maspéro wanted to reprint, I would sally forth out of the air-conditioned coolness of the hotel; I went out to read on the lawn, breathing in the scents of the grass and the ocean; in the evening, leaving the air-conditioned foyer, I would feel the dampness of the night against my face, its smell of hothouses and swooning flowers. Sartre knew old Havana a bit; he showed me its packed, old-fashioned streets, its arcades, its squares full of people daydreaming. We used to eat dinner there, alone or with friends. When I went into a restaurant, it was as though someone had dropped a cool scarf around my shoulders. Often we'd go and sit in Ciro's, which Hemingway used to frequent. One night we had supper, a Chinese stew, at a stall in the market with the poet Baragagno, the photographer Korda and his wife, a model and member of the Women's Armed Services, amid a strong smell of vegetables and fish. Every day the newspapers carried pictures of Sartre with Guevara, with Jiménez, with Castro; after he'd given a talk on television, everyone recognized him. "Sartre, it's Sartre!" the taxi drivers would shout as we went by. Men and women stopped him in the street; before the talk they'd never even heard his name; their friendly effusions were addressed to the man Castro had told them was their friend, thereby giving us some idea of the extent of his popularity.

It was Carnival time. On Sunday evenings, troupes of amateurs appeared in the streets, joyfully putting on shows they'd spent the

whole year preparing; costumes, music, mimes, dances, acrobatics—
we were dazzled by the taste, the invention, the virtuosity of these
*comparsas*. Two ballets illustrating peasant ceremonies were per-
formed by Negro dancers with magical abandon; the second of them
appeared, at first sight, to be danced by only women: bewigged and
made up, the men too were wearing the colored skirts, the petticoats,
the laces, the shawls of their remote ancestresses. With a crowd of
friends, we stayed out until dawn, joining in the delirious joy of this
crowd still drunk with victory. In the theater we also saw some Negro
ceremonies still very close to those of Africa, despite certain Catholic
influences; the manager had invited several groups to stage their rites
in his theater just for one evening; they were not giving a theatrical
performance, they were actually living a moment of their religious
life. Many of the spectators were amazed at having been made to pay
to see these familiar ceremonies; some of them were annoyed at not
having been asked to perform and criticized those who were doing so.
"I can do that much better," they murmured. After the final curtain,
we saw the women dancers in the wings still not entirely released
from their state of trance. This transformation of ritual into spec-
tacle was an indication both of the Cubans' respect for their African
traditions and their desire to tear away the veil of secrecy which had
hitherto concealed them.

On March 5th, we were lunching out of doors on a sort of ranch
outside Havana, with Oltuski, the very young Communications Min-
ister, and two of his colleagues, when we heard a loud noise; the
Minister of the Interior was called to the telephone. La Coubre had
just blown up; some dockers, all Negroes, had been killed. Then
came the foggy day when we stood shivering in the stand with Castro,
watching their funeral. The hearses went by in procession, each one
followed by its weeping family of mourners; it was as though the
carnival floats and the *comparsas* had undergone some funereal
metamorphosis. Then Castro spoke for two hours. Five hundred
thousand people listened to him, strained and serious, convinced,
and rightly so, it seemed to us, that the sabotage was due, if not to
America, at least to Americans.

The Sunday evening processions and celebrations were canceled.
A fund-raising campaign was started to make possible the purchase of
a fresh consignment of arms. Along the Prado—that long, wide ter-
race stretching along the fringes of the old town—young women
stood selling fruit juice and snacks to raise money for the State; well-

known performers danced or sang in the squares to swell the fund; pretty girls in their carnival fancy dress, led by a band, went through the streets making collections.

"It's the honeymoon of the Revolution," Sartre said to me. No machinery, no bureaucracy, but a direct contact between leaders and people, and a mass of seething and slightly confused hopes. It wouldn't last forever, but it was a comforting sight. For the first time in our lives, we were witnessing happiness that had been attained by violence; all our previous experience, especially the war in Algeria, had presented us with its negative aspect: the rejection of the oppressor. Here, the "rebels," the people who had supported them, the soldiers of the militia who might soon perhaps be fighting again, were all radiant and bursting with gaiety. It restored a pleasure in just being alive that I had thought I had lost forever. It was counteracted by the news which reached us from France. Lanzmann sent us letters stuffed with newspaper cuttings: the police had arrested several members of Francis Jeanson's underground movement, though he himself had escaped. The comments of the press were enough to make one vomit. The men in the movement had been bought; as for the "Parisiennes" involved, whose photographs were printed on the front page of *Paris-Presse*, they had supposedly been seduced into it by handsome men sent over for this purpose by the F.L.N. Money and sex: it was impossible for my fellow countrymen to conceive of any other motives for human behavior.

It was without much joy, therefore, that we prepared to return to France. As far as New York, we traveled with Chanderli, who was representing the G.P.R.A. at the UN as an observer, and whom we had met once in Havana. Plump and jovial, he was taking back some of those farmers' straw hats with the brims teased into a fringe for his children, and kept putting them on and laughing.

I had never been in New York with Sartre before. We landed at two in the afternoon and were due to take off for London at ten—only a brief visit. And suddenly there was a Cuban attaché telling us that he'd organized a cocktail party for the press at four o'clock in the Waldorf! I realized then that I was still far from the resigned wisdom of old age. Sartre told him firmly that we were not free until six. In a cab, on foot, in another cab, we plowed through the town. It was a Sunday and a cold one. After the multicolored tumult of Havana, its blue skies, its passionate jostling people, New York seemed bleak and almost poverty-stricken; people in the streets looked shabby and

seemed rather bored; there were some new skyscrapers, designed with daring elegance, but many neighborhoods had been rebuilt in the style of our own H.L.M.s. The contrast we had noticed in 1947 between American luxury and European poverty no longer existed, and I was looking at the United States with new eyes; it was still the most prosperous country in the world, but no longer the one that was creating the future; the people I was seeing were no longer in the vanguard of humanity, but members of a society afflicted with Organization sclerosis, poisoned by lies, cut off from the rest of the world by a Dollar Curtain; like Paris in 1945, New York gave me the impression of a Babylon after the fall. Though no doubt the way in which I passed through it helped dim its effect. There was no time to relive the past, to begin a future. When we emerged from the Sherry-Netherland, where we rediscovered the taste of real martinis, I suddenly recognized the Central Park I had known, Manhattan's beauty reviving as night fell—but it was time for us to go to the Waldorf.

There were a lot of people there: malicious Sauvage from the *Figaro,* French and American journalists, and also nice old Waldo Frank and my friend Harold Rosenberg who still contributed to *Les Temps Modernes* occasionally, and other people who were sympathetic to the Cuban Revolution. To be genuinely left-wing in the United States takes a great deal of character and independence as well as openness of mind. I felt a great surge of friendship for these lonely and courageous men and women.

After the summer of 1951, I had continued to correspond with Algren. I told him all about Paris, about my life; he wrote that his marriage with A. was not faring any better than the first, that America was changing, that he no longer felt at home there. Finally, silence fell between us. From time to time I would hear rumors about him, always extravagant ones. He had torn up fabulous contracts, signed disastrous agreements, lost fortunes at poker; once, on a winter morning, he had fallen into a hole full of water and, unable to get out, had all but frozen to death, standing there with only his head visible; he had arranged to meet a woman literary agent in a Philadelphia brothel which then caught on fire, whereupon he made his escape through a window; shortly afterward, the literary agent had put a bullet through her head. In 1956, the translation of *The Mandarins* was published in America at the same time as his latest novel; the journalists subjected him to a battery of questions which

he rebuffed with a bluntness apparently directed at me. I wasn't offended; I knew all about his moods. However, when Lanzmann said to me one evening: "Algren will be telephoning you in a moment from Chicago, they've just said the call was coming through," I realized that he wanted to explain his reaction. I got into a terrible state of nerves at the thought of hearing that familiar voice coming from so far away: five years, more than 4,000 miles. He didn't call; he'd been afraid, too. One day I dropped him a line; he replied. We began writing to each other again, very occasionally. He'd been divorced again; he was living in Chicago once more, in an apartment; there were enormous new buildings now where the old Wabansia house used to be. He was vaguely hoping he would be able to get a passport and come over to Paris. "Yes," I wrote to him once, "I'd so much like to see you again before I die." As he read these words, he realized suddenly that neither of us had so much longer to live. In November 1959, a letter arrived announcing that he had finally been granted permission to travel abroad again, that he was landing in London at the beginning of March, and that ten days later he would land at Orly. I wasn't going to be in Paris until the 20th, I answered, but he could make himself at home in my apartment.

I was feeling worked up and a little uneasy when I rang my front doorbell; there was no reply, yet I'd sent a telegram. I rang again, harder; Algren opened the door. "You?" he asked me, with stupefaction; Bost, who had gone with Olga to meet him at the airport and whom he was seeing a lot of, had assured him there would be no plane from New York before the following day. Algren's eyes were naked; he had replaced his old spectacles with a pair of contact lenses which he hadn't been able to get used to and decided to do without. Apart from this detail he didn't seem to me to have changed at all; it was when I hunted up some old photographs that I realized how much he had aged; that first moment—forty, fifty, thirty, anything— all I saw was that it was Algren. He told me later that it had taken him too, several days to discover that time had left its mark on me. We weren't surprised to find that right away, despite the years of separation and the stormy summers of 1950 and '51, we felt as close as during the best days of 1949.

Algren had just come from Dublin; he told me about his stay among the Irish mists, surrounded by inspired beer drinkers; Brendan Behan, whose work he admired enormously, had been too deep in an alcoholic stupor to be able to respond with more than a few

grunts. He told me about Chicago, old friends, new friends, also drug addicts, pimps and thieves; the arrogance of the respectable he found more intolerable than ever; society was always in the right, its victims were treated as criminals: that was one of the changes in America that Algren was least able to forgive. He was awakened every morning by his own anger: "I've been eaten alive, made a sucker of, betrayed." He had been promised one world and then found himself in a quite different one, a world directly opposed to all his convictions and all his hopes. His anger always lasted till the evening. "Once I used to live in America," he said to me, "now I live on American occupied territory."

And yet it was still there under his skin—this country in which he felt himself as exiled as I did in mine. Chicago came alive again in my studio; he was wearing the same corduroy pants as he had there, the same worn jackets, the same cap in the street; he had put out his electric typewriter and reams of yellow paper on one of the desks; the furniture and the floor were piled with cans of American food, American gadgets, products, books, newspapers. I read the New York *Herald Tribune* every morning; we listened to the records he'd brought over: Bessie Smith, Charlie Parker, Mahalia Jackson, Big Bill Broonzy; no cool jazz, it left him cold. Often, Americans passing through Paris would ring at the door; he would take them around and show them the Musée Grévin. The only one I saw was his friend Studs who was doing free-lance work for a Chicago radio station; I let him do an interview with me about Cuba which earned me several friendly letters when it was broadcast. Algren became friendly with some fellow Americans living in the building; through them he got to know others—among them James Jones—who had formed an exclusive colony in Paris, cut off from the French, whose language they could not even speak, and from the United States which they had all left, indifferent to politics but marked by their origins. Algren preferred his daily bouts of anger to their rootlessness.

I was living a much more retired life than in 1949, so I had fewer people to show him. After the Bosts, he met Sartre and Michelle again; I introduced him to Lanzmann, Monique Lange, who was accustomed to shepherding Gallimard's foreign writers around Paris, and her friend Juan Goytisolo. Algren surprised our visitors with an apparatus consisting of a battery hidden in one of his pockets and a little red light bulb that lit up in the middle of his bow tie.

Especially when he first arrived, I went for long walks with him

around Paris. We made a pilgrimage to the Rue de la Bûcherie: all my links with the old house had been broken, and there was some talk of its being pulled down. Jacques Lanzmann had left it, Olga and Bost had moved elsewhere, and so had the dressmaker and her husband; Betty Stern was dead, the little concierge had been killed in an automobile accident. All that remained of my past was Nora Stern and her dogs. We revisited the Flea Market and the Musée de l'Homme. Bost took us for a drive. Algren, alas! had borrowed a movie camera, and used it as shamelessly as ever. He was enchanted by the Rue Saint-Denis and its prostitutes. He leaned out of the window and took a long shot of one group around the entrance of a hotel as we passed; the traffic lights changed to red and the car stopped; the women began shouting abuse at him, and I thought they were going to spit in his face. I began to go out to restaurants again. Algren was very fond of the Akvavit in the Rue Saint-Benoît because the bottles were all encased in sheaths of ice and the spirits as they were poured out looked so clear and cool; he also enjoyed the Baobab, where they served "witch-doctor chicken" and pineapple flambé to a background of African music. We went to Les Halles for onion soup, and to masses of bistros for steak washed down with Beaujolais. One evening we ate dinner on a Seine pleasure boat, watching the quays with their bums and their lovers slide past before our eyes.

Algren was fed up with American films and didn't know any French, so we didn't go to the movies much. I took him to see Becker's *Le Trou,* since I was sure that silent story of an escape would interest him; he liked Reichenbach's *L'Amérique Insolite* more than I did, possibly because he couldn't understand the commentary which kept spoiling the photography for me. Despite its occasional clumsiness, we were both struck by *Come Back Africa;* it was a topical film; a state of emergency had just been declared in South Africa following an outbreak of rioting that had, officially, killed 54 Negroes and injured 195 others.

I went to a great deal of trouble thinking up places to go that Algren would enjoy. I enjoyed myself too, trailing around Paris at night like a foreigner. We went to the Olympia to hear Amalia Rodriguez, so beautiful in her black dress, seducing that audience into rapt attention for her recital of flamencos and fados. At Les Catalans, we drank sangría, heard more flamencos and saw some excellent dancing. Since he liked cherries in brandy and old French

songs, we went to the Lapin Agile, though the clientele and the acts there had deteriorated pitifully; and to the Abbaye as well, where old French airs were interspersed with American folk songs. I saw Harold again after a gap of many years, at the Ecluse, where he was presenting several very successful new acts. Olga and Bost went with us to the Crazy Horse Saloon; according to Algren, striptease had been developed into a much more refined art in Paris than in Chicago.

The most memorable evening was one thought up by Monique Lange and Goytisolo. After dinner at the Baobab, Monique suggested a drink at the Fiacre. I had certainly got out of touch with things, because I was a bit taken aback by the crush of boys and much older men who were there chattering away and coaxing each other, their hands sliding quite openly under the angora pullovers: it was stifling, and as soon as our glasses were empty we made for the exit; a teen-ager whom Monique knew gestured in my direction. "What's she doing here?" "She's just interested." "Ah! Then she's on our side?" he said, quite delighted. Algren was even more astounded than I was.

At the Carrousel, charmed by the first set of strippers, he was so mystified when he discovered that they were of the masculine gender that he almost flew into a rage. At Elle et Lui he lost his head completely: there were women, and men dressed as women; then there were women dressed as men, and men too; he didn't know which sex to turn to.

Monique had invited him to Formentor, where a lot of publishers and writers from various countries were meeting to establish an annual international prize. I let him set off on his own, and then ten days later took a plane to Madrid, where he was waiting for me with Goytisolo. It was early May, the weather was beautiful. Algren had enjoyed himself enormously, meeting all sorts of different people. He'd quite fallen in love with Barcelona; he'd spent three days climbing up onto the roofs and wandering round the Barrio Chino and the docks. Meanwhile, Goytisolo had been in Madrid wearing himself out trying to get his brother Luis out of gaol; he'd been incarcerated several weeks earlier, after a trip to Czechoslovakia, and was very ill. We spent an interesting evening in an old tavern with painted walls talking to some young intellectuals who explained to us the efforts and the difficulties of the opposition; they pointed out to me that Sartre's books were forbidden but that Camus' were on display in all the bookshop windows.

Algren found Madrid dull, so I flew with him to Seville; trees covered with dazzling violet flowers relieved the aridity of its streets. At Triana, in sleazy dance halls, beneath ceilings hung with paper wreaths, we listened to the harsh sobbing of the flamenco singers. At Málaga we rejoined Goytisolo and his friend V., a photographer, who took us by car to Torremolinos. Goytisolo knew a great many stories about the homosexuals and society ladies packing the resort. We found somewhere to sleep in a little port whose whitewashed houses roofed with shiny tiles were terraced up the side of a hill. "The more dilapidated it is inside, the more whitewash they put on outside," Goytisolo told us as we walked through the streets the next morning. It was true; we saw naked children in the streets and caught glimpses of sordid interiors. At the top of the village, Algren took some pictures. "Yes, you think it's picturesque," a woman grumbled at him, "but when you've got to go up and down all day!" All the fountains were at the foot of the cliff. I had no hesitation, therefore, when we reached Almería the next day and Algren decided to go and take pictures of the troglodyte settlements, in deciding not to accompany him; Goytisolo went off with him to revisit some places and people he knew while I went up to the Alcabaza with V., amazed to think that I had been through this town twice and had both times neglected to visit these gardens and terraces, their violent-looking blooms, their bristling, scaly, contorted cactuses. V., too, was taking pictures of the cave-riddled cliffs and their poverty-stricken inhabitants moving up and down along the almost perpendicular paths, but he was doing it with a telescopic lens. I read Cela's *The Hive*, feeling very lighthearted in the morning sun surrounded by friends, and thought it a very good book. Then there was the wonderful road to Granada over red, ochre, ashen and bloated terrain. I spent three days at the Alhambra with Algren. Spain had conquered a much larger place in his heart than Italy.

Algren was counting on staying five or six months, and I didn't want to spend as long a time as that away from my normal routine. I continued to work at home in the morning, then at Sartre's during the afternoon, also spending several evenings a week in his company. Algren had articles to write, he had no lack of friends, and he liked being alone; this arrangement suited him as well.

A few days after our return from Cuba, Sartre and I attended the reception given by Khrushchev at the Soviet Embassy. What an

aviary! There were the Gaullist ladies wearing amazing hats made of ribbons, of feathers, of lace, of flowers, and low-cut gowns covered in furbelows, costly and very complicated; prejudices apart, the ladies of the Left really did produce the better impression, without hats and wearing quiet suits. As for Nina Khrushchev, her placid smile and her black dress disqualified the very idea of elegance from the start. Debré made a speech. There was a crush as people moved forward to catch a glimpse of Khrushchev; he walked through the crowd and shook hands with people. Sartre had missed a meeting of writers and journalists at which he would have been able to see more of him. Khrushchev was to meet Eisenhower shortly in Paris: doves were hovering over the champagne glasses.[1]

The Critique de la Raison Dialectique was published; attacked by the Right, by the Communists and by the ethnographers, it gained the approval of the philosophers. Nizan's book Aden-Arabie and Sartre's preface to it were also very well received. In Havana, Sartre had often been irritated at having to write this piece when there were so many other things to do; but the confrontation of his own youth with the youth of Cuba today had been of use to him; his preface was particularly affecting to girls and boys of twenty or so. Young people loved him; I had a further chance of observing this the evening he talked at the Sorbonne about theater. He was applauded as much as if he had been a great conductor, and when he left, the students escorted him in a body to his taxi; these feelings were aroused not only by the writer but also by the man and by the political choices he had made. As exhaustive as ever, he had begun an enormous work on Cuba that was going to be far larger in scope than the reporting he had offered to do for France-Soir. Lanzmann helped him abstract a series of articles from it. He went on with this work until our departure for Brazil.

When I returned from Spain I gave Gallimard my new book, still untitled, and Les Temps Modernes printed the beginning of it under the noncommittal heading Suite. I wanted to continue it, so went off to the Bibliothèque Nationale to refresh my memories of the years 1944 to 1948. I had given an account of these years in The Mandarins, feeling that the best way to reveal the meaning of an experience was to project it into an imaginary dimension. But it was a matter of regret for me that a novel always failed to render the

---

[1] Shortly after this, the U-2 incident brought the plans for a summit conference to a halt—though Khrushchev may have had other reasons for declining it as well.

contingency of life: the imitations of it a novelist may attempt are
soon belied by exigencies of form. In an autobiography, on the other
hand, events retain all the gratuitousness, the unpredictability and
the often preposterous complications that marked their original oc-
currence; this fidelity to real life conveys better than even the most
skillful transposition how things really happen to people. The dan-
ger is that the reader may not be able to discern any clear image amid
this welter of caprice, just a hodgepodge. In the same way that it is
impossible for a doctor to define both the position of a corpuscle and
the length of the wave attached to it, so the writer is unable to depict
the facts of a life and its meaning at one and the same time. Neither
of these two aspects of reality is any more true than the other. So *The
Mandarins* was no excuse for not continuing these memoirs, which in
any case were to extend much further in time than the novel.

I had for some time been interested in the efforts of a woman,
Doctor Weil-Hallé, to gain wider acceptance for the use of contra-
ceptives in France. Having received so many confidences, I knew the
tragedies caused by unintended pregnancies and by abortions. "For a
woman, freedom begins in the womb," one woman had written me. I
agreed with her, and the Communists' attitude had annoyed me, four
years earlier, when Mme Weil-Hallé, Derogy, Colette Audry and
several others had mapped out a campaign for the encouragement of
birth control. Thorez accused them of Malthusianism: they wanted
to weaken the proletariat by depriving it of children. A delegation of
women attempted a debate with Jeannette Vermersch; Colette
Audry was still wide-eyed when she told me about the interview. The
language Jeannette Vermersch had used to vaunt the beauties of
conception had been worthy of Pétain: "You are trying to take all
the poetry out of love!" A little later she suddenly became very
practical and added: "These young working people do it in the cor-
ridors, you know, on their way from one room to the next. . . ." In
fact, the majority of those whom the lack of contraceptives forces into
abortions are married women. With an optimism worthy of that
which inspires M. Louis Armand today, the Communists used as
their argument against planned parenthood the prosperity France
*might* achieve, which would enable her to provide for a population
of seventy million: the private misfortunes of working-class women
today just didn't exist for them. I wrote a short preface for Mme
Weil-Hallé's book *Le Planning Familial* and another for *La Grande
Peur d'Aimer*. When this latter work came out, I attended the au-

thor's press conference in the new Julliard offices. There were about a hundred people present: psychoanalysts, doctors, various more or less qualified specialists in the human heart. Mme Weil-Hallé in a white dress, blond, fresh, virginal-looking, expounded in her musical voice the advantages of the pessary; some fifty-year-olds asked uneasily if the use of such things was not harmful to the romantic side of love. The vocabulary employed was edifying in the extreme. They talked, not about birth control but about the joys of maternity, not about contraception but about orthogenesis. At the word abortion, faces were turned away; as for sex, that wasn't allowed in the room at all.

Toward the end of April, Francis Jeanson called a meeting in the heart of Paris of all the correspondents of the principle foreign newspapers. George Arnaud was present and published an eyewitness account in *Paris-Presse;* the newspaper itself was left in peace, but Arnaud was arrested on April 27th for "failing to denounce a malefactor." Meanwhile, although completely discredited by the Audin Committee during the court proceedings they had instituted in Lille against *La Voix du Nord,* Captain Charbonnier was awarded the Legion of Honor. In Algiers they were beginning the Alleg trial, as well as preparing a case against Audin for "desertion." It was at this time, too, that the 13th Arrondissement introduced auxiliary Moslem police—the *harkis;* as I walked round Paris with Algren, we often passed these blue-uniformed men paid to betray their fellows.

One morning toward the end of May Gisèle Halimi telephoned to ask me to see her at once; we met on the sunlit terrace of the Oriental in the Avenue d'Orléans. She had just arrived from Algiers, where she had gone to appear for the defense in the trial of an Algerian woman on May 18th. Since her entry permit didn't allow her to take up residence there until the 16th, she had succeeded in having the trial postponed until June 17th. The girl had told her how she had been tortured; pale and emaciated, visibly in a state of shock, she still had burns on her skin and could cite witnesses. Gisèle Halimi had urged her to make an official deposition and request an inquiry, which would necessitate a further delay: would I agree to write an article insisting on it? Yes, of course I would. I limited myself, more or less, to transcribing Djamila's own account of the affair and sent the article to *Le Monde.* M. Gaughier telephoned me. "You know, what we've found out about Djamila Boupacha doesn't

look too good!" he said, as though I'd recommended her as a house-maid. "A high official who knows all about the case says she's under the gravest suspicion," he added. "I don't see that that's any justification for sticking a coke bottle into her," I said. "No, obviously not. . . ." And while we were on the subject, he asked me to change the word "vagina," which was the one Djamila had used, to "womb." "In case teen-agers read the article," he explained. "They might start asking their parents for explanations. . . ." Is that the only question they're likely to ask? I wondered to myself. Beauve-Méry also found it shocking, M. Gauther added, that I had written: "Djamila was a virgin"; would I not paraphrase this somehow? I wouldn't. They printed those four words in parenthesis.

*Le Monde* received fourteen letters of sympathy addressed to me, and three furious ones. "Everyone knows that these torture stories are a stock weapon in the arsenal of the F.L.N. lawyers; and even if some of them should happen to be genuine, all one can say is that it is one of the forms of immanent justice," wrote one woman, a *pied noir* who had taken refuge in Paris. More friendly letters reached me. "No, we're not becoming inured to these horrors; but we don't hear about them!" one man wrote. Then there was a woman who wrote in great distress: "My husband and I thought people weren't tortured any more after De Gaulle came back." We organized a committee for the defense of Djamila Boupacha. Telegrams were sent to the President of the Republic asking for a postponement of the trial. Françoise Sagan wrote an article in *L'Express* supporting this campaign. *Le Mode* was suppressed in Algiers because of my article and a page on the Audin affair. "We lose four hundred thousand francs each time!" M. Gauthier told me over the telephone, his voice heavy with reproach.

A congress "for Peace in Algeria," scheduled for June 12th in the Mutualité building, was forbidden. Georges Arnaud's trial took place on June 17th; Sartre was a witness; I got there early and waited a long time outside the gate of Reuilly barracks with Péju, Lanzmann, Evelyne and Arnaud's wife; he was very pleased about this spell in prison, she told us, because it had given him a chance to talk with the Algerian prisoners there. I sat near the front; it was a packed house, and a very Parisian one, all the left-wing intelligentsia having arranged to meet there. Doctor Lacour, one of the outstanding figures in the Lacaze affair, was in evidence with his fiancée, a very pretty Negro girl who was Vergès' secretary. Arnold spoke very

well, without trying for effects or overdoing it. Several witnesses con-
fined themselves to defending him on a professional level; many,
helped by the questions of the lawyers, strengthened the prosecu-
tion's case. Through Arnaud, the trial aimed at intellectuals in gen-
eral, and Maspero got a big laugh when he introduced himself with
the challenging words: "I am an intellectual, I am proud of being an
intellectual from an old intellectual family, three generations of in-
tellectuals." The heat in the overcrowded room was appalling, and
shortly after Sartre had finished giving his evidence I left with him.
Arnaud was convicted—that was in the nature of things—but with a
suspended sentence. He was released that same evening.

A journalist had informed me during the trial that Djamila's had
been postponed. Gisèle Halimi had been turned back by the authori-
ties in Algiers, and the court, knowing the scandal the affair had
aroused, hadn't dared try the girl in the absence of her defending
counsel. There remained the matter of prosecuting her torturers; if
the case were tried in Algeria, the evidence would automatically be
thrown out of court. The Algiers courts had to be forced to relin-
quish the case, and only Michelet, the Minister of Justice, was quali-
fied to request this in the Court of Appeals.

A delegation consisting of Germaine Tillon, Anise Postel-Vinay,
both ex-deportees, Gisèle Halimi and myself went to see him on June
25th. The Melun talks were just beginning, and despite the gulf
between De Gaulle's point of view and that of the G.P.R.A., these
governmental gentlemen considered the war and its horrors as al-
ready a thing of the past. This was how I explained the Chancellor's
attitude to myself; nervous, evasive, he didn't even bother to contest
the facts we presented to him. "The Boupacha family has been
through a terrible ordeal," Germaine Tillon said. "Everyone has!"
he replied in a clipped, hurt tone, as though he were talking about
some unavoidable misfortune in which the government had played
no part; he made no attempt to dispute the truth of Djamila's
claims: torture was nothing new to him! He simply hesitated about
the decision he should make. As he escorted us to the door, he said to
me in anguished tones: "It's terrible, this gangrene the Nazis have
bequeathed us. It infects everything, it rots everything, we simply
aren't able to root it out. Roughing up is one thing—you can't have a
police force without it; but torture! . . . I try to make them un-
derstand; the line must be drawn somewhere. . . ." He shrugged his
shoulders to indicate his powerlessness. "It's a gangrene," he re-

peated. Then he recovered himself. "Fortunately it will all be over soon!" he concluded with a sprightly air; I didn't feel particularly proud of having to shake hands with him.

In the afternoon, escorted by M. Postel-Vinay, we presented ourselves in M. Patin's office. Gisèle Halimi has already given an account of this interview,[1] but it made too strong an impression on me for me to leave it out. Bald, bug-eyed, glancing evasively from behind his glasses, M. Patin's lips wore the infinitely superior and rather weary smile of a man it is impossible to take in. He sat opposite his assistant, M. Damour, who didn't speak more than three sentences the whole time we were there; he just nodded when Patin was speaking. Germaine Tillon led the attack: she had been intimately connected with a great many cases of torture, and not one complaint had ever resulted in a punishment; hence she had decided that this time we must appeal to public opinion. Patin turned to me: I had committed a misdemeanor in publishing Djamila's complaint. "And you didn't give an accurate account of the facts," he said reproachfully. "It was a group of soldiers under the command of a captain that searched the house, not a rabble." "In my version it was *harkis,* police inspectors and *gardes mobiles,*" I said, "it's you who are calling them a rabble." There were gestures warning me to tone down my answers, and I realized that it would be to our advantage if I kept my mouth shut as much as possible. "Your Djamila made a bad impression on me," he continued. "She doesn't like France. . . ." And when Gisèle Halimi quoted the words of old Boupacha, who still retained a naïve faith in France despite the tortures, he shrugged his shoulders. "He's a coward and a clown. . . ." He went on: "These officers you're attacking are such fine men. . . . I had lunch the other day with a young lieutenant; you know, in civilian life he's an agricultural engineer," he said compassionately, as though studying agriculture somehow put one above suspicion. "They find articles like yours very damaging," he added with reproach in his eyes. Germaine Tillon again made the point that no member of the Army had up till now been publicly reprimanded; yet the number of Moslem civilians massacred was infinitely greater than that of the European victims. He stretched out one hand toward a heap of folders. "I know," he said, "I know." How I wished that all the skeptics could have seen that almost conciliatory gesture on the part of the President of the Safeguard Committee! Rapes, deaths, tortures, it was all recorded there, he admitted it; and

[1] *Djamila Boupacha.*

he seemed to be asking us: What can I do? "Try to understand; Algiers is a big city; the police are insufficient to maintain order there; the Army has to take over their job, but they're novices. . . . The suspects are brought into the guardroom; at night, the officers go back to their homes; and there the prisoners are, left to the mercies of a rabble that sometimes goes a bit too far. . . ." This time it was the National Servicemen he was calling a rabble. Anise Postel-Vinay became indignant. "Even the Germans never left prisoners alone with ranking soldiers. There was always an officer on duty." (In fact, the tortures in Algeria, too, were always supervised by one or more officers; which doesn't improve the situation.) Nettled, he burst out: "Try to understand: if the Army weren't allowed some leeway it would be impossible to go out into the streets of Algiers at all." "In other words, you are saying that the use of torture is justified!" Gisèle Halimi protested. He looked worried. "Don't force me to say that!" She thought it scandalous, she told him, that a lawyer hadn't the right to assist his client during the preliminary examination. "Oh come, come," he said with a weary smile, "if there had to be a lawyer there, there wouldn't be any examination at all. The suspects would just get a bullet through their heads on the q.t. We're protecting them." I could scarcely believe my ears. Patin was freely admitting that his dear, irreproachable officers would not hesitate—hadn't hesitated—to murder any of their adversaries whom a due process of law threatened to release from their clutches.

We got back to Djamila. "Exactly what did she tell you about the bottle?" he asked Gisèle Halimi with a slightly suggestive look. She told him, he nodded his head. "That's right, that's right!" He smiled knowingly. "I was rather afraid they'd *sat* her on a bottle, the way they used to do in Indochina with the Viets." (Who did *they* refer to, if not his beloved, guiltless officers?) "That means the intestines are perforated and the victim dies. But that's not what happened. . . ." Various murmurs of reaction. He went on quickly: "You claim she was a virgin. But after all, we have photographs of her taken in her room; she is between two A.L.N. soldiers with guns in their hands, and she herself is holding a Sten gun." What did that prove? She never made any secret of her work for the A.L.N.; that had nothing to do with whether she was a virgin or not, we said. "All the same, she was running a bit of a risk in that respect, wasn't she?" he replied; then he complained: "When I questioned her in the prison in Algiers, she refused to talk to me." "Naturally. She has pretty good reason to

mistrust the French and their police." "Police! She took me for a policeman? Do I look like a policeman?" We answered with polite circumspection: "Neither more nor less than anyone else, to the eyes of a young Moslem girl in jail." "But that's enough to make one give up in despair: what good are we doing?" M. Patin's eyes sought those of his assistant. "What good are we doing, M. Damour?" "When you went to see her again, Djamila suggested that you visit the selection camps at El-Biar and Hussein-Day; but you didn't do so," Gisèle Halimi said. "What! Did you expect me to? I should have got myself thrown out!" Patin's voice swelled with terror and indignation. "I might even have been arrested!" He mused for a moment. "You don't seem to realize! They're very tiring, these investigations. And they cost me a great deal. Isn't that so, M. Damour? We don't get all our expenses back; a lot of it comes out of our own pockets." He'd touched a sensitive spot; M. Damour came to life. "Your Djamila cost us twenty-five thousand francs," he told us reproachfully. "Any way, at least we're coming to the end of all these dramas!" M. Patin concluded. He still had a few observations to make on Djamila's psychology: "She thinks she's another Joan of Arc!" "In 1940, when we were twenty, there were quite a lot of us who thought we were Joan of Arc," said Anise Postel-Vinay. "Yes, Madame," Patin replied, "but you were French!" When I told Sartre and Bost about this interview that evening, they were as stunned as I had been by so much frankness. We must have allowed our disgust to show, because Patin later told Vidal-Naquet: "I like the Audin Committee much better, I really got on very badly with the Boupacha Committee." Shortly after that, the judges in Algiers intimated in so many words that they were ready to make a deal: Djamila was to agree to be examined by an expert who would declare her insane and not re-sponsible for her acts; she would be released, and at the same time her complaint would lose its validity, thereby making the case null and void. She refused. At the end of July, she was transferred to Fresnes, and a judge from Caen was put in charge of the investiga-tion.

The Melun talks ended in failure; but the youth of the country would not consent to a recurrence of the inertia into which their elders' cowardice had let the country sink in 1956. The U.N.E.F. rec-ognized the U.G.E.M.A.; the Minister of Education cut off its supply lines. Nonviolent demonstrators walked in procession through Vin-cennes, where some Algerians had been arbitrarily interned; we

could not accept their principles, but the method had its effectiveness. The number of those who would not submit to the regime was increasing. One afternoon, in the Rue Jacob, we met Rose Masson, torn between pride and anguish; her eldest son, Diego, had been arrested at Annemasse while helping conscripts to cross the frontier. Before the examining magistrate, he claimed full responsibility; born of a Jewish mother, exiled in the United States since early childhood, he had sworn to himself never to compromise in his fight against racism. His cousin, Laurence Bataille, was also arrested and charged with the possession of arms and having transported an important member of the F.L.N. in his car. In *Esprit,* Jean le Meur, who had been imprisoned, expounded a Christian's reasons for civil disobedience. A novel, *Le Déserteur,* written by someone who called himself Maurienne, explained why some conscripts preferred exile to this war. It was because of the pressure brought to bear on them by these young rebels that Blanchot, Nadeau and several others decided to draw up a manifesto expressing the intellectuals' recognition of the right to disobey; Sartre signed it, as well as everyone working at *Les Temps Modernes.* In opposition, the Communists presented us with a truncated version of a passage from Lenin: one opposes war by participating in it; but apart from the fact that this does not apply to colonial wars, there wasn't a single place, either in the barracks or in Algeria, where the Communists had produced antimilitaristic agitation. Servan-Schreiber and Thorez joined in comdemning us in the name of "action of the masses"—but at that time the masses were on vacation. Undoubtedly only a small minority would take the path of illegal opposition; by giving support to that minority and thereby implicating ourselves as well, we hoped to restore some radical feeling to a Left that had become deplorably "respectful," as Péju put it; and we thought that this piece of avant-garde action might create serious repercussions.

My sister exhibited her latest pictures at the Synthèses gallery, and I found them very beautiful. At the *vernissage,* I met Marie Le Hardouin, very upset over the execution of Chessman, about whom she was writing a book. The war in Algeria was mobilizing all my emotions, I had none left over for anything else, but I understood how she felt. In Marseilles, where I spent several days with Algren, we wondered about the future of his country. In Seoul, the students had driven out Syngman Rhee; in Japan, they had demonstrated

violently against Hagerty. Che Guevara had predicted to the United States: "You are going to lose the whole planet," and his prophecy was coming true. Algren was not counting on either Nixon or Kennedy to make any great change in American politics. "Whoever wins," he said to me, "my only consolation will be that the other one has lost."

A little later, I took a plane with him for a two-week trip to Istanbul and Greece. We were on a jet, and I felt something almost approaching anguish as it compressed vast stretches of my past into the space of a few hours; I felt that I was dead, and flying over my own life, looking down on it from high in the sky. Lake Geneva: I had seen it for the first time in 1946, with Sartre. It was stupefying to be able to see Milan and Turin at the same time, separated by the hundred miles of *autostrada* I had impatiently driven along so many times. And already I could make out Genoa, the coast road Sartre and I had taken so many times from Rome to Milan; we used to lunch at Grosseto, in the Bucca San Lorenzo. . . . Suddenly I awakened Algren, who was dozing beside me; we were flying over Capri, invisible beneath us, and the light was so bright and clear that from our 38,000 feet we could make out quite clearly the contours of Ischia; I recognized Forio and the rocky headland we had visited by a horse-drawn cab; Algren pointed out a crevasse with wisps of smoke coming out of it that were actually from his cigarette, and he laughed at my credulity. Then came Amalfi, the Galli, the whole coast with its layer upon layer of memories, and the South, with a sea on either side. Dusk was falling over Corfu. I made a great leap into the past, back as far as the deck of the *Cairo City*, when the coast of Greece appeared, the islands and the Canal of Corinth. As we surged on toward Istanbul through the purple and sulphur sky, my heart ached with the memory of how alive I had once been, and how new the world. Yet at that moment I felt happy: but on the other side of a line that I could never turn and recross ever again.

Istanbul at night looked deserted. Next morning it was teeming with life. Buses, automobiles, handcarts, horse-drawn carriages, bicycles, porters, people walking, the traffic was so thick on the Eminonu bridge that one could scarcely cross the road without risking certain death; all along the wharves, there were clusters of ships: steamships, tugboats, tenders, barges. Their sirens were wailing, their engines hiccuping; on the road, overloaded taxis rushed up, skidded, screaming, to a stop, then drove away again in a series of minor

explosions; there was the clanging of metal, yells, whistles, a vast discordant uproar reverberating inside our heads already battered by the violent bombardment of the sun. It was like a sledgehammer, yet no reflections spattered the blackish waters of the Golden Horn, cluttered with old tubs and pieces of rotting wood jammed between the warehouses. In the heart of old Stamboul, we clambered up dead streets lined with wooden houses more or less in a state of collapse, and along others with shops and workshops opening off them. Shoeshine boys, cobblers, crouching inside with their gear in front of them, gazed at us with hostility; we got the same looks in the wretched bistro where we drank our coffee at wooden tables; was it Americans they hated, or just tourists? Not a woman in the place; almost none in the streets; nothing but masculine faces, and not one wearing a smile. The covered bazaar, bathed in a flat gray light, made me think of a vast hardware store; everything about the markets in the dusty streets was ugly—the utensils, the stuffs and the cheap pictures. One thing roused our curiosity: the quantity of automatic scales and the number of people, often quite poverty-stricken, who were prepared to sacrifice a coin to weigh themselves. Where were we? These jostling crowds, entirely male, were a sign of the East, of Islam; but the color of Africa and the picturesqueness of China were missing. It felt as though we were on the fringe of a disinherited country, and of some dismal Middle Ages. The interiors of Sancta Sofia and the Blue Mosque lived up to all my expectations; I had seen and liked smaller mosques, more intimate and more alive, with their courtyards, their fountains and pigeons circling overhead; but there was almost nothing left in them of the long-extinguished past. Byzantium, Constantinople, Istanbul: the town did not live up to the promises of these names, except at that hour when its domes and their slender, pointed minarets were silhouetted along the hilltop against the glowing sky at dusk; then all its sumptuous, bloodstained past appeared through its beauty.

We wanted to get to know some Turks. A few weeks earlier, a military *coup d'état* had ousted Menderes; there had been riots in the city with the students joining in: what were they thinking now, what were they doing? Organized tourism has its disadvantages, but our isolation had even more. Annoyed at not being able to get beneath the décor of the place, we left after three days.

Athens, by comparison, seemed feminine, almost voluptuous; we spent a week on Crete: wonderful landscapes, several affecting ruins,

especially those at Phaestos. Then we went back to Paris and the moment came to part. Not a single shadow of disagreement had troubled our five months together. I wasn't tearing myself to pieces, as I used to, at the thought that our intimacy had no future: we ourselves didn't have much left either; I no longer felt that our relationship was being thwarted, but instead completed, saved from destruction, as though we were already dead. Our old times together didn't even inspire in me the nostalgia that betrays a lingering hope. Algren told me how, at the end of a walk one day, his steps turned automatically toward the Rue de la Bûcherie. "As if my body hadn't given up the past," he said with regret in his voice. "Was it so much better, the past?" I asked him. "When I was forty, I didn't realize I was forty; everything was beginning!" he blurted out impulsively. Yes, I could remember that. But it was already quite a while since I had heard the news; I was aging, I was old. By the way we had rediscovered each other, we had erased ten years from the score, but the serenity of our farewells was a reminder of my true condition: I was an old woman.

Our visit to Havana had given us new reasons for going to Brazil. Cuba's future would be settled for the most part in Latin America, where Castroist currents were already becoming apparent; Sartre had made it his intention to talk to the Brazilians about Cuba. We had witnessed a revolution in triumph. To understand the world outside the Cold War, we had to get to know an underdeveloped, semi-colonized country where the revolutionary forces had not yet been unleashed, and perhaps would not be for some time. The Brazilians we met persuaded Sartre that by combatting Malraux's propaganda in their country he would be rendering a useful service to Algeria and the French Left; their insistence finally convinced us that we should make the trip.

We were away only two months; if I give a detailed account of all that we saw there, I shall probably be criticized for breaking the line of my narrative. But Brazil is such a fascinating country, and one so little known in France, that I should always regret not having shared the whole of my experience there with my readers. Those who are bored by this piece of reporting can always skip it.

Before taking the plane for Recife, where a congress of critics was being held, we were invited to dinner at the home of M. Diaz, a

painter who had been kind enough to get our tickets and visas for us.
In his apartment, pleasantly decorated with some of his own paint-
ings, a hot buffet had been laid out according to the custom of his
country, which I decided was much more civilized in this respect
than ours: we could move about and talk to different people. There
were some pretty women, very well turned out, and some intellec-
tuals, many of whom had served jail sentences under Vargas; among
others, the painter Di Cavalcanti, gay and corpulent beneath his
thick head of white hair. We chatted with Freyre who had described
the way of life in northeast Brazil during the colonial period in his
*Maîtres et Esclaves;* he gave me an illustrated book about Ouro-
Prêto. There was a lot of talk about Brasília; while admiring the
conceptions of Lùcio Costa and the buildings of Niemeyer, most of
the people there thought it a pity that Kubitschek should have sunk
such a fortune in this abstract city where none of them would ever
want to live. "All the same," Di Cavalcanti said, "in the chapel of the
Presidential palace I see there is now a little bunch of flowers made
out of shells: At last a touch of bad taste! At last a sign of life! It's a
beginning."

And once more, in the middle of August, I was arrowing through
the solitudes of the sky. Beneath my feet, forming then melting away,
lie roads, beaches, oceans, islands, mountains and gulfs that I see with
my own eyes and which don't exist. Nothing changes, neither the
climate, nor the smells, nor the multiform monotony of the clouds,
and suddenly, without having budged, I find myself *elsewhere.* I set
off once more, my heart assailed by a strange weariness at the thought
of circling like this around the earth as it circled in its turn, trailing
its lights behind it, putting them out too soon as my watch lost count
of the hours. There was the somber ribbon of the Tagus, then Lis-
bon airport; a voice called through the loudspeakers: all passengers
for Elisabethville; I looked curiously at the men and women making
their way toward their plane—and toward what destiny? A little later,
I stepped off my plane into a muggy, black country. Dark men in
white jackets bustling noiselessly among the tables; Dakar, Africa,
that enormous continent with the Congo bleeding at its heart; I
glimpsed some soldiers wearing shorts and blue helmets: the United
Nations had just decided to intervene in Katanga.

Another morning was born, and with it a green sea, breakers, a
coast fringed with white foam. Recife: rivers, canals, bridges, a grid
of roads, hills, on one peak a Portuguese church, palm trees. The

docks again, and the bridges, and the church; again; again; we circled, and another tiny plane circled beside us. "They can't get the landing gear down," Sartre told me. But they will, I thought. Nothing bad could happen to me at that moment, under that sky, at the edge of that new continent. Half an hour later, the wheels appeared, the plane landed. Ambulances and fire engines were massed out near the runway; the little military aircraft escorting us was to have transmitted orders to our pilot in case he had to make a crash landing.

Sartre was not in very good shape; he was suffering from an attack of shingles brought on by overwork and persistent depression. I too swayed slightly when I stepped out into the fresh air and the sun. There were so many hands stretched out to us, flowers, journalists, photographers, women with bare arms, men in white jackets, the face of Jorge Amado. Police, customs; as in Havana, I was dopey with fatigue by the time a car came to take us into the center of town: first to our hotel, then along a riverbank, then to a cool, gay restaurant. I drank my first *batida:* a mixture of sugarcane brandy—*cachaça*—and lemon juice. It was a first link between these strangers and myself, this new taste so familiar to them; I also learned to enjoy *maracuja*—passion fruit—whose rich, tango-colored juice filled the carafes on all the tables. I noticed that there were also bottles of flour on all the tables; this was powdered manioc which they sprinkle over all their dishes. It was difficult to predict which of these people we were going to like or dislike, which we should see again, or when: the Congress had drawn people from all the states of Brazil. We learned with satisfaction that Amado, who was there specifically to welcome us, would act as our guide for at least a month.

We spent a few minutes at the Congress, and then Amado took us off with a group of people to rest in a friend's *fazenda*. It fitted exactly the descriptions I had read in Freyre's book: below, the workers' quarters, the sugarcane mill, a chapel farther off; on the hill, the house. The master of it painted, and his pictures filled it with light; the gently sloping garden, its trees, its flowers, the undulating landscape of sugarcane, palm trees and banana palms seemed to me such a paradise for the senses that I let myself slide away for an instant into the most heretical of dreams: to slip under the skin of a great landowner. Amado's friend and his family were away; I had a first glimpse of Brazilian hospitality: everyone found it quite normal to sit on the terrace and ask for drinks to be served. Amado filled my glass with the pale yellow juice of the *cajou;* he felt,

as I do, that one learns to know a country to a large extent through the mouth. At his request, some of his friends invited us the following day to visit them and eat the most characteristic dish of the Northeast, the *fetjuada:* for the *caboclo* a hash of black haricot beans, for the middle-class gastronome, a sort of rich cassoulet.

I had read in Freyre that girls in the Northeast used to marry at thirteen, in the full bloom of their beauty which, at fifteen, had already begun to fade. A professor introduced me to his daughter, very pretty, very heavily made up, with smoldering eyes and a red rose stuck in a bosom already full: she was fourteen. I met no teenage girls at all—either children or grown women. The latter, however, now fade less quickly than their grandmothers; Lucia and Christina T., at twenty-six and twenty-four, both sparkled with youth. Despite the partriarchal customs of the Northeast, they had a certain amount of freedom. Lucia was a teacher, and Christina, since their father's death, was managing a luxury hotel near Recife that belonged to the family; both did a certain amount of journalism; both traveled. It was they who took us around Recife in their car.

We saw Olinda, the first town to be built in the country—three hundred years before Brasília—according to the plans of an architect. Maurice of Nassau, who governed the district between 1630 and 1654 on behalf of the Dutch, had it built by Pieter Post, then decorated by a team of painters and sculptors. It is built in tiers on a hillside three miles outside Recife and a good many of its old houses are still intact. When the Dutch had been driven out, the Portuguese artists built churches there in a sober baroque style. I recognized the same staircases, the same porches and façades, bathed in the steamy odor of the tropics, that had moved me when I saw them rising from the dry earth of Portugal. We went down to an endless beach. How I loved the indolence of the tall coconut palms fringing the imperious tumult of the ocean! How white against the water shone the triangular sails of the *jangadas*—masted rafts, made of five or six tree trunks held together with wooden pegs; they are quite seaworthy on calm days but don't stand up well in storms. Every year there are many fishermen who don't come back. We went into a kiosk and tasted coconut milk: they bore through the fiber and the shell, then you suck it out through a straw; it was lukewarm and insipid.

Recife also contains some beautiful baroque churches; their windows, decorated with wrought iron balconies, give them a charming

frivolous expression. In the marketplace, people clustered around the storytellers; some were improvising songs; others were reading from clumsily illustrated paperbound books. They would stop before they reached the end; to know how it came out, you had to buy the book. In the center of town there were old squares planted with dark trees, streams, small shops, peddlers; but as soon as one ventured away from them into the grid of dry streets with scaling walls and roads of beaten earth, one saw nothing but decrepitude and desolation. "In Recife, there is a beggar under every palm tree," Bost had told me. No, this year it had rained and the peasants around the city had a few roots to gnaw at; but when the drought comes they swarm into the city. There are twenty million of them suffering from chronic starvation in an arid polygon as large as France. Christina showed us an area on the outskirts where a competely destitute section of the population was stacked in little wooden shacks. She told us about the peasant leagues which, encouraged by Julião, a Socialist member of Parliament and a lawyer in Recife, were trying to unite the peasants and promote agrarian reform; several of her friends belonged to it. "When I first took on the hotel," Christina told us, "I was still very young, and I wanted to be thought of as a hard taskmaster. I made my employees work as much as possible for the least possible money. Then I saw how they lived . . ." She was a sincere Catholic, and revolted by social inequalities. On Sunday morning she went sailing with the most exclusive club in town and raced her boat passionately; but she would quarrel with the other members and, generally speaking, with all the people of her own class. She drove like a fury through the residential district of Recife, with the express purpose of frightening the pedestrians. "They have to be reminded that they're mortal," she said with a laugh.

As a result of one of those complicated arrangements in which the Brazilians excel, we found that we had ended up with four airplane tickets for just the two of us; Amado then arranged for Lucia and Christina to use them. He had spent his youth in Bahia where we had an extra guide in the person of a young professor of ethnography, Vivaldo, a half-caste with the stocky figure of a football player. Zelia Amado joined us too; she arrived a night late; another aircraft having overturned on the runway, hers was unable to land. So we made up a group of seven people, all French-speaking and all happy in each other's company. To get around, we had a sort of minibus with a driver at our disposal. Sartre was feeling better; our only official

obligations were a lecture and two official lunches. We spent a very happy week together.

Bahia consists of two towns connected by elevators and funiculars, one of them running along the coast, the other perched on top of a cliff. That was where our hotel was, very modern, enormous, elegantly proportioned. From my room, and from the immense glass-walled bar full of green plants and birds, where we drank *batidas,* there was a view, under a perpetually agitated sky, across the "Bay of All Saints," its reefs, its beaches, its tranquil coconut palms, its boats and their trapezoid sails; brief squalls would lash the ocean as we watched. Amado showed us the commercial streets in the upper town. On the door of the University there was a notice: PHILOSOPHY ON STRIKE. The rector and the students were having a disagreement. Churches everywhere. One of the best known was built by Spanish artists; not a square inch of plain stone: shells, volutes, lace. The Portuguese façades are sober; inside, however, good taste yields to richness of ornament: facings of gold chased in the most extravagant patterns, bosses and pendentives, birds, palms, demons hiding like the policeman in the child's puzzle amid the protuberances of walls and ceiling; the sacristies have displays of rosewood or black jaca-randa chests, Delft pottery, Portuguese tiles, porcelain, gold plate, life-size wax saints worthy of the Musée Grévin—emaciated, scarred, contorted with pain or ecstasy beneath their wigs of real hair—and Christs, scourged, bruised, bristling with thorns, long red ribbons bleeding from their wounds. They made me think of Bobo-Diou-lasso's fetish.

The narrow old streets where Amado spent his childhood all run parallel down a steep slope to the sea; on one side is the neighbor-hood of the "professional women." We went into bazaars packed with all sorts of merchandise jumbled together; walls and ceilings were passed over with dazzling butterflies cut out of magazine covers. The car plunged along precipitous ramps and brought us out onto the docks, near the covered market. Except for the lack of hygiene, it reminded me of the one in Peking; in its narrow alleys are sold the plainest of foodstuffs, salted things, leather, textiles, millinery, cast-iron ware; but there is also an extraordinary profusion of popular art, articles indicating the survival of an ancient and varied culture. Both for us and for himself, Amado bought necklaces and bracelets of colored seeds, pottery, earthenware figurines, black-faced dolls dressed in traditional Bahian clothes and ornaments, brass Exus—

spirits that are more mischievous than evil, though the forks they carry suggest our devils—musical instruments, heaps of knicknacks; he explained to us the meanings of all the amulets, pictures, plants, drums, and jewels connected with their religious ceremonies. The stalls spilled out into the open air, right up to the edges of the docks where a flotilla of *saveiros* rose and dipped on the swell, their hulls touching, their masts rising like a dense thicket from the water; there were peddlers selling lengths of peeled sugarcane, which one chews and then spits out once all the juice is gone, coconut cakes, bean fritters, large pots, amphoras, more pottery, some pretty, some hideous, bananas and other fruit; the smell of palm oil mingled with that of brine; coming and going all the time, on the boats as well as on land, was a crowd of men and women with skins shading through all variations of brown, from chocolate to white. We went through a barber's shop where the occupants were placing bets on the *bicho* or *animal game,* a sort of lottery which together with soccer is the most popular form of amusement in Brazil. On the second floor, a Negro woman was running a bistro which looked pretty nondescript but was in fact famous; on the wall, a picture of Yemanja, goddess of the sea; in a pot, some "swords of Ogun," cactus leaves shaped like large knife blades, very common in France and extremely necessary in Brazil for the protection of houses and property. Sartre didn't touch the oily stews they served—vermilion, coral, pistachio-colored— though I tasted them with caution; the crab soufflé won me completely.

Several days later, as we were leaving the city we saw another market. "The Brazilians won't take you there," a Frenchwoman had told me. But Amado took us everywhere. It had been raining and we had to splash our way through all sorts of filth; except for some rather beautiful pottery, the wares displayed reflected the poverty of the customers: hunger was an ever-present threat in Bahia too, especially in the places Amado referred to as the "invasion areas" because so many squatters had settled there. One of them was built over a lagoon; it was obvious no one would try to claim that piece of land back; the hovels were built on stilts over the water and joined to the mainland by shaky catwalks. It reminded me of the "water district" in Canton, except that here the people had let themselves go completely and were living without the slightest effort at hygiene. There were other poor districts scattered about over the green hills, among the banana palms with their slashed leaves; they were crisscrossed

with telegraph wires forming a cemetery for the kites the children played with; the rich, brown earth gave off a country smell; these suburbs were almost villages, still preserving the traditions and organic ties of rural communities.

The fact is that the population of Bahia, 70 percent of which is Negro—this was the sugarcane and consequently the slave-owning region—shares an intense communal life. The Nago African rites were perpetuated here, cautiously concealed behind a façade of Catholic liturgy with which they eventually fused, forming a religious amalgam similar to the voodoo of Haiti and called here *candomblé*.[1] It is a complex tissue of beliefs and practices, without any formal church hierarchy and therefore comprising many individual variations. Roger Bastide's book *Les Religions Africaines au Brésil* had just come out and I read it. There is a supreme God, Father of Heaven and Earth, with an entourage of spirits, the Orixa, which correspond to certain of our saints; Oxala approximates Jesus, Yemanja the Virgin Mary, Ogun St. George, Xango St. Jerome, Omuh St. Lazarus. Exu, who is more like the Greek Hermes than our Devil, serves as a mischievous intermediary between mankind and the "enchanted ones." These latter live in Africa, but their power extends over great distances. Every individual belongs to a particular Orixa (the priests reveal to him which one) who protects him if he offers the required gifts and sacrifices. Certain privileged people, who have submitted to the long and complicated rites of initiation, are called upon to serve as "horses" for their god: he is brought into their bodies by means of ceremonies which—as with the descent of God into the wafer in the Catholic religion—constitute the culminating moment of the *candomblé*.

At Recife, an evening's entertainment had been organized for us in which Negroes disguised as Indians danced a number of very sophisticated ballets; but we had not been able to see a Xango.[2] In Bahia there are religious celebrations almost every day, and the entire intelligentsia takes an interest in them. Amado, who had been enthroned in office while still a youth, is one of the highest dignitaries of the *candomblé;* Vivaldo occupies a less exalted position in it, but he knows all the "mothers of the saints," and the *babalaô* (soothsayers, half priests half witch doctors) of the town. Twice our car

---

[1] The word signifies the religion as a whole, the communities which carry on its traditions and the religious ceremonies themselves.

[2] In the Pernambuco region this is the equivalent of the Bahian *candomblé*.

took us at night, through the Russian-looking mountains that form the suburbs of Bahia, out to distant houses throbbing with drums. On both occasions the mother of the saints first took us into a kitchen where a woman was preparing food, both sacred and profane, then into the room where the altar stood. Amid a mysterious jumble of fetishes—ribbons with the colors of the gods, offerings, stones, pots— the Orixa are represented by statues in the sentimental Catholic style: St. George and his dragon, St. Jerome, St. Cosmos and St. Damian (the twins with multiple and important powers), St. Lazarus, etc. In a fenced-in courtyard there was a crowd of Negroes— mostly women—the members of that fraternity and their guests; a few white people, too: a painter who had often drawn inspiration from the dances, a journalist from Rio—Rubem Barga—and the Frenchman Pierre Verger, a great initiate, we were told, and the man who knew most about the inner secrets of the *candomblé*. There were men beating the sacred drums and others playing instruments we didn't recognize. The "mother of the saints" joined the dance of the "daughters of the saints": women who had already been initiated and "ridden" by their god in the course of previous ceremonies of a similar kind. Some were very young, some very old; they had on their very best finery, long cotton skirts, embroidered bodices, bandannas— and also jewelry and amulets; they moved in a circle, walking to a swaying rhythm that sometimes became more jerky but was always quite calm; most of them were joking and laughing together. Suddenly a face would be transformed; the eyes would go blank; after a period of anxious concentration varying in length, or sometimes instantaneously, the woman's body would be shaken by a violent agitation, she would begin to stagger; as if to support her, the initiates— Amado and Vivaldo among others—stretched out the palms of their hands toward her. One of the saints' handmaidens—an initiate deprived on this occasion of a divine visitation—having calmed the possessed woman by pressing her in a close embrace, unknotted her bandanna, took off her shoes (to make her into an African once more) and led her off into the house. At both ceremonies all the women dancing fell into trances, as did two or three women guests, who were led off with the others. They returned, dressed in sumptuous liturgical costumes corresponding to their particular saint and holding various emblems in their hands, among others a sort of horsehair whisk which they twirled in the air; the solemnity of the gestures and the grave expressions on their faces were signs that they

bore a god within them. They resumed their dancing, each one in-
tensely absorbed in her own ecstasy yet always in harmony with the
movements of the group. Sartre had told me about the frenzy of the
voodoo; here, the individual manifestations were kept under control
by a collective discipline; some of the women were affected very
violently by these manifestations, but without once becoming iso-
lated from their companions. At one of the two ceremonies we at-
tended, a young Negro woman was just finishing her cycle of initia-
tion. She remained lying on the ground during the whole of the first
part of the evening, her head shaved, dressed in white; she was
trembling slightly, her eyes fixed on something invisible, both with
us and elsewhere, like my father on his deathbed. Toward the end,
she went into a trance, was led off, and came back transfigured by a
mysterious joy.

I asked the classic question: "How can these trances be ex-
plained?" Only the "mother of the saints" has the right to simulate
them, in order to help bring about the descent of the Orixa; and it
seemed to me that one of the two I saw did in fact avail herself of this
prerogative. Everyone who has watched these rites agrees that the
others employ no trickery, and I'd swear that they don't: their
metamorphosis, when it comes, is as much a surprise to them as it is
to the spectator; nor did they look at all like neurotics or drug ad-
dicts. The old women in particular, lively and ironic as ever, turned
up for the *candomblé* with all their everyday good sense. What then?
Vivaldo talked quite openly about supernatural intervention; Pierre
Verger too, though rather more guardedly. Amado and all the others
admitted their ignorance. What is quite certain is that these things
are entirely of a cultural nature and have nothing pathological about
them; analogous results may be found wherever people are torn be-
tween two civilizations. Forced to bow before the strength of the
Western world, the Negroes of Bahia, once slaves, now an exploited
class, live in a state of such oppression that they can scarcely call their
lives their own; to preserve their customs, their traditions, their be-
liefs, is not a sufficient defense; they also cultivate those techniques
which will help them attain a state of ecstasy and so tear themselves
free of the false earthly manifestation in which they have been im-
prisoned. At the moment when they seem to lose themselves in the
dance, they in fact find their true selves; they are possessed, yes, but
by their own truth. Even if the *candomblé* does not change men into
gods, at least it uses the mediating action of imaginary spirits to

restore their humanity to a group of men who have been forced to the status of cattle. The Catholic religion hurls the poor down on their knees before God and His priests. By means of the *candomblé*, on the other hand, they are enabled to experience that sense of personal sovereignty all men should be able to claim. All present do not achieve the state of ecstasy, even among the group previously disposed to it by initiation; but if only a few experience it, that is enough to save them all from their state of abjection. The supreme moment of her individual life—when she is transformed from pancake vendor or dishwasher into Ogun or Yemanja—is also the one in which the "daughter of the saints" becomes most closely integrated with the rest of the community. Few societies offer their members such an opportunity: to realize one's ties with all those around one, not just in the banality of everyday life, but through all that one holds most secret and most precious. The *candomblé* is not particularly entertaining or picturesque, being slow-moving and rather monotonous; if the leftist intellectuals pay such attention to it, it is because—in the absence of the changes they hope one day to see—it enables these disinherited people to maintain a sense of their own dignity.

After plunging up and down steep streets—luckily Zelia had an amulet in her possession that was sovereign against all accidents—we drew up one morning at the door, guarded by an Exu, of the oldest, the largest and the most famous *candomblé* in all Bahia. This sanctuary is to Bahia what Montserrat is to Spain, and the most venerated of the "mothers of the saints" reigns over it: except that this religion is for the poor and not the rich; instead of marble, gold plate and great organs, here there is beaten earth, cheap pottery and a few drums. Situated on a hilltop, the enclosure contains the little houses where the neophytes live during their initiation period, and to which in certain circumstances the daughters and handmaidens of the saints return; there is a large hall for the dances, constructed, like our own churches, according to the rules of a complicated symbolism; the "mother of the saints" lives in the main building. The divinities of the various towns—in the form of sentimental plaster figures—stand all together on an altar; those of the country districts, have their chapels outside: they are arranged so as to recall the location of the temples on the gods' original continent, for every *candomblé* is a microcosm of Africa. After glancing around these outbuildings— some of which are hidden in the surrounding countryside—we went

back to the quarters of the "mother of the saints"; in front of her door, pecking rather listlessly at the ground, were two chickens singled out for an approaching sacrifice. Amado and his sister belonged to her *candomblé;* they took her aside to settle the question of their obligations, which they never fail to fulfill. Warned in advance of our visit, she had put on her most magnificent costume: skirts and petticoats, shawls, necklaces, jewels. She was lively, talkative and mischievous; she complained about Clouzot, who had tried to violate her secrets, then delivered an ardent eulogy of Pierre Verger, who had brought her certain objects from Africa that had strengthened her relations with the Orixa. She had been to Africa herself, and I understood her to say that when presented with a choice between the two sets of gods she had inherited, she had opted for the Nago cult. She spoke Nago a little: a knowledge of the African tongue is obligatory for one who wishes to have dealings with the saints. While we went off to the kitchen, where a young woman served us various kinds of food, the "mother of the saints" consulted some shells in order to find out which of the spirits we were dependent on: Sartre was Oxala and I was Oxun. Along the road, we had noticed chickens lying at the foot of trees with their throats cut; we told her about them: they certainly had something to do with black magic, of which she expressed disapproval. "I work only for good, never for evil," she declared. It is the sorcerers who with the aid of the "dog"—the devil— make people fall sick, ruin them or kill them. The mothers of the saints, the fathers of the saints, and the *babalaô* intercede for the good of mankind. We talked with her for quite a while. The marriage of *candomblé* and Catholicism does sometimes produce individual absurdities; but on the whole, the native peasant fetishism absorbed by the Christian tradition blends very well with the surviving strain of African fetishism, and the people of Bahia feel as much at ease in the church of San Francisco as on their own *terreiros.*

The half-pagan, half-Christian ceremonies, in which the blood of chickens is spilled amid the fumes of incense, take place above all in the church of Senhor do Bonfim. We went on a long and beautiful trip to take a look at it, following the intricate indentations of the coast, gazing as we passed at the old fort of Monteserate and the chapel with its porch extending out into the sea. The church rises above a large square. In front of the porch you can buy ritual necklaces and beads, crucifixes and amulets, pictures of the Sacred Heart and of Yemanja, advancing across the waves with her long hair

streaming behind her. In the vestry there is an astonishing collection of ex-votos: plaster casts and canes, photographs, paintings, casts of the organs the Senhor has cured.

At night, in the streets of Bahia, the young toughs still practice the ancient French sport of foot-boxing or *savate;* when they attach razor blades to their ankles, it becomes a fight to the death. This sport has inspired a dance which I saw once in a sort of open-air café in the middle of an "invasion area," another time in the center of Bahia in a big room decorated with wreaths and flags and multi-colored streamers. The dancers are all men, each one lifting his part-ner in the air, hurling him to the ground, then gesturing menacingly at the fallen man's face with his foot, though without actually touch-ing it. Both the attacks and the evasion tactics are susceptible of numerous variations. There are musicians who play an accompani-ment to this mock combat. The champion and teacher of the dance, an old, thin, very tiny Negro with a knowing air, gave an astounding exhibition of his art.

Amado's father had been a cacao planter; at nineteen Jorge had written his first story, *Cacao,* describing the condition of the agri-cultural workers. Later, in *Violent Earth,* he depicted the courage and the misdeeds of the first conquerors of the forest, the "colonels," who exercized the right of life and death over hordes of slaves and settled their quarrels with bullets. *La Terre aux Fruits d'Or* evokes the generation that followed them: speculators and exploiters who respected the outward appearances of legality. In his book *Gabriela,* which was having an enormous success that year, Amado had gone on to describe Ilhéus, the cacao port. He wanted to show it to us.

We flew off over a moving landscape of hills and forests swollen with water. It was raining the evening when we reached Itabuna, though it didn't look any less dismal the next morning in sunlight. To get acquainted with a country, Amado was of the opinion that one should first of all know what they eat there. He took us to the market: red beans, manioc, bad rice, pumpkins, sweet potatoes, bars of raw sugar that looked like black soap, beef dried in the sun—noth-ing fresh; on the backs of the little donkeys, amphoras swathed in hay; set out on the ground, ropes and goatskin gourds; we were in the open air, but it smelled like an old barn. The people—Indian and Portuguese half-castes with very little or no Negro blood—all had gloomy faces. The land here is rich, but all in the hands of a privi-leged few; the tobacco and cacao plantations leave no room for grow-

ing food. Amado and a few notables escorted us to a *fazenda,* a model one we were told. We followed the course of a torrential river through lovely country. The master's house was built on a rise in the middle of a garden. Like the great majority of big landowners, he preferred to live in Rio rather than on his own domain. It was his bailiff who received us. With a smile on his lips he led us to the place—more like stables than a village—where the workers lived. No water, no light, no heating, no furniture: four walls surrounding a square of beaten earth; a few packing cases. These rooms formed the sides of a courtyard where we saw some naked, swollen-bellied children and some tattered-looking women dragging themselves about; the dark-skinned, dark-haired men watched us go by, their machetes in their hands, hate in their eyes. *In Cuba, they had the same skin, the same hair, the same machetes, and their eyes fixed on Castro burned with love.* In a corridor was thumbtacked a ludicrous poster of an elegantly dressed woman traveler stepping down from a sleeping car; I saw no other decoration. The cacao beans darkening on the roofs in the sun gave off a sweetish fermenting odor that mingled with other, unnamable smells. We walked along a muddy path into the forest where the golden fruits grow: the cacao shrubs need the shade of the tall palms around them and the damp, soft earth our feet sank into. Amado picked one of the husks and split it open; white, rather slimy, the bean did very faintly suggest the taste of chocolate. On the way back I asked why we had been told it was a model *fazenda.* "I suppose because a doctor drops by once in a while; because the place where they get their water is less than half a mile away; because the roofs keep out the rain. In any case," he added, "compared to the peasants of the Sertan, these people are privileged: they eat."

Along a road that ran by the river, with forests on either side, through a countryside which looked as though one could be happy in it, we drove to Ilhéus. Bales of cacao piled in the warehouses; men, mostly Negroes, loading them onto little boats moored in the peaceful bay whose waters joined to the ocean by the narrowest of channels, were the same shade of soft green as the palm trees, softened by the evening light. The dockers work hard, but they are unionized and earn good money. We could see from their muscles, from their healthy appearance, from the songs and laughter that seemed natural to their lips, that they could eat as much as they liked. The ocean outside the harbor of Ilhéus is so rough that big ships cannot get near

the port; we could see two of them standing a long way out, waiting for their cargoes to be brought to them. In *Gabriela,* Amado demanded that the port of Ilhéus be modernized; such is his credit in Brazil that work has already begun. Battered by wind and spray, we went out to the end of the jetty they had begun to build.

Another of the region's resources is cattle. We set out one morning for the Feira de Santa Ana, about sixty miles from Bahia. It was market day. There was a thick, jostling crowd that stretched for more than two miles; musicians dressed up as *cangaceiros* were using their guitars and their vocal chords to make as much noise as they could; there were pancakes being sold, fruit tarts, coconut cakes, candies; but this illusion of gaiety was swiftly dissipated: the market was almost as meager as the one in Itabuna; no popular art, with the exception of some nondescript earthenware figurines. A far cry from Bahia, this place was lapped by the desolation of the surrounding country, where living means simply exhausting oneself in the effort to survive; there is no room for superfluities. At the edge of the town, there were corrals in which we could see enormous herds of steers, and *vaqueiros* galloping around them, raising the dust. To protect the men from the cactuses and thorns out in the brush, they are armored with leather from hats to boots. Their herds do not belong to them; they receive a very small share in the profits from raising them, but it is not at all a profitable business because of the droughts and epidemics. Lying spread out on the ground were hats, shoes, pants, jackets, belts, overalls, all made of a pretty fawn-pink leather, but with a strong animal smell.

There now remained—since Amado is systematic—only the tobacco industry to inspect. "Cachoeira is only an hour's drive from here," the professor with whom we were lunching told us. It took us three hours, and the jolts from the craters pitting the road painfully reawakened Sartre's shingles. We glimpsed two or three isolated shacks with tobacco plants growing around them. The town lay stretched out peacefully on both sides of a river; old houses, old churches; we wandered around a bit. Then we went into a dim shed where some tired-looking women were trampling tobacco leaves with their bare feet; the acrid odor of the dead plants was reinforced by the smell of the latrines where piles of filth were decomposing in the sun; it all seemed like the vision of a hell in which women were condemned to splash continually through their own excrement. On the way out they all rushed to soak their feet in a trickle of muddy

water by the door: no washbasins, no running water, yet there was a river flowing only a few feet away. Many of the women workers were wearing sacred necklaces. "Ah!" Vivaldo said to one of them. "You are a daughter of Oxun then?" He questioned her about the *candomblés* in Cachoeira. Hesitant at first, her face lit up later, he told us afterward, when she realized that he was himself an initiate. Having seen the abject conditions in which these women were forced to live, I understood fully what a miracle the *candomblé* effects.

Our last excursion took us out one morning to the oil town at the end of the bay. One of the Brazilian's sources of pride is that the oil industry is now nationalized. In 1953, impelled by a violent wave of anti-American feeling, Vargas established a state monopoly called Petrobraz: from that moment onward, no foreign capital could be invested in Brazilian oil, a move that came as a blow to the American companies. A year later the "American" faction forced Vargas to suicide, but the state monopoly remained. Petrobraz sometimes hires foreign technicians, but there are no longer any oil fields which it does not own. A giant refinery stretches along the sea; we looked down on it from the nearby hillside where the very comfortable workers' quarters have been built. Compared to the peasants, the industrial working class in Brazil forms an aristocracy, and the workers of Petrobraz occupy the highest rung. We also went into the forest and saw the derrick of a drill that was working at a depth of 13,000 feet.

These trips made us familiar with the physical aspects of Brazil, the indentations of its coast, the color of its forests. And at the same time our friends were straightening out our initial difficulty in understanding the political situation.

We had arrived in the middle of an election. Added to which, Rio, recently deprived of its status as a capital in favor of Brasília, henceforth constituted the new State of Guanabara, whose first governor and representatives were about to be named. There were three men running for President. Since Adhemar—to whom the slogan "I steal but I act" was being attributed—stood no chance at all, it was virtually a straight fight between Jânio Quadros and Marshal Lott; Jânio was the right-wing candidate; once in power, he would favor the interests of the great capitalists, though he had sent declarations of friendship to the Algerians and Cuba. Christina had decided to vote for him; she wore shoes decorated with the little broom that was his emblem: he was promising that he would put a stop to corrup-

tion. "He'll just put a new lot of profiteers in power," Lucia said. "He supports Cuba and Algeria, he'll do something for the peasants," Christina replied. "He's a hysteric; he's full of promises, but he won't keep them," her sister retorted. She was going to vote for Lott, as was Amado and all the Left. A Nationalist and an anti-American, he was promising to fight for Brazil's economic independence. He was supported by Kubitschek—who was forbidden by the constitution to stand for office, but whose prestige was very high—and by the Communists; the drawback was that Lott was a soldier, one of the old guard, and very reactionary in his foreign policy: he was opposed to the new Cuba. On the subject of his stupidity, stories as distressing as they were laughable were being circulated even by his own supporters. Prevented by illness from taking part in some maneuvers, he once decided to reproduce them in his own home. He set off with his orderly to march twenty-five miles around and around his own garden. Halfway they came to a halt. The soldier felt thirsty and, realizing he had left his water bottle behind, walked over to get it. Lott stopped him. "It's twelve miles away," he said. For six weeks there were banners, posters, records and loudspeaker cars noisily informing us of the merits of the rival candidates; there were fireworks displays in their honor.

We followed the campaign in the newspapers, which our knowledge of Spanish enabled us to make out more or less. I read most of the works on Brazil written or translated into French; I got to know a little about its literature from French translations.

We said good-bye to Christina and Lucia, and to Vivaldo, who was waiting with feverish impatience for the arrival of an African teacher from whom he was going to learn Nago. When we left Bahia, its showers and its laughter, its yellow mud, its black crowds, its churches where the Christs are fetishes, its altars where the plaster saints have the faces of African gods, its markets, its folklore, its peasant magic, we knew that we were going into another world. Three hours in the plane. The ground began to bristle with sawtoothed mountains, with "God's fingers," with stark needles, with sugar loaves; I made out a bay sown with innumerable little islands and so vast that my eyes could not encompass it all: Rio. A populous, ugly road, several overcrowded avenues flapping with election banners, a tunnel, and we had reached our hotel in Copacabana.

The beauty of Copacabana is so simple that it doesn't show on the

postcards, and it took some time before it got through to me. I opened my window on the sixth floor; a warm vapor wafted into my room carrying the fresh scent of iodine and salt and the noise of the ocean breakers. For three miles the tall buildings faithfully follow the gentle curve of the vast beach that receives the ocean's dying waves; between the two, an avenue rigorously bare. There is nothing to break up the curved encounter of vertical façades and flat sand; the austerity of the architecture is in harmony with the nakedness of land and water. Only one splash of color breaks the whiteness of the beach: kites for hire, red and yellow, speckled with black. It was winter, I could make out only a very few silhouettes, some stationary, some moving, between the roadway and the sea. Early in the morning, the neighborhood domestics appear, then at about eight, the white-collar workers, people who work during the day, then the people who don't have to work, and the children. People don't bathe much, the sea is too high; there are creeks and beaches which offer more shelter elsewhere; here they paddle, lie in the sun and play soccer. It was difficult to believe that this carefree solitude, the brute splendor of the ocean and its rocks, was part of a compact and feverish great city. In the evening, a steamy-smelling mist filtered the lights of the apartment houses and the glare of the neon signs, and there was nothing else in the world left to desire but that soft glitter, that cool, moist air.

Copacabana has 300,000 inhabitants, mostly upper or lower middle-class; it was pleasant walking among its handsome apartment buildings, often built on piles in the style of Le Corbusier. The district comes to an end at the foot of a cliff one usually goes through by tunnel, though there are several roads climbing up over the top. The whole of Rio is convulsed into sudden hills and sugar loaves suddenly blocking its streets in mid-career and pierced by subterranean avenues. These stone humps are covered with greenery, and the town, already besieged by the ocean, is also invaded by the forest; no other great city belongs so entirely to nature. A car ride in Rio is a succession of steep climbs and bends, of unexpected engulfments, of abrupt downward plunges, with sudden magnificent views of the rocky coast and its necklace of beaches. Looking down from the Corcavado, where they have erected a 60-foot figure of Christ 2,200 feet above sea level, one is dazzled by this wild yet urban landscape.

None of the buildings are very high except in the richer districts; the city stretches so far that the taxi drivers have divided it into two

zones: the taxis of the northern zone never go over into the southern zone, and vice versa. We drove several times through the ugly industrial agglomerations of the north, but we only became really familiar with the south. The Avenida Presidente Vargas intimidated us with its vast width, but we often wandered along the Avenue Rio-Branco: a sea of pedestrians on the sidewalks, the roadway packed with vehicles; stores, kiosks, posters, bars opening out onto the street with coffee machines glittering beside big jars of juices—pineapple, orange, *cajou,* passion fruit; then banners and slogans. It was all so animated that it seemed gay at first, but the people in fact looked sad. Off to the right and left, the no-traffic streets were black with people; then even pedestrians became rare, the stores turned into meager little shops; right in the heart of the city we found ourselves wandering through a little old-fashioned village. Several times we climbed into a street car, which we liked because it went so slowly and kept stopping. We visited the buildings designed by the various young Brazilian architects: the Museum of Modern Art, Affonso Reidy's new housing project, Nino Levi's apartment buildings, and others by Niemeyer and Lúcio Costa, two of Le Corbusier's pupils who helped him on the Ministry of National Education building; their work was more elegant to look at than his. There was very little of Portugal left. I've forgotten the name of the tiled *largo* we saw, which forms a big courtyard with only one exit, far from the city's noise, surrounded by colonial houses and gardens full of fine old trees. One of the places we liked best was the square of the wharf: there were steamboats getting under way for their trips around the islands in the bay; ferryboats transporting passengers, cars, and merchandise over to Niterói, which with its 200,000 inhabitants and its skyscrapers seems to stand on the other bank like Rio's mistreated stepsister. The boats are always overloaded, and one quite frequently reads in the newspapers that 30 or 50 passengers have been drowned. Taxis and street cars keep flowing into the square; there are itinerant peddlers and vendors selling food and drink out of stalls. Along one side stretch the great covered markets, giving off a smell of fresh vegetables and pineapple, as well as fish and dried meat. From a restaurant on the second floor, we could watch the boats in the bay and all the activity on land. One Sunday, as we were walking along a dingy avenue split in two by a canal, we noticed in the distance a lot of men in bright-colored shirts: pink, yellow, green especially (green is the Brazilians' favorite color). They were laughing and chatting

with groups of women leaning out of the windows of some big, low houses. Through the half-open doors we caught glimpses of beautiful mulatto girls sitting on the staircases in bathing suits. Nothing clandestine; openly, in the middle of the afternoon, it was just like a village celebration.

In the evening, Rio was resplendent: necklaces, belts, bracelets of brilliant stones encircled her somber flesh. Still more, I loved the little streets with their shops all closed in the blue-gray falling light of dusk. There is something tired and faded about Rio—the black and white mosaic sidewalks are full of cracks, the asphalt is warped, the walls scaling, the pavements filthy—that is hidden by the sun and the crowds. The poorer districts, when they are allowed to slip back into silence and darkness, are full of floating phantoms and regrets.

Out of Rio's three million inhabitants, 700,000 live in *favelas;* the starving peasants who come, often from a long way away, to seek their fortune in the town crowd together on bits of land that the owners have allowed to become derelict—marshy stretches, rocky hillocks; when they have managed to get together enough planks, cardboard and old scraps of iron sheeting to make themselves some sort of hut, the authorities no longer consider themselves entitled to expel them. The steep slopes of the rocky hills, in the very heart of Rio, teem with these *favelas.* An official in the town's tourist office suggested that they might look less poverty-stricken if they had patterns painted on them, like circus wagons. The project never reached fruition, but a few of the huts are now brightly colored; from a distance, perched on the highest hills dominating the city and the ocean, some of these neighborhoods look just like contented villages. The Brazilians don't like showing you their *favelas.* However, Teresa Carneiro, whom we had known in Paris, did take us to see one. It was in Copacabana, an agglomeration of about four thousand souls, mostly Negroes, rising in tiers up the sides of a hill more than 300 feet high. Poverty, filth, disease—it was an exact copy of all the others, except for one detail: there was a nun living there called Sister Renée, or quite simply Renée. Daughter of a French consul, she had been so overcome in her youth by the poverty of the Spanish people that she had taken the veil and followed in the footsteps of the worker-priests. She had been advised to come to Rio. She had "squatted," with the approval of the owner, on a piece of land where the men of the *favela* had helped her set up a dispensary and a school. Blond, pink-faced with high cheekbones, almost beautiful, she wore a

blue nurse's smock. She surprised us by her intelligence, her culture, and her good sense about material things. "The people here need a bit of water before we begin telling them about God. . . . Morality yes, but sewers first. Sewers first, morality afterwards." She spoke in their defense: "People accuse them of all sorts of crimes; I think they commit very few, considering the conditions they live in." She pointed to the club at the seashore where the rich young girls and boys of the town came to play tennis and bask in the sun. "I was born to that, but I'd willingly go down and strangle the lot of them all the same. The poor people don't get enough to eat, that's why they haven't got the energy to fight back." There was a vast tome on hemp lying on her table: both men and women here were in the habit of intoxicating themselves with drugs that threw them into a state of acute delirium. On Saturday nights, there were several huts where they celebrated their *macumbas,* a very different thing from the beneficient *candomblés* of Bahia; among this subproletariat, cut off from all rural tradition, possession was an individual as opposed to a collective adventure; in their trances, the initiates would burn and wound themselves, sometimes seriously; on Sunday mornings they came to Renée for treatment. But they themselves possessed magic remedies, she said; she had seen deep cuts which an hour later had formed scar tissue. "There's something in their religion," she declared, though the idea didn't worry her, presumably because she believed that there are many ways to reach God. Her methods of administration were very similar to those I had seen applied in China: she had persuaded the population to work for its own good. Some of the men had laid out cement paths and were digging sewers as best they could; she helped them steal electricity from the town; at the same time she was pressuring the municipal authorities to provide it legally, together with a water supply and a real sewage system. Several women in the neighborhood were assisting her, and she was trying to train them as her auxiliaries. There was a fairly large white minority living among the Negroes, and she was fighting their racist attitude. She had her problems. The place was overpopulated; both the municipal authorities and common sense forbade the acceptance of newcomers; she was flying in the face of both. "But it isn't charity," she said. "It just isn't right to refuse people a roof over their heads." During the month off her superiors allowed her, she was hoping to work among the Indians on the Amazon. "One has to have something to do with oneself on a holiday," she said with a smile.

Direct, spontaneous, without a shadow of self-consciousness, she disarmed in advance all the criticisms one can usually make of lady dogooders and sisters of charity; she didn't look at the people in her care through the eyes of society or the eyes of God, but rather at God and society through their eyes.

Zelia could drive, and Christina, who had come to Rio with her mother, had a car; they showed us the surrounding countryside: the wild cliff road that extends up from the beaches; and 3,000 feet above sea level, along the sides of the Pico da Tijuca, the magnificent luxuriance of the forest that today replaces the now-exhausted coffee plantations. Amado and his sister took us up into the mountains to Petrópolis; in the summer, when Rio lies suffocating in the heat, they rent rooms there in an enormous hotel that was to have been a casino. Gambling is now forbidden; and there are long vistas of deserted saloons, one leading into another. We saw the villa where Stefan Zweig killed himself. Another day we went with Zelia by boat to the island of Paquetá and drove round it in a horse-drawn carriage; the carriage was old and harmonized perfectly with the beautiful faded mansions we passed, whose abandoned gardens exhaled the ancient scent of eucalyptus.

In the evening we would eat dinner on one of the terraces of the Atlantica, absorbed by the glittering lights, the murmur of the waves, the warm, damp caresses of the air. We often lunched in one of the *churrascarias*. Here quarters of pork, mutton and beef are spitted on iron pikes which are then stuck upright into the ground in front of wood fires; this is the gaucho method of cooking meat in the south. The *churrasco* is served in a piece of equipment that holds the pike in a horizontal position; nowhere in the world have I eaten more succulent meat. Europeans don't usually care very much for the manioc served with it; fried and well prepared, I found it delectable. The air was scented with the smell of burning wood.

In Brazil, the more modest sort of hotel-restaurant is called a *boîte* (the French word); there are also a good many small nightclubs in Copacabana, which is what the French usually mean by the same word, but Amado and his wife weren't familiar with them. We visited only the dim bars they term "little hells" on account of the more or less venal love affairs that come to fruition there in an atmosphere of dance music and drink. It was in these places that Graham Greene, having come to Rio for the Pen-Club congress and fleeing literary discussions, spent most of his time in the city.

We had felt an immediate sympathy for Jorge and Zelia when we first met them; in Rio, we became intimate friends. At our age, having seen so many links snap or disintegrate, we had not expected to experience again the heady sensation of budding friendship. The daughter of a Communist killed by the police and a Communist herself, Zelia had first met Jorge in the course of an election campaign; he had won her in an open fight from a husband whom she no longer loved; for fifteen years they had maintained a happy and vital relationship together. Zelia possessed a childlike naturalness and spontaneity which she owed to her Italian origins; she had character and warmth, a sharp eye and a lively tongue; her presence had a tonic effect on me, and she is one of the rare women with whom I have been able to laugh. In Jorge, too, passion and reserve were in equilibrium; one sensed, behind his deliberate manner, the violence of the forces held in check. He appreciated what he called "the good little things of life": food, landscapes, a woman's charm, conversation, laughter. Sensitive to others, always ready to understand and help them, he also had very decided aversions and a good deal of irony in his makeup. Solidly rooted in the soil of Brazil, he enjoyed a privileged position there: at a time when a country is struggling to overcome its internal divisions, it honors as heroes the writers and artists who reflect an image of the national unity to which it aspires. Everyone in Brazil who could read was familiar with *Gabriela,* and in no other country in the world have I seen an author who enjoyed such universal popularity. As much at ease in an "invasion area" as in the home of a millionaire, he was able to take us to see President Kubitschek exactly as he took us to visit the "mother of the saints."

As a young man, he had served a prison sentence under the Vargas regime. Later, when the Communist Party was declared illegal, he had gone with Zelia into exile. They had spent two or three years in Czechoslovakia during a difficult period. They had been to Paris, Italy, Vienna, Helsinki, Moscow, Pakistan, India, China, and I can't remember where else besides. He often teamed up with the Cuban poet Nicolás Guillen and the Chilean Pablo Neruda at congresses and on trips; to relieve the tedium of official visits, he used to play practical jokes on them. Watching an opera in Peking, between Guillen and their interpreter, he relayed a version of the plot to Guillen that shocked him by its obscenity. A few days after that, they had a discussion with some Chinese writers about the theater. "I fail

to understand," Guillen told them indignantly, "how you can re-
spect tradition to the extent of preserving whole scenes of pornog-
raphy in the plays you present for the people." The Chinese looked
quite stunned; Amado was choking with laughter, and Guillen sud-
denly understood. "Oh, you!" he said, without finding it funny at all.
In Vienna, Amado sent Neruda a series of telegrams addressed "To
the greatest poet of Latin America" just to annoy Guillen. However
he did include the latter in his confidence when he wrote a letter,
purportedly by a woman admirer who offered herself to Neruda.
Over breakfast Neruda read it to them, then suddenly grew morose:
"What a fool she must be! She's forgotten to give me her phone
number!" Both Zelia and Jorge knew scores of stories about scores of
people.

Zelia attended classes at the Alliance Française and spoke French
very well. Jorge spoke less correctly, but very fluently, as did the
majority of Brazilians we encountered. Both had a few "Brazilian-
isms" in common; instead of individual, man, fellow, or character,
Amado would always say monsieur. "I don't much care for the face of
that monsieur over there. . . . I think he's a rather unpleasant mon-
sieur." When telling us about our appointments for the day, he
would say: "You have three compromises this afternoon"; there was a
subtlety in his use of these expressions that we found too enjoyable
ever to correct.

The Amados lived two minutes from our hotel in a big apart-
ment with tiled floors, huge windows and a great many books; their
shelves were filled with pieces of folk art; from every corner of the
earth they had brought back vases, pots, toys, boxes, dolls, statuettes,
earthenware, pottery, musical instruments, masks, mirrors, embroid-
ery, jewels. A delicately colored bird flew at liberty around the
studio. They had a son and a daughter of about twelve and eight
respectively. The son, Juan, though urged by his high-school news-
paper to get an interview from Sartre, refused to do so for a long
while. "He says he hasn't anything to say to young people any more,"
he objected.[1] They had a friend staying with them, a Frenchwoman,
and Jorge's brother, a journalist, was a frequent visitor. It was like a
home to us. We went there almost every evening to drink passion
fruit, *cajou,* lemon, or mint *batidas;* sometimes we ate dinner there
or, if we dined out, the Amados accompanied us. Jorge decided
whom we should and shouldn't meet, he protected us from trouble-

---

[1] Alluding to the preface Sartre wrote for *Aden-Arabie.*

some people with a stubborn patience that infuriated more than one; one journalist to whom he had shown the door wrote a poisonous article accusing Jorge of keeping us under lock and key. The official lunches with university professors, writers, journalists, all took place at the edge of the bay; the place was so beautiful and the food so good that I scarcely got bored at all.

*Ultima Hora* was publishing *Ouragan sur le Sucre*. Rubem Braga and one of his friends, a left-wing Catholic, decided to put it out in book form. We discussed it with them. We saw Di Cavalcanti again. We drove along a series of sharply winding roads over the Tijuca to see Niemeyer. He lived up on the heights in a villa of his own design that looked more like an abstract sculpture than a house; there was a roof over the terrace, and the studio was open to the sky. He made us gin-and-tonics, and we sat down to chat as though we had known each other for ages. To build a whole city from scratch is an extraordinary opportunity for an architect; he was very grateful to Kubitschek for having offered him that chance and then upholding his choice against all comers. But he was a Communist—as was Costa, who had conceived the plan of the new capital—and he was asking himself a number of questions that he hoped to discuss with us at greater length in Brasília itself.

Apart from Villa-Lôbos, we scarcely knew any Brazilian music. The "samba schools" where the Carnival is rehearsed were not yet open. Amado played us some records. He invited over a composer who sang and accompanied himself on the guitar. The author of the play *Orfeù Negro* got up a musical evening for us. (He didn't like the film at all because it had betrayed the original, he said. All the Brazilians I met blamed Marcel Camus for having given such a facile and untruthful picture of their country.) We went to his house and met a group of boys and girls from the *Bossa Nova* who played piano, guitar and sang in a style of such discretion that "cool" jazz would have burned one's ears by comparison. As we left, Sartre told me that he felt the same embarrassment in the presence of the young girls there that Algren had experienced when confronted with the transvestites at the Carrousel. He would let his eye rest with pleasure on the pleasing face, the generous proportions of a young woman, and then suddenly wake up to the fact that he was ogling a little girl of thirteen!

We spent an evening at the home of Josué de Castro, whose enemies were saying of him, with great injustice: "Hunger feeds

him well." He was as interesting as his books, and funny as well. There were some young technocrats who told us about the Brazilian economy; that started a furious discussion. One of the subjects we touched on was the frequency of various kinds of accidents in Brazil. The Rio streetcars are always overloaded with clusters of people hanging on outside, and a single jolt is enough to send them flying. "And that's nothing compared to the suburban trains," Amado told us; passengers often fall off onto the tracks and get injured or killed. Castro and Amado, despite the fact that they'd both flown around the world almost three times, admitted that they almost died of fear every time they flew in a Brazilian plane,[1] and Niemeyer, they said, whenever he had to make one of his frequent trips between Brasília and Rio, always did the eighteen-hour journey by car rather than spend an hour flying it. Because there are so few roads and railroads, Brazil has the most extensive airline network of any country in the world except the United States, but its plant and equipment are very inadequate. As a country—and this is the reason for one of the most striking traits in the Brazilian character: bluff—it is living far beyond its means. It already has one foot in the future: prosperous industries, modern cities, abundant oil; yet it walks forward with only the poor tools it has inherited from the past: old tubs and flivvers, rattletraps and roads full of holes, inadequate laboratories, techniques, and administration; so it keeps falling flat on its face. Added to which, as in all countries under the domination of foreign imperialism—Cuba before Castro, China before Mao—corruption is rife; faced with a defenseless people in bottomless misery, the rich form a sort of Mafia which thinks of nothing but filling its own pockets as fast as possible; in building, transport, vaccines, food, the most elementary standards of safety are ignored. At a time when their undertakings have suddenly multiplied out of all proportion in every sphere—manpower, raw materials, space—the Brazilians have scarcely succeeded at all in reducing the risks inherent in all such enterprises during the nineteenth century.[2] Fires in the *favelas,* scaffolds collapsing, ferries sinking, overloaded trucks careening into ditches—something about these disasters reminded me of Italy on a gigantic scale; in Italy they wait for the workers to be killed before they start

[1] Two years later, in the summer of 1962, Castro was with his daughter and infant grandson in the plane that crashed into the sea after taking off from Rio. The baby was drowned.

[2] The dramatic affair of the Fortaleza vaccines and the monster fire in the Niterói circus have since provided tragic illustrations of what I have written here.

to get worried about the conditions they have to work in, but they do at least get worried; in Brazil they don't: there is a superabundance of unskilled labor, human lives aren't worth a pin.

Toward the end of the evening, Prestes arrived. I had read the book Amado wrote about him. In 1924, while still a captain in the army, he had taken his battalion with him and joined a Paulist revolution that had failed; for a period of six years, with a column of fifteen hundred men, he cut his way through Brazil, pursued by the police, preaching revolt. In the course of this first "long march," he was converted to Communism. In 1935, he attempted to stir up the army against Vargas and was sentenced to forty-six years and eight months in jail. His wife, of German origin, had her breasts cut off by the "green shirts" and was handed over to the Germans; she died in a concentration camp. In 1945, when Vargas left office, Prestes was released and took over the leadership of the Brazilian Communist Party, at that time the largest on the continent. The Party was dissolved in Dutra in 1947, and Prestes went underground. But from 1955 on, having succeeded in winning all the Communist votes over to Kubitschek, the Nationalist candidate, he had been able to live out in the open again. The position of the Communists in Brazil is curious. The Party still remains illegal; but every person has the right, on the grounds of individual liberty, to be a Communist and to meet with other people of the same opinions. Prestes no longer bore any resemblance to the handsome young "knight errant of hope" he had been in more heroic days. He delivered a long, dogmatic harangue attacking the peasant leagues and preaching moderation: Brazil would only become a Socialist country by doing nothing to try to become one. He was making the rounds of the public squares, speaking in favor of Lott, the governmental candidate, whom my friends were finding increasingly distasteful every day. "I'll vote for him, but he'll arrest me," was how Amado put it. Why didn't the Communists run a candidate who, without saying so openly, would be their representative? There were too few of them, they didn't like the idea of being counted. Only half the population was involved in the election battle: illiterates don't vote, and the peasants can neither read nor write. Yet the Brazilians claim they are democratic, and up to a certain point it's true. Arrogance is entirely foreign to them; superficially, masters and servants live together on an equal footing; in Itabuna, when the bailiff of the *fazenda* offered us a drink, our driver stayed in the salon and drank with us. The

split occurs lower down in the scale; the bailiffs don't treat the plan-
tation workers as equals, or even indeed as men. Up to a certain
point, too, the Brazilians refuse to adopt racist attitudes. Almost all
of them have Jewish blood, for the majority of the Portuguese who
emigrated to South America were Jews; almost all of them have
Negro blood. Yet I observed a marked anti-Semitic attitude in
middle-class circles. And not once, either in their drawing rooms, in
their universities,[1] or in the audiences at our lectures, did we see a
single dark or light-brown face. Sartre commented aloud on this fact
once, during a lecture at São Paulo, then he corrected himself; there
was one Negro in the hall, but he turned out to be a television
technician. It may be that the segregation is economic; the fact of the
matter is that all the descendants of the slaves have remained in the
working class, and in the *favelas* the poor whites consider themselves
superior to the Negroes.

This doesn't prevent the Brazilians from being attached to their
African traditions. All the ones I met were under the influence of the
Nago cults. Even if they were not, like Vivaldo, convinced of the
existence of the saints, they all believed in their powers at least.
When the "mother of the saints" revealed to us the names of our
divine patrons, Amado assured us that a consultation with another
priestess would give the same results. He was a high dignitary of the
*candomblé* and observed its precepts. Pushing away a dish of kidney
beans, he said to Sartre: "My saint forbids me to eat them; you're
Oxala; you're allowed everything white." He smiled as he said it; but
he certainly preferred to yield to such superstitions than to risk flout-
ing them. Sartre questioned Zelia, a practical, rationalist daughter of
the cities: without believing in the supernatural, she couldn't bring
herself not to believe in it. Amado's father was suffering from a
cancer and believed that an evil spirit was torturing him. Zelia con-
jured up a good spirit; the whole household took part in the rite, and
the housemaid went off into a trance; the old man's pains disap-
peared; every time they came back, the good spirit drove them away
again. "What is one to think?" Zelia asked. She usually wore a con-
secrated necklace in the colors of her saint. One little incident
seemed to us significant. Someone had given Sartre an amulet which
would assure him of Oxala's protection. After dinner one evening, at
a journalist's house, the guests all congratulated the cook. Zelia

[1] Vivaldo was the only exception; this was in Bahia, and although he was a half-
caste, his skin was very pale in color.

pointed to Sartre and said to her: "He has the same saint you do." Sartre showed her his amulet; the cook thought he was giving it to her and took it with thanks. The following day the journalist telephoned to Amado: Was Sartre sure he hadn't changed his mind about this gift now that he'd thought it over? Didn't he want the amulet back?

One morning, Zelia told us, one of their friends, O., who was running for Parliament, asked her to drive himself and his wife to the top of Tijuca before dawn. Obeying the prescriptions of a *babalaô*, they got out of the car, took a basket of eggs, and rubbed a dozen of them over their bodies, throwing each one into a ravine when they'd finished with it. They were supposed to distribute alms during the night; they scoured the town looking for a beggar and finally awakened a hobo sleeping on a bench. O. was not elected. He ran again while we were there and organized an *umbanda* ceremony which Amado suggested we attend. We crossed Rio in Zelia's car behind O.'s electoral van covered with stickers: *Vote for O.* Little Juan Amado was in the van and started shouting through the loudspeaker: "Vote for O. Vote for Sartre, for Amado. Don't vote for O." The van kept making detours to pick up O.'s campaign workers. It took us two hours to reach the northern sector; we wandered through the outlying suburbs for some time before we found the garden full of banners announcing the meeting O. was holding in the late afternoon. There was a hedge of shrubs around a big country-style house where a "mother of the saints" was raising a dozen adopted children; they slept anywhere and played under the trees. Very black, very fat, magnificently attired, she proudly showed us an altar, similar to those in Bahia but much more sumptuous. The vast table where we were to eat lunch was still bare. In the open-air kitchen women were bustling around the stoves. We were almost faint with hunger by the time three o'clock came around and they served us shrimps and rice, fried pork, all succulent but slightly spoiled by a pompous speech from O. Since we had some "compromises" in Rio that day, we slipped away in the middle of the banquet. O. was defeated in the elections again.

The Brazilian Left was hoping to establish close economic relations with the young nations of Black Africa. It was therefore critical of Kubitschek's visit to Salazar. The Brazilians have experienced dictatorship and loathe it, and colonialism is repugnant to them; the Portuguese exiles we met, democrats in Portugal, had a Fascist atti-

tude with regard to Africa: they wanted the Angolan revolt sup-
pressed. The Brazilians, who won their own independence only 140
years ago, are always on the side of any people fighting for it now.
That is why Sartre was able to awaken such a response by talking to
them about Algeria and Cuba; about Cuba especially. The Castroist
revolution involved them directly; they too were living under the
thumb of the United States and deeply preoccupied with agrarian
reform.

In Recife, to the great relief of the French consul, a big, kindly
man, Sartre spoke about Algeria without openly attacking the
French Government. He maintained this moderate attitude in Bahia
too. When the University of Rio—thereby demonstrating its liberal
attitude—offered one of its amphitheaters for his press conference,
Sartre decided to take the bull by the horns. When he was asked
questions about De Gaulle, about Malraux, he replied without equiv-
ocation. All the newspapers printed accounts of these conversations,
and from that time on, all the newspapers in Rio and São Paulo,
dailies and weeklies alike, carried pictures and detailed accounts of
Sartre's activities in every issue. An enormous number of people at-
tended the lecture he gave at the University, and also the one on the
colonial system sponsored by some young technocrats; it was given
at their Educational Center, and the hall was too small to accom-
modate the audience, which crowded onto the balconies and into the
gardens. Lecturer and listeners were all sweating like pigs, to such an
extent that when Sartre finally tore himself away from the applause
at the end, the dye in his jacket had run and turned his shirt blue.
Rubem Braga managed the *tour de force* of bringing out *Ouragan
sur le Sucre* before we left, and Sartre agreed, as a demonstration of
solidarity with Cuba, to sign copies of it publicly; for the same rea-
son, and despite my scruples, I sat beside him in a brightly decked
hall, behind a table loaded with copies of his book fresh from the
press, and signed some too. One person who bought a book, thinking
to give Sartre pleasure, had brought him a portrait of De Gaulle that
he had painted and framed with his own hands. At the University I
spoke—not because I wanted to, but because I had been asked—on
the position of women.

The French colony showed us unequivocal hostility. Not only
was Sartre expounding his point of view—in lectures, articles, radio
and television interviews, etc.—on Algeria and De Gaulle, he also

paid a visit to the G.P.R.A. representative living in Copacabana with his wife, a Frenchwoman who had been a teacher in Algeria. It was at their house that we saw some bogus issues of *El Moujahid* that had been doctored by the psychological service of the French army. They considered the work Sartre was doing on behalf of their cause in Brazil very important.[1]

Our stay in Rio was interrupted by the week or so that we spent in São Paulo, about an hour's plane journey away. "Wouldn't you rather have a nice quiet night in a sleeping car?" Amado suggested. He yielded with good grace. There was a crowd at the airport when we arrived, mostly young people carrying placards—CUBA SI, YANKEE NO—and acclaiming Sartre and Castro. We were taken under the wing of the "Sartre Society," consisting of students and very young professors.

The town isn't beautiful, but it's full of life. It's one of the cradles of Brazil; the Jesuits set up a headquarters here in the middle of the sixteenth century, and it was from here that the *bandeirantes* set out to conquer the interior. It is also the most modern city in Brazil: wide arterial roads, viaducts, tall buildings, bustling crowds, dense traffic, a profusion of little shops and luxury stores. Between 1900 and 1960, its population jumped from 80,000 to 3,500,000 and the city is still under construction; half-finished apartment blocks are everywhere. We noticed, however, that the construction workers only functioned in slow motion and, on certain sites, not at all. The enormous inflation into which the country had been forced was bringing on a recession; many projects had been abandoned. We were shown the Italian quarter, which has no character, and the Japanese quarter, which has a great deal; its inhabitants are almost all Japanese; the stores sell Japanese products, the restaurants serve Japanese specialties in the Japanese style. There is a very rich residential district: gardens full of flowers, colonial-style houses, ultramodern villas. There are also some *favelas;* there was a great deal of talk about the diary kept by a Negro woman called Caroline which gave a day-by-day description of the life of her *favela* in the harshest terms. A young reporter had discovered it by chance and the book

[1] When Ben Kheddah visited Brazil in the fall of 1961, he was struck by the services Sartre had rendered to the Algerian cause. He told Lanzmann and Fanon how, when he landed, the authorities had wanted to keep him out of the country; but the students who had come *en masse* to greet him marched him out of the airport in triumph. And immediately began talking about Sartre.

was on the way to becoming a best seller.[1] We noticed a great many posters in the busier streets vaunting the merits of the spiritist religion or announcing spiritist séances. I went down into Santos; it was a Sunday and the port was asleep. The promenade along the sea, with its palm trees, its squares, its kiosks, its baby carriages, reminded me of the beauty of Copacabana.

Intellectually, São Paulo, more industrialized, was even more alive than Rio. Press conferences, television appearances, meetings, discussions with young sociologists and economists, book signings, lunches with writers, a visit to the Museum with a group of painters who—what an ordeal!—looked at us while we looked at their paintings: we were kept busy. The more we got to know them, the more warmly we felt toward the Brazilian intellectuals. Conscious of belonging to a country on the way up, with the whole future of Latin America dependent on it, their work was for all of them a battle to which they had committed the whole of their lives; their curiosity was vast and insatiable; since they were on the whole very cultured and had quick minds, it was profitable and pleasant to talk to them. They were acutely conscious of social problems. With so many *favelas* dotted about their towns, the Brazilians can never forget the existence of poverty; it is a perpetual wound to their national pride; it is a challenge to their democratic sentiments; even the right-wingers worry about it and try to fight it.[2] The middle-class leftists and the intellectuals are forced to take up revolutionary attitudes. We were struck by one phenomenon that is to be observed all over Latin America: there are great landowners and very rich businessmen who are Communists. This is because they feel that only socialism can enable their countries to free themselves from the imperialist yoke of the United States and so save the great mass of their compatriots from a degradation that reflects on them. Obviously these are exceptions, and the intellectuals play only a very small role. It must not be thought that revolution is just around the corner.

One morning *Ultima Hora* arranged a meeting for Sartre with the trade union leaders. They didn't all give the same answers to his questions, but several definite facts emerged from this conversation

[1] It has since been translated into French under the title: *Le Dépotoir.*

[2] It goes without saying that the immense majority of the privileged classes are fighting tooth and nail, above all else, to defend their privileges, and it is they who are largely responsible for the poverty. At least they do not evince the same indifference to it that one finds in other countries. The *Estado de São Paulo*, which is a right-wing publication, printed a noteworthy study of the city's *favelas* while we were there.

which further talks later confirmed. The workers of Brazil have only just emerged from the peasant class; either they have been peasants themselves or their fathers were; since their standard of living is considerably higher than that of the country districts, they think of themselves as a privileged class. They have no solidarity of interest with the starving people of the Northeast or the day laborers in the South. Some of them are strongly aware of belonging to an exploited class; but all believe that at the moment a certain degree of collaboration with the great capitalists is necessary. The attitude of the latter is ambiguous. They would like to appropriate for themselves the entire resources of Brazil, which at the moment are for the most part in the hands of American corporations; but in order to develop their resources, they need the financial support of the United States; consequently they end up fighting imperialism and playing into its hands at the same time. Insofar as the capitalists aim at making the country economically independent, the working class sees their success as a promise of future prosperity; this is the explanation of the support accorded first to Kubitschek and then to Lott by the Communists. Leaving aside its state of subordination to the United States, the situation of Brazil as a nation recalls that of Italy, conditions in the North and the South being reversed, but it is more tragic because of the underdevelopment and the extent of the territory concerned. National unity works against the North, because the great landowners in that region invest their profits in the industries of the South, thus denying the North any opportunity for development. Doomed to hunger, the peasants are in a revolutionary situation; but their dispersion, their apathy, their ignorance, all work against the possibility of their acquiring class-consciousness, and they are almost entirely unable to come to grips with the situation; the working class is awakened and possesses the practical means necessary for the struggle, but it is not in a revolutionary situation. As for the lower middle class, in Cuba their lack of opportunities roused them against Batista; here, their hopes are fed by the growing industrialization, and they accept the status quo. It would be a long while, in the opinion of the people we talked to, before socialism would stand much chance in Brazil.

Once more I found myself talking about women in a large flower-decked and scented hall, addressing a lot of bedizened ladies who were thinking exactly the opposite of what I was saying; but a young woman lawyer thanked me on behalf of all working women. The

condition of women in Brazil is difficult to define. It varies from region to region. In the Northeast, a young girl—even if she lives in a *favela*—has no chance whatever of marrying if she isn't a virgin; she is kept under strict surveillance by those around her. The big industrial towns of the South are much more liberal. In Brazil, divorce does not exist. But if a man and a woman, one of whom is already married, decide to start living together, they put an announcement in the newspaper. They are then accepted as a legitimate couple even in the starchiest and most old-fashioned circles, and their children have the right to bear the father's name and inherit his property. All well and good, but the price a mother has to pay is that when she leaves her home, she forfeits all rights to her children. And when a man dies, only his first wife can inherit his property; the companion who has shared his life without an official contract doesn't get a cruzeiro.

Sartre gave a lecture on literature and another on colonialism in a theater holding six hundred; it was full when we arrived, and the police were holding off a crowd of about four hundred milling around outside the doors; their shouts of frustration could still be heard as Sartre began to speak. Suddenly, having broken through the cordon, they surged into the auditorium, sat down in the aisles and clung to the walls, to the accompaniment of loud applause. There were two Frenchmen who demanded to be allowed to speak in defense of "French Algeria"; one might almost have thought they were accomplices deliberately planted by Sartre to make fools of his adversaries; one of them, in any case, was a notorious eccentric. A French professor and a French priest also in the audience both assured Sartre of their solidarity.

There is an attempt on foot in Brazil to decentralize higher education. A university had just been founded at Araraquara, a town of some 80,000 inhabitants a few hours' drive from São Paulo. Professor L., hoping to gain some publicity for himself, maneuvered so persistently and so cleverly that Sartre finally agreed to go there and talk on dialectics to the philosophers and on colonialism to the students. We left as darkness fell and then stopped for the night at the *fazenda* owned by M., the editor of the *Estado de São Paulo,* as Amado had arranged. M.'s newspaper is a right-wing publication, but very different from the ones at home. I have already mentioned that it was conducting a campaign against poverty in the *favelas;* left-wingers also wrote for it; it was giving Sartre and his lectures a great deal of favorable publicity. As a "liberal" opposed to Vargas's semi-dictatorship, M. had been in prison with Amado, and they still maintained  a

polite relationship. Some reporters photographed us on behalf of the paper. During dinner, M. talked to us about the Negro problem. "We're not at all racist here," he explained, "only—and it's our fault—we haven't managed to educate the Negroes to our own intellectual and moral level. So of course they inevitably stay at the bottom of the social scale." At the other end of the table, his three grown-up sons sat grinding their teeth; they would doubtless have expressed the same ideas, but with more subtlety. The father, astonishingly hale and hearty, despite his great age, launched into a diatribe against women who smoke: the neuroses particular to our sex, according to him, are all exacerbated by tobacco. His wife, who seemed to have her nerves under perfect control, then showed us to the vast, old-fashioned rooms that had been prepared for us.

When I awoke, I was dazzled by the brilliance of the trees, the grass, the passion flowers, the hibiscus, the yellow, orange, pink, purple bougainvillea. We inspected the plantation. The coffee torn up by the roots, burned, thrown into the sea—that abstract scandal of 1928 or so—was these dark-green plants stretching across the plateaux; the whitish seed inside the tiny fruits had almost no taste. Vast and monotonous, but with pleasant valleys, and great trees on the horizon, the countryside looked contented under its pale sky. But Amado had already described to us the drudgery of the harvest; it only lasts a few weeks, during which the agricultural workers are given lodgings by the owner; sometimes he keeps them on till the following year, but if he decides to reduce his labor force, or renew it, he is within his rights: they simply have to leave and look for an opening somewhere else. Below the M. family's estate, along one side of the courtyard where the coffee beans were drying, was a schoolhouse containing twenty or so children. Next year they would probably be a hundred miles away; it wouldn't be easy for them to learn to read. The quarters for the day laborers were better than the pigsties we'd seen at Itabuna, but still very poor.

At Araraquara, Sartre bolted down a few sandwiches and then, at about two, went into the banner-hung amphitheater: "Viva Cuba! Viva Sartre! You've talked about the *bohios;* now talk about the *favelas.*" The students had a discussion with Sartre about the possibilities of a revolution in Brazil similar to the one in Cuba. Sartre asked them questions about the peasant leagues, and spoke to them about the necessity of agrarian reform. "They all seem to be revolutionaries to a man!" I said to Amado, with whom I took a walk later

on through the deserted Sunday streets, while Sartre was looking over his notes. "It will pass when they've become doctors or lawyers," he answered. "Then they'll ask for nothing better than a national capitalism independent of the United States. The peasants won't be any better off." As we neared Professor L.'s house on our way back, we saw a great stream of automobiles, trucks, vans and coaches appear. It was the enormous crowd coming back from a soccer match; the Brazilians are fanatical about them.

Sartre spoke on dialectics. We left late, ate dinner in a *churras-caria,* and the night was already far advanced when we drove off the main road in order to get to M.'s *fazenda* where we were to spend the night again; the driver got lost on the dirt roads that connect the plantations. At last we glimpsed a tiny light in the distance, we began navigating by it, losing it, finding it again, circling around it without being able to reach it. It was two in the morning before our car finally drew up at the foot of the steps; the lamps were lit, the doors wide open; we went in and found our rooms. Yet another example of the Brazilian hospitality which added so much charm to our trip. When I came down next morning, there was Amado in the corridor, hilarious at the reactions of Professor L., whom he didn't like. "That poor monsieur almost had a heart attack!" he told me. Unfolding his paper that morning, L.'s eye had fallen upon the headline: SARTRE PREACHES REVOLUTION. He had given a great groan: "I'm ruined!"

Sartre had become very popular with the young people. Two or three times in São Paulo we arranged to spend the evening on our own. The harshness of the city was softened in the dusk, the pedestrians walked less quickly, a Negro went by singing; after the tumult of the day, we enjoyed this dreaming calm. Often, cars would draw up: "Can we take you anywhere?"

In Rio, students would accost us on every street corner. "What do you think about yourself, Monsieur Sartre?" one girl asked at the end of a lecture. "I don't know," he answered with a laugh, "I've never met myself." "Oh! How sad for you!" she cried impulsively. There happened to be a representative of the French Government in Rio at the same time as ourselves; there was a cocktail party in his honor; a Brazilian friend of ours, more than a little tight—according to his own account—took the guest of honor aside: "It isn't you who represents France; it's Jean-Paul Sartre." The official smiled; since Brazil was according Sartre a triumph, it would have been a blunder to try to clip this feather out of France's cap. "We represent two different

aspects of France," he said. The Brazilian intellectuals were grateful to Sartre for embodying the *other* aspect. Rio awarded us the title of "honorary citizens." There was a brief reception during which our diplomas were presented to us.

It was difficult for us to get hold of French newspapers, but our friends kept us up to date on what was happening in France by letter and telephone. The Jeanson trial began on September 7th; Jeanson's lawyers wanted Sartre to be there, but he had accepted commitments in Brazil and did not want to abandon the action he had engaged there on Algeria's behalf. He was of the opinion that a letter would carry just as much weight as his oral testimony. The mail service from Rio to Paris is not quick, and letters even risk getting lost en route. Sartre telephoned Lanzmann and Péju and explained to them at length what he wanted to include in his declaration to the court. He then charged them with the actual writing of the text which was read out on September 22nd:

> Finding myself unable to attend the hearing of the military court, a state of affairs I profoundly regret, I should like to explain myself in greater detail on the matter discussed in the telegram that I dispatched earlier. Merely to have affirmed my "total solidarity" with the accused is, in fact, not enough: I must still say why. I do not think that I have ever met Hélène Cuènat, but I am fairly familiar, through Francis Jeanson, with the conditions surrounding the work of the "organization of support" now on trial. Jeanson, I repeat, was a colleague of mine for a long time, and if we were not always in complete agreement, as is natural enough, the Algerian problem in any case brought us together again. I followed his efforts day by day, and they were those of the French Left Wing attempting to find a solution to this problem by legal means. It was only when confronted by the failure of those efforts, by the manifest impotence of the Left, that he resolved to engage in a clandestine action that would provide concrete support to the Algerian people in their struggle for independence.
>
> But it is as well to clear up an ambiguity at this point: this practical solidarity with the Algerian fighters was not dictated to him solely by the nobility of his principles or by his general wish to combat oppression wherever manifested; it sprang too from a political analysis of the situation in France itself. The independence of Algeria has in fact been won. Whether it will occur in a year's time or in five years' time, with the agreement of France or without it, after a referendum or through internationalization of the conflict there, I do not know, but it is already a fact, and General De Gaulle himself, brought into office

by the champions of French Algeria, now finds himself constrained to admit: "Algerians, Algeria is yours."

This independence therefore, I repeat, is a certain fact. What is not certain is the future of democracy in France. For the war in Algeria has made this country rotten. The increasing restriction of liberties, the disappearance of political life, the general acceptance of the use of torture, the permanent opposition of the military to the civil powers, are all marks of a development that one can without exaggeration qualify as Fascist. In the face of this development, the Left is powerless, and it will remain so as long as it refuses to unite its efforts with those of the only force which today is truly fighting the common enemy of Algerian and French liberties. And that force is the F.L.N.

This was the conclusion reached by Francis Jeanson, it is the conclusion I have reached myself. And I think I may say that there are now more and more French people every day, especially among the young, who have decided to translate it into action. One is able to see things more clearly when one comes into contact, as I am doing in Latin America at this moment, with public opinion abroad. Those whom the right-wing press is accusing of "treason," and whom a certain section of the Left is hesitating to defend as they should be defended, are widely considered abroad as the hope of the France that is to be and its noblest manifestation today. Not a day passes without my being asked about them, about what they are doing, about what they feel; the newspapers are ready to open their columns to them. The representatives of the "young resistance" protest movements are invited to their congresses. And the declaration of the right to disobedience in the Algerian war, which I signed together with a hundred and twenty other university teachers, writers, artists and journalists, has been acclaimed as a reawakening of the French intelligence.

In short, it is important in my opinion to understand clearly two points that you will excuse me for setting out rather superficially, but it is difficult in a statement of this kind to get to the bottom of things.

Firstly, those French people who are helping the F.L.N. are not animated simply by noble sentiments with regard to an oppressed people, nor are they putting themselves at the service of a foreign cause; they are working for themselves, for their own freedom and for their future. They are working for the establishment of true democracy in France. Secondly, they are not isolated, but benefit constantly from an ever more numerous body of helpers and from an active or passive sympathy that never ceases to grow. They were in the van of a movement that will perhaps have awakened the Left, recently bogged down in a despicable caution. They will have made it better prepared to face

the inevitable trial of strength with the Army that has been hanging fire since May of 1958.

It is obviously difficult for me to imagine, far away as I am, what questions the military court would have wished to put to me. I suppose, however, that one of them would have concerned the interviews that I gave to Francis Jeanson for his broadsheet *Vérité pour . . .*, and I shall reply to it without evasion. I do not recall either the exact date or the precise terms of this conversation. But you will be able to find it easily enough if the text in question is included in the prosecution's file.

What I am certain of, on the other hand, is that Jeanson came to see me in his capacity as the prime mover in the "organization of support" and of this broadsheet which was its mouthpiece, and that I received him knowing exactly what was at stake. I met him two or three times more after that. He concealed none of his activities from me, and I approved of them entirely.

I do not believe that there exist noble tasks and common tasks in this field, activities reserved for intellectuals only and others that are unworthy of them. During the Resistance, the Professors of the Sorbonne did not hesitate to carry messages and work as contacts. If Jeanson had asked me to carry dispatch cases or give shelter to militant Algerians, and I had been able to do so without risk to them, I should have agreed to do so without hesitation.

These things must be said, I think; for the moment is now approaching when each one of us must assume his responsibilities. It so happens that those most deeply engaged in political action, hampered by some lingering respect or other for the outward forms of legality, still hesitate to go beyond certain bounds. So that it is in fact the young people, supported by the intellectuals, who, as in Korea and Japan and Turkey, are beginning to tear aside the mystifications of which we have been made victims. Hence the extraordinary importance of this trial. For the first time, despite all the obstacles, all the prejudices, all the promptings of caution, Algerians and Frenchmen, fraternally united by a common combat, are standing side by side in the prisoner's box.

All efforts to separate them are vain. Vain, too, will be the attempt to present these Frenchmen as lunatics, as criminals, or as romantics. We are beginning to be tired of false indulgence, of "psychological explanations." It must be said quite openly, quite clearly, that these men and these women are not alone, that there are hundreds of others who have already taken over where they left off, and thousands who are ready to do so. A contrary fate has temporarily separated them from us, but I dare say that they stand in that box as our representatives. What they represent is the future of France, and the ephemeral

power that is now preparing to pass judgment on them has already ceased to represent anything at all.

The entire French press considered this statement as a challenge that the government must, for its self-respect, take up. M. Battesi, the deputy for Seine-et-Marne, in a written question, asked that legal action be taken against Sartre. *"Sartre,"* wrote P.–H. Simon, *"has presented the government with the choice of either sparing him, in other words showing themselves to be weak, or of taking action against him, in other words weakening themselves by entering into conflict with a great mind."* Meanwhile, in the matter of the Manifesto of the 121, disapproved of by *L'Express* and *Humanité*, an investigation of persons unknown had been opened. On September 8th, *Paris-Presse* carried the front-page headline: JEAN-PAUL SARTRE, SIMONE SIGNORET AND 100 OTHERS RISK FIVE YEARS IN JAIL. The French embassy in Rio was letting the whole world know that Sartre would be arrested when he got back to Paris. The French Government announced that in future the penalty for incitement to disobedience would be from one to three years' imprisonment; it would be more severely punished on the part of a civil servant. By the time we left Rio, several signatories had been charged; among others, Daniel Guérin, Lanzmann, Marguerite Duras, Antelme, and Claude Roy. In the course of a banquet, M. Terrenoire, then Minister of Information, had declared: *"Sartre has replaced Maurras and represents an anarchic and suicidal dictatorship aiming to impose itself on a bewildered and decadent intelligentsia."* Whole pages in the newspapers were devoted to the Jeanson organization, to the "121" in general and to Sartre in particular. A cloudburst of insults and threats.

With Amado, his brother and Zelia, we landed one morning at Belo Horizonte, the capital of Minas Gerais State, which had at one time overflowed with gold and diamonds. Niemeyer had promised to send us a station wagon and driver from Brasília. No one was to be seen; our trip was beginning badly. Finally the car arrived, driven by a man with moustachios. We saw a Niemeyer-designed chapel beside a blue lake, and then, in the town, another sample of his work, a very beautiful apartment building that seems to move as you go around it.

We spent the afternoon at Sabará, once inhabited by gold pros-

pectors; in the Gold Museum, an old colonial-style house where the gold was once weighed and stored, there were samples, nuggets, tools, models and panoramas re-creating the town's past. With its narrow streets, its tiled roofs, Sabará looked like a little town in Europe. In the churches, with their gaily painted moldings, their red and blue walls, we observed with surprise that in the frescoes, God, the angels and the saints all had slanting eyes: the Portuguese artists who painted them had once lived in Macao.

We had already seen some minor works of Aleijadinho,[1] the slave with hands gnawed by leprosy, who ranks as the greatest sculptor and architect of colonial Brazil. We went up the central street of Congonhas, very straight, narrow, full of rubbish, cripples, and hungry-eyed children, as far as the great terrace above which rises the church he erected there, together with the twelve soapstone statues of the prophets; several of them, roughhewn and inspired, are very beautiful and the group as a whole is striking. From the porch down to the foot of the hill, there are over-life-size figures inside glass kiosks representing scenes from the Passion; garishly colored, naturalistic, theatrical, they prove that Aleijadinho was prolific, but also that he sometimes lacked discrimination. At Ouro Prêto we sensed his genius: it was he who had conceived those admirable façades, the cunning balance of their curves that catch and hold the light, the diversity of their designs.

We arrived in the capital of black gold as night fell. The hotel where we spent the night was an early work of Niemeyer's; he was so fond of staircases at the time that he had put one in every room. Next morning, I looked down from my balcony onto faded red roofs, tortuous streets, gardens, terraces, here and there yellow or blue windows making a bright splash of color, all around, hills covered with glossy greenery; there were steps leading up to distant churches; a light, gentle air with a smell of the country caressed my lungs. We set out on foot. From church to church, from square to square, we went up and down streets and steps, across old bridges. One of the old painted houses was pointed out to us as being the one where they arrested Tiradentes—the teeth puller—who plotted against Portuguese domination in 1788; a statue has been put up in Rio, in the square where he was hanged and quartered. On the main square of Ouro Prêto there is a museum devoted to the *Inconfidentes* of which

[1] "The little cripple." His name was Antonio Francisco Lisboa and he lived from 1739 to 1814.

he was the leader. I left Ouro Prêto regretfully; it was a place where I should have liked to stay longer.

The next morning in Belo Horizonte we had another long wait for our driver. During the journey we understood why he was always late: all the dashboard compartments were packed with watches and jewelry he was hoping to sell in the towns where we stopped. He explained to Amado that he was combining the functions of chauffeur and cop and that this double function provided many fruitful contacts with a professional body very important in Brazil—the smugglers. He confiscated their merchandise from them or bought it at low prices, then took it on to Brasília, where the people were cut off from the rest of the world and willing to pay very high prices. He described his various ruses with typically Brazilian innocence, we were told by a delighted Amado.

We drove all morning across the *cerrado* along an infinitely straight road: brush, thorny shrubs, stunted trees without a single green leaf or a flower, except, at rare intervals, unexpectedly, great purple clusters swaying amid the bare branches. For hours we didn't see so much as a hamlet, not even a house, only, two or three times, one of those "sullen animals" La Bruyère described: a barefooted, ragged, emaciated peasant. Despite the opposition of our cop-driver, who didn't consider the place a suitable one for his particular commerce, we stopped for lunch in the middle of the desert, in the artificial town that has been created on the bank of the San Francisco during the construction of a large dam. Laborers, engineers, technicians with their families, about fifteen thousand people live there in huts set directly on the gravel and surrounded by barbed wire. To get in, we had to show our identification papers. An official escorted us around and showed us the colossal dam, still unfinished, which was to make irrigation of the region possible. After lunching in the restaurant hut, we set off again on our dismal way. The town where we spent the night had an airport, but no electricity; we went out walking after dinner along dark streets full of people coming home after an election meeting, all bumping into each other in the dark; every so often there were acetylene lamps or candles in a bistro; we drank *cachaça* as a few fireworks were set off, rather desultorily. Then the same brush, the same solitude for another whole day; that evening, at last, we reached Brasília.

"A life-size model," I noted down. I learned with regret later that I had overlapped Lacerda's phrase: "An architectural exhibition, life-

size." This inhumanity is the first thing that strikes one. The main avenue, 400 feet wide and 16 miles long, is curved, but so slightly that it seems quite straight; all the other main roads are parallel to it or cross it at right angles, all danger of collision being removed by the use of cloverleaf crossovers. The only way to get around is by car. In any case, what possible interest could there be in wandering about among the six- or eight-story *quadra* and *super quadra,* raised on stilts and all, despite superficial variations, exuding the same air of elegant monotony? They intend to build a section for pedestrians only, on the model of Venice and its network of *calle;* so you'll have to get in a car and drive six miles just to be able to walk. But the street, that meeting ground of riverside dwellers and passers-by, of stores and houses, of vehicles and pedestrians—thanks to the capricious, always unexpectedly changing mixture—the street, as fascinating in Chicago as in Rome, in London as in Peking, in Bahia as in Rio, sometimes deserted and dreaming, but alive even in its silence, the street does not exist in Brasília and never will. Each section of housing, designed for fifteen thousand people, has its own church, its own school, stores and playground. While he was with us, Niemeyer sadly wondered out loud: "Is it possible to create Socialist architecture in a non-Socialist country?"; he answered his own question: "Obviously not." Social segregation here is more radical than in any other city, since there are luxury blocks, middle-income blocks and low-income blocks. The people who live in them do not mix; rich children do not rub elbows with poor children on the school benches; nor does the wife of the highly placed civil servant brush against the clerk's wife at the market or in the church. As in American suburbia, these communities allow their members only the absolute minimum of privacy; since they are all the same, they have nothing to hide from each other. Brasília is like the crystal city Zamiatin envisaged in *Nous Autres:* great glass windows take up the whole façade of the buildings and people feel no need to draw their curtains; in the evening, the avenues are so wide that you can see all the families from top to bottom of the buildings living inside their brightly lighted rooms. There are certain residential streets lined with low houses that are referred to as "the *catingo*'s television";[1] through the large windows on the ground floor the workers can watch the rich dine, read the newspaper, and watch their own television. Apparently there are

[1] The *"catingos"* are the workers brought in from the country districts to build Brasília.

clerks and secretaries who are mad about Brasília. But the ministers themselves are still nostalgic for Rio, and Kubitschek had to threaten to ask for their resignations in order to make them settle in the new capital. Tiny jet planes allow them to hop from one city to the other in an hour.

However, each of the public buildings Niemeyer has designed is individually very fine: the Palace of Government, the High Court building, the two skyscrapers of offices, the inverted hemispheres containing the House of Representatives and the Senate, the cathedral in the form of a crown of thorns. They are made to balance and harmonize with each other by a series of subtle asymmetries and bold contrasts that is completely satisfying to the eye. Niemeyer pointed out how the sun-screens, such an important element of modern Brazilian architecture, fulfill the same role as the volutes of baroque art: they give protection from the sun while at the same time avoiding straight lines. He explained the problems he had to solve in order to achieve certain feats; the horizontal sweep of one sun-screen, apparently without support, never fails to astonish visitors. Thanks to his measured extravagance, in this palace of functionaries one escapes—at last!—from the functional.

A long way off, at least six miles, rises the Dawn Palace, the residence of the President, flanked by a spiral chapel which is perfection. It is reflected in a pool in which two bronze nymphs are arranging their hairdos; the story runs that they represent Kubitschek's daughters, tearing out their hair in despair over their exile in Brasília. As we were driving along a track through the brush, the mayor, who was escorting us around that day, suddenly cried eagerly: "Ah, there's the French Embassy!" I looked back; there was a big placard that read FRENCH EMBASSY; there were other placards indicating the sites of other embassies.

The Brasília Palace, half a mile from the Dawn Palace, is also a Niemeyer building and very lovely, but suffocating inside; and what a long way to go! Even by car, buying a bottle of ink or a lipstick was an arduous expedition because of the heat and the dust. The wind and the soil have not proved amenable to the planners' decisions, which are flouted everywhere by incandescent whirlwinds of dust. On the Plaza of the Three Powers it would take fortunes to cover the red laterite with asphalt. Man wrested this most arbitrary of cities from the desert, and the desert will take it back from him if ever his determination begins to weaken; it lies there on every side, menac-

ing. The artificial lake is no refreshment to the eye; the sheet of blue water seems no more than an earthly reflection of the burning sky.

Amado and Niemeyer took us in to meet Kubitschek; we had a brief, very formal talk with him in his office. He considers Brasília as his personal accomplishment. On the Plaza of the Three Powers there is a museum, designed by Niemeyer, devoted to the history of the new capital. It looks like an abstract sculpture, simple, unexpected and very beautiful; unfortunately, from one of the walls, larger than life and green, protrudes the head of Juscelino; underneath are carved the tremendous eulogies he inspired. On Sunday, people go on pilgrimages—where else would they go? Outside Brasília there is literally *nothing*—to the wooden house where he would come for short periods when work was just beginning on the city; they look around it, have a drink in the café in the shade of the few trees, and contemplate his statue which has inscribed on its base the words: THE FOUNDER, and an account of his exploits.

If you need an airplane ticket, medicine, or anything at all, you go about twelve miles out to the "free city" where building is not officially regulated. As soon as the plan of Brasília had been laid out, the workmen hurriedly threw up a lot of wooden huts which were made into stores, hotels, restaurants, agencies and homes. It looks almost like a frontier town, except that instead of horses and carts there is a deafening stream of automobiles, vans, and trucks plowing up the red roads; stores belch out ear-shattering music, the advertising vans shriek slogans at you. The sidewalks are a madhouse; your feet get trampled, the dust turns your shoes red, gets in your ears, irritates your nostrils, and makes your eyes smart, while the sun bludgeons the top of your head; yet you are happy here, simply because you are back in the land of men. Fires are frequent; in the dry heat, the wood ignites quickly; just before we got there, a whole neighborhood had burned down; no victims, but charred remnants, twisted wood, blackened furniture, ironwork, disemboweled mattresses. The gloom of these sights was dispelled, however, as we watched the *catingos* slapping each other on the shoulder in the street and laughing. No one laughs in Brasília. During the day, people worked; sometimes in the evening they would wander dismally around this world they were building and that was not for them.

To understand them, I had to remind myself of the human animals we had passed on our way here, of the hovels of Recife, and all I knew of the Northeast. I had just read Amado's *Hunger Road* in

which he tells the story of an exodus long ago through the *catinga;* at that time the peasants scourged by hunger—the *flagelados*—set off on foot toward the South, and very few survived. Now they all huddle into old dilapidated trucks which are referred to as "parrot perches." Overloaded, with the drivers keeping themselves going on *cachaça,* they often end up down in the ditch; the newspapers tuck away the announcement of the twenty or perhaps fifty deaths on a back page. Sometimes—and I was told this happened in Brasília—when a contractor needs an unskilled labor force, he pays a conveyer a small sum per head to bring in recruits. Once on the site, the men are obliged to accept the wages and living conditions that are offered them. The laborers working on Brasília were all squashed together in "satellite towns," gigantic *favelas* ten or fifteen miles away from their work. I observed that the drivers of the trucks that take them across the city treat them with incredible brutality; they wouldn't slow down at the stops, and the *catingos* had to jump off while the truck was moving, often falling head over heels on the ground. I was told that they were sometimes injured, or even killed.[1]

I heard a great many discussions about Brasília. The rulers of Brazil had been thinking of transferring the capital of the country inland for nearly a hundred years, and the scheme has always been popular. But the site of Brasília isn't in the real center of the country; rising as it does on the fringe of vast tracts of unexplored territory, it is more like a "last frontier outpost." And the scrub around it will not be reclaimed by civilization for a long time to come. A German agronomist who was approached on the subject of getting it under cultivation replied: "All right. But it means importing thousands of bulldozers, trucks, tractors. And then tons of fertilizer . . . and also soil." There are no agricultural, mineral, or industrial resources whatsoever around Brasília. It risks remaining for a long time to come nothing but a very distant suburb of São Paulo and Rio, linked to them by a single road—the one we came by—and by air. But that is exactly the reason, Kubitschek told us, why Brasília, by its very existence, will force into being a network of roads that will help unify the country; the highway through the virgin forest that is to link Belém to Brasília is already under construction. His opponents reply that the work has already cost a sum, in human lives as well as

[1] The satellite towns were scheduled for demolition once the capital was finished. But the laborers preferred to stay and try their luck in Brasília rather than go back to the country, so the towns are still there.

in cruzeiros, that no practical advantage can ever repay, unless it be the creation of a smuggling route—American automobiles, scent, etc.—from Belém down to Sãn Paulo and Rio. The fact is that the Northeast doesn't need any outlets, because it has almost no products; on the other hand, its poor artisan class—the cobblers for example—risk being ruined by an influx of manufactured goods from São Paulo. The capital that has been sunk into Brasília should have been used to give the Northeast a network of local roads, to irrigate it and set up industries there. Amado admitted that Brasília was a myth, but, he added, Kubitschek was able to obtain support, credit and sacrifices from the people only because it was a myth he was selling; any more rational, less fascinating project the nation would have rejected outright. Perhaps. I still retain the impression of having seen the birth of a monster whose heart and lungs are made to function artificially by methods devised at breathtaking cost. In any case, if Brasília survives it will fall prey to speculators. The lands along the lake, which in Lúcio Costa's original plan were to remain public property, are already being sold off by the municipality to private buyers. Yet another example of the contradictions prevalent in Brazil: the number-one city of this capitalist country was built by architects who were also adherents of the Socialist cause. They have accomplished beautiful work and built a great dream, but it was never possible for them to win out.

I wanted to see some Indians. Amado told us that there were some to be found about 500 miles away, on an enormous and almost deserted river island where Kubitschek had just founded a new town, the farthest west in all Brazil. The governor of the island invited us there. Amado, who really did dislike airplanes, stayed in Brasília. His brother and Zelia climbed with us into the little aircraft that had been put at our disposal; there were just the four of us plus the pilot and a steward. We flew over still-virgin savannas of dark, changing green. After two hours, the river appeared, clasping between its giant arms an island so long we couldn't see the other end. "The Indians will be at the airfield," the pilot said with a laugh. He wasn't joking. We could see them from a long way off, almost naked, feathers on their heads, bows in hand, their long straight hair framing their red and black painted faces. "Do you want to go up to them, or would you rather they came to you?" we were asked as we climbed out of the cockpit. We went to them. They shouted greetings at us with utter lack of conviction. There were women hanging back behind them

dressed in their usual rags, babies in their arms, looking worn out. We felt appallingly embarrassed by this masquerade and our idiotic role in it. Exchange of smiles, handshakes; they gave us—as they had been told to do—weapons, arrows, feather headdresses which they had to put on our heads themselves. Then, although it was like walking through a furnace, we were taken around their village: along a bamboo hedge, huge tents full of women and children lying on the ground or sleeping in hammocks. Protected by the government, they fish, cultivate a few plots of ground, make clay dolls and pots which are sold on their behalf or which they give as presents to visitors— who in exchange hand over a sum of money to the foundation. We left with some baked-clay drinking vessels decorated with black and red patterns, and some figurines: sitting and standing women, some cradling infants, some working. Inside the dark tents I noticed some wretched featherless parrots; they had been stripped of their plumage to provide the headdresses we had been given. With their ceremonial paint washed off, some of the men looked quite robust and contented; the women, although we had been told they had a great deal of influence within the community, seemed degenerate. Removed from their natural way of life, without having been assimilated like the Indians in the reservations of New Mexico, their existences were as artificial as those of wild animals in a zoo. The pilot had suggested that another hour's flight would allow us to see another less domesticated tribe. I was hoping we'd be able to snatch a quick lunch and then set off again.

A jeep took us into the center—canteen, dormitory, dispensary— where the people working for the foundation lived. There was a young doctor full of blind contempt for the Indians and two bearded men who loved them and hence quite deliberately scorned the other white people. They had recently just missed being massacred by a tribe on the Mato Grosso, but that hadn't made them feel any differently. They could have given us the information we would have liked about the village, but despising as they did all tourists who came looking at other men as though they were strange beasts, they turned their backs on us with admirable discourtesy. We stayed sitting on the veranda, looking out across the vast river flowing beneath us toward the danger-filled Mato Grosso on the other side. At last we heard the thrumming of an airplane: the governor and supplies. The governor greeted us, emptied a bottle of beer without offering any to anyone else, and lay down in a hammock. People began piling tables, chairs, crates of dishes and food into jeeps and an

amphibian truck: we were going to eat in the new town Kubitschek
had founded, a few miles away. When? I was hungry, I was thirsty, I
was hot, the whole expedition seemed to me an idiotic mistake. An
old ex-*cacique* came and smoked his pipe near us, delivering a mono-
logue in Portuguese. Someone told us that when he was named
*cacique,* one of his cousins had disputed his claim and lodged a com-
plaint with Vargas, when he came to visit the village. "Let the best
man win," the President said, and invited them to settle the dispute
in single combat. The cousin won. Vargas was strongly criticized for
having allowed the tribe's decision to be questioned. At about three
we got into a boat. The sun felt like a sledgehammer on my head, the
river seemed to be giving off blinding flames. One of the bearded
men was bathing near the wharf, cautiously, because the water is full
of tiny carnivorous fish with very sharp teeth. He didn't join our
party. "Where is the town?" I asked. They pointed to a hotel eventu-
ally intended for tourists but not yet completed. A fine example of
Brazilian bluff! The site had its grandeur: beaches of white sand, the
steel-colored river, and the brush-covered plateaux stretching away to
infinity under the metallic sky. But so hot, so stark! We took refuge
under the house, between the piles—the only place where there was
any shade—and while the women set the table, the doctor put on
some Carlos Gardel records. Zelia managed to snatch a bottle of beer
out of the governor's hand, and we drank it. At last we were served
rice and shrimps; I was so hungry by then I couldn't eat. Sartre made
an effort to start a conversation. "Veeery interesting," he kept saying
to whatever the governor said. "The hotel will certainly attract
young honeymoon couples." "Veeery interesting." He even asked
some questions: "Will there be planes to bring them here?" These
excessive demonstrations of goodwill were too much for Zelia, who
exploded in a fit of hysterical laughter and had to leave the table and
pretend to be admiring a shrub covered with cottony flowers; one of
the guests leaped up to show her the way to the rest rooms.

No question of going to see the other village; in any case, that too
was administered by white people and wouldn't have taught us any-
thing new. The only interesting tribes are both inaccessible and dan-
gerous. There are a great many outlaws hiding out in the district
who have guns and amuse themselves by killing the "savages." The
authorities have had one of these murderers executed in front of the
Indians, but even that wasn't sufficient to reassure them; when they
see a white man they attack.

It was six when the boat took us back to the center. The doctor

had stayed behind at the hotel with the jeep. "If we don't leave immediately, we'll have to spend the night here," the pilot said. The Brasília airfield isn't lighted at night, and landing is forbidden after sundown. Sartre leaped to his feet. "Let's walk!" Despite our burden of pottery, we covered the half mile out to the airfield on foot. We were all settled in, the propellers turning, when the doctor appeared, completely drunk and waving his arms. We hauled him up. He sank down at full length on the floor and went to sleep. We all four sighed with relief at finding ourselves alone again.

A few days later, the Amados flew off to Rio. I was upset at saying good-bye to them. We were continuing north, and then going on from Manaus to Havana. We had been invited back there, and our plane tickets were supposed to be waiting for us at an agency; otherwise we would go back to Recife and get a plane to Paris. After being so very close for six weeks, it was difficult to believe we wouldn't see them again for many years; or even, perhaps, forever.

The rector of Fortaleza, introduced to us in Recife, had invited us there. The coolness of the wind was astonishing so close to the equator; what a pleasure to see the sea leaping once more, and a real live town! There were the white-sailed *jangadas* again, a covered market full of strong smells, narrow shopping streets—cloth, shoes, clothing, drugstores—wonderfully casual squares, little parks, kiosks, and human bustle. Sartre gave a lecture, there was an official lunch in a club at the edge of the sea, and a cocktail party in the rectory gardens with the students' choral society singing folk songs. But we had a great deal of time to ourselves. In the evenings, we sat beneath the glossy fronds of a big square, on the terrace of a café-restaurant where soldiers brought young prostitutes for a drink; they picked them up in the nearby brothel district, a section of the teeming *favela* squashed down along the sea. In its bistros, open wide to the night, along its alleys, men and women were laughing and talking, united beyond the venality of their commerce by their common poverty. One evening, at sunset, I crossed through another section of the *favela*. There was something disturbingly beautiful about the swiftness of the dusks there; no sooner had the afternoon light begun to fade than the horizon was already flaming and it was night. The *jangadas* beached on the sand looked like great dying birds; men and women, coming on foot or riding donkeys, were buying the catch the fisherman had just brought in; they scarcely spoke in the gentle light

of the dying day, and this silent exchange between equally dispossessed buyers and sellers had all the simplicity of primitive barter. As I retraced my steps, there were faint lights glowing in the shanties of the *favela*.

In the little café on the square they were always playing one record over and over again, a song in praise of Jânio Quadros. One evening he arrived at our hotel with his entourage. The night broke into bedlam. There were groups of young people running through the streets yelling and dancing with brooms in their hands. An hour before his speech the place was covered with people carrying brooms. Loudspeakers, fireworks, yells and laughter. Jânio's victory seemed to be assured and Sartre would have liked to meet him; but our friends, grimly preparing to vote for Lott, would have been put in a difficult position if he had.

After having heard so much about it, we wanted to have a look at the *catinga*—the white forest. A professor procured for us the good offices of the local chief of police, who spoke French and owned land in that district. Between fifty and sixty, bald, he treated us to a series of admiring comments on Rostand's *Cyrano* as we drove out of the town. At first the landscape was dominated by tall, spiky palm trees, the *carnaúba;* their trunks are used to make fences and walls, their fibers to cover roofs, and their pith and their fruit as food; and above all, the wax that protects the leaves against the drought by preventing transpiration is collected and exported to make films, records, candles, matches. They belong to the great landcwners who are opposed, or so I heard, to irrigation plans for the region. Soon they disappeared behind us; there was nothing to be seen but stunted bushes, woody and spiky, with dismal grayish leaves; and cactuses— cactuses like candles, like many-branched candelabra, like giant artichokes, like shuttlecocks, like octopuses, like rosettes, like sea urchins. It was in this ungrateful land that the mystics flourished and the *cangaceiros* who put their hope in God or their confidence in their weapons to change their interminable agony into a human life. Saints and brigands are now both extinct. In the fight against hunger one can no longer count on anything but the açudes which store up the water of the rainy season; most of them are dry. We saw one, the size of a lake, to which men were coming with donkeys and filling little barrels to take away with them, often for great distances; it would have been possible to use this natural reservoir for the irrigation of a great tract of this land, which produces as soon as it is

moistened, but no system of canalization had at that time been even begun. Some economists claim that any program of irrigation for the "polygon" is utopian; the only solution would be to transport the entire population to the South. Others are of the opinion that if enough money were put into it, this zone could be made to yield crops; still others think that for the moment the lot of the peasants would be made more tolerable if they could use the land for their own profit and according to their own needs; but it would take a revolution to bring about any real agrarian reform, and that is highly unlikely.[1] There is no doubt that for a long time to come the children of the polygon will go on eating, for lack of other food, the earth that nourishes and kills them at the same time. Our policeman, however, was complaining that in Brazil everything moves too fast; "they" had abolished slavery prematurely, and were now intending to arouse and educate the peasants prematurely. Engine trouble finally brought these lucubrations to a halt. We walked a few steps along the road in the hope of finding shelter in the shade of some house; the sun was flaying me alive.

The car repaired, we passed a couple leading by the hand a little boy dressed up as a Franciscan; farther on, there was a family resting in the ditch under a tarpaulin. The feast of Saint Francis was approaching, and on that day the little town we were going to was invaded by an enormous pilgrimage. The pickpockets become very active during the celebrations, and our chief of police was coming to see that the streets were properly patrolled. We lunched in a shady inn; our hostess wouldn't accept a cent from us—nor would the café owner, in whose place we had a drink on the way back. The friendship of the chief of police was well worth a few little concessions of this sort.

In the street, they were selling hideous pictures of the sanctuary dedicated to Saint Francis; it was as ugly as they were. But the shed containing the ex-votos was even more extraordinary than the sacristy of Senhor do Bonfim. In the middle were piled up all the wooden objects that are burned on a bonfire every year: effigies of witches, arms, legs, feet, hands, head, sexual organs, crutches; the pile almost reached up to the ceiling. On the walls were photographs, drawings, paintings representing the accidents from which the true believer had escaped or the diseases Saint Francis had cured: ulcers,

[1] Since 1960, the peasant leagues have developed considerably; the peasants have appropriated land for themselves, they are beginning to be organized.

wounds, tumors, wens, goiters, pustules, eczemas, chronic ailments, deformities. Modeled out of plaster and wax were facsimiles of offending organs and limbs: livers, kidneys, and innumerable sexual organs; with the passage of time these simulacra had become moldy and rotten. It was enough to make the idea of having a body at all quite disgusting.

On the way back, in the gentle evening air, the *catinga* appeared less implacable. We drove through a village full of banners, garlands and vendors' booths giving promise of an approaching celebration; we passed some old jalopies full of youngsters, while others walked along in groups; the boys were wearing brilliant green shirts, the girls brightly colored dresses; they were holding their shoes in their hands in order not to spoil them, and to give their feet a rest.

Sartre didn't much want to go to Amazonia, and no one had invited us to. But Bost had once written a description of Manaus for *Les Temps Modernes* that had inflamed my curiousity; Alejo Carpentier and Lévi-Strauss had kept it alive. "Yes, you must go to Amazonia," Christina T. said, "the people there are completely different from the ones here." And so, one evening, we landed at Belém. It was a pleasant change not being expected, but there were no taxis, and we felt a bit lost as we wandered about through the suffocating damp of the airport. At last we got a cab to take us to our hotel. Our rooms were like Turkish baths; in the air-conditioned bar we sat and shivered. As soon as we went out, the humid heat enveloped us, making it impossible to breathe. We had only French money left; the hotel refused to accept it, as did the bank I went to; they told me to try another, the only one which would change foreign currency—American dollars exclusively. What was I to do? I argued in English with the clerk, who finally called up one of his acquaintances. The acquaintance turned out to be a curio dealer—stuffed snakes, feather headdresses, Indian pottery—who bought my francs for half their value. I inquired if there was a plane for Manaus: no seats for the next three days. Three days seems a long time when the climate and the circumstances preclude all activity. Yet I have pleasant memories of Belém. On the wharves along the Amazon, in the market, between the stalls piled one against the other, wandered Negroes, foreigners, smugglers, adventurers, all sorts of people on the loose who also packed the taverns. The mouth of the river, 200 miles wide, contained an island bigger than Switzerland,

and one could make out the damp verdure of its banks across the swollen waters. The old Portuguese town had remained almost intact: churches, colonial-style houses, squares planted with somber trees and decorated with *azulêjos*. Far out of town, along vast avenues cutting through empty lots, straw huts bathed in the luxuriance of the banana trees; superb palms exploded into the troubled sky; from the yellowish alluvial soil rose a smell of greenhouses, of dying plants and freshly plowed land. There were gardens stretching out in front of our hotel; we used to eat exotic ices in an exotically decorated kiosk and watch the flamboyant parade of American cars, smuggled into Belém and almost never seen in Rio or São Paulo. Belém's reputation is such that perfumes sent from São Paulo are sold there as being illegally imported from Paris. All day long, the loudspeakers never stopped urging the electors to vote for Jânio, and at night a thousand fireworks were set off. Election day itself, on the other hand, was very calm.

One morning in the hotel bar, a journalist came up to Sartre. "I was the first person to announce your death," he told him. A few years earlier, during the course of a fairly high-powered drinking bout, he had sent a telegram to his paper saying that Sartre had just been killed in a car accident outside Belém. A Parisian journalist had called at Rue Bonaparte and asked Sartre's mother if he was in Brazil at the time. "No, of course not," she said, "he's here." "Oh! Good! Because there's been an announcement that he's just had a car accident over there. . . ." She thought she was going to faint; she opened the door of his study to make sure Sartre was really inside. This fantasy gained its originator a certain notoriety. "Don't go and get killed in a plane crash," he said finally, "because this time no one would believe me. . . ."

I flew over the Amazon, the infinite network of its tributaries, the infinite green expanses of its forests, delighted yet at the same time disappointed, because I knew that was all I was going to get to see. Every month a plane leaves Manaus taking fresh supplies to the distant trading stations where the Indians come to get their provisions; but we wouldn't have been able to visit their villages and, in any case, there could be no question of staying in Manaus more than three or four days. I had been told that it was an astonishing place. Having become a wealthy capital at the end of the nineteenth century, thanks to the discovery of rubber and Brazilian hevea, it was

ruined in the course of a few months when the seeds stolen by the Englishman Wickham gave rise in 1913 to hevea plantations in Ceylon and Java with which Manaus was unable to compete. It was abandoned by almost all its inhabitants, who left a carcass that soon began to decompose; the introduction of some light industries drew back a population of about 170,000 which now languishes there amid the vestiges of the town's past splendor, between the impenetrable jungle and the Rio Negro, which apart from the air route is the only means of access to the place.

On the walls of the Amazonas Hotel, a handsome, prismatic edifice built only a few years ago, are murals of narrow rivers overhung by low vaults of thick foliage, with tourists, guns in hand, gliding laughingly along in boats. About ten years before, these pictures, reproduced in tourist leaflets, had attracted the attention of a lot of rich, young people in São Paulo who then arrived eager to sample the hunting, the fishing, the mysterious glamour. They left again without having seen anything or fired a single shot, and they didn't keep their disappointment to themselves. The hotel was almost deserted. It was the reverse of Belém in that you froze in your room and sweated in the bar and the restaurant. Outside, you turned into a sticky rag. At six in the evening, when the sun was snuffed out like a candle, a new wave of heat rose up from the ground, as dense as the night without a single light to pierce its gloom: there is no electricity in Manaus (though the hotel did have its own generator). The saliva dried inside our mouths, it was impossible to eat. The rich mansions of the city's golden age—marble brought from Italy, carved masonry —had grown old without grace, the weeds were devouring them; only the port was alive, with its boats packed with passengers and cargoes, its floating docks, its little houses projecting out over the water and the black, heavy flow of the river.

As in Belém there was no bank that would risk such a perilous speculation as changing French francs; but an old jeweler from Alsace provided us with some cruzeiros at the normal rate of exchange and without any fuss. His friend the consular agent, another old Frenchman, who had been living in Amazonia for fifty years, made us very welcome and took us out by car along the road that cuts into the jungle for several miles. Tijuca had been much more attractive; here, we *knew* that we were surrounded by an ocean of chlorophyll, but all we could see was two curtains of trees; we could have been

anywhere. The following day's excursion left us feeling even more bewildered. Amazonia is still putting all its hopes on oil, and Petrobraz is having it prospected. We went down the river on one of the company's boats with the consul and a Swiss technician. Its bronze-tinted waters are separated from the White Amazon by a line so clear-cut that it seems to have been drawn by hand across solid land. Fishermen were sitting in their boats throwing nets into the piranha-infested water. We turned into a tributary and went up it till we reached a group of floating huts, the refectories and dormitories of the oil workers and technicians; we shared their meal with them; then we drove in an uncovered truck, viciously hammered by the sun, out to a derrick; on either side of the road and all around the clearing, the jungle's hermetic density shut off our gaze. We were far from the translucent mysteries evoked in the pages of Alejo Carpentier. I came back completely exhausted. Next morning, the consul took us to admire the town's crowning and most ludicrous glory: the theater, all marble, topped with a polychrome cupola, in which the most famous artists of the world had danced and sung. By this time I could scarcely stand; the earth was in a fever, I was dripping with its sweat, feverish and sweating myself. I went to bed. "Do you want to leave anyway?" Sartre asked. Yes, oh yes! Apart from the sinister atmosphere of the town, apart from my fatigue, there was the feeling of panic at being cut off from the world. There had been no tickets to Cuba waiting for us, and we hadn't been able to get through to Rio by telephone. Our attempts to exchange telegrams with the Amados proved futile. In Brazil, only the American telegraphic service works properly, and their lines don't come up to Manaus; a wire takes a week to get through from Rio, the consul told us—if it does get through. There were things happening in Paris; the telephone company announced the connection I'd been waiting two hours for: Lanzmann's voice crackled a long way away, he was telling me not to come back to France before I'd received a letter, he couldn't hear me, and his voice suddenly faded away in the middle of a word. I was in a hurry to get back to Recife, to Paris. The consul took us out to the airport during the night, telling us about the elections on the way. It takes weeks to count all the votes because the country is so vast and communications so bad; but Jânio was so far ahead that his victory was already certain. The governor of Manaus had voted for Lott, however; he was a member of the Left, and honest. "There are two kinds of governors," the consul explained, "the bad ones, who put all

the money in their own pockets and do nothing; and the good ones, who put some of the money in their own pockets and do something."

It was an eighteen-hour journey; every two hours we landed and almost suffocated in the little airports. When we arrived at about eight in the evening, the customs officer tried to search our luggage: everyone coming from Amazonia is suspected of smuggling. Sartre's anger, and the intervention of Christina T. who had come to meet us, made him change his mind. I went with them to a restaurant despite my fatigue, since it is improper in the Northeast for a man to go out alone in the evening with a young woman. For the same reason I took part in the excursion Christina had planned for us next day. We were glad to see her again. Her rebellions had as much real depth as impetuosity and drew on a great fund of natural generosity; they were not directed at the conformism of her immediate circle— which she found restricting—but against injustice. The word Communist frightened her; she had arrived at her present position only by cutting through a number of prejudices, which was a guarantee of its sincerity and its solidity. And then she was always bursting with life, she had gaiety and humor, though underneath lay a basic melancholy, for she felt very much alone. But I really was in very bad shape. I dragged myself along through the dreary marketplaces of the dreary villages whose poverty-stricken state she wanted us to see. For two months I had loved Brazil; I love it now when I look back on it; but at that moment I was suddenly sick to death of all the dryness, all the hunger, all the misery of the place.

That night I was burning hot, and the next morning I committed the imprudence of asking for a doctor. A friend of Doctor T.—the brother of Lucia and Christina—diagnosed typhoid; but the Brazilian kind lasts only a few days. A penicillin injection brought down my fever. Nevertheless, he still had me removed to the hospital for tropical diseases.

I shall never forget those few days, the feeling of being in hell, eternally. I had a private room with a bathroom, and very nice nurses. But I was just strong enough and just weak enough to find this enforced retreat intolerable. The patients and the staff kept chattering on late into the night; every quarter of an hour a great clock chimed; I almost became hysterical the first morning, when they woke me up at dawn just as I had at long last closed my eyes. After that I got used to the noise; at five in the morning I would haul

myself up in bed and feel my heart sink at the thought of the long day stretching ahead, waiting to be filled. I had things on my mind as well. In the evening, Sartre would down one or two melancholy Scotches in the hotel bar, then go upstairs to bed at ten; he was stuffing himself with gardénal so he could sleep. The Brazilian pharmacist didn't even ask for a prescription. "Orally, or for an injection?" was his only question. (The Brazilians are amazing the way they're prepared to give themselves injections—of penicillin, of practically anything—at the drop of a hat.) All the same, Sartre sometimes woke up again at two in the morning and was so bored he'd get up and shave. When he got out of bed in the morning he'd stagger around to visit me, and once when I was having an intravenous feeding, he nearly sent the whole apparatus flying. Since the fall of 1958, death takes me by the throat at the slightest alert. I waited for him and said good-bye to him with fear in my heart; and the English detective novels he bought me in the town's only bookstore were not entirely successful as a means of distraction since I'd read almost every one of them before.

Besides, the letter Lanzmann had told me about still hadn't arrived; and we couldn't get any French newspapers. The Embassy in Rio was plugging ever more insistently the rumor that Sartre would be thrown into jail as soon as he got back. The French colony in Recife was saying that my illness was a diplomatic maneuver and that we were afraid to return to France. In fact, we couldn't wait to be arraigned like all our friends. I loathed the feeling of being imprisoned in that hospital, of eating the inevitable rice and chicken soup every morning and every night. From my bed I could look out and see coconut palms stretching up into a washed-out blue sky, reeds, bamboo, some rather insipid foliage and, on the horizon, the town itself; I would lean out of the window and stare at the straw huts and the women bustling around their little fires. There were a few showers of rain, violent and quickly over, often a slow, heavy wind. Hypnotized by the excessive calm of this landscape, by its humid silence, I felt I had been put under a curse: I was never going to get away from here. In the suspicious calm of one early morning, while the world was still asleep, I saw a young Negro climbing barefoot up the trunk of a coconut palm; he tossed the nuts down on to the ground. Agile, graceful, so near, so far from me, his presence—and mine— brought tears to my eyes. The evenings were beautiful, with the green and red lights of Recife in the distance, but my throat was

always tight with the thought of the night still to be got through, the nightmares to be fought off, the next day to be faced.

This eternity lasted seven days. I received Lanzmann's letter. The Jeanson trial had been brought to an end on October 4th by a despicable verdict. Charges against the "121"—of whom by now there were considerably more—continued to multiply. Those who had signed the manifesto were no longer allowed to appear on the radio or on television, nor even to have their names mentioned on any program. Vidal-Naquet had been suspended, Barrat arrested. In Metz, Debré had denounced the "121" and their "appalling and at the same time laughable attempts to cause trouble." On October 1st, there had been searches and arrests on the premises of *Les Temps Modernes, Esprit, Vérité et Liberté;* Domenach, Péju and several others had been held for some hours by the police. The October issue of *Les Temps Modernes* had been seized. In the course of a demonstration which had been given a great deal of publicity by the press, five thousand veterans had paraded down the Champs-Élysées shouting: "Shoot Sartre." On behalf of all our friends, Lanzmann asked us to come back no closer than Barcelona, where they would keep us informed of the situation.

I told the doctor I wanted to leave. I had typhoid, he objected— the hotel would turn me away. The T. sisters, who were at that moment staying with their family at a villa down on the beach, offered me the use of their house in Recife. I spent three days in a room full of antique furniture and scarcely cooled at all by its primitive and noisy air conditioner; summer was beginning, and beyond the windows the heat was settling down for a siege. Early every morning, some cousins of the T. family who lived opposite would have breakfast sent over to me. Once, at about six in the morning, I was astonished to hear Sartre's voice floating up from the garden; furious at not being able to sleep, he'd got up and come around. One evening the young Doctor T. came to examine me; he took rather a long time, so I told his sisters and Sartre to go off and eat without waiting for him. They refused; it was not permitted to leave a man alone in a house with a woman, even one of my age. They didn't subscribe to these prejudices themselves, but the street was full of cousins who were keeping an eye on them. The doctor gave me permission to go out for a bit. After a quarter of an hour walking along streets full of air that felt like treacle, with Sartre staggering along beside me, I collapsed into a chair on a café terrace, feeling

more dead than alive; two days later, during our first lunch with the Amados, in a familiar *churrascaria,* I fainted completely.

The Cuban *chargé d'affaires,* despairing of ever getting through to us by phone, had come to Recife. Havana was insisting that we spend a few days there; the only way of getting there was to go back down to Rio, 1,000 miles away. The pleasure of seeing the Amados and Copacabana again was spoiled for me by my fatigue; and I was homesick, even though Lanzmann had told me again by phone that the ultras were after Sartre's head.

The evening we were due to leave for Cuba, a tornado swept the airfield; it ruffled the potted palms in the waiting room and filled it with whirling bits of paper. We sat for hours, dozing, stupefied, waiting for it to pass. Finally we got into the plane. The engines were spitting out too much flame; it was one of those nights when the worst seems certain to happen; when we landed into the grimy darkness at Belém, the absurdity of being back there at all confirmed my presentiment: this continent was a great net from which we were never going to escape. I recovered my calm only the next morning when I looked out and saw a plateau crushed between a cliff and the turquoise sea; Caracas was below us. We landed. As we drank a coffee in the buffet, I gazed out at the glittering aircraft, all its windows spitting back the sun, which in an hour or two was going to tear us away from these poverty-stricken lands; an old woman was going among the tables, picking up bread crusts, chop bones, remains of egg white, which she then wrapped up in a piece of paper to feast her family on later. Some students came and asked Sartre to stop for a few days in Caracas. We felt sympathetic toward them; Venezuela was on the move. (There was a student demonstration that very afternoon, and a few days later the police killed several of the participants.) But we were expected in Cuba, and we were frantically eager to get back there.

An airport official came up. "Have you a return ticket? Your ticket on to Paris? No? Then you can't leave: orders from Havana." "But we've been invited there," Sartre said. "Prove it." We hadn't a cent between us to pay for return tickets, and no official papers. The glittering plane was going to fly off without us! Sartre telephoned the Cuban Embassy and opposed the airport officials with a rage that finally carried the day. At the last moment, we were allowed on board. We were never to discover the reasons for this contretemps; the Cubans had absolutely no immigration restrictions.

At last the coast was behind us! At last! We flew over Jamaica, and it was as though with a single beat of our wings we had reached England: glowing green lawns, cottages flanked by swimming pools. Sartre, who had been there, told me that there is no more baleful colony in the world. And soon we were in Havana with our friends waiting for us—except Franqui and Arcocha, who were in Moscow at the time—and a group of musicians in costume plucking their guitars.

Havana had changed; no more nightclubs, no more gambling, no more American tourists; in the half-empty Nacional Hotel, some very young members of the militia, boys and girls, were holding a conference. On every side, in the streets, on the roofs, the militia was drilling. It was known, through Guatemalan diplomats, that an army of Cuban émigrés and American mercenaries was being trained in Guatemala. They were going to try to gain a foothold on the island and then, in the name of an imaginary government, call for help from the United States. Faced with these threats, Cuba was toughening up; the "honeymoon of the revolution" was over.

Oltuski was no longer a minister. He was working at the Institute which Guevara had just founded for the country's industrialization and which he took us to see. The leaders didn't hide their difficulties from us. There was a shortage of trained men; certain engineers were each working on the planning of three or four different industries; and yet it had still not been possible to utilize the whole of the capital allotted for the creation or renovation of the industrial plant.

We visited a cloth mill near Havana: an already outmoded plant, with well-designed workrooms, surrounded by trees and lawn, with comfortable housing for the executives and workers. There was a celebration going on in the park: the workers and their wives, in their best clothes and low-cut dresses, their children, ice-cream and candy vendors. Standing in a kiosk in the middle of the lawn, Sartre spoke of his friendship for Cuba. He was asked about France, and then he asked questions in his turn: What advantages had the mill workers gained from the change of regime? Some of the workers were about to reply when a union leader stopped them and answered for them instead.

During our conversation with the intellectuals, Rafael and Guillen, who hadn't opened their mouths in April, had a great deal to say. Talking about poetry, Guillen declared: "I consider all research

into technique and form counterrevolutionary." They were insistent that writers should comply with the rules of socialist realism. Some writers told us in private that they were beginning, against their will, to censor their own work, each asking himself the question: "Am I really a revolutionary?"

Less gaiety, less freedom; but much progress on certain fronts. The cooperative we visited was a great deal more advanced than any of the ones we had seen before. It was growing mostly rice, but using intensive methods of cultivation to such good effect that it had reclaimed more land, on which tomatoes and various vegetables were now being grown. With the help of masons from town, the peasants had just finished building a village: comfortable houses, a movie theater, schools, playgrounds. There was a State store selling the products of prime necessity to life at almost cost price. There was a shoe factory and also a tomato-canning factory working directly for the cooperative; in this way they were realizing on a modest scale what the Chinese communes had aimed at: direct contact between industry and agriculture. The peasants seemed even more attached to the regime than before, but feverish. The village was near the spot where the landing was expected. The head of the cooperative was overexcited; he had a revolver stuck in his belt and told us he was waiting impatiently for his opportunity to fight.

The evening before our departure, Sartre gave a press conference; just as it was about to begin, one of our journalist friends whispered in his ear that troops were landing at that moment along the Santiago coast. Sartre nonetheless declared before the press, the radio microphones and the television cameras that he did not believe there would be any intervention by the United States in the immediate future; America was in the middle of a Presidential election, and the Republican Party wasn't going to spoil Nixon's chances by assuming the responsibility of any such risky adventure. We had supper with the reporters from *Revolución* at the bar-restaurant of the old Hilton, now the Habana-Libre. It was a dismal sight, that vast room with its psuedo-Polynesian décor. Our friends kept leaving the table to go and phone; the invasion rumor was apparently true. "We'll throw them back," they said darkly. The next day, the rumor was denied, but to the Cubans this only meant that the battle had been postponed.

We hadn't seen Castro. We went to visit Dorticós the day we were due to leave; it was the anniversary of the death of Camillo Cen-

fuegos, who had been idolized almost as much as Castro and whose plane had crashed into the sea a year before. There were processions of students, laborers, clerks, women and children filing through the streets carrying sheaves of flowers and crowns which they were throwing into the ocean. While we were talking to the President, Jiménez was talking to Castro's secretary on the telephone: he happened to be in the neighborhood of Havana and was asking us to wait so that he could see us. Impossible, it was six already, the plane was due to take off at eight. Jiménez took us to our hotel and we went up to collect our luggage; we pressed the button for the elevator; it came up, the door opened, and out burst Castro followed by four bearded men and Edith Depestre. He had lost none of his gaiety and his warmth. He put us into his car. What had we seen? What hadn't we seen? It was difficult to make much progress; there were processions blocking the streets and the crowd kept stopping the car with cries of "Fidel! Fidel!" "I'll take you to see the Students' Quarters at the University," Castro said as we finally drove out of Havana. "But the plane leaves at eight . . ." I murmured. "It will wait!" The largest of the barracks in Havana had been transformed into a group of pavilions, buildings and sports grounds. We had a quick look at it, then, on the pretext that it was a shortcut, the driver plunged into a series of deserted byroads punctuated by great puddles. The plane has left without us, I said to myself. At the airport, the barriers were raised and the car took us out onto the airfield and put us down right beside our plane, which the mechanics were still checking; they would be a long time yet. Oblivious of all the signs forbidding it, Castro stood chewing his huge cigar a few yards away from the engines. "The landing is a certainty," he told us. "But it is also a certainty that we'll repulse it. And if you hear I've been killed, just don't believe it."

He left. Jiménez, Edith, Otero, Oltuski and some other friends took us to have dinner in the buffet. The airport was full of people giving us very unfriendly looks. "They're waiting for the plane to Miami, and they won't be coming back." You could tell their class from their clothes. When the loudspeakers announced: "All passengers for Miami," they rushed in a body to the boarding gates.

We took off. There was a landing in Bermuda. I was expecting another on the Azores; we seemed to be up a long time. Here we are! I thought as I saw land appear. But there didn't seem to be any other side to these islands. And I thought I recognized the color of the earth, its contours, the indentations of the coast, the green of that

river—the Tagus; it was Spain, the snowy crest of the Sierras, Madrid, reached in fourteen hours, but already clothed in dusk. Another plane took us on to Barcelona.

We'd arranged to meet our friends at the Colón Hotel; the one I knew no longer existed, we were told by the reporters who nabbed us as we arrived. But another with the same name had opened near the cathedral and was very pleasant. We met Bost and Pouillon there the next morning. They gave us a detailed account of all that had happened since September. The Jeanson trial and the manifesto of the "121" had been instrumental in causing the Communist and Socialist youth groups, the trade unions, the Communist Party and the Socialist Party to take various forms of action against the war. The trade unionists and university teachers had launched an appeal for "a negotiated peace." The unions had supported the demonstration organized by the U.N.E.F. on October 27th, which had been an enormous success, despite the scuffles and truncheon charges. The measures taken against the "121" had raised a good deal of protest. All the actors engaged on television work had gone on strike as an expression of solidarity with Evelyne when she was fired from a program. Meanwhile, Laurent Schwartz had been dismissed from his chair at the École Polytechnique, the professors had been suspended, and so had Pouillon and Pingaud, recording secretaries in the Assembly. Marshal Juin had signed a manifesto against "the professors of treason." The National Union of Armed Services was asking for "the sternest possible measures against irresponsible persons, and above all against traitors." The central committee of the U.N.R. stigmatized the actions of "so-called intellectuals." The National Union of Reserve Officers was demanding that action be taken against them; the list of the "121" had been posted in all messes, etc. Sartre was the one most attacked. His statement to the court had caused many people to hate him passionately. By telephone, Lanzmann, who had been detained in Paris, asked us, as did his comrades, to come back by car; if we took the plane, Sartre would get a very stormy reception at the airport, there would be brawls, he would be forced to answer the reporters' questions in such a way that the police would haul him in. I think now that it would have been better to create as much publicity for the "121" as possible; but we listened to the advice of our friends, whose solicitude I can sympathize with, for there is a certain frivolity in worrying too little about others. We went out and strolled around Barcelona, which Sartre found no more

pleasant to revisit than Madrid; I, on the other hand, was quite happy just being on the Ramblas. We looked at Gaudi's fantastic and never-to-be-finished cathedral; we went up to Tibidabo, looked around the Museum of Catalan Art, and the following afternoon we set off for the frontier.

The press had been insulting Sartre so copiously for the past two months—traitor, enemy of France, etc.—that we expected to get a pretty rough reception when we got back. Night had already fallen when we reached the frontier post. Bost took the four passports in to the police and came back. The commissioner wanted to see us. He had orders to advise Paris when we crossed the frontier, he told us apologetically. He sent one of his subordinates to buy us newspapers, offered us cartons of cigars and cigarettes—no doubt confiscated from returning tourists—and as we were saying good-bye asked us to sign his visitors' book. He advised us to get in touch with the police when we got back to Paris. We spent the night at Béziers. After so many foreign splendors, I was very moved next morning as we drove along under a pale blue sky and I found myself looking out at the pale gilt of the plane trees, the vineyards flaming in the autumn sun and, instead of hovels scattered about over wasteland, real villages. Would I be permitted, one day, to love this country again?

In Paris, our first concern was to get ourselves officially charged; we hired Roland Dumas, who had been counsel for the defense in the Jeanson trial, as our lawyer and he undertook all the necessary arrangements. The police pushed politeness to the point of coming around themselves to my apartment for the official interview; the youngest officer, stiff with embarrassment, hurt his finger typing out our statements and bled all over the keys. Commissioner M. helped us phrase our statements and vary them a bit. He had been astonished at first by the determination of the "121" to inculpate themselves as much as possible; now he just smiled. "Well then, you can set your minds at rest now, you've been quite properly charged," he concluded encouragingly. But no. The night before the day set for our hearing, the examining magistrate reported sick. A new date was set; at the last moment it was postponed *sine die* on the absurd pretext that our files were still in the office of the Public Prosecutor. Then they announced that no more charges were to be made. Obsessed as ever with its greatness, the seat of power had seen fit to deprive civil servants of their daily bread but not to appear in the eyes of the world as the persecutor of famous writers. It also hoped to shatter the

unity of the "121" by sparing some and keeping a permanent threat hanging over the heads of the others.

To counter this ploy, Sartre called a press conference; before some thirty French and foreign journalists gathered in my apartment, he explained his part in the manifesto and gave an exposition of the present situation. Thierry Maulnier, sitting cross-legged on the carpet, wanted to ask him a question: "I wouldn't like to misrepresent what you've said . . ." "Then it would be the first time such a thing has worried you," Sartre answered. The press printed only summary accounts of what he had said. And the incident was closed.

# CHAPTER VI

BY THE SHABBY EXPEDIENT OF barricades, the government was encouraging a Fascist revival; but the youth of the country had begun to move, we thought that they were going to act. In December, the green and white flag waved over the Casbah, crowds acclaimed Abbas,[1] and the truth became apparent to the whole world: behind the wall of silence and the masquerades imposed on them by force, the Algerian masses were unanimously demanding their independence; it was a political triumph for the F.L.N. that brought its hour of victory nearer.

*The Prime of Life* came out, with a success that would have satisfied me completely when I was a beginner. In fact, when I visited Gallimard in November and was told that forty thousand had been sold before publication, I was rather unpleasantly affected by the news. Had I become one of those best-seller manufacturers with a recognized public, the value of whose works no longer has anything to do with their sales? Many critics assured me that I had just written my best book; there was something disquieting about this verdict. Should I, as some of them suggested, burn everything I had written up till now? Above all, I converted such praise into demands; when I received letters that moved me, I felt I still had to deserve them. This final volume of memoirs was giving me trouble, and I said to myself sadly that at best it would turn out as good as the preceding one, without having the same freshness. On the whole, however, my satisfaction prevailed over my doubts. I had feared misrepresenting the things dearest to my heart; but my readers had understood. The *Memoirs of a Dutiful Daughter* had appealed to a great many people,

---

[1] At a terrible price: the F.L.N. announced thousands of victims to the UN.

but in a somewhat ambiguous way; I took it that those who liked *The Prime of Life* were really on my side.

I accommodated myself without regret to the austerity of my everyday life. We had been living in semiretirement for a long time; now we stopped going out altogether. The usual sort of restaurant customers often showed hostility toward us, and we could no longer bear sitting next to them. We spent our evenings together in my studio, dining on a slice of ham, talking and listening to records; when I was alone, I would listen to them for hours on end. I never put my nose outside the door at night, except with Lanzmann or Olga. This life of seclusion strengthened our ties with our little group of friends. The *Temps Modernes* team, enlarged by two new members, Gorz and Pingaud, used to meet at my place two mornings a month. Gorz would arrive first. "I just can't help being on time," he used to say. There were fewer of us than in the bagpipe days, so our discussions were more closely argued. My taste for it reawakened by an evening Sartre and I had spent at Monique Langes' with Florence Malraux, Goytisolo and Serge Lafaurie, I gave an all-night party. I didn't arrange it deliberately, but all our friends naturally tended to be "committed"; at least one member of all the couples I invited had signed the "121" manifesto. I'd prepared a sequence of jazz records, but they weren't needed: we talked.

There was another dinner at the Soviet Embassy. I was placed next to Mauriac, whom I was meeting for the first time; Sartre had told me he had a sharp tongue and a comic gift; was it age that had extinguished him, or his De Gaulle worship that had worn him out? I looked for him, but there was no one there. Sartre talked to Aragon, whom he advised to visit Cuba. "We're too old," Aragon said. "Bah!" Sartre replied. "You're not so much older than I am." "How old are you?" "Fifty-Five." "*It* begins at fifty-five," Aragon said, with a knowing look. Elsa gave us a graceful account of the troubles that had forced her to start putting artificial tears in her eyes and then, in her knees, "parallel hearts." The occasion was in honor of Galina Nikolaeva, the author of *The Engineer Bakhirev;* in her book she had written in a very lively and even romantic way about a subject that is rarely and badly treated in the West: work. I only caught a glimpse of her but we invited her and her husband around to my apartment. She was suffering from a serious heart disease and had an attack that day, so he came alone with an interpreter. He greeted us with formality and behaved during the entire conversation as though he had a whole delegation standing behind him. He told us that the

writers of Russia would be very happy to see us in Moscow. We would very much like to go, Sartre answered.

André Masson had signed the "121" manifesto. We admired his work and found his face and his slyly ingenuous remarks full of charm. He was an old anarchist, and we had been alienated by his excessively apolitical attitude. Diego's arrest had opened his eyes. Rose was spending all her time helping the Algerian prisoners and their families. I saw her on various occasions, and we had dinner at their apartment in the Rue Sainte-Anne, once with just the two of them, once with Boulez, who had also signed the manifesto. Masson, who wore a beard now, told us delightful stories about the golden age of Surrealism. Of Boulez's work we already knew and liked *Le Marteau sans Maître* and the first *Structure;* we had not gone to the performance of *Pli selon Pli,* fearing we wouldn't be able to make head or tail of it on just one hearing. The image of him we had formed from Goléa's book and Masson's stories pleased us greatly. A young German composer performing one of his works during a concert conducted by Boulez was hissed and fled at the end of the piece, completely crushed. Boulez dragged him back onto the stage. "Your booing proves you haven't understood anything; he will now play it again." The composer did play it again, and the audience listened in silence. Boulez's appearance matched what I had heard of him. He was working in Baden-Baden because he found that the standard of playing in Germany was much higher than in France. I asked him some questions. He explained how old music is reconstructed, and how works are recorded: not, as I had thought, all in one piece but in small fragments; the bits of tape are then spliced together rather the way a film is edited. It takes several hours to perfect five to ten minutes of music; the slightest error or extraneous noise, which would pass unnoticed in a concert, becomes intolerable when repeated every time the record is played. That's why records are so expensive; it takes a considerable amount of work to produce them. The methods used permit certain tricks. One virtuoso performer was able to play both the piano part and the violin part in a recording of some Bach sonatas. Boulez talked about his work as a conductor. The instrumentalists, he told us, each know only a particular profile of a piece, determined by their place, the instrument they play, and the instruments around them; the triangle doesn't hear the same symphony as the first violin. If you change their usual seating arrangements, they get completely bewildered.

Shortly after the referendum in January 1961, there was a meet-

ing of the Boupacha committee. I noticed Anne Philipe, very serious and touching, and the bizarre close-cropped head of Françoise Mallet-Joris; Laurent Schwartz seemed much younger than I had imagined him. Being able to regard all these people with sympathy was a great comfort to me; sympathy had become such a rare thing. Suddenly, there were noises and shouts, and all the people attending our meeting rushed to the windows; some P.S.U. members were holding a meeting in a room on the ground floor to decide how to reply to the referendum; two of them rushed in: "The fascists are attacking us, come and help." Schwartz rose to his feet, determined hands restrained him, and some of the young people went downstairs. There was a lot of running up and down the stairs, then two cops opened the door and asked for the chairlady. "You must give her back to us," someone said politely. They wanted to know if two militant P.S.U. members, picked up after a brawl, belonged to our committee; I didn't destroy their alibi. Exchange of courtesies; on the way out, some members of the P.S.U. escorted Claudine Chonez and me to her car.

Some students asked me to go out to the Antony Cité Universitaire to discuss why one should answer No to the referendum. I had never seen those vast buildings before; I believe they accommodate four thousand young people who can live there for weeks, as though they were on an ocean liner, without having to go outside for anything. The entrance hall was hung with slogans—VOTE NO PEACE IN ALGERIA—and photographs depicting French atrocities; the committee was entirely leftist; the right-wing students were not very numerous and kept very quiet. I took my place with Arnault, a Communist, and Chéramy, an ex-Trotskyite, in a big hall packed with students and decorated with banners: VOTE NO. There was lively applause for the position taken by the "121," whom I was considered to represent. I emphasized the absence of a Third Force in Algeria and also De Gaulle's repugnance at having to come to terms with mere peasants. On the question of disobedience, Arnault and I defended different points of view, but without making our dissensions too obvious, even though I was very much irritated by his official optimism: he knew perfectly well that the "French people" weren't fraternizing with the Algerians either in the army or in the factories. On the way out I talked with the students; we were in agreement on everything.

A little later, some Belgian students belonging to *La Gauche*—the extreme left wing of the Belgian Socialist Party—reminded me of the

promise they had extracted from me a year earlier to give a lecture in Brussels. Their newspaper had opposed the Algerian war; many of them were secretly helping the Algerians, taking them in and getting them over the border; they had no objections when I warned them that under the title "The Intellectual and the Government," I should in fact be talking about Algeria.

I am always nervous when I appear before an audience; I am afraid I may not measure up to their expectations or to my own intentions. I talk too fast, terrified by the length of the silence I must fill and by the quantity of things to be said in such a short time. On this occasion my anxiety was worse than usual. My talk was what is called "an open lecture" which meant it had attracted, from motives of snobbery, idleness or curiosity, people who had nothing whatever in common with myself: big businessmen and even government ministers. And as soon as I started, I had the feeling that in one way or another they'd all made up their minds in advance. On the way out, a Communist criticized me for not being Communist, a rebel for not castigating those who conformed. Several people thought it regrettable that I hadn't tackled the problems of the Congo: I had alluded to them, but didn't feel I was qualified to discuss them at length. I was depressed even more by the reception that followed my lecture than by these criticisms as I left. People would come up to me with beaming smiles and say: "I don't agree with you politically; but I liked your book so much!" "Let's hope you don't like the next one," I replied to one of them. It is true that in *The Prime of Life* I had taken a very objective attitude toward my past beliefs; all the same, I did make it perfectly clear how distasteful I find bourgeois institutions and ideologies; I shouldn't have been receiving the approval of people who were attached to them. Lallemand, a lawyer forbidden to practice in France because he had supported the Algerians, consoled me: "It's the paradox of their position; they lump all culture together. They swallow Sartre, they swallow you; but it means they have to swallow your attacks as well; it all helps their ideological breakdown."

I spent three interesting days. I visited the museum again, alone and at length; Lallemand drove me around Brussels. I had dinner with the *La Gauche* team, who told me a lot about the Congo; I gave a lecture on Cuba to a small and politically minded audience. Then Lallemand drove me out to Mons and arranged for me to meet fifteen or so trade unionists who explained the reasons behind the

thirty-two-day strikes involving a million workers. The Belgian workers' standard of living was relatively high; many arrived at the meetings in automobiles. They had been fighting to consolidate their position, to make sure they wouldn't have to meet the expenses of decolonization, and above all to bring a new economic policy into being; it had been the first general strike in Europe intended to reorganize a country's economy on a socialist basis. They all expressed different opinions on the personality of Renard, who had both fermented the strike and held it in check; but they all agreed in accusing the parliamentary Socialists of robbing them of their victory; it was in part against the conservatism of their leaders that their struggle had been directed.

Invited by these same members of Parliament whom the strikers considered traitors, I gave the same lecture in the Mons Hôtel-de-Ville that I had given in Brussels, though with less distress, since the audience was quite obviously all left-wing. Afterward, I had dinner with my hosts. "Those are your real enemies," Lallemand had told me, "the ones who don't integrate: they don't read your books. Culture's just a joke to them; that's their strength." Over the duck with peaches, we asked them some embarrassing questions: "Why had the strike been called off in mid-career?" "Because it would have ended in a revolution, and we are reformists." "And how does the rank and file feel about it?" "Very badly indeed," M. replied placidly; his fellow politicians then told us with a great deal of accompanying laughter how he had got himself booed by twenty thousand strikers. One of them rallied to his support: "You know what the masses are; you have to know how to manage them. . . ." "Do you mean to say," I said, "that you, a Socialist, despise the masses?" People looked at him, scandalized: "Did you say you despised the masses?" C. spoke in a hurt tone about the French Left: "I realized that the union of left-wing parties didn't stand a chance when I heard Daniel Mayer talking with such hate about . . ." I was afraid he was going to say: "the Communists," but what he said in fact was: "Guy Mollet." "But he was quite right," I said. "Guy Mollet is an honest man," C. said. There were murmurs from some of the guests. "He is honest. He's never taken a sou for himself," C. said in a tone of reverence. I had never frequented professional politicians, and the fatuity of this particular tableful stupefied me. "The only thing they're interested in is getting re-elected," Lallemand told me next day, when he came around to my hotel at dawn to show me the rest of Mons and its

outskirts before taking me to my train. In the town, with its closed shutters, the light turned all the stone buildings pink, like the cathedral at Strasbourg. I saw Verlaine's prison, the Borinage, where Van Gogh had lived, the slag heaps of abandoned mines, already covered by thick vegetation: in the middle of the plain, an abrupt landscape of artificial hills. The closing of the mines could not be avoided; what was so revolting was that the operation should have been carried out at the miners' expense; the only inhabitants left in the mining villages were old-age pensioners. Though even normally, Lallemand told me, no one tended to go on working here after the age of forty. The prevalent silicosis had been aggravated by the use of the pneumatic drill; he described the strange faces of the men with silica-encrusted eyelids.

I took part in the C.N.E. sale. The Communists had criticized the action of the "121"; by going together to the Palais des Sport in one bloc, we would be demonstrating the solidarity that still existed between us; it was a way of getting them, willy-nilly, into the soup with us. As it turned out, we found ourselves scattered all over the place, each one squeezed behind his or her counter. There were loud-speakers braying Bach at us rather too emphatically. I felt closer to the public there than I had to the people who came to hear me in Brussels, though I was too busy signing my name to be able to establish much contact with them. I was still disturbed about my success. The book had been so well received because of an optimism which I was far from feeling at present. The various resistance movements had not proved so strong as we had expected. We were falling back into our previous state of isolation.

I went with Sartre to the Dubuffet exhibition, whose work we had rather misjudged in 1947. The pictures of his latest period wrenched us out of our everyday routines of perception, replaced them with a science-fiction vision of the world. A Martian would see our landscapes and our faces thus, in their naked materiality, capable of indefinite and minute variations, but stripped of all human meaning. When I came out, I couldn't look at people's faces in any other way: an opaque mass covered by a superficial network of lines.

I met Christiane Rochefort several times, always with great pleasure. I liked *The Gallery Gods* very much. To convey with appropriate savagery the world of the psychotic, she had invented a voice, a tone, that—even more than her assiduous re-creation of a Communist family—suggested the possibility of a quite different world. This

book had caused less of a scandal than her first, but she'd had another cartload of self-righteous filth emptied on top of her all the same. "It's happened to me too," I told her. "It must have been worse for you, though," she said sympathetically, "because I'm a tramp anyway, you know." And indeed, I was always conscious of my middle-class origins when I was with her; she was a real working-class girl, and there wasn't much she hadn't seen: I envied her daring, her fire, her inner freedom. For the time being, she wasn't writing. "I can't get interested in my piddling little stories, not at the moment!"

I understood how she felt. The assassination of Lumumba, the last pictures of him, the photographs of his wife leading his mourners, head shaved, breast bared—what novel could compete with that? This murder was a stain on the good name not only of Kasavubu and Tshombe, but of America, the UN, Belgium, the entire Western world and Lumumba's immediate circle of followers. "Everyone was betraying him, even his relations," Lanzmann was told by Serge Michel, who had been Lumumba's press attaché. "He didn't want to believe it. And he thought all he had to do was go down into the street and talk to the people, and all the plots would just vanish into thin air." He also said: "He hated violence; that's what killed him." Lanzmann had this conversation in Tunis, where he had gone with Péju to represent *Les Temps Modernes* at the anticolonialist conference there. They had a talk with Ferhat Abbas, who bounced his little niece up and down on his knees during the entire conversation. "He thought we were from *Esprit*," Lanzmann told me. "What can you expect," Abbas told them, "these Communists give people bread to eat, and that's good; but man does not live by bread alone. We're Moslems, you see, we believe in God, we want to elevate their minds; the mind must be nourished too." It was evident that his role in the revolution was no longer more than a decorative one. Which is what we were also told by an F.L.N. leader. "Abbas is old, sixty. There's the generation in its sixties, then the one in its forties, and one in its twenties. It's good for the revolution to have a figurehead. But he isn't the man who's giving the orders, and he won't be giving orders in the future." There were two generally recognized tendencies among the leaders, he said: the classic politician, prepared to accept collaboration with France, in other words to call a halt to the revolution; and the other type, supported by the guerrillas and the rank and file, who demanded agrarian reform and socialism. "And if the revolution is sabotaged, we'll take to the hills," was the attitude of

certain leaders, the ones who wanted to wage war to the bitter end, with the help of the Chinese if necessary.

Fanon, the author of *Peaux Noires, Masques Blancs* and *L'An V de la Révolution Algérienne,* was among those opposed to a compromise peace. A psychiatrist born in Martinique, he had won great applause in Accra by opposing Nkrumah's pacifist theories with a speech on the necessity and value of violence. *Les Temps Modernes* had published a striking article by him on the same subject. From his books and all we had heard of him, we had the impression that he must be one of the most remarkable personalities of our time. Lanzmann had a great shock when he discovered him sick in bed and his wife, as soon as she came out of his room, in tears. He had developed leukemia; according to the doctors, he had less than a year to live. "Let's talk about something else," he said immediately. He asked some questions about Sartre, whose philosophy had influenced him; he had been passionately interested by *La Critique de la Raison Dialectique,* especially by the analyses of terror and brotherhood. He was being torn apart by events in Black Africa. Like so many African revolutionaries, he had dreamed of a united Africa freed from all foreign exploitation. And then, in Accra, he had realized that before achieving brotherhood, the Negroes of Africa were going to go through a stage of killing each other. Lumumba's assassination had completely shattered him. He himself, during one of his trips through Africa, had only just escaped a similar attack on his life.

Everyone was very uncertain at that particular time—De Gaulle having abandoned the "preliminary talks at Melun"—as to what concessions the Algerians were prepared to make. We knew they wouldn't compromise on the question of Algeria's independence and their refusal to alter the present frontiers. But would their victory lead to socialism? We thought it would.

Six women prisoners in the La Roquette prison escaped; a pretty feat, well organized, and one that should have been a help to all women in getting rid of their inferiority complexes. I went with Sartre to the Lapoujade exhibition. Sartre had written a study of "committed" painting with reference to his work; I liked his paintings. Spring appeared, unbelievably mild: 70° in March, the first time since 1880, according to the newspapers. The sky was so blue that as I sat facing my open window I wanted to write just for the sake of writing, as I would have sung just to sing, if I'd had any voice. "I've got some things to show you," Lanzmann said one evening. He

took me to dinner just outside Paris in a sleepy village full of country
smells, and suddenly, hell was back on earth. Marie-Claude Radziew-
ski had given him a file which contained accounts of the treatment
inflicted by the *harkis,* in the cellars of the Goutte d'Or, on Mos-
lems handed over to them by the D.S.T.: electrodes, burning, impal-
ing on bottles, hangings, stranglings. The physical tortures were inter-
spersed with psychological treatments. Lanzmann wrote an article on
the subject for *Les Temps Modernes* and published the dossier of
complaints. A girl student told me that she had been in the street near
the Goutte d'Or and seen bleeding men being dragged from one
house to another by the *harkis.* The people living in the neighbor-
hood heard their screams every night. "Why? Why? Why?" The un-
endingly repeated cry of a fifteen-year-old Algerian boy who had
watched his whole family being tortured[1] kept tearing at my ear-
drums and my throat. Oh, how mild they had been in comparison,
those abstract storms of revolt I had once felt against the human
condition and the idea of death! One can engage in convulsive
struggles against fatality, but it discourages anger. And at least my
horror had been directed at something outside myself. Now, I had
become an object of horror in my own eyes. Why? Why? Why must I
wake up every morning filled with pain and rage, infected to the very
marrow of my bones with a disease I could neither accept nor exor-
cise? Old age is, in any case, an ordeal, the least deserved, according
to Kant, and the most unexpected according to Trotsky; but I could
not bear its driving the existence which until then had contented me
into this abyss of shame. "My old age is being made a living horror!"
I told myself. And when there is no pride left in life, death becomes
even more unacceptable; I never stopped thinking about it now:
about mine, about Sartre's. Opening my eyes each morning, I would
say to myself: "We're going to die." And: "Life is a hell." I had
nightmares every night. There was one that came quite often, and I
noted down one version of it.

"Last night, a dream of extreme violence. I am with Sartre in this
studio; the phonograph is motionless beneath its cloth cover. Sud-
denly, music, without my having moved. There is a record on the
turntable, it revolves. I twist the control to stop it; impossible to do
so, it turns faster and faster, the needle can't keep up, the tone arm
gets into the most amazing positions, the inside of the phonograph is
roaring like a furnace, there seem to be flames, and the black surface

[1] Reported by Benoît Rey in an excellent and appalling book: *Les Égorgeurs.*

of the record is becoming insanely shiny. At first, the notion that the phonograph is going to collapse under the strain, mild panic which then becomes all-devouring: EVERYTHING is going to explode; a supernatural rebellion, incomprehensible, the collapse of all that exists. I am afraid, I am at the end of my rope; I think of calling a specialist. I seem to think he's been here, but then I'm the one who thought of disconnecting the phonograph, and I was afraid when I touched the plug; it stopped. What a mess! The tone arm reduced to a twisted little stick, the needle in shreds, the record shattered, the turntable already ruined, the accessories blasted out of existence, and the disease still lurking inside the machine." At the moment when I awoke and went back over it in my mind, this dream seemed to me to have an obvious meaning: the mysterious and untamable force was that of time and circumstance, it was laying waste my body (that pitiful, blasted twig that had once been an arm), it was hacking away, threatening my past, my life, all that makes me what I am, with total destruction.

"Man is elastic"[1]; that is his good fortune and his shame. Against the background of my revolt and my disgust, I went on with my other occupations, experienced pleasures—rarely unalloyed. The Berlin Opera presented Schoenberg's *Moses und Aaron;* I went to hear it twice, once with Olga, once with Sartre. I found it painful, before the overture, to see Malraux enthroned up there in his flower-decked box and hear them play the *Marseillaise*. In the circumstances it seemed to fit in too well with the *Deutschland Uber Alles* they launched into immediately afterward, and much as I tried, I couldn't forget that enemy audience sitting all around me; I couldn't forget that I was making myself their accomplice yet again.

Sartre left for Milan to receive the Omonia prize, which the Italians had awarded him for his struggle against the Algerian war; they had given it to Alleg the year before, and that was why, despite his aversion to ceremonies, he had accepted it. As soon as he left, I moved to a hotel just outside Paris with my work, some books, my record player and a transistor radio. In this mournful period, the happy days stand out. I was the only person staying there. I used to sit in the sun in the park where a few trees were beginning to turn green; most of them were still just black lace against the sky, with white pompons ornamenting the tips of their branches; there were ducks gliding across the waters of the pond, or copulating violently

1 Sartre, *Saint Genet.*

on its edges. For the first time in my life I heard nightingales singing in the darkness, as deliciously as they do in Handel and Scarlatti. Above this peaceful scene, great white bellies would pass by, screaming thunderously. The lights of Paris shone on the horizon. The jets and the birds, the neon and the scent of grass: there were moments when it did seem important again to put down on paper what this earth had been like in our time (this earth, where, in the cellars of the Goutte d'Or . . .).

I had suggested to Sartre, who found Paris tiring, that we should leave for Antibes. We went there, with Bost, by way of Vaison, so gay, and the summit of Mont Ventoux, swept by a great wind, lunching in a garden above Manosque; whenever we stopped I applied myself stubbornly to the match game, made fashionable by *Last Year at Marienbad,* until I had worked out the secret. On arriving, we learned about the attempt to invade Cuba. The accounts we heard, disquieting enough in themselves, conformed so exactly to the plans of the émigré forces—as they had been explained to us by the Cubans —that they sounded more like wishful thinking on their part than like descriptions of actual events. And it turned out in fact that they hadn't so much as set foot on the Isle of Pines, and that their leader had been completely unable to land. Soon they began to accuse each other and then all turned and attacked the Americans, who began to have doubts about the efficiency of their intelligence service. Anybody who wanted to was free to go to Cuba and see the situation for himself. It took an Allan Dulles to imagine that the peasants there would fall into the arms of the mercenaries and landowners' sons who were coming to take their lands away from them again. The ludicrousness of this escapade disposed of the danger of an American intervention for a long time to come. So our stay started off well. From the hotel terrace we looked out over the sea, the ramparts, the mountains; every evening we made the trip around the headland to see the lights shining along the coast; we went on a pilgrimage to the villa of Mme Lemaine, now surrounded by tall buildings and transformed into a clinic. We visited the Léger museum at Biot.

As soon as the new negotiations were announced, the ultras had exploded a series of plastic bombs in public places; they set two in the home of the mayor of Évian, who was killed: the Secret Army Organization had just come into being. Generals Salan, Challe, Jouhaud and Zeller seized power in Algiers; most of the high-ranking officers throughout Algeria rallied to their cause. Their only hope of

maintaining their position was to bring off a *putsch* in France with the minimum possible delay.

One Sunday night, I was asleep in bed, having listened to Tebaldi sing Turandot on my transistor radio, when the telephone rang. It was Sartre: "I'm coming up to your room." He'd just had a call from Paris saying the paras were expected any moment. Debré was begging the people of Paris to stop them with their bare hands; they had put buses across all the bridges to block them. This detail, because of its very incongruity, seemed to us particularly disquieting. We tried to get more news on my radio, but without success. I finally got to sleep again. Next morning, the paras still hadn't arrived; that afternoon, twelve million workers throughout France went on strike. By the following evening, the generals and their faction were all in flight or arrested. The attempt to seize power in France had failed, largely because of the attitude of the ranks; urged to disobey their superiors by De Gaulle's speech on the evening of the 23rd, fearing to find themselves cut off from France and doomed to continue their military service indefinitely—some of them because of their political convictions as well—the soldiers had opposed the officers' sedition either by passive disobedience or by violence.

At the beginning of the winter, Richard Wright had suddenly succumbed to a heart attack. I had discovered New York with him, I had kept a whole store of precious images of him that were suddenly snatched from me into the void. In Antibes, a telephone call informed me of the death of Merleau-Ponty; in his case too, quite suddenly, the heart had stopped. This life I'm living isn't mine any more, I thought. Certainly I no longer imagined I could maneuver it the way I wanted, but I still believed I had some contribution to make toward its construction; in fact, I had no control over it at all. I was merely an impotent onlooker watching the play of alien forces: history, time and death. This inevitability did not even leave me the consolation of tears. I had exhausted all my capacities for revolt, for regret, I was vanquished, I let go. Hostile to the society to which I belonged, banished by my age from the future, stripped fiber by fiber of my past, I was reduced to facing each moment with nothing but my naked existence. Oh, the cold!

Giacometti exhibited his great walking figures and some paintings at the Maeght gallery. I am always very happy and yet slightly horrified when I see his works torn from the chalky gloom of his

studio and arranged between well-dusted walls with plenty of space around them. I went to a private showing of *Last Year at Marienbad,* which didn't live up to its ambitions, and Buñuel's *Viridiana* which burns with such genuine fire that I was willing to accept its excesses and its occasional old-fashionedness. I saw several other films; I read, I wrote. Sartre was taking refuge in work, so frenetically that he had no control over it any more; he wrote a second version of his essay on Tintoretto without even taking the time to re-read the first.

Whipped into a fury by the opening of the Évian negotiations—in any case doomed to failure by the French claims to the Sahara—the activists began setting plastic bombs in the homes of prominent left-wingers and members of the U.N.R. One such attack having devastated the headquarters of *L'Observateur,* Sartre commented on the incident in an interview and began receiving threatening letters. Bourdet showed us one advising him of the imminent liquidation of the "121"; it was likely they would start with Sartre's apartment. He put his mother in a hotel and came and camped out in my place.

Lanzmann came back from Tunisia, where he had spent several days on the frontiers, with A.L.N. units and at Boumedienne's headquarters. Finding himself transported, in three hours, from Paris to the *maquis,* sleeping on the ground beside Algerian fighters, sharing their life, had been a striking experience for him which he described to me at length. He had also visited a village of evacuated peasants whom the army had managed to get out of a camp near the frontier and across the border. There was nothing new in what he told me; but he had seen with his own eyes the old man with his shoulders torn to shreds by the dogs, the women's faces haggard with hate, the children. . . .

In July, the Massons passed on an invitation to us from Aït Ahmed, who was in the prison hospital at Fresnes. We drove in along an avenue flanked by little houses with automobiles parked in front of them. The wives of the *putsch* leaders were visiting their husbands; they were allowed in at once, whereas the Algerian wives were forced to wait outside for hours. Michelle Beauvilard, the lawyer, took us through a first door; cops, I.D.s; a little farther on, more cops, another checkpoint. Because he was a cabinet minister, Aït Ahmed had the right to a decently kept cell and a special diet. He preferred Fresnes to Turquant because he came into contact with his compatriots there and could be of service to them. As he was telling us about the exterminations of entire populations, about the slaugh-

tered flocks, about the scorched earth, two men came in, one of them a frail old man with gentle glowing eyes set in a face carved with scars—Boumaza, thirty-one years old: "Prison and maltreatment have turned him into an old man." The cliché could be a fact, then; the tortures, the hunger strikes—the water cut off by the thoughtful M. Michelet—had destroyed him. He spoke to us in a tone of friendship that filled me with shame. "After all, it's not as though it's my fault," I said to myself. But then the same old refrain was there in my head: I'm French.

On July 3rd, a general strike cost the Algerians 18 dead and 91 wounded, according to the French press. The French admitted that 80 Moslems were killed and 266 wounded during the evening of the "National Day" on July 5th[1]; according to Yazid, the number of victims ran to several hundred. In Lyons, despite the overwhelming weight of the evidence against him, they acquitted the activist Thomas, accused of having deliberately brutalized an Arab prisoner. In Algiers, every day brought more news of Moslem stores devastated by plastic bombs.

Toward the middle of July, we had lunch at the Coupole with C. Wright Mills and one of his friends. Mills' book *White Collar* had opened the way for all the subsequent studies of American society today. *Les Temps Modernes* had published long extracts from another of his books, *The Power Elite*. Bright-eyed, bearded, he said to me gaily: "We have the same enemies," reeling off the names of certain American critics who didn't have much use for me. He had become so disgusted with America that he was settling in England. His friend, married, with children, was not allowed back in the United States because he had stayed on in Cuba after diplomatic relations between Havana and Washington had been broken off; his wife was not allowed a passport because she had visited China; they could only meet in Mexico or Canada.

C. Wright Mills was popular in Cuba; he had lived there for some time and then written a book about it in an attempt to share his experiences with his fellow Americans. Like us, he was wondering what was happening there at the moment. The Communist Party was providing the regime with an administrative framework that it had lacked, true enough; unfortunately, it contained within its ranks a clique, led by Aníbal Escalante—whom we had thought a pompous

[1] Organized as a protest against the partition of Algeria which France had been considering since the failure of the Évian talks.

imbecile in February 1960—whose sectarianism and opportunism were threatening to force the Castroist revolution into a blind alley. Rafael's newspaper *Hoy* was gaining ground from *Revolución,* which was now threatened with either collapse or reversion to another group.

We were going to spend the summer in Rome once more; it would give us a rest from France, and I was hoping that Sartre would work less there. He was writing an article on Merleau-Ponty and taking so much corydrame that he was quite deaf by evening. One afternoon when I came as usual to join him in his apartment, I rang his doorbell for five minutes without getting an answer. As I sat on the stairs waiting for his mother to come back, it occurred to me that he'd had an attack. When I finally made my way into his study I saw that he was perfectly well; he just hadn't heard the bell ringing.

The morning of our departure, we were just putting the finishing touches to our packing when, at half past seven, the telephone rang. It was Sartre's mother. A plastic bomb had exploded in the entrance hall of 42, Rue Bonaparte; the damage was not serious.

Sartre having been won over by the artificial coolness of the Nacional in Havana, we booked communicating rooms in Rome equipped with air conditioning. The machinery didn't work very well, but luckily the hotel was up on a plateau at the edge of the city, and the temperature was a little less savage than in the downtown area. As I sat working in front of my big plate-glass window, I looked out at *The Tiber near the Milvio Bridge, about 1960.* The landscape was still half rustic: the green river with canoes gliding over it, yellowish grass scarred by wide paths, pine woods, and the Alban hills in the distance; but they were already beginning to build there, and it was easy to think back to old engravings of Paris or Amsterdam or Saragossa and imagine what it would be like with those houses, those avenues and wharves and parapets and bridges. Below me, the little train to Viterbo would go by between the pale blue reservoirs. Just under my window, on the other side of the street, was a skeet shooting booth. I couldn't see the marksmen, but occasionally one of the clay rounds would come flying out of the trap, and there would be the bang of a gun. Next door there was a family who ran a market garden; I would wake up in the morning to the smell of burning weeds.

Up late, we'd listen to some *bel canto* on my transistor, then go

down for coffee and read the newspapers. We worked, then spent a few minutes getting into the center of Rome by car and went for a walk. A few more hours of work, then we'd eat dinner in one of our favorite places, often the Piazza Santa Maria del Trastevere where we'd sit absorbed in the fountains and the faded gold of the mosaics; an orange flame flickered under the greenery of a terrace roof; a Vespa rushed in from a side street, tied on the handlebars a giant bunch of multicolored balloons. Then a last drink near our hotel on the tree-planted terrace overlooking the plain. Below us, luminous serpents wreathed around dark pits of shadow, their blackness occasionally broken by a passing flicker of red light; headlights sliced brilliant furrows of light through the somber hills; the hum of the cicadas kept up its stubborn earthly answer to the stars glittering in the cold velvet sky. The sight of artifice and nature glorifying and denouncing each other made me feel that I was somewhere that didn't exist, or perhaps on an interplanetary space station.

I wasn't getting on very well with my book; we were being hounded by the present. The Lugrin talks ended in failure. In Metz, amid general indifference, the paras were hunting down Arabs: 4 killed, 18 wounded. And then the slaughter in Bizerte. I found it difficult to get interested in myself and in my past. Sartre had stopped work altogether. We read books that taught us more about the world, and a lot of detective novels.

Fanon had asked Sartre to write a preface for *Les Damnés de la Terre* and had sent him the manuscript via Lanzmann. While in Cuba, Sartre had realized the truth of what Fanon was saying: it is only in violence that the oppressed can attain their human status. He was in agreement with Fanon's book—an extreme, total, incendiary, but at the same time complex and subtle manifesto of the "Rest of the World"; he agreed gladly to do a preface for it. We were very pleased when Fanon, who was going to the North of Italy to be treated for his rheumatism, said he would pay us a visit. I went with Lanzmann, who had arrived the evening before, to meet him at the airport. Two years earlier, having been wounded on the Moroccan border, he had been sent to Rome for treatment; an assassin had managed to get into the hospital and made his way to Fanon's room; by chance, the intended victim had read in a newspaper that morning that his presence there had been disclosed, and had had himself moved, as secretly as possible, to another floor. This memory was obviously very much on his mind on landing. We saw him before he

noticed us. He was sitting down, getting up, sitting down again, changing his money, collecting his baggage, all with abrupt gestures, agitated facial movements, suspiciously flickering eyes. In the car, he talked feverishly: in forty-eight hours time, the French Army would be invading Tunisia, blood would be flowing in torrents. We joined Sartre for lunch; the conversation lasted until two in the morning; I finally broke it off as politely as possible by explaining that Sartre needed sleep. Fanon was outraged. "I don't like people who hoard their resources," he commented to Lanzmann, whom he kept up till eight the next morning. Like the Cubans, the Algerian revolutionaries never slept more than four hours a night. Fanon had an enormous quantity of things to tell Sartre and questions to ask him. "I'd give twenty thousand francs a day to be able to talk to Sartre from morning to night for two weeks," he told Lanzmann, laughing. Friday, Saturday, all Sunday until he caught his train to Abano, we talked without stopping. And again when he came back through Rome ten days later before flying on to Tunis. With a razor-sharp intelligence, intensely alive, endowed with a grim sense of humor, he explained things, made jokes, questioned us, gave imitations, told stories; everything he talked about seemed to live again before our eyes.

In his youth he had thought it possible to break the color barrier on the strength of his education and personal merit; he wanted to be French. During the war he had left Martinique to join up and fight. While he was pursuing his medical studies in Lyons, he realized that in the eyes of the French a Negro was always a Negro, and he had aggressively accepted the conditions forced on him by the color of his skin. One of his best friends, when they were cramming for their finals, exclaimed: "We've really worked like nig . . ." "For goodness sake, say it," Fanon said. "Like niggers." And they didn't speak to each other for months. An examiner asked him: "And where are you from, *boy?* . . . Ah, Martinique, a beautiful country. . . ." Then, paternally: "What would you like me to ask you about, *boy?*" "I plunged my hand into the basket and took out a question," said Fanon. "He gave me five out of ten when I deserved nine. But he stopped calling me *boy.*" Fanon had attended Merleau-Ponty's philosophy classes without ever speaking to him; he found him distant.

He married a Frenchwoman and was appointed director of the psychiatric hospital at Blida: this was the integration he had dreamed of in his youth. When the Algerian war broke out, he was torn in all

directions at once; he hated to give up a status it had cost so much to attain, yet all colonized peoples were his brothers; he recognized the Algerian cause as identical with his own. For a year he helped the revolution without relinquishing his post. He harbored guerrilla leaders both in his own home and in the hospital, gave them drugs, taught the freedom fighters how to care for their wounded, trained teams of Moslem nurses. Eight assassination attempts out of ten were failing because the "terrorists," completely terrorized, were either getting discovered straight off or else bungling the actual attack. "This just can't go on," Fanon said. They would have to train the *Fidayines*. With the consent of the leaders, he took the job on; he taught them to control their reactions when they were setting a bomb or throwing a grenade; and also what psychological and physical attitudes would enable them to resist torture best. He would then leave these lessons to attend to a French police commissioner suffering from nervous exhaustion brought on by too many "interrogations." This contradiction became intolerable. At the height of the battle of Algiers, this French civil servant sent Lacoste a letter of resignation in which he broke completely with France and openly declared himself an Algerian.

After a short stay in France with Francis Jeanson, he went to Tunis, where he became political editor of *El Moujahid;* he wrote the article attacking the French Left that so upset them. Two years later the G.P.R.A. sent him as their ambassador to Accra; he made many trips through Africa, assuring Algerian support to all those who rose in revolt against colonialist domination. He maintained very close ties with Roberto Holden, leader of the U.P.A., and persuaded the G.P.R.A. to train Angolan freedom fighters in the A.L.N. *maquis.* His principal objective was to bring the African peoples to awareness of their solidarity; but he knew they would not find it easy to overcome their various cultural antagonisms and idiosyncrasies. In Tunis, the eyes that turned to watch him in the street never let him forget the color of his skin. He went with some delegates from a Negro country—Mali or Guinea—to see a film they'd been invited to by the Minister of Information. During intermission there was a commercial: some cannibals dancing around a white man tied to a stake who saved his skin by giving them all Eskimo Pies. "It's too hot in here," the delegates said, and left. Fanon complained to the Tunisian minister. "Oh, you *Africans,* you're all so sensitive," came the answer. In Guinea, on the other hand, his friends couldn't bring

themselves to hold important conversations in the presence of his wife, a white woman. He also described his embarrassment one evening when he took a delegation of Algerians to a theatrical performance mounted by the government of Guinea in their honor; some beautiful Negro women came on and danced. "Breasts flying; they've got breasts so they show them," Fanon said; but the austere Algerian peasants were deeply shocked. "Are these women respectable?" they asked him. "Is this a Socialist country?"

It was while Fanon was in Ghana that he fell ill and that the doctor discovered an excess of white corpuscles. He went on working and traveling. When he got back to Tunis, his wife was so terrified by the amount of weight he'd lost that she forced him to see a specialist: he had leukemia. On several occasions after that he thought his last hour had come; for a week or two he had lost his sight; he felt sometimes that he had become a dead weight and was "sinking into the mattress." He'd been sent to the U.S.S.R., where more specialists confirmed the diagnosis. They advised him to go to the United States for treatment; but he found the idea of being in a hospital in that country of lynchers repugnant, he told us. There were moments when he refused to recognize his illness; he would make plans as though he still had years and years ahead of him. But death always haunted him. This was to a large extent the explanation of his impatience, his talkativeness, and also of the obsession with disaster which so struck me from the moment he began to speak. He was satisfied with the decisions taken by the C.N.R.A. at Tripoli and by the nomination of Ben Khedda; he believed victory to be at hand, but at what a price! "The towns will rise in revolt; there will be five hundred thousand people killed," he said once; and on another occasion: "a million." He added that the aftermath would be "frightful."

The complacent way in which he always accepted the worse possible outcome as being the most likely also betrayed serious inner difficulties. Though an advocate of violence, he was horrified by it; when he described the mutilations inflicted on the Congolese by the Belgians or by the Portuguese on the Angolans—lips pierced and padlocked, faces flattened by *palmatorio* blows—his expression would betray his anguish; but it did so no less when he talked about the "counterviolence" of the Negroes and the terrible reckonings implied by the Algerian revolution. He attributed this repugnance to his intellectual conditioning; everything he had written against the intellectuals had been written against himself as well. His origin

made this inner conflict even worse; Martinique was not yet ready for a rising. Anything gained in Africa serves to advance the cause of the Antilles as well, yet it was evident that he found it distressing not to be fighting the battle on his native soil, and even more so not to be an Algerian-born. "Above all, I don't want to become a professional revolutionary," he told us anxiously; theoretically there was no reason why he shouldn't work for the revolution in one place rather than in another, but—and this is what made his situation so pathetic—he had a passionate desire to send down roots. He was constantly reaffirming his commitment: the Algerian people was his people; but the difficulty was that no one person or group among the leaders could really be said to represent that people completely. About the dissensions, the intrigues, the liquidations, the antagonisms that were destined to break out into such open and violent conflict later on, Fanon already knew much more than he was able to tell us at the time. These dark secrets, and perhaps his personal hesitations, too, invested his remarks with an enigmatic quality, as though they contained obscure, disturbing prophecies.

He defended himself against the future and the present by exaggerating his past feats in a way that astonished us, since their undoubted importance made such inflation unnecessary. "I have two deaths on my conscience for which I can never forgive myself: Abbane's and Lumumba's," he said; if he had forced them to follow his advice they would have escaped with their lives. Often he spoke as though he were the G.P.R.A. all by himself. "Perhaps I'm a paraphrenic," he admitted once without prompting. And once, when Sartre had made some comment, he gave an explanation of his egocentricity: a member of a colonized people must be constantly aware of his position, of his image; he is being threatened from all sides; impossible to forget for an instant the need to keep up one's defenses. In Italy, for example, it was always his wife who booked the hotel rooms; he would be asked to leave, for fear his presence might upset the American customers or, less specifically, cause some sort of scene. On his way back from Abano he told us how a chambermaid there had watched him for several days and then asked: "Is it true what they say? That you hate white people?" And he concluded angrily: "The heart of the matter is that you white people have a physiological horror of Negroes."

This conviction did not simplify relations with him in certain difficult respects. When Fanon was discussing questions of philosophy

or his own problems with Sartre, he was open and relaxed. I recall a conversation in a *trattoria* on the Appian Way. He couldn't understand why we had taken him there, since the European tradition had no value in his eyes; but then Sartre began asking him about his psychiatric experiences and he came to life. He had been very disappointed by Russian psychiatry; he disapproved very strongly of confinement and wanted mental patients to be treated without removal from their home environment; he attributed great importance to economic and social factors in the formations of the psychoses and dreamed of supplementing psychotherapy with civic education for the patients. "All political leaders should be psychiatrists as well," he said. He described several curious cases, among others that of a homosexual who, at every successive stage in his psychological deterioration, took refuge in a lower social stratum, as though he were aware that anomalies of behavior visible at the top of the social scale may be easily confused, lower down on it, with irregularities due to extreme poverty; his psychosis progressed in this way until finally he was living in a state of semi-dementia in the colonies, just one bum among all the others. By then his social disintegration was so complete that his mental deterioration was scarcely noticeable.

Yet Fanon could not forget that Sartre was French, and he blamed him for not having expiated that crime sufficiently. "We have claims on you. How can you continue to live normally, to write?" Sometimes he would demand expiation through the discovery of some effective means of action, sometimes by martyrdom. He lived in a different world from ours; he imagined that Sartre would shake public opinion to its foundations by announcing he would not write another word until the war was over. Or let him get himself thrown into jail: that would provoke nationwide horror. We couldn't manage to persuade him that this wasn't so. He quoted us the example of Yveton who, with his dying breath, had declared: "I am Algerian." Sartre, for his part, asserted his entire solidarity with the Algerian people—as a Frenchman.

Our conversations were always extremely interesting, thanks to the wealth of his knowledge, his powers of description and the rapidity and daring of his thought. Because of the friendship we felt for him, and also because of what he could do for the future of Algeria and Africa, we hoped that his illness would allow him a long reprieve. He was an exceptional man. When I shook his feverish hand in farewell, I seemed to be touching the very passion that was con-

suming him. He communicated this fire to others; when one was with him, life seemed to be a tragic adventure, often horrible, but of infinite worth.

After his departure, Sartre settled down to write a preface for *Les Damnés de la Terre,* but without haste; he had finally sickened of the struggle he had been waging blindly all these months against the clock, against death. "I am re-composing myself," he told me. Calm was winning me over again, too, more or less. I could get interested in news that wasn't about Algeria. As we sat having breakfast in the Square of the Muses, we saw that the front page of the newspaper our neighbor was reading contained nothing but an enormous picture of a face: Titov was circling the earth. A little later on, we followed events in Brazil. It was a country that existed for us now; Quadros, Lacerda, Jango, were real live people; the names Brasília and Rio conjured up definite pictures. We asked ourselves: "What are the Amados thinking? What are Lucia and Christina doing?" Jânio was confirming the judgment of our friends: "A fine program, but he won't have the nerve to put it through." We were glad that the Army's attempt to seize power failed, both for Brazil and for France; a success there might have encouraged our own generals back home.

The Viareggio prize, increased that year by the Olivetti firm to four million lire, was awarded to Moravia, a decision that produced a lot of malicious comment in the Italian press, which we found unjust but entertaining; Moravia himself wasn't in Rome, we didn't see him. We encountered Carlo Levi. We had dinner in Trastevere with the Alicatas and Bandinelli, whom we got on with just as well as in 1946. There was talk of a discussion the Istituto Gramsci wanted to organize in the spring between the Italian Marxists and Sartre, on the subject of subjectivity and the problems the latest capitalist tactics were producing in Italy and France.

We made several expeditions into the countryside around Rome. I hadn't been back to Hadrian's Villa since 1933. I could remember being greatly moved by brick walls and cypress trees; and it was in fact very moving when I did see it again, the ruins faded by the sun, the dark green of the pines and cypresses spilling their color onto the blue sky. Taking a road that had just been opened, we climbed up to Cervera, a black and haughty village that dominates the plain of Latium from a height of three thousand feet. We saw Nettuno again, and Anzio, where we were intrigued by the sight of a red galley floating on the blue sea: Cleopatra's galley from Liz Taylor's film

they were having such trouble shooting. From Frascati we went up to Tusculum; the view could scarcely have changed at all since ancient times: the Alban hills and their villages, Latium, the site of Rome in the distance. Sitting beside Sartre in the ruins of the little theater, for an instant I caught once more the taste of past happiness. Little by little, Rome had lulled me back into a state of calm; my dreams at night were peaceful ones. I said to myself, I said to Sartre: "If we've got another twenty years to live, let's try to enjoy them." Isn't it possible to stay alive in the world and not tear oneself to pieces all the time with emotions that don't do anyone a scrap of good?

Evidently not. The answer of the O.A.S. to the new policy of "disengagement" was an attempt to assassinate De Gaulle[1]—which didn't upset me particularly—and a general incitement to murder. The Arab-hunts in Oran, the Moslems stoned to death, burned alive in their automobiles—how could one think of these things and stay calm? Our Roman holiday had been only a truce; I was to find Paris and my life there completely unchanged when I got back.

Sartre, who gets bored on long car trips, was going to return by plane, so I left him behind and started on the journey north with Lanzmann, who had come down to drive with me. Lanzmann was making frequent visits to Fresnes. The Algerian prisoners there were convinced that an agreement would soon be reached. He told me all about Boumaza's plan to escape. Every day, an electrician—a common-law prisoner—came to work on a ladder resting against the inside surface of the prison wall; there was always a warden keeping an eye on him; one of these mornings the electrician would be sick; when that happened his place would be taken by Boumaza, and that of the warden by a common-law prisoner. The *garde mobile,* accustomed to the two figures, would see nothing amiss; at a suitable moment the two accomplices would leap over the wall, where an automobile would be awaiting them on the other side.

I left Lanzmann in Zürich and went to visit my sister, who lives in a village near Strasbourg. The house smelt of woodsmoke; Lionel, who has to travel a lot in his profession, had brought back some hangings from Dahomey that made a pleasant decoration for the studio. More daring and more inspired than in the old days, my sister's latest pictures left everything she had done till then far be-

[1] On September 5th, De Gaulle had finally recognized the "Algerian character" of the Sahara.

hind; I spent a long time looking at them, we chatted, and spent a carefree day together. I set out with her next morning for a drive through the Black Forest and stopped at Strasbourg to telephone to Lanzmann; he raged to me about the clubbings at the Arc de Triomphe. The police waited for the Algerians to come up out of the métro stations, made them stand still with their hands above their heads, then hit them with their truncheons. He'd seen teeth smashed in and skulls fractured with his own eyes; to protect themselves, the Algerians had covered their heads with their hands; the police just smashed their fingers. Corpses were being found hanging in the Bois de Boulogne, and others, disfigured and mutilated, in the Seine. Lanzmann and Péju had immediately taken the initiative in launching an appeal urging the whole of the French people to show that they could no longer be satisfied by moral protests and to "demonstrate their opposition on the spot to the renewal of such acts of violence." There were only 160 of us who signed it[1]; respectfully, the *Express* team, with two exceptions, and nearly all the staff of *L'Observateur,* took part in a protest march. A fine welcome home to my mother country! I thought to myself as I drove through the pine trees along the roads edged with snow. It was impossible to get to sleep that night; I stayed up alone for a long time next to the fire, the old horror, the old despair burning at the backs of my eyes, welling up like the refrain of some too-familiar old song. The next day, I went with my sister and Lionel to see Riquewihr and Ribeauvillé again; the villages and vineyards were as pretty as they'd always been, we ate pheasant cooked with grapes, but I couldn't bear any more of the prettiness, the gastronomy, the old traditions that had brought us to this pass. In the evening I listened to the radio. Keeping to his plan, step by step, Boumaza had escaped. But then I listened to the interview with Frey and all his calm lies: two deaths, when fifty corpses had been discovered already. Ten thousand Algerians had been herded into the Vel' d'Hiv', like the Jews at Drancy once before. Again I loathed it all—this country, myself, the whole world. And I told myself that even the most beautiful things in it—much as I have loved them, well as I've known them—are not really so beautiful after all; you reach the bottom pretty soon; only the evil in the world is bottomless; they could have blown up the Acropolis then, and Rome, and the whole earth, and I wouldn't have lifted a finger to stop them.

[1] At the end of a week there were 229 of us.

The following Sunday, early in the afternoon, I arrived in a deserted, dismal Paris crawling with cops. My friends told me that more than fifteen people had been found hanged in the Bois de Boulogne and that more corpses were being fished out of the Seine every day. They would have liked to be able to do something; but what? We were living through days of police dictatorship: newspapers seized, meetings forbidden. Neither the political parties nor the trade unions had as yet been able to get into action. On October 18th, several small groups and a few people on their own had decided to make some protest, whatever the cost. The Committee of the 6th Arrondissement's section of the Communist Party had asked its members to demonstrate. Only a few of them had appeared. Lanzmann and Pouillon had provoked the cops and got themselves arrested. Evelyne had tried in vain to follow their example. The cops had knocked them about a bit: "Ah! You cocksuckers! The cops can go out and get themselves killed and you don't give a shit, but if it's those Algerian bastards who get it, then you start screaming." I talked through the whole night, first with one group, then with another. At five in the morning, I was in the Falstaff with Olga and Bost when a brawl started between the customers and the waiters; the waiters got hold of a man who'd been knocked senseless and were dragging him outside while his wife was screaming: "We'll blow up this dump of yours; we're *pieds noirs.* . . ."

Sartre came back the next day and I began to get a foothold once more in this Paris full of autumn leaves and blood. Lanzmann spent a day at Nanterre: wounds, disfigurements, mutilations—they had to amputate the hands of the ones with shattered wrists; women mourning the husbands who had not come back. . . . . To our surprise, several newspapers denounced the "police brutalities"; it almost looked as though certain members of the government were hostile to Papon and were encouraging the publication of these truths. Then too, a great many readers, outraged by what they'd seen, had written letters to *Le Monde* and *Figaro;* apparently if they actually had their noses rubbed in blood, people could still react. Pouillon told us about a session in the Chamber during which Claudius Petit said to Frey: "Now we know what it meant to be a German when the Nazis were in power!"; his words were greeted by a dead silence. It was five years since Marrou had reminded them of Buchenwald and the Gestapo; for years now, the French people had been just as much accomplices to what was going on as the Germans under Nazi rule; the

belated uneasiness some of them were feeling about this fact did nothing to reconcile me with them.

On November 1st, the Federation of France forbade the Algerians to stage any more demonstrations that would provide pretexts for fresh massacres. In the Police State that France had now become, there was almost no possibility for action on the part of the Left. Schwartz and Sartre summoned the intellectuals to a silent demonstration in the Place Maubert. We all met, one cool and sunny morning, in the Square Cluny. Rose and André Masson were there, agonized because the Algerian prisoners and their French "brothers" in all the prisons throughout France were just beginning a hunger strike. I recognized a great many other faces as we walked off toward the statue of Étienne Dolet, near which about twelve hundred people were assembled.

A police cordon halted us near the entrance to the métro. Schwartz talked to the commissioner, who had evidently been given orders to avoid any sort of trouble, and he allowed us to stand there for ten minutes in silence. There was one short speech: Sartre explained the reason for the demonstration. Some photographers took photographs; Schwartz and Sartre murmured a few words into a microphone. After five minutes, the commissioner gave the order: "Move on." There were protests. Chauvin, a P.S.U. member used to trouble, shouted: "Shoot then. Go on, shoot!" The cop (in plain clothes) shrugged his shoulders, as if no cop within living memory had ever shot at anybody. Someone suggested: "Let's sit down," and the commissioner raised his eyes to heaven in exasperation. Since the boulevard had been blocked and the press alerted, there was nothing more to be gained by our all languishing in jail for several hours, so we broke up. I went off toward the Rue Lagrange with Pouillon, Pontalis, Bost, Lanzmann and Evelyne. "Thank you for coming," a woman said to me as I went by, which gave me something to think about. Suddenly I heard the noise of an explosion behind me, someone shouted: "Oh, the bastards!" and I glimpsed some blackish smoke trails curving down toward the crowd in the Place Maubert. We rushed back the way we'd come. But a plastic bomb is scarcely more dangerous than fireworks in the open air; some windows had been blown in, and two people had been grazed by flying splinters (one of them the son of my cousin Jacques who happened to be going by just then). I bumped into Olga, who had arrived late and hadn't been able to get into the Place Maubert; in the corner

where she was, and in the Place Médicis, people had started a sit-down on the sidewalk, and some of them had been pulled in. Afterward, I went with Sartre and a group I met up with at the Balzar to have lunch in a restaurant on the Boulevard Saint-Michel. The radio was giving our demonstration a lot of publicity; during the course of the meal they broadcast three separate accounts of it.

That afternoon, about twelve hundred P.S.U. members had cleverly arranged to meet in a movie queue in the Place Clichy; they were able to form a procession without being disturbed. Then, carrying banners and chanting slogans, they marched down as far as Rex et Depreux to lay bunches of flowers on the spot where two Moslems had been shot.

At noon, however, while declaring that "everything is calm in Algeria," the radio announced that forty people had been killed. That evening, on Europe N°1, the French Government delegate came out with the story that the Algerian people had not been involved, that *agents provocateurs* had fired on a police patrol while on duty and killed three of them—and that seventy-six Moslems had been killed! Some reporters then added that they had heard bursts of gunfire, but that they had not been allowed to go and investigate: another massacre. In Oran, all had remained quiet. And in some Moslem districts, the anniversary had been a real day of celebration; the radio rebroadcast recordings of joyful cries, chants, and songs.

No one was in much doubt that independence was just around the corner. Negotiations were in progress, and the entire press was giving them coverage. De Gaulle was being forced into making peace—by the F.L.N., by public opinion, and by the harm the war was doing to his policy of *grandeur*. When he announced at Bastia that "the last quarter of an hour" had come, we felt that his words corresponded, for the very first time, to some sort of reality. But until Ben Khedda was finally established in Algiers, the Fascists would go on making life difficult for us. We needed to organize.

In the U.S.S.R., with the report of the 22nd Congress, de-Stalinization had moved into its second phase.[1] In the French Communist Party, there were several intellectuals, Vigier among others, who

---

[1] Khrushchev had expressed antagonism to Albania and China; he had delivered another attack on Stalin, whose remains had been removed from their resting place in the Red Square, together with the wreaths and garlands around them (including the one Chou En-lai had placed there eight days earlier). He had been buried in the group of tombs backed up against the Kremlin wall, and Khrushchev had suggested that a memorial be erected to "the despot's victims."

were in favor of a rapprochement with the non-Communist Left; he suggested that Sartre sign, and get others to sign, a pamphlet directed against the present regime and against racism. This was to form the jumping-off point for a demonstration and the basis for an anti-Fascist organization. But difficulties began to arise immediately. Sartre and our friends wanted to express their solidarity with the Algerian revolution in acts; to destroy the O.A.S. it was imperative, in their opinion, to attack the government which was the organization's objective accomplice. The Communists, being concerned to "retain what unites and reject what divides," wanted to limit the movement to fighting the O.A.S. Sartre decided that an attempt should be made to overcome these differences; without the Communists we could do nothing. We won't be able to do anything with them, predicted Lanzmann, Péju, Pouillon. Finally, for want of anything better, they decided to make an attempt, and supported Sartre when he joined Schwartz and Vigier in the creation of a "League for Anti-Fascist Movements."

The assassination attempts had begun again, and were even more serious than before the summer vacation. Sartre wanted to take a room in a hotel, but the manager turned him away; he had just had the outside of his place repainted. We were forced to resort to trickery. Claude Faux—who had taken over Cau's job as Sartre's secretary some years before—rented a furnished apartment on the Boulevard Saint-Germain in his name, and we moved there; the building was still not finished, there was no light in the rubble-filled staircase, and from eight in the morning till six at night there were workmen banging in nails; there was no sun from the windows overlooking the narrow little Rue Saint-Guillaume, and we were forced to keep the electric lights on all day. I have lived in more squalid places, but never in one so depressing.

I wrote a preface to Gisèle Halimi's book on Djamila Boupacha; General Ailleret and Cabinet Minister Mesmer had been reduced to openly obstructing the course of Justice; we wanted to show all the traps we had to spring before they were finally forced into the open. Gisèle Halimi also had the idea, approved by experts like Hauriou and Duverger, of instituting legal proceedings against Ailleret and Mesmer; we obviously wouldn't succeed in getting them inculpated, but it seemed to us a good thing in the circumstances to make it perfectly clear what they had done. We did not then foresee the quiet explosion the military courts were about to cause by suddenly join-

ing in our attack, nor the series of revelations that were later to confirm their verdicts, amid public indifference. The Committee contained a certain number of left-wing Gaullists who were hoping to combat the use of torture while keeping the fight within a purely moral sphere. They hung back, a section of the board resigned and another was elected.

A surprise demonstration against Fascism and racism was planned for November 18th; it was essentially the young Communists who organized it. Such a demonstration stood no chance of success unless it could be started without the police hearing of it; the meeting place was kept so secret that when the League assembled in front of the Paramount no one knew where to go. There were scores of police cars parked in the Place Saint-Germain-des Prés; the Left Bank was in a state of siege. Vigier gave us the order: Strasbourg-Saint-Denis. "Go there by métro," he advised us; I went with Sartre, Lanzmann, Adamov and Masson, the latter saying sheepishly: "I know it's bad and undemocratic, but I've never been able to take a subway." (In New York, he had a label with his address on it sewn inside his jacket which he showed to cab drivers. . . .) With his cap, his black leather jacket, his pale eyes, he looked as though he'd just popped up, green and astonished, from some bygone anarchist era. There were a lot of young people in the métro. A few yards in front of me, in the exit corridor, three fifteen-year-old boys were having a discussion. "I feel very nervous; I'm keeping myself under control all right, but I'm nervous," one of them was saying. The Saturday night crowd was packing the sidewalks; it looked to me as though our scattered groups waiting in different places would be submerged by them. "You'll see," Lanzmann said, "in a minute, all of a sudden, it'll begin to *take*." And at that moment a procession appeared carrying a placard: PEACE IN ALGERIA, which soon had hundreds of people clustering behind it; others began coming from all sides; we ran to get a place just behind the placard, in the front of the procession. I took hold of Sartre's arm on one side and that of someone I didn't know on the other, noticing with surprise that the boulevard suddenly stretched as far as the eye could see in front of us, quite empty. (It was a one-way street; the procession was blocking the traffic behind us; in all the side streets, cars were suffering from very opportune breakdowns in the middle of the pavement and preventing the police cars from getting through.) We had spread onto the sidewalks too by this time; it was as though all Paris belonged to us. At the

windows—except those of *Humanité,* noisy and triumphant—a row of expressionless faces; lots of reporters and photographers along the whole route. As we marched we chanted: *Peace in Algeria—Solidarity with the Algerians—Free Ben Bella—O.A.S. murderers;* less frequently: *United action—Hang Salan.* As we went past the Musée Grévin, some people shouted: *The Museum for Charlie,* and at the sight of a para: *Put the paras in the factories;* I also heard one or two shouts of: *Hang Charlie.* But the slogan *Peace in Algeria* was far and away the most popular. Astonished to find itself walking along like this unmolested, the crowd became infected with tremendous gaiety. And how good I felt! Solitude is a form of death, and as I felt the warmth of human contact flow through me again, I came back to life. We reached Richelieu-Drouot; as we moved on into the Boulevard Haussmann, there was a movement in the crowd and a stampede. The cops had started using their truncheons; a lot of people disappeared down a street to the right; Lanzmann, Sartre and I followed them, then turned left and went into a bistro whose doors were promptly slammed shut behind us. "You're afraid!" Lanzmann said. "I don't want my place busted up," the owner said. "The tobacco shop on the corner stayed open the other day, trying to be smart; the cops turned up—two million francs' worth of damage." Then, addressing Sartre with a half smile, he added: "You can write a novel about it and put me in it, but that won't do *me* any good. . . . I've got three kids, I don't want anything to do with politics; politics, that's for the big time." He mimed vast piles of gold with his hand. "The real big time; we're not in that class." After a short while we went back to the main intersection; there were big splashes of blood on the street corner and police cars along the boulevard; the demonstrators had just finished dispersing. We went home in a taxi, and the telephone rang as soon as we got back; Gisèle Halimi and Faux, who were just beside us at Richelieu-Drouot, had been caught in the police charge; they had seen one demonstrator with the flesh hanging away from his face, another knocked senseless and his skull fractured. The cops had been using special truncheons, jumbo size; they had been hitting out just for the fun of it, since the crowd was quite satisfied with the run it had had, and would have dispersed as soon as it was ordered to. Yet Evelyne, Péju, Adamov, Olga and Bost, only a few rows behind us, had known nothing about this incident; they had gone on to the Gare Saint-Lazare, via the Boulevard des Italiens and the Rue Tronchet, without meeting any police at all; the dem-

onstrators—of whom there were by then about eight thousand—disbanded at the request of the organizers. When I went down to buy something for dinner, I heard distant noises, the traffic was jammed along the Boulevard Saint-Germain; demonstrations were still going on near the Odéon, and we heard later that there had been some fighting in the Latin Quarter. It had been a marvelous day, and one that encouraged us to hope.

A flash in the pan. This already dark autumn turned finally to utter blackness in a drama enacted on the other side of the Atlantic. At the beginning of October Fanon had suffered a relapse and his friends had sent him to the United States for treatment; despite his repugnance he had accepted. He had stopped over in Rome, and Sartre spent a few hours in his hotel room along with Boulahrouf, the G.P.R.A. representative in Italy. Fanon lay flat on his bed, so exhausted that he didn't open his mouth during the whole interview; his face tense, he kept shifting his position the whole time, the only way he could express revolt against the passivity to which his body had been reduced.

On my return to Paris, Lanzmann had shown me some letters and cables from Fanon's wife. As a member of the G.P.R.A., Fanon had supposed that he would be warmly welcomed in Washington; he had been left to rot in his hotel room for ten days, alone and without medical attention. She had gone over to join him with their six-year-old son. Finally admitted to a hopsital, Fanon had just been operated on; they had changed all his blood, in the hope that the shock to his system would start his marrow functioning again, but there was no hope of recovery; at the most, he would live another year. She wrote again, she telephoned; at a distance of 4,000 miles we followed his death agony day by day. Fanon's book came out, there were articles loading him with praise; his wife read him the ones in *L'Express* and *L'Observateur*. "That's not going to get me my marrow back," he said. One night, at about two, she telephoned through to Lanzmann: "Franz is dead." He had caught double pneumonia. Beneath the restrained tone of her letters, one could detect her real despair, and Lanzmann, though not knowing her very well, flew over to Washington. He returned after a few days, appalled and shaken. Fanon had lived every moment of his death and savagely refused to accept it; his aggressive sensitivity had cast off all restraint in his deathbed fantasies; he loathed the Americans, all racists in his eyes, and distrusted the entire hospital staff; the last morning, as he woke up, he betrayed

his obsessions by saying to his wife: "Last night they put me in the washing machine. . . ." His son had gone into his room one day when they were giving him a transfusion; he was lying there with tubes connecting him to a series of plastic bags, some full of red corpuscles, some of white corpuscles and blood platelets; the child rushed out screaming: "The bad men have cut Daddy up with knives!" He went through the streets of Washington waving the green and white flag defiantly. The Algerians sent a special airplane to take Fanon's body back to Tunis. He was buried in Algeria in an A.L.N. cemetery; for the first time, and in the middle of the war, the Algerians gave one of their people a national funeral. For a week or two I kept seeing Fanon's photograph all over the place in Paris: in the kiosks on the cover of *Jeune Afrique,* in the window of the Maspero bookstore, younger, calmer than I had ever seen him, and very handsome. His death lay heavy on us because he had weighted it with all the intensity of his life.

Sartre received the invitation from the Istituto Gramsci that we had talked about in September; he stayed a few days in Rome and held a press conference about Algeria, at which Boulahrouf was present. The Italians, no longer having any colonies, are all anticolonialist and applauded him wildly. There were a few Fascists there nevertheless—heroes according to Sartre—to throw handbills—*Sartre is nothingness, not being*—and to boo. Everyone turned around, ready to rush at them, and the president said calmly: "Let their neighbors see to them." Guttuso tried to get at them all the same, but the wretches were already halfway down the stairs, head first; some of them were taken to the hospital, the rest to jail. The French press reported that Sartre had been bombarded with rotten eggs and published a photograph of him side by side with Boulahrouf. When he got back he began receiving threatening letters from Oran.

On December 19th, there was yet another anti-O.A.S. demonstration, forbidden at the last moment. All the same, we went to our meeting point in front of the Musset statue; all the same faces as at the Balzar on November 1st and in front of the Paramount on November 18th, everyone knew everybody else, it was like being at a literary cocktail party. This time the procession was supposed to start on the Boulevard Henri-IV; I took the métro with Sartre, Lanzmann and Godemant, whose apartment had been blown up a few days earlier. His wife had been inside and was still in a state of shock. The boulevard was black with people but blocked by a police cordon in

the directon of the Bastille. I don't know exactly what happened—it's
all a bit like Stendahl's battle of Waterloo, a demonstration; one only
sees such tiny fragments—we came out of the Rue Saint-Antoine on
the other side of the barrier; Bourdet, who looked radiant under-
neath his stunning pointed hat, came and took Sartre by the arm
before disappearing into the vast procession that was moving in
orderly fashion along the street and both sidewalks; at the head of it,
a few rows in front of us, were municipal and national councilors
carrying placards; the police cars and policemen stationed along the
sidewalks watched us go by without moving a muscle. Suddenly, at
the Saint-Paul métro, we were caught up as the crowd began to eddy;
the people in front were moving back. Behind, they were still ad-
vancing with cries of: "Don't turn back!" I was being suffocated, I
was swaying, and so many people had stamped on my feet that my
right shoe had come off; afraid of falling and being trampled on,
hanging on to Sartre's arm which I didn't want to let go, though it
hampered my movements, I felt myself turning pale. Lanzmann, who
is taller than either of us, could breathe better; he helped us reach a
side street, where even so it was impossible to move because so many
other people had taken refuge there too. I sat down with Sartre in a
little café on the Place des Vosges, and Bianca brought me a woolen
sock, fortunately, because I had to hobble about for an hour before
we got a taxi. Then the driver said to us angrily: "They're blocking
all the streets." The telephone calls that evening were less gay than
the month before. Some of our friends had walked in circles around
the Place de la Bastille and then choked with tear gas; there had been
fighting at Réaumur-Sébastopol; Pouillon's son, a believer in non-
violence, had helped some friends turn over a police car and then
beaten a policeman with a stick. Bianca had gone down to take the
métro at Saint-Paul; there was a young man on the platform at the
next station fighting off a C.R.S. man who was pushing him into a
car: "I've lost my glasses! Let me find my glasses." The C.R.S. man
began hitting him; some fifteen men rushed out of the train yelling:
"Murderer"; the policeman threw himself down on a bench with his
heavy boots out toward them, and then some more C.R.S. came to his
rescue. Several more passengers wanted to get off and join the fight,
but the guard had closed the doors. As Bianca was trying to open
them, a man with skis on his shoulder stopped her. "What good
would it have done?" he said to her in a voice from another world.
The next day we learned that the police had suddenly charged the

head of the procession and beaten up the dignitaries carrying the placards. Some people had been badly wounded, women were trampled on, and yet this peaceful procession had been a demonstration against enemies of the government. "Next time, we must be armed," was the conclusion drawn by Bourdet in his article.

The government was playing the game of the O.A.S., and except for a small minority the country accepted the government. Negotiations were under way, but the massacres and the tortures still went on. "My first reaction is no longer to fight these things, as it once was, nor even to protest, for they are taking place under the presidency of General De Gaulle," wrote Mauriac.

All we could do was work. Sartre had gone back to the Flaubert study he had sketched out a few years earlier and was writing away with desperate concentration. He took part, with Vigier, Garaudy and Hippolyte, in a debate at the Mutualité on the dialectics of Nature which a public of six thousand seemed to find passionately interesting. But he couldn't really give more than a summary account of his thought in a mere twenty minutes, and I would rather he hadn't made the attempt. I had reached the years between 1957 and 1960, and the story of that abominable time seemed to suit only too well the abominable winter we were living through. I wasn't in the mood for all the New Year's festivities. I stayed in my dismal apartment. De Gaulle spoke on New Year's Eve, and I turned the radio off after two minutes, sick to my stomach with all that neurotic narcissism and empty grandiloquence. At about midnight, I heard a chorus of car horns: hundreds of cars moving in noisy procession along the Boulevard Saint-Germain. I thought something was happening; but no, it was just a sudden outburst of joy, without rhyme or reason, just because it was New Year's Eve and they all owned cars. I took some belladénal to escape all that hateful gaiety, the gaiety of the French people, of murderers, of butchers. *How I loved those nights, on the Boulevard Montparnasse, in the bright glare of the lights, surrounded by laughter and shouts, how I loved the crowds and their gay festivity, when I was twenty, when I was thirty.*

At the beginning of January we arranged to have dinner with the Giacomettis and went to their place to fetch them. He was sitting down, glasses on his nose, in front of an easel, working at a very beautiful portrait of Annette in gray and black; against the walls there were more portraits, also gray and black. I expressed astonishment at seeing a splash of red on his pallette; Giacometti laughed

and pointed at the floor: there were four red marks indicating the
exact spot for the model's chair. As usual, I was intrigued by the
statues swathed in their wet cloths. At one time, Giacometti had
modeled the human form in its general aspect; for the past ten years
he had been seeking to individualize it, and was never satisfied with
the result. He uncovered one of his busts and there before my eyes, as
dense, as inevitable as any of his earlier works, was the head of An-
nette. It was so obviously a success and therefore of course so appar-
ently simple that one wondered: "Why has it taken him ten years?"
He admitted that he wasn't displeased with it himself. For an instant
it seemed to me important again to take plaster, or words, and create
something.

I read *The Letters to Madame Z* by the Polish writer Brandys;
and also, in manuscript, Collette Audry's *Derrière la Baignoire* and
Gorz's *Le Vieillissement*. Very different works, but all three free and
direct; they hurled me into the heart of an experience different from
my own, and so took me out of myself, while still talking about
things that I found interesting.

One night, at about two in the morning, I was awakened by a
very loud but dull noise; I found Sartre out on the balcony. "Well,
they've nosed us out," he said. There was smoke floating up from the
Rue Saint-Guillaume, some planks had been blasted out into the
roadway, and in the silence we could hear the faint tinkling of a
xylophone: shards of glass still falling into the street. No one stirred.
After ten minutes, the windows in the house opposite lit up; men
and women appeared in bathrobes, carrying brooms, each one alone,
and began sweeping up the debris piled up on their balconies; not a
word spoken; side by side, one above the other, they all went through
the same gestures unaware of each other's presence. Concierges ap-
peared, wearing pajamas under their topcoats. Finally, police cars
and firemen appeared. I threw on some clothes and went down. The
shirt shop on the corner was blown to bits. A policeman questioned
me and followed me to the door of the apartment; seeing me open it,
he didn't ask for identification, but it was a near thing. Was it the
shirt shop they'd been trying for? Too odd a coincidence; no, we
were the ones they were after; but in that case the O.A.S. was curi-
ously well informed. At ten next morning, Claude Faux came to see
us in a state of consternation: there could be no doubt that the
plastic bomb had been meant for us. Lanzmann telephoned: the
same story. We thought we were going to be forced to move again;

we were shivering where we were because the heating had been cut off, and felt pretty gloomy. It was a relief to discover that the bomb had been intended for Romoli, a *pied noir* who had refused to collect funds for the O.A.S. In his window there was an enormous placard with the announcement: STORE BOMBED, BUSINESS AS USUAL. There were glaziers working on every floor of the building opposite, and we could see the tenants wandering about their apartments, still as isolated as ever in the midst of their collective adventure.

Three days passed; toward eleven one evening Faux telephoned. *Libération* had just called him to say that 42 Rue Bonaparte had been blown up. It occurred to us that there was a faintly amusing irony in the coincidence; but when Faux called again an hour later he wasn't laughing any more. "They were really after your blood this time." He had told the policeman standing guard on the house: "I'm the owner's secretary, I've got keys." "O you won't need keys!" was the reply. The plastic bomb had been left on the floor above Sartre's; the two fifth-floor apartments had been blown up, as well as the bedrooms on the sixth; Sartre's place hadn't suffered much, but the door had been torn off and the Norman cupboard standing on the landing smashed into oblivion; from the third story up, the staircase was hanging out over a void, the wall having collapsed. Evelyne telephoned to say that she had been passing nearby in a car and heard the explosion; she had mingled with the crowd of onlookers around the door of the building, who didn't seem at all curious. "If he had any sense of publicity he'd come down and give autographs," one young man said. The bomb had been a reprisal for the press conference Sartre had called in Rome. I went next day with Bost to see how much damage had been done; one of the tenants in the building, a well-to-do man in his fifties, shouted after me as I picked my way across the rubble in the courtyard: "This is what happens because of all your politics, making trouble for everyone!"

We went up the service stairs, passing tenants coming down with suitcases in their hands. The vanished cupboard, the staircase open to the sky—even though I'd been told, I couldn't believe my eyes; inside the apartment, there were papers all over the floor, doors torn off, walls, ceilings and floors covered with a sort of soot. Sartre would never be able to move back into it—another piece of my past disappearing into the blue. Sartre received a great many letters and telegrams expressing sympathy, and phone calls too, taken by Faux. Some of his friends demonstrated under his windows: *O.A.S. mur-*

*derers.* In a restaurant, a customer came up to him, hand out-stretched: "Bravo, Monsieur Sartre!"

A few days afterward, when Sartre had gone down to fetch the newspapers one morning, there was a knock at the door. "Precinct police," said a big fat man, showing me his card. "I'm looking for a well-known person . . . a writer . . ." "Who?" "I may be able to tell you later . . . he lives in this building, but there doesn't seem to be a concierge. . . . Do you live alone?" "Yes." He couldn't make up his mind to leave. I heard steps on the landing. "Which writer is it you're looking for?" "M. Jean-Paul Sartre." "Well, here he is!" I said as Sartre walked through the door. "We've received a request for protection on behalf of M. Jean-Paul Sartre," our policeman explained. Apparently the initiative for this move had come from M. Papon; this was his odd way of assuring that certain "well-known persons" were protected; there would be a policeman keeping watch in front of the building all day; and Sartre was to let him know in the evening when he came home for good, whereupon the policeman would go away. "But that will simply advertise the fact that I live here," Sartre said. "Quite true," replied M. Papon's envoy, "the *plastiquers* work at night. And in any case," he added jovially, "they don't arrive carrying a trunk: a little parcel in their pocket, no way of seeing, no way of knowing." His parting words as he took his leave were: "If you should move, tell the fellow on duty outside"; then, when an air of complicity: "But you don't need to tell him where you're going." So from then on, there were two policemen in front of our door; they stood and chatted with another couple who were stationed twenty yards up the street looking after Frédéric Dupont.

There was nothing surprising about the police knowing our address. The house painters, the architects, the laborers working in the staircase and also the house agent all knew who we were; when they found out, the owners tried to throw us out. That didn't worry us; the police were really becoming far too solicitous of our welfare. The morning after the night there had been eighteen bomb attacks, we received a further visit from two plain-clothes policemen. They addressed Sartre as "Maître" and gave him the telephone number of the police precinct he should phone for help if he was in danger. They commented on the arrest of two Saint-Cyr students who had been caught red-handed setting some plastic bombs: "Boys from good families! It's all got beyond us!"

They were really putting their backs into it, the boys from good families. In Algeria there was a reign of terror: thefts of arms, rackets, bank holdups, Sten-gun attacks, assassinations, plastic bombs. At Bône, a Moslem tenement was blown sky high. In Paris, the sound of explosions was heard almost daily. A bomb left in the Quai d'Orsay killed one man and injured fifty-five others. Yet a military court at Reuilly acquitted three officers who admitted having tortured a Moslem woman to death; the effrontery of this caused a certain uneasiness among the press.

We lunched at the Massons' with Diégo and the Abbé Corre who had just come out of prison. They were not finding it too easy readapting to the solitude of middle-class life; at one stroke they had lost six hundred friends. "It's so complicated to see people," said Diégo. "You have to write, telephone, arrange to meet. Back there, all you did was open a door."

The very same day we left the Boulevard Saint-Germain, Romoli was given a second dose of plastic; the tenants of the building opposite had their windows all broken again, and some were on the verge of hysteria. Our house agent had found us an apartment on the Quai Blériot in an immense barracks of a place (in which two O.A.S. killers were hiding, it was later discovered); it was expensive, huge, with great big windows overlooking the Seine. When I woke up, there was bright, pale sunlight flooding across the wooden floor; a smell of the countryside wafted in through the window, and I had something to look at while I worked. Through the black trelliswork of the plane trees the geometric façades on the opposite bank showed through just like a Buffet painting; at night, the water glittered, very black, stretching, spreading, breaking, re-forming the rippling reflections on its surface. The snow came, immaculate on the motionless barges and the abandoned riverbanks; at noon, it shone resplendent in the sun, and the gray surface of the river sparkled as the gulls caressed it with their wings. From the kitchen, which we usually ate in, there was a view over a big protected "green space" that was also used as a parking lot. The whole life of the "Organization Man" and his wife was on display there—the French product copied from the American model. He left for work, she went out shopping; in the morning she took the dog out (the husband walked it in the evening), in the afternoon her children. On Sunday, he would clean the car, then the family would go off to church or on a picnic.

Most of the left-wing journalists, political figures, writers and

university teachers had by now been the target of a bomb attack. The day after the book abut Djamila Boupacha came out—I had finally accepted co-authorship with Gisèle Halimi in order to share the responsibility—I went back to my apartment to collect my mail; the super and his wife hadn't slept a wink all night; they had received a telephone call: "Watch out! Simone de Beauvoir is getting blown up tonight!" The husband was an ex-F.T.P. member and a left-winger, his wife too, and I knew they would do all they could to protect me, but I didn't like to think of their not being able to sleep for the next few nights. The police refused to help them; the private protection agencies did little more than make very infrequent visits. For five days I could get no one to do anything; finally the F.U.A. sent a few students to spend the nights in my place; among them was Benoît Rey, to whom the caretaker lent a big monkey wrench on one occasion; as he was walking up and down keeping guard outside, some policemen came by and whipped him off to jail on a charge of possessing illegal weapons; his publisher, Lindon, had him released after five hours, but they still maintained the charge against him.[1]

My young lookouts, leaning out of the windows, spying through the door, often saw suspicious cars draw up in the night; we certainly owed it to them that the house was left untouched. One night, Evelyne was sleeping in her apartment on the Rue Jacob when she heard a bang. Oh hell, I've got plastic bombs on the brain, she thought to herself. There were shouts of *O.A.S. murderers* in the street. Throwing a topcoat over her pajamas, she rushed down to join the handful of people—several of them antique dealers in the Rue Jacob—who were demonstrating in front of the damaged *Seuil* offices. The district commissaire came up: "Keep quiet, there are people asleep; there are sick people, you'll wake them up." Several days after that, Pozner was seriously wounded; skull fractures, loss of memory, they had to operate several times and he took months to recover.

Sartre and Lanzmann were devoting a lot of their time to organizing preliminary meetings for the League. With Schwartz and many others, they had set themselves the task of fighting the country's indifference and its gradual slide to the Right by radical action among the masses. The Communists didn't agree with this. They stubbornly insisted that the offensive should be directed exclusively against the O.A.S. They were afraid that the League might become involved with the Party district committees and assume political im-

[1] Nevertheless in June the court acquitted him.

portance; they wanted to limit the membership to intellectuals only. Sartre refused to be shut up in a ghetto like this. He wasn't finding the support among the "open" Communists that he had been counting on. "You'll get us in trouble with the party," they told him; thus they were keeping the whole enterprise up in the air. Sartre was thinking of handing in his resignation.

On February 8th, he lunched with Schwartz and Panigel to discuss these problems; I joined them for coffee. There was an anti-O.A.S. demonstration planned for that afternoon as a protest against the bomb attack that had cost little Delphine Renard an eye. It had been arranged only the evening before, and none of us was going. The following morning there was a call from Lanzmann: five dead at the Bastille, one a child of sixteen, and many seriously injured. During the day we heard about it from people who'd been there. "There's only Communists left now, go get them," a sergeant had shouted as the demonstrators were beginning to disband; the police charged; people hurried down into the Charonne métro station; the cops tore up the metal tree guards and hurled them down the steps after them. The child had been *strangled*. One of the cops was crying, and another one said to him: "Well, he's had it; what's it to do with you?" Many newspapers published detailed accounts of this butchery; the Right, however, quickly took up the slogan provided for them by the government: "The crowd crushed itself."

The trade unions decided to make the funeral into a mass demonstration and the government was obliged to give its consent. A few members of the League, ourselves included, arranged to meet at nine near the Bourse du Travail where the caskets were on view. There would be very few taxis. (I had spoken to a woman cab driver the day before who said: "Tomorrow I'll stay home." "Aren't you going to the funeral?" "Oh no! I can't take crowds. My husband took me to the Kermesse aux Etoiles once; I found out what it's like!") Lanzmann was to call for us at half past eight. From the kitchen, beginning at eight, we could see enormous red sheaves and wreaths of flowers on the top of cars moving bumper to bumper down the Avenue de Versailles. Lanzmann arrived late, in a taxi, his car having broken down. The jams were so bad that the driver let us out at the entrance to a métro station. It was ten by the time we arrived at the Place de la République. From then on, there was just no means of transport available; all the workers of Paris were on strike. There was an immense crowd on the sidewalks, behind the police barriers;

many groups, laden with red wreaths, were moving in the direction of the Bourse de Travail. We went into the hall where the delegations were waiting; then they were called; a lot of Communists and a proportionate number of P.S.U. members; no Socialist delegation. We took our place in the procession, behind the hearses. Out in the square there were thousands of people gravely, patiently waiting to take their places in the cortege. On the Boulevard du Temple I got up onto a traffic island. I could see the hearses covered with red flowers, the black and red boulevard, the slow-moving clumps of men and flowers solemnly punctuated by dark gaps of asphalt; behind me, stretching to infinity, the crowd; vaster than in Peking on October 1st—at least seven hundred thousand people. When the unions get together, then the people march.

The government had shed blood in order to disperse fifty thousand demonstrators; it was now obliged to allow seven hundred thousand of them to march through the heart of a Paris on strike. Silent, disciplined, this mass of people was proving that if left to themselves they had no desire to turn their city into a bloody chaos, and that if the police could refrain from attacking them, no one would be smothered, no one trampled on. There were militants posted along the whole route maintaining impeccable order. In the stormy light, a great wind lashed the black trees into motion against the black sky; melting snow fell and froze our feet; we walked on, numbed, our hearts warmed by the vast presence of all the fellow beings around us. I hoped that it would be of some comfort to the victims' families, that it would give some meaning to their grief. For the dead, this apotheosis was as unexpected as their deaths had been. A "good funeral": usually a whole life has gone into the preparation of it, so much so that the deceased is in a way present for it. In this case, they were not. Even from this reverse of their absence, they were still absent.

As we reached the gates of Père-Lachaise, the sky turned blue. There were men perched up on the wall of the cemetery, others on the graves. Quite still, we listened to Beethoven's *Marche Funèbre*. The wind played amid the black branches as if to make the moment more dramatic. My God! How I had hated the French! I was overwhelmed by this suddenly recovered sense of brotherhood. Why so long? First Dominique Wallon, on behalf of the U.N.E.F., then a secretary of the C.F.T.C. made speeches, recalling the massacres of October 17th, laying the murders of February 8th to the charge of

the government. Everyone seemed to approve of these speeches and I asked myself: "If the Communist Party, if the unions, had called their ranks to action against the Algerian war, wouldn't they have obeyed? Doubtless one couldn't lay all the blame on circumstances, on party structures, on the complications and cleavages of party machines; but there was also no doubt that there was an enormous fund of goodwill being demonstrated that morning that had been allowed to go to waste. I didn't know whether this discovery was comforting or distressing.

We went on across the cemetery. Victor Leduc had his forehead crisscrossed with Band-Aid; he had been truncheoned on February 8th. Our way lay between marble slabs carved with the names of great bourgeois families; half-naked women were playing lutes or stretching their arms to heaven in dire lament. Near the Mur des Fédérés we came to a halt at the edge of a vast carpet of red and white flowers. There were people still filing past when the cemetery closed, late in the afternoon. Being unable to minimize the event, the newspapers chose to recognize its importance but to attribute all the credit for it to the government, as though the murderers at Charonne had been O.A.S. killers and not loyal partisans of those in power.

The preliminary League meetings took place that Sunday at Grange-aux-Belles. The afternoon session proved rather stormy. On one point Sartre and his friends had yielded to the Communists; the result of their appeasement was that the movement was now called "Front for Action and Coordination among University Teachers and Intellectuals for an Anti-Fascist Movement."[1] But they convinced the meeting that in the text to be published as a result of the day's discussion the F.A.C. should proclaim its solidarity with the Algerians and declare its determination to fight both the present regime and the O.A.S. at the same time. There was a meeting several days later which I attended. There were eighty people packed into a smoky, overheated room intended for thirty, who spent three hours discussing the definition of the Front all over again. Nothing concrete was decided about the action to be taken. Not that day, nor on any subsequent day.

Peace was being negotiated. "The peace at all costs, on which we spit," Lanzmann wrote to one of his Algerian friends. On the evening of Sunday the 18th, down in one corner of a newspaper, we read that it had been signed; we felt not the slightest surge of joy. There

[1] F.A.C. for short.

were still the Army and the *pieds noirs* to be reckoned with. And the Algerians' victory didn't just wipe out of the seven years of French atrocities, suddenly brought out into the light of day. One of the torturers acquitted by the Reuilly court, Sanchez, was outraged when his teaching post was taken away from him and said angrily: "It's the use of torture itself they're trying to condemn, through me!" All the people in the village supported him. "Well, what do you expect? There's always torture in wartime. . . ." Now the French people knew at last, and it made not an atom of difference, because they'd always known. They were told: "You're like the Germans under the Nazis!" And they answered—I heard it with my own ears, and it was the prevailing sentiment—"Yes, the poor Germans; one realizes now it wasn't their fault." But what about that funeral, then? The answer is that collective egoism is a matter of politics, not of psychology. In the victims of February 8th, the people of Paris were recognizing *their own*.

Sartre had agreed to give a lecture in Brussels on Algeria and Fascism. Bost took us up in his car. Since there are a great many French Fascists in Belgium over and beyond the actual Belgian right-wing groups, it was just as well to take certain precautions. The principle organizer, a man of thirty-five called Jean, had spent years getting Algerians over the border; accustomed to the strict security measures entailed in this work, he applied them to Sartre's visit. It was not until the moment we were due to leave, and then only in prearranged terms, that he gave us our itinerary over the phone. At Rocroi, Sartre joined Lallemand and L., a young, dark-haired Communist, in a Belgian car escorted by vehicles full of armed militants. A young, blond Communist took Sartre's place between Bost and myself. "The situation is very unpleasant at the moment," he told us. "It's the unity-of-action business we're having; it causes all sorts of squabbles." We stopped off at Jean's house for a short television interview, and then zigzagged for half an hour through the town before arriving at L.'s place for dinner. He had invited various representatives of the Belgian Left and the burgomaster who had agreed, despite certain pressures, to let the lecture be given in his district. During the meal, Jean left the table; after a moment, a distraught maid rushed in. "The gentleman has fallen down in the bathroom!" He had fainted and split his head open against the tub. "I behaved like some green girl," he told us the next day with embarrassment. In fact, his friends looked upon him as a hero; the risks he'd been

running—all the Algerians he helped had been determined to sell themselves dear if the need arose—and the responsibilities he assumed had worn him out. We slept at Lallemand's place; when we came down for breakfast, we discovered that our young bodyguards had spent the night in the hall—their revolvers within reach in a nearby plant stand.

The lecture was given that evening up on the sixth floor of a factory building in a room containing an audience of six thousand. There were a great many police deployed all aroung the block, in the garages, and on every side of the platform; the chief of police claimed that he was completely gripped by Sartre's logic. Sartre gave a full, but austere account of his subject; he found it difficult talking to the Belgian audience because they were too well-informed for him merely to feed them the facts, and yet there was not that fund of shared experience and things unsaid which he could count on with his French public; many there criticized him—as they had me the year before—for not dealing with *their* problems. Lallemand was situated to the left of the P.S.B.; we had to keep the balance even; after a thousand and one twists and turns, a thousand and one cunning maneuvers, we got to the house of the militant Communist where we were to spend the night. During supper, we talked about the numerous attacks that had been made on the lives of Belgian left-wing leaders. Professor G. told us how his wife had received a package similar to one that had killed one of his colleagues—a doctored copy of *La Pacification;* smelling a suspicious odor, she had put it out in the middle of the garden.

The following day, our friends escorted us to the border, down through the Meuse valley full of the scent of spring. As we said good-bye, young L. asked Bost: "What have you got in the way of weapons?" "Nothing," Bost said. "But you must have thought we were all crazy. . . ." L. said, stunned by this piece of French frivolity, but a bit worried. In fact, we had been very touched to see how concerned they were for our safety.

I locked myself up once more. Through Bost, we heard saddening rumors about the old Saint-Germain-des-Prés we used to know. Rolland had inherited money and become a Gaullist; he had his estate to think of. Scipion had followed him. Anne-Marie Cazalis had amused herself for a long time flitting between Left and Right; her marriage had finally forced her to make a choice, which in the circumstances could not be taken lightly; her left-wing friends didn't see her any

more. The dissolution of our past was almost complete. When Pouillon and Pingaud lost their salaries because they had signed the "121" manifesto, their colleagues made a collection on their behalf; Pagniez didn't give anything. Mme Lemaire, whom we hadn't seen for some time, telephoned Sartre's mother just after the apartment in the Rue Bonaparte was blown up; she made no reference to the incident. "Of course, you know, I'm for Algeria staying French," she said. She came to dinner with us in our apartment on the Quai Blériot all the same. "I hope there's no plastic bomb here," she said with a laugh. It was her only allusion to such things. We didn't seem to have much to talk about.

I loathed the district where we were living, and sometimes didn't put my nose outside the door for three days on end. I no longer listened to music; I was too tense. I read, but hardly any novels. All writing, my own as well as that of others, seemed so meaningless I couldn't bring myself to bother with it. So many things have happened since 1945, and hardly any of them have really been expressed in books. Future generations will have to look to sociological works, statistics, or simply the newspapers, if they want to find out about us. I find the preconceptions involved in what's called the *Nouveau Roman* particularly distressing. Sartre had predicted the return of what he called "consumer's literature": the writing of a society that has lost its grip on the future. In 1947, he was writing: *"The producer's literature now coming into being[1] will not force consumer's literature, its antithesis, into oblivion. . . . Perhaps it may even disappear itself: the generation coming after us seems hesitant. And even if this literature of* praxis *does succeed in establishing itself, it will pass one day, like the literature of* exis, *and perhaps the history of these next decades will see them alternate continually. If so, it will mean that mankind has failed once and for all to bring about a Revolution of infinitely greater importance."* In consumer's literature, he went on to say: *"One does not come into contact with the world; one swallows it raw with one's eyes."*[2] The literature of *exis* is that of Nathalie Sarraute; remodeling the old French psychologism to her own purposes, she uses her talent to describe the paranoiac attitude of the lower middle classes as if it constituted the immutable nature of mankind. The "objective" school, on the other hand, aims at swallowing the world raw with its eyes; and it expels

[1] What has been called "committed literature."
[2] *What Is Literature?*

man from that world even more completely than nineteenth-century naturalism did. The work of art should be able to stand on its own, surrounded by a collection of objects all completely devoid of meaning. The idea of the work-thing haunted the generation of poets, sculptors and painters which preceded my own; Marcel Duchamp carried it to extreme lengths; the great creators—Picasso, Giacometti—moved beyond it. As for the "objective" theories, the metaphysic they imply represents such a regression in relation to modern ideologies that the writers who advance them cannot possibly believe in them. Not that the weaknesses of a system are of great importance if the researches they inspire are fruitful in themselves; both the Impressionists and the Cubists entertained false theories about perception. But in the "objective" school the justifications and the discoveries coincide: the Revolution has failed, the future is slipping from our grasp, the country is sinking into political apathy, man's progress has come to a halt; if he is written about, it will be as an object; or we may even follow the example of the economists and technocrats who put objects in his place; in any event, he will be stripped of his historical dimension. That is the common ground shared by Sarraute and Robbe-Grillet; she confuses truth and psychology, while he refuses to admit interiority; she reduces exteriority to appearances, in other words, a false show; for him, appearances are everything, it is forbidden to go beyond them; in both cases, the world of enterprises, struggles, need, work, the whole real world, disappears into thin air. This vanishing act is common to all the different varieties of the *Nouveau Roman*. Sometimes, with the intention of saying nothing, they mask the absence of content with formal convolutions in a pastiche of Faulkner and Joyce, who both invented hitherto unheard-of ways to say something new. Sometimes they put their money on the eternal: an exploration of the human heart or the space-time complex. Or literature becomes its own object: Butor insists on the spatial and temporal inadequacy of the narrative. Or things are described—or so the writer supposes—in their immediate being.[1] In any case, man is kept resolutely out of the picture. Robbe-Grillet, Sarraute, Butor, interest us insofar as they are unable to keep themselves, their schizophrenia, their obsessions, their manias, their personal relations to things, people and the age

---

[1] This prejudice leads to a great deal of very ugly writing among Robbe-Grillet's acolytes; for want of a subject, they are forced into making objects animate and so fall into the stereotyped phraseology characteristic of a worn-out academicism: the bridge *straddles*, the bushes *part*. Etc.

out of their writing. But on the whole, one of the constant factors of this whole school of writing is boredom; it takes all the savor, all the fire out of life, its impulse toward the future. Sartre defined literature as a celebration: joyful or tragic, but a celebration; we're a far cry from that! It is a dead world they are building, these disciples of the new school. (There is no connection with Beckett who makes the world of the living decompose itself before our eyes.) And it is an artificial world in which they themselves can find no place, since they are living beings. As a consequence, the man in them becomes dissociated from the writer; they vote, they sign manifestos, they take sides—usually against exploitation, the privileged classes and injustice. Then they go back into their old ivory tower. "When I sit down at my desk," Nathalie Sarraute said in Moscow, "I leave politics, current events, the world, outside the door; I become a different person." How is it possible not to put the whole of oneself into the act that for a writer is the most important one of all—writing? This deliberate maiming of oneself and of one's work, this escape into fantasies about the absolute, are evidence of a defeatism justified by the depths to which our country has sunk. France, once the subject, is now no more than the object of history; her novelists reflect this degradation.

In Algiers, there were a hundred and four explosions in one night. People began to wonder if the Army was going to go over to the *pieds noirs*. One morning, taking a taxi, I heard over the radio that an automobile with a bomb secreted in it had exploded in front of the hall in Issy-les-Moulineaux where the Peace Movement Congress was about to take place; there had been deaths and injuries. Witnesses described the incident. Not a day that was not poisoned somehow.

The F.A.C. held a meeting at the Mutualité. At the beginning of the meeting the organizers received a telephone call warning them that a bomb was going to explode—a classic maneuver. Sartre spoke in a much warmer and more human way than at Brussels. But not many people came: two thousand when we should have been able to count on six. The conclusion of the cease-fire negotiations had speeded the decline of the French people toward complete political apathy; also the F.A.C. was still not really in favor with the Communist Party, and the Communist members helping to organize the

meeting had not made as much of an effort as they might. In the end, Sartre and Lanzmann were both right; they couldn't have done anything without the Communists, and they hadn't been able to do anything with them. This failure saddened them both.

The referendum on April 8th showed that almost everyone in France was now in favor of the liquidation of the war in Algeria; but it was being carried out in the worst possible conditions. After the shooting at Isly and the roundup at Bab el-Oued, the *pieds noirs* knew they had lost; they started systematically sabotaging the already devastated country and launched into a series of massacres even more horrible than the war itself; the O.A.S. bombarded the Moslem districts with mortars, drove flaming trucks into them, mowed down unemployed men with Sten guns in front of the Labor Exchange, and murdered their Moslem charwomen. I opened the newspaper every morning in a state of dread: what was there worse to come? At first, the press honored these crimes with a place on the front page; the Moslems would soon strike back; people were frightened. And then, with great relief, they began expressing admiration for their discipline; they were really behaving very well! Whereupon the twenty or thirty (official figures) Moslems shot every day in Algiers or Oran were promptly relegated to a little corner on the back page, among the automobile accidents. The prisoners murdered in the jails, the wounded finished off in the hospitals, merely provoked mild, hypocritical expressions of indignation. It was only when the *pieds noirs* rushed into France, competing with the French for work and housing, that they finally became unpopula·; just in time to replace the old one, we watched the rise of a new sort of racism between members of the same race, as if we always needed the Other to hate, in order to be assured of our own innocence. As if the army, as if the governments that had conducted this war had not been composed of Frenchmen from France, as if the entire country had not been behind them! Every day brought fresh evidence of hidden complicities: torturers received an amnesty, but not deserters, those who had disobeyed or the members of the assistance organization. Jouhaud, condemned to death, was not executed; Salan was saving his neck. Only the hangers-on were shot; in the course of the trials, the only thing people were worried about was the loyalism of the defendants and the sincerity of their chauvinism; the murdered Algerians didn't count. Never had the Algerian war been more hateful

to me than during those weeks when in its last agony it proclaimed the final truth.

We had been very much concerned the whole year by what was happening in Cuba. Apparently Aníbal Escalante was becoming a law unto himself. Even though the blockade and a succession of serious errors had lowered the standard of living, there was no serious opposition in existence; nevertheless the police had established a preventive reign of terror. Small landowners had been forced to join cooperatives. Most of our friends were being harmed by these changes. Oltuski had lost his post. *Revolución* was in its death agony; the price of the subscription to *Hoy* was being deducted from the workers' wages, and they were not buying any other newspaper. A homosexual writer of our acquaintance had been marched through the streets of Havana with a whole group of pederasts; they were made to wear a big P on their backs and then thrown into jail. All this information reached us in snatches and without commentary. There seemed no explanation for the Cuban Communist Party's condemnation of "Polish deviationism," or its alignment with China and Albania and adoption of Stalinist methods. And above all, it was stupefying that Castro was letting it happen. No doubt he had been severely shaken by certain setbacks; the I.N.R.A. had suffered a great many. He had felt the need for an administrative framework and decided to put his faith in the only one already existing, the Communist Party. But faced by the errors that had been committed, how was it that he had not taken things back into his own hands?

He did so. On March 26th, he delivered a speech attacking Escalante and all the little Escalantes who had begun swarming all over the place. He expelled him from Cuba. He set himself the task of repairing all the mistakes of recent months. He destroyed the cooperatives created by force. He called back Oltuski and his team. *Revolución* regained its importance. During our trip to Moscow we met Oltuski and Arcocha; no more police rule, no more sectarianism, they told us. There were Communists sharing in the task of government, relations between Cuba and the U.S.S.R. were excellent; but Castro was master of the ship once more. Despite the difficulties caused by the blockade and the absence of administrators, there was a feeling that the revolution had come alive again.

The Union of Soviet Writers had invited us to Moscow. In the field that particularly interested us, that of culture, the 20th and

22nd Congresses had borne fruit; the trips made by Yevtushenko confirmed this, as did the presence in Paris of students from Russian universities. I had met a girl from Georgia who had been working for a whole year in complete freedom on a thesis on Sartre; there was really something new under the Soviet sun.

Three hours in the air and on June 1st we touched down on an airfield encircled by birches and pines. Soon I was seeing Red Square again, the Kremlin, the Moskova, Gorki Street, old Moscow, with the lace of its *isbas,* its labyrinth of courtyards and gardens, its peaceful squares full of men playing chess. The women were dressed more gaily than in 1955, the store displays—despite fairly strong evidence of shortages—more attractive. Their information advertising had made great progress; there were posters on the walls, often inspired by the drawings of Mayakovsky, and amusing; also still photographs from the movies being shown. The evening was bright with neon signs. The streets were pleasant; very animated, but without any jostling or undue haste; bustle, but leisure as well, young people and laughter; fairly heavy traffic on the roads, mostly trucks and vans. The new residential districts however are as boring as our own H.L.M., despite the abundance of trees; they form a ring right around the city, which now has a population of eight million.

We saw some of our old acquaintances again—Simonov, Fedin, Surkov, Olga P., Korneychuk, Ehrenburg's wife (he wasn't in Russia at the time)—and met some new people. Lena Zonina, secretary to the French section of the Union of Writers and Critics, acted as our interpreter; she knew our books well and had written articles on *The Mandarins* and *The Condemned of Altona;* she quickly became a friend. The secretary of the Italian section, George Breitbourd, who spoke French well, sometimes stood in for her. We were amazed to find ourselves getting on so well with them.

We had decided to limit ourselves to meetings with intellectuals: writers, critics, movie makers, theater people, architects. And we had the impression that we were present, after the austerity of the Dark Ages, at the dawn of a Renaissance.

An ardent and stormy dawn; a struggle was in progress between innovators and conformists. Most of the young people were in the former camp; but it also contained older men, Paustovsky, Ehrenburg, whose *Memoirs* were being devoured by the students; some of the young ones on the other hand were opportunist and sectarian. But despite these anomalies, it was without doubt largely a conflict between the generations. "The most remarkable thing in our coun-

try today is the young people," all our friends told us; but there were
a lot of people who wanted to keep them on a leash. "Everything
seems so easy to these young people!" said one fifty-year-old, who was
nevertheless quite friendly toward them. We understood this bitter-
ness. The sons were covertly blaming their fathers for having sup-
ported Stalinism; what would they have done in their place? They
had had to live; they lived. A life that involved contradictions, com-
promises, lacerations, sometimes cowardice; but examples of loyalty
too, of generosity, of daring that had taken more courage than any
Soviet citizen of twenty-five had ever had the opportunity to show.
To take a superior attitude to people whose difficulties one hasn't
shared is never just. And yet, these young people were right in want-
ing de-Stalinization not to remain merely negative, in wanting to be
allowed to blaze new trails into the future. There was no hint of
their returning to bourgeois values; they were fighting against the
remnants of Stalinism; after so many lies they were demanding the
truth; it was their belief that revolutionary art and thought need
freedom.

In one field they had won their victory: poetry. We only caught a
glimpse of Yevtushenko, but we often saw his younger colleague
Voznesensky, who is almost as popular, though his work is more
difficult. We met him by chance on the railway platform, the evening
we were leaving for Kiev; very young, very pink, with a laughing
mouth, liquid eyes, wearing an odd little blue skullcap, he spoke to
me in English with a pleasant spontaneity. When we got back, he
suggested we might like to attend a discussion of his poems in the
library near his home; he was already quite used to the recitals that
are traditional in Russia, and which often attract audiences of thou-
sands, either in halls or in the open air; on this occasion it was a
rather smaller meeting—four or five hundred—at which he was asked
to reply to a severely critical article in the *Literary Gazette*. He was
nervous. "They're enemies out there," he whispered to us as he took
his place facing the audience. Standing up, eyes half-closed, he de-
claimed some poems, of which Lena Zonina gave us a murmured
translation. The applause nearly brought the place down around
our ears. A young girl got up. She had heard some of Voznesensky's
poems for the first time in Mayakovsky Square; the boy who was recit-
ing them, the people who were listening, seemed to her rather shady,
and there were terrible things in the poems about women; she had
gone home quite upset, cried, couldn't eat her dinner, her parents

were worried. There were hostile murmurs and laughs during this complacent description of her virtuous horror. Today, she ended by saying, it was different; what she had just heard had pleased her. Teachers and students spoke of their admiration for Voznesensky. "Is it good poetry? Poetry that will last? We don't care; it's our poetry, the poetry of our generation," one of them said. "The first time I read his poems," said a woman doctor, "I didn't understand them at all, they were too hermetic. And then I realized that it was precisely for that reason that some of the images, some of the lines, had stayed in my head; I found I was saying them over to myself quite often. I read Voznesensky again several times, each time I enjoyed him more. So the question I'd like answered is this: Poets like Voznesensky, and painters like Picasso—are they right in not wanting us to understand them straight off? They force us to make an effort that enriches us. But on the other hand, it takes up quite a bit of time; and when one works ten hours a day, time is precious." The general opinion was that one had no right to criticize a poet for being difficult. "When I read an article on my own subject, I expect to go back over it more than once," said an engineer, "why shouldn't poets ask us to do the same for them?" A woman teacher, about forty, got up and began to read out a long essay—a criticism of Voznesensky's obscurity; her class of twelve-year-olds couldn't make head nor tail of him. (Shouts of protest, laughter.) He used hermetic words, such as *chimaera* (laughter, boos). He talked about *The color of blotting paper* when blotting paper can be any color. Undeterred by the angry and sarcastic storm of protest raging around her, she plowed on calmly to the end of her indictment. "And she teaches literature to *our children!* It's shameful!" the teen-agers shouted. When she had finished, a young Oriental stood up; he was taking a correspondence course in creative writing from the Gorki Institute, and knew Boznesensky by heart. "You are wrong to insult this woman," he said gently, "she deserves all our pity." All the young people we met subsequently were devotees of the Boznesensky cult. "We are specialists, you see," the physicists and technicians would explain to us. "He speaks for us, and when we read him we feel like complete men again." He himself said to us: "Poetry is the form prayer takes in socialist countries." There are critics who attack the young poets, and bureaucrats who make things difficult for them, but to prevent their expressing themselves as they please there would have to be a complete return to Stalinist methods; to begin with, the suppression of

the meetings that Voznesensky refers to as "my concerts." In fact, they suffer from very few restrictions.[1] They can travel. A group of them went to the United States, where they got on very well with the beat poets. Their books are published in printings of hundreds of thousands.

The prose writers, not having any direct contact with their readers, are dependent on the publishing houses and magazines, whose freedom is restricted by their fear of displeasing the public on the one hand and the authorities on the other. The *Novy Mir* team is the most daring; among the others, caution has the upper hand. No short story or novel of any originality can be got into print without a struggle from scratch every time. Certain critics have trouble finding someone to print the articles that really express their thought. They are asked to dilute them, to disguise them, to cut bits out; they agree or they refuse, they maneuver, forcing themselves to be content with wearing away the resistances little by little; in the long run, this policy gets results. There are articles and essays being published today that would never have seen the light of day a few years before.

The public is avid for novelty; at the time we were there, translations had just appeared of the complete works of Remarque— why?—and Saint-Exupéry; they were selling like hotcakes. "Translate Camus, Sagan, Sartre, everything," the young people were crying. In a discussion with the *Foreign Literature* team, Sartre produced a shiver of pleasure by suddenly bringing out the name of Kafka; the other faction got very spiky: "He has been taken over by the bourgeois intellectuals." "Then it's up to you to take him back," said Sartre. The magazine was about to publish a Kafka short story, all the same. Brecht, who was regarded for a long time with suspicion in the U.S.S.R., as I have said, was beginning to make an appearance. In Leningrad, we saw a version of *The Good Woman of Setzuan* put on in realistic Stanislavski style. The result was deplorable; the text disconcerted the general public, and the Brechtians were shocked by the production. But Yushkevitch was going to put the play on in Moscow. Was it thanks to Brecht's influence that Schwarz's *Dragon* was put on with such freedom and wealth of invention? Written as an attack on Fascism, but withdrawn after its first performance in 1944 because the dragon made people think of Stalin as much as of Hitler, this comedy had just been revived in Leningrad with great success.

[1] Things have changed a great deal since our trip, as everyone knows.

The public is also very much attracted by the Italian cinema.[1] The conformists are afraid that its influence may lead the young directors to break with their own national tradition. But no film has made me feel what the war was like for the people of the U.S.S.R. as much as *My Name Is Ivan.* "It's more than just the story of a child," George Breitbourd told us, "it's the story of a whole generation of children." His mother killed before his eyes, his village burned to the ground, Ivan goes half mad; his dreams are the innocent dreams of a ten-year-old; awake, he is possessed by hatred and the desire to kill; he is charming, pathetic, touching and heroic, but a monster. He is entrusted with a mission by some officers against their better judgment, and never comes back. In Berlin, amid the tumult of victory, one of the officers comes across a filing card with Ivan's name and photograph: hanged. The beauty and the novelty of this film is that Tarkovski shows at the same time the greatness of the triumph won by the U.S.S.R. and the irreparable nature of this shocking event: the murder of a child. Tarkovski is twenty-six. His film aroused violent hostility; but it was sent to Venice and won the Golden Lion in the festival there. There have also been a great many attacks on Yushkevitch's film, inspired by Mayakovsky's *The Bathhouse,* in which he made use of a mixture of animation, puppets and documentaries; and yet the daring originality of this film marks it as a work that could have been conceived nowhere but in the U.S.S.R. In a local movie house we saw *And if It Were Love?,* a film directed against the *"petit-bourgeois* attitude" prevalent in the apartment blocks. Two young people reminiscent of Christiane Rochefort's *Gallery Gods,* a girl and a boy, both students, innocently fall in love; the persecutions of their parents and their neighbors, the gossip and the lies told about them, drive them into such a state of bewilderment and unhappiness that they end up going to bed together and making a terrible mess of it, one infers, since the girl tries to kill herself and then goes a long way away. A mediocre film, but speaking with a new voice: harshly critical, without a positive hero, without a happy end.

"In sculpture and painting, we're mere provincials," a friend told us. Though this was not intended to include Neizvestny, whose studio we visited with him: a high-ceilinged, narrow room, so packed with sculptures that there was hardly room to move; a steep little staircase leading up to a tiny bedroom. Neizvestny is trying to express

[1] *Cabiria, Rocco and His Brothers.*

the "automated man" of our times, which has led him to invent some
pretty daring forms. The State has commissioned several things from
him. The young painters are seriously handicapped; they have seen
scarcely any Western art, they are having to start practically from
scratch, and their attempts to find their own direction are looked on
with a rather bilious eye, since Khrushchev doesn't like abstract art
or modern art in general.[1] The nonconformists work in semisecrecy
and only show to a closed circle of friends. They sell their work, but
life is a struggle for them. We went to visit two of them; they both
had rather small single rooms in a communal apartment that had to
serve as both studio and bedroom. Yet for some years now there have
been splendid collections of the Impressionists on show in Moscow
and Leningrad, paintings by Van Gogh, Gauguin, Matisse. Picasso
was awarded the Lenin prize; there is a book available about him
with reproductions of his pictures; in the Hermitage there is a whole
room devoted to him.[2] The crowds are much more shocked by the
"woman with the fan," in which the human body is treated as an
object, than by the Cubist canvases which suggest still lifes. I had
repeated to me the commentary of a guide who was taking a group
around and lecturing them on the paintings; he spoke with respect of
the Blue Period Picassos, then, with a gesture around the rest of the
room: "Here we have a painter who instead of continuing to make
progress simply retrogressed." Faced with the Gauguins, he said:
"Unfortunately all the colors are false." On the other hand, the
woman director of the French section of the Hermitage showed us a
quantity of modern works acquired by the Museum which she dis-
cussed in the most enlightened terms.

Because they hate any "distortion" of the human figure, the Rus-
sians—who are so anxious to lay claim to their past in every other
field—don't do justice to their primitives. Rublov is the equal of
Giotto and Duccio; when he saw the icons, Matisse—who drew in-
spiration from them—wept with admiration. There are only a hun-
dred or so on exhibition, though they have immense quantities
hidden away in storage. It took quite a fight to found the Rublov
Museum, where a collection of original works and reproductions by
the master and his followers is on show. Tarkovski would like to
make a film about him; he is faced with lively opposition. Obviously

1 The incident in December was evidence of this: Neizvestny was forced to criticize
himself publicly. I saw a program on Moscow television ridiculing his work.
2 By January 1963 there were two.

it is difficult to boost Rublov and Repin at the same time; officialdom has opted for Repin.

The public is also passionate about painting. The morning we went to the Hermitage, it was a public holiday; people were fighting to get near the doors, and a young girl had all the buttons of her topcoat torn off. Lena Zonina asked one of the administrators to get us in through a private entrance. There are such stampedes at the entrances to exhibitions that they have to call the police in to keep order. When a bookshop announces the arrival of a book on Impressionism or on Miró, there is a queue in front of the door as early as five in the morning; every copy has been snatched up an hour after they open. Will this pressure be powerful enough to force further concessions?[1]

For the architects, the situation is much better. Khrushchev is interested in architecture and likes simplicity. He gave his approval to the Memorial for the Unknown Soldier in Kiev, even though most of the city's notables were horrified by its starkness. The Palace of the Pioneers, which has just been built, looks almost as if it could have been designed by Niemeyer; the pensioners in a home for old people on the other side of the valley have written letters of protest: this horror is ruining their view. But Khrushchev likes the Palace; the letters were sent on to the architects, and that was the end of it. When we met them, they said to us: "We've got bad consciences too: all those rows of pillars upon those fourth floors." But that style of ugly ostentation so dear to Stalin is now a thing of the past; the new apartment blocks are dismal, but built with some care for economy. The finest of the new buildings is the Palace of Congress. "They shouldn't have put it inside the Kremlin," some of our friends said; but the Middle Ages, the eighteenth century and the nineteenth century all seem to have got on very well in there so far, why shouldn't there be a place for the twentieth century as well? answer the others. The Russians have discussed the subject a lot, among themselves and in the newspapers. I must say I found the sight of the old gilded onion domes reflected in the glittering glass of the new Palace very beautiful. Another modern building, of an ingenious and sober elegance, is the Palace of Youth; as we were having tea in the

1 Since December 1962, one is tempted to give a pessimistic reply. However, the toughening attitude of the official camp seems to imply that despite the retractions wrung from some of its members, the resistance in the innovators' camp is very strong.

main hall with Simonov's wife[1] who works in an Institute of Applied Art and is an art critic herself, she pointed out that the furniture and the china were completely out of keeping with the room itself. There is nothing more difficult in Moscow than to find a really good plate or cup or chair; it will not be easy to dissuade the Muscovites from their predilection for baubles, ruching, chasing, molding, embossing and overdecoration in general; but a big effort was being made, she said; they are trying to design and produce good things and to teach people to like them.

When Sartre visited a class of students in 1954, he had mentioned Dostoyevsky. "Why do you bother with him?" a girl of twelve had asked rather aggressively. Now they were reading him, and liking him. We had been struck by the way in which Pasternak was being spoken of. When Yevtushenko was in England and said: "In my opinion he is a very good poet," many people criticized him for this understatement; everyone in Russia, they said, believes him to be one of the very greatest Russian poets. "His death has forced us to write," said Voznesensky. "Before, there was no point; he *was* poetry." When we were driven in a car lent by the Writers' Union to visit Fedin, the driver stopped in front of a house surrounded by trees. "Pasternak's *dacha!*" he said with reverence. Even officialdom does not attack him any more. If his erstwhile mistress was sent to a camp,[2] it was because she had engaged in illegal currency transactions.

The camps: the subject was approached without reticence. "Every night for a whole year my father used to sit down in his armchair, gazing straight in front of him, waiting for them to come and arrest him; all his comrades had been shot; he never knew how he came to escape," a young woman told me. "My father was in a camp for six years," a woman teacher said, "and yet, the night Stalin died, I wept." "I was sent to a camp in 1942 for humanitarianism," a professor told us, "because I was against shooting prisoners of war. I was there five years." Many of the internees, went one story, approved of the camps in principle; they found the incarceration of their fellow prisoners quite reasonable; they themselves had been the victims of an error which did not invalidate the system in general. Until 1936, apparently, the camps really were rehabilitation centers: moderate work hours, liberal regime, theaters, libraries, discussion

1 His second wife. He divorced the first and remarried.
2 Only nonpolitical prisoners are interned in them now.

groups, familiar, almost friendly relations between inmates and those in charge. In 1936 there were changes; the maximum penalty was still ten years, as it had been before, but the prisoner either had the right to correspond with his family or not. Accurately construed, this meant that those in the second category were shot; conditions in the penal camps became so bad that many inmates died; after 1944 as well, but the shooting was stopped. Whether from simple repugnance, ignorance, or because it was an officially forbidden subject, no one gave us any details about life in the concentration camps. All we heard were anecdotes: A Pushkin specialist who was deported to one let it be known that he had discovered the last cantos of *Eugene Onegin* just before the event; his papers had been lost, but he had an excellent memory and would be able, given the leisure, to reconstruct the text; he began the attempt and was encouraged to continue, for Pushkin seemed almost to have anticipated the Jadnovian esthetic: nationalism, heroism, optimism, everything was there. He finished the work and continued to enjoy preferential treatment, so delighted were the Stalinists to have discovered a Pushkin exactly after their own heart. Other specialists began saying it was a forgery; but they were forced to recant until the day the prisoners were released and the critic admitted he had made up the whole thing. The return of the prisoners had given rise to many practical, moral and emotional complications. Victor Nekrasov produced a novel about the difficulty one of these ghostly figures had in readjusting to reality. Ex-prisoners in concentration camps had written or were writing their reminiscences, in the hope of getting them into print one day.

We were not entertained at all in the same way as Sartre had been in 1954. No more banquets or solemn toasts, no more propaganda. People invited us to their homes with just a few other people; sometimes agreeing with them, sometimes disagreeing, we discussed things on our own ground. We had dinner at Simonov's *dacha* with Dorosh, a writer of about fifty who lives in Moscow but spends long periods out in the country at Great-Rostov; he had rented a little room in an *isba;* he loves the peasants, takes an interest in their life and describes it in his books, without hiding its difficulties or its harshness, and without glossing over the mistakes made by the people in charge of agriculture. The Writers' Union lent us a car, and he took us to spend two days in Rostov. His wife went with us; a physics professor and a very good cook, she had packed the trunk of the car with everything necessary to feed us for two days. Rostov, 120 miles from

Moscow, is the cradle of Russia; today it is a large village with a
population of 25,000, on the edge of a lake, dominated by a Kremlin
older than the one in Moscow, more rustic and on the whole more
beautiful. The architect who is restoring it was camping out in one
of the round towers on the walls; we were expecting to be able to eat
our meals in his quarters; he was to show us all the places of interest,
and Dorosh was to introduce us to a few of the peasants he knew. But
on the way there he warned us: "The gentlemen of Yaroslavl[1] have
their own ideas about what French writers find interesting." We
went in through one of the gates of the Kremlin, we got out of the
car. Three men in straw hats advanced toward us and greeted us
stiffly; two of them were leading members of the local Soviet, the
third was Head of Propaganda. They came up with us into the tower
and shared our meal. Through the narrow windows, there were
glimpses of the silken water and the plain; the round room was
charming, so was the architect, but the presence of the three officials
got on our nerves. They followed us as we went on a tour of the
churches with their azure-colored, golden, slaty onion domes, some
smooth, some with scales. The frescoes decorating the chapels are
more serene than ours, there are hardly any scenes of hell at all. After
that we were supposed to visit a kolkhoz; they postponed our de-
parture until late afternoon. When we arrived the peasants had al-
most all gone home, except for one woman who lingered behind in
the barn and turned out to be the best milker in the district. Could
we visit her *isba?* No, it just happened that she'd washed all her linen
that day. We were taken for a walk around a field of kidney beans;
Khrushchev had just officially recommended that they be grown, and
the head of the kolkhoz had come to the same decision two years
before! Dorosh had wandered off and was kicking at lumps of earth.
Our guides then led us off to see the home of one of the section
heads. The inside looked more like the house of a poor lower-middle-
class family than a French farm. Although the owner was a Party
member, there was a lamp burning in front of an icon. As we left I
asked: "Are there a lot of peasants who are practicing Christians?"
"They can all decide for themselves," was the propagandist's answer.
He evaded all our questions. To explain the "peasant mentality" to
us, he quoted a famous phrase from Lenin followed by a string of
platitudes. During dinner Sartre advanced to the attack. Tomorrow,

[1] The center of local government for the area, a large town on the Volga thirty
miles from Rostov.

we wanted to see some peasants, alone with Dorosh. Writers understand each other, he would be able to make them talk in a way that would interest us. The officials did not reply. They took us off, Lena Zonina, Sartre and myself, to Yaroslavl where they had booked rooms for us, and next morning they tried to take us on a visit to a shoe factory. We refused. The Head of Propaganda showed us the banks of the Volga, the house where Natasha found Prince André dying, some old churches. It was a very pleasant outing, but he got us back to Rostov two hours later than the time we had agreed upon with Dorosh; and he was quite determined to stay with us the rest of the day. We gave up. After lunch we went back to Moscow. During the return journey, and later in Moscow when we saw him again, Dorosh talked to us at length about the human problems that arise in the country: the condition of women, the ambitions of the young people, the relations between workers and peasants, the attraction of the towns, what ought to be done and what had been done to keep the new generation in the villages when even mechanization had proved insufficient to attach them to the land, the conflict between those who want a radical transformation of rural conditions and those who wish to see certain traditions maintained.

One night by train took us to Leningrad, one of the most beautiful cities in the world. It was a stroke of genius on the part of Catherine II to order Rastrelli to bring the Italian Baroque to the banks of the Neva, where it has made a perfect marriage with the pinks and blues and greens that clothe it here in the pale nordic light. Like Rome, Leningrad is an enchantress; above all in the immense square glittering with the windows of the Winter Palace. Superimposed by my memory on its mysterious majesty lay black and white scenes from the "ten days that shook the world" and from the revolts that heralded them. A bustling crowd hurried up and down the Nevsky Prospect: I recalled a photograph showing the roadway and the sidewalks piled with dead and dying. In the middle of the Neva Bridge, I saw a horse-drawn cab: the bridge rose; horse and vehicle went tumbling down, caught in the deep silence of those old films. Smolny. The Admiralty. The Fortress of Peter and Paul. Oh, the reverberation of those words inside me as I read them for the first time when I was twenty. During the day, it was Lenin's city I was walking in (and that other's, who is never named).

And then, in all its brightness, came the night. "The White Nights of St. Petersburg": in Norway, in Finland, I had thought I

knew what they were like; but the magic of the nighttime sun needs this ghost-haunted, petrified décor from the past to complete its spell.

We had dinner at the home of the writer Guerman, his family, and also Heifitz, the director of *The Lady with a Dog*. We knew that he had escaped deportation to Siberia only by going into hiding and also, in part, thanks to Ehrenburg. "Not once did I write the name of Stalin," he told us, piling our plates with Siberian ravioli. We talked about the cinema and about theater; he told us some of the things he remembered about Meyerhold. Heifitz's wife and twenty-year-old son arrived in time for coffee. They had been to see *Rocco and His Brothers;* she was very stirred and delighted. Young Heifitz and Guerman's children compared the merits of Voznesensky and Yevtushenko; he preferred the former, they the latter. Sartre had a long discussion with Mme Heifitz on the relations of children with their parents; he based some of his remarks on Freudian theories that she opposed passionately. At midnight we all went down together to the Campus Martius. There were lovers kissing on the benches in the fresh smell of early morning, young people playing the guitar and groups of boys and girls walking along laughing.

Two days later, we met them again in a restaurant at about eleven, after the theater. They took us by car to see the Dostoyevsky neighborhood by the light of the pale sky: his house, the place where Rogojine had lived, the courtyard of the old woman moneylender killed by Raskolnikov, the canal where he disposed of the ax. On the way we glimpsed the window of the room where Essenin killed himself. They showed us the very first place where Peter the Great had lived, and the first canals. On the outskirts of the town, at the spot where Pushkin came to fight the duel in which he was mortally wounded, we drank vodka to his memory.

There are now four million people living in Leningrad, the same figure as before the war, but almost all of them are new arrivals; during the siege, three and a half million people succumbed to famine, the food warehouses having been burned down in the first few days. An old professor described to Sartre the ice-covered roads piled high with corpses that the passers-by no longer even noticed; all anyone could think of was getting his bowl of soup home without collapsing from weakness. If you did, you wouldn't have the strength to get up again; and even if someone had stretched out his hand to help you, it would have done no good; he would have fallen over too.

The Russians still boast about the beauty of Kiev; Sancta Sofia, which we were taken to see by the Ukrainian poet Bajan, deserves its

fame. But all the mid-town neighborhoods—half the city—were pounded into dust by the Germans; Stalin had one of the city's most famous churches demolished, and rebuilt Kiev in the style he loved so much; arcades and colonnades, the main avenue is a colossal nightmare. In the Ukraine, too, the people are all obsessed by their memories of the war. Kiev was a mound of ashes when Bajan got back to it, the rare passers-by seemed to him like ghosts; he recognized the face of a friend; they stayed looking into each other's eyes for a long time without a word, unable to believe their eyes. The Nazis, who had made the total annihilation of Slav culture one of their aims, had deliberately set fire to the Avra monastery, a famous pilgrimage site; on a hill above the Dnieper, there is a stretch of painted wall, an onion dome, its gold roofs blackened by the flames, and a few charred remnants. The shots from *My Name Is Ivan* were still in my mind's eye, and beneath the strawberry fields where the peasants from a nearby kolkhoz were gathering their baskets of fruit, huge and succulent, I could see those tracts of devastated land.

We had lunch with Korneychuk and his wife, Wanda Wassileska, in their *dacha* just outside Kiev; they had a garden full of tulips sloping down to the edge of a lake. He wanted very much for Sartre to attend the Peace Congress that was going to be held in Moscow, and to speak there on the subject of culture. Ehrenburg, through his wife, Surkov and Fedin were also insisting that Sartre take part in the Congress; they wanted him to cooperate with them in organizing a discussion between intellectuals from all over the world. *Hyena with a fountain pen, enemy of mankind, filth peddler, tool of the bourgeoisie, gravedigger*—as he came out of these conversations, Sartre remembered these things and laughed.

In Moscow, we stayed at the Peking Hotel, one of the buildings that have been put up here and there throughout the town in the belief that they harmonize with the towers of the Kremlin. But we were in it as little as possible. We preferred queuing up with the people of Moscow outside the restaurants and cafés. Sometimes we ate dinner at the writers' club or the theater club. All the public places close at eleven in the evening, except the restaurants of a few big hotels, where one can eat, drink and dance until half past twelve; yet the streets remain full of life until quite late; people pay each other visits. Housing conditions are still bad; 80 percent still live in communal apartments; but there has been no relaxation in efforts to construct more living space, and the new buildings are very pleasant inside. George Breitbourd was living in a block reserved exclusively

for intellectuals and had quite a big, light studio, with bathroom and kitchen that many a French bachelor of about the same professional status as himself might well have envied. In old Moscow, you have to go through more or less squalid courtyards, climb up dilapidated staircases or take elevators that are really more like builders' hoists; but the apartments of the writers and directors who invited us—of course they're a privileged class—were quite large and often elegant. The public transport system is very convenient. Not many taxis, but a great many buses, and a considerable subway system with escalators in most of the stations. However, the day of the housewife in Moscow is made rather wearing by the paucity of goods to be had; she must run from store to store and stand in lines all the time; and even then she doesn't always get everything she's looking for.

This is because the U.S.S.R., as its leaders openly admit, is in the grip of serious economic difficulties; its agriculture has never gone well; there have been numerous denunciations recently of officials who have accepted bribes and generally used their powers for their own ends—the socialist equivalents of the frauds and swindles and financial scandals that we get back home. Such things are severely punished, the death penalty even being applied in really serious cases. And there is little doubt that this poverty is the price the Russians must pay for their successes in the exploration of space. Will it decrease or get worse? The articles of the economists and the statisticians' figures will be of more help in answering such questions than our three-week trip. But for us they were a profitable three weeks. When the Cold War began, we backed the U.S.S.R.; since it began to change over to a peace policy and become de-Stalinized, our doubts about this choice had ceased; its cause and its opportunities are ours too. Our stay this time turned this bond into a living friendship. A truth is rich insofar as it has *become;* it would be wrong to think of the conquests of the Russian intellectuals as small: those conquests include all the obstacles they have vanquished. The contradictions in their past experience—among others the rejected heritage of their Stalinist past—are forcing them to think for themselves, and this is what gives their thought a depth that is quite exceptional in our age of *other-conditioning.* One senses in the people, especially among the young, a passionate desire to know and to understand: cinema, theater, ballet, poetry, concerts—every seat is always taken in advance; the museums and exhibitions have to turn people away; books are sold as soon as they come off the press. Everywhere, discus-

sion and argument. In the technocratic world that the West is attempting to impose on us, the only things that count are tools and organization, the means of attaining other means, with no end ever in sight. In the U.S.S.R. man is in the process of making himself, and even if he is encountering difficulties on the way, even if there are hard knocks to be taken, relapses, mistakes, all the things surrounding him, all the things that happen, are heavy with meanings.

On the way back we stopped in Poland. Warsaw, the ghetto: ruins, mass graves, a desert of ashes. And I saw a great new city, with wide avenues, parks, workshops and here and there, for no reason, a house half collapsing. Of the ghetto, there remains only a stretch of wall and a tower set in the midst of empty lots disguised as green lawns and elegant apartment blocks. The old town has been reconstructed very well: the marketplace, the cathedral, the little streets with their low, bright-colored houses. The rest of the town—ugly in some places, pretty in others, according to the year in which it was rebuilt—lacks cohesion, personality, soul; it is a magnificent victory over death, but it is as though life has still not made up its mind to come back again. Praga on the other side of the Vistula, industrial, populous, old and dirty—the Russian armies halted there so it escaped destruction—I found reassuring because here time had never stopped.

Lissowski, a Communist, who speaks French as well as he does Polish, took us around in a little automobile. We were struck by how empty the roads were. But the streets were full of life and, at least in the center, gay: slim, well made-up women; elegant window displays; all the objects in everyday use—the furniture, the restaurant and café décors—were pleasant to look at. At ten in the evening, all the public places close, so the heavy drinkers get to work earlier; there are already quite a few drunks on the street by nine. There is less inequality in the matter of wages than in the U.S.S.R., but the standard of living is very low. Food costs almost nothing, but on the other hand clothing is fabulously expensive; a pair of shoes costs as much as a quarter of the average monthly salary. Housing is free, but very difficult to come by; Warsaw is a closed city, no one is allowed to move into it simply because a large proportion of its present population is still living piled on top of each other in hovels. The architects are not quite sure what to do. They have designed all their apartments with bathrooms; because they're not used to such things, the

tenants don't use them; wouldn't it be better to leave them out and increase the number of available apartments? But that just means trouble in the future; the people of Warsaw aren't going to learn to be hygienic if the means of being so aren't available. Should they put the immediate need for accommodation first, or the welfare of the rising generation? It is the second consideration that has prevailed.

We saw Cracow, a charming, old-fashioned, provincial town: the University, Doktor Faust's study, his alembics, and the mark of Mephistopheles' foot; the cathedral standing in the market, its beautiful tall tower with a trumpet that sounds to the four corners of the horizon every hour on the hour; the royal castle, the study and private projection room that Frank, the butcher of Poland, had installed for him. We caught glimpses of Nowa Huta, the immense *combinat*, the Workers' City, a fine Cistercian monastery and a wooden church set in the middle of a meadow. We returned to Warsaw by car. For nearly two hundred miles the road winds through meadows, fields of tender green crops and thatched peasant houses with walls washed yellow or blue. Nothing but private property; the "Polish October" set the seal on the failure of collectivization. Frequently we passed groups of peasant women dressed in traditional costume: brightly colored capes and skirts, kerchiefs tied under the chin; there were children with them holding candles, showing that they were on the way back from some religious ceremony. In the country, religion still weighs on the peasants as heavily as ever. We were shown an astonishing documentary film which the clergy had allowed to be made only on condition that no commentary be added to it: a re-enactment of the Stations of the Cross that takes place every year in a certain village and is attended by a vast audience that flows in from every corner of the surrounding district. Christ, bearing his cross, climbs a hill, struggling, gasping, sweating, stumbling; he falls with such extraordinary conviction and art that the moment becomes an event that is really happening; there are men following him, staggering under the weight of the stones biting into their shoulders; the women look on, lost in ecstasy, weeping, ready to break out into lamentation; and with its beautiful, disciplined chants, the clergy provides an austere framework for this frenzy of masochism. Moving because of the question it asks, revolting because of the answer it gives, this film has not been publicly shown. In the towns, 6o percent are believers, one of our friends told us; others consider this figure to be completely false. Warsaw Cathedral was full on Sunday morning, but the population of the old neighborhoods

are of bourgeois origin; the workers don't go to church, at least not the men. What is still very much alive and kicking is Polish anti-Semitism: in one of the mouths of the admittedly hideous memorial erected to the memory of the ghetto Jews, someone had stuck the butt end of a cigarette.

Through the newspaper *Politica*, we met some journalists who had recently taken part in an inquiry into the workers' councils, and also the president of the councils himself. They are slowly dying; they take up a great deal of time, and the workers, feeling they don't know much about such things, generally leave all the decisions to the engineers and executives. So the councils will probably disappear altogether.

I was already quite familiar with postwar Polish culture; I had seen most of the Polish films shown in France, including *Ashes and Diamonds,* which has all the freshness and sincerity sought by the "New Wave" and also means something as well. Since 1956, we had read and published in *Les Temps Modernes* a great many pieces of Polish writing. The Poles had reciprocated by putting on most of Sartre's plays and by translating both his works and mine. Almost all their writers spoke French. We had met several in Paris; we always got on very well with them. But we'd never met Brandys before, though we'd published *The Defense of Granada, The Mother of the Kings,* and *The Letters of Mme Z.* Warm beneath his aloof exterior, as sensitive as he is intelligent, his conception of writing coincided exactly with ours. We spent a long time with the Polish translator of Sartre's plays, Jan Kott, whose remarkable book *Shakespeare, Our Contemporary* was about to be published in the *Temps Modernes* series. The intellectuals in Poland are spared the perpetual struggle that goes on in the U.S.S.R. between those who are for and those who are against cultural freedom. They know all that's going on in the West, they write and paint more or less as they choose. But they have their own troubles; they belong to a country less advanced than the U.S.S.R. on the path of socialism, a country in which many reactionary forces still subsist—religion, anti-Semitism, a peasantry clinging to the idea of private property; they are opposed to the idea of removing these concepts by main force, but suffer from the knowledge of their country's backwardness. Since they are relatively few in number and not very industrialized, the fate of the Polish people is bound up with that of Russia; but though they are ideologically and politically in agreement with her, they have many reasons, some old, some new, for not losing much love over their great neighbor. The

writers are very sensitive to this feeling of dissatisfaction, and it is admirably expressed in the works of some of them.

While in Moscow, we learned of the agreements reached between the G.P.R.A. and the O.A.S. Their safety once assured by the amnesty, the secret army had ceased its attacks; in fact, it was capitulating. A complete reversal of attitude had immediately appeared among the *pieds noirs;* all those who stayed in Algeria voted Yes on the day of self-determination.

On July 5th, the Algerians celebrated their independence; they invited their French friends and the officials of various countries to a reception at the Continental Hotel in the late afternoon. We asked the door-man where it was being held. "The Algerian meeting? It didn't come off," he replied in a triumphant tone. In an adjacent street, there were about a hundred or so people—the ones we always saw at the demonstrations—stamping their feet beneath an icy sky; some ambassadors had come and left again. There was talk of the hotel having been threatened by the O.A.S., or else the local authorities had refused to provide the protection the manager had deemed necessary. Whatever the pretext, we were completely sickened by this final piece of French boorishness. We stood there, bewildered, chatting to each other, while a group of helmeted cops stood at the end of the street muttering: "What's up? Why don't we clear them out?" Sartre and I joined up with a little group and went off to the North African students' headquarters on the Boulevard Saint-Michel. There was an enormous crowd of people there, and a lot of smoke; we almost suffocated in the little overcrowded room; up on a platform, some beautiful Algerian girls dressed in white and green were singing to the accompaniment of a small orchestra. This gaiety was not unclouded; serious differences of opinion had broken out among the Algerian leaders. Eventually they would be settled. But for us, the French, the situation in which we were leaving Algeria left no room for joy. For seven years we had desired this victory; it came too late to console us for the price it had cost.

I went off on vacation, I came back; I am settled once more in my own apartment, a cold, blue autumn streaming into my studio. For the first time in years, I have walked through the Paris streets and seen Algerian laborers who were smiling. The sky is not so heavy any more. A page has been turned and I can attempt to sum up.

# EPILOGUE

**T**HERE HAS BEEN ONE UNDOUBTED success in my life: my relationship with Sartre. In more than thirty years, we have only once gone to sleep at night disunited. These years spent side by side have not decreased the interest we find in each other's conversation: a woman friend[1] has observed that we always listen to each other with the closest attention. Yet so assiduously have we always criticized, corrected or ratified each other's thought that we might almost be said to think in common. We have a common store of memories, knowledge and images behind us; our attempts to grasp the world are undertaken with the same tools, set within the same framework, guided by the same touchstones. Very often one of us begins a sentence and the other finishes it; if someone asks us a question, we have been known to produce identical answers. The stimulus of a word, a sensation, a shadow, sends us both traveling along the same inner path, and we arrive simultaneously at a conclusion—a memory, an association—completely inexplicable to a third person. We are no longer astonished when we run into each other even in our work; I recently read some reflections noted down by Sartre in 1952 which I had not known about till now; there were passages in them which occur again, almost word for word, in my *Memoirs,* written ten years later. Our temperaments, our directions, our previous decisions, remain different, and our writings are on the whole almost totally dissimilar. But they have sprung from the same plot of ground.

This relationship has been stigmatized by some as a contradiction of the views on morality expressed in *The Second Sex:* I insist that

---

[1] María-Rosen Oliver in an interview she gave to an Argentine newspaper.

women be independent, yet I have never been alone. The two words are not synonymous; but before I explain myself further on that point, there are a few stupid misconceptions I should like to dispose of.

It has been said by some people that Sartre writes my books. The day after I was awarded the Goncourt, someone advised me with no malicious intention whatever: "If you give any interviews, make it quite clear that you did write *Les Mandarins*; you know what people are saying: that Sartre stands behind you . . ." It has also been said that he made me as a writer. The only thing he ever did in this line was to pass two of my manuscripts on to Brice Parrain, one of which was in any case rejected. Let it pass. Long before I came on the scene they were saying that Colette "slept her way" to fame; so anxious is our society to maintain the accepted status of members of my sex as secondary beings, reflections, toys or parasites of the all-important male.

Even more strongly held is the belief that all my convictions were put into my head by Sartre. "With someone else, she would have been a mystic," wrote Jean Guitton; and quite recently a critic, Belgian if I remember rightly, mused in print: "If it had been Brasillach she had met up with!" In a broadsheet called the *Tribune des Assurances*, I read: "If instead of being a pupil of Sartre, she had come under the influence of a theologian, she would have been a passionate theist." Fifty years have gone by, but this is still the same old idea my father held: "A woman is what her husband makes her." He was deceiving himself; he never altered by so much as a hairsbreadth the beliefs of the pious young lady formed by the Couvent des Oiseaux. Even the gigantic personality of Jaurès shattered against the stubborn piety of his wife. Youth has its own specific gravity, its own resilience; how could the girl I was at twenty possibly have succumbed to the influence of a believer or a Fascist? But people in our society really do believe that a woman thinks with her uterus—what low-mindedness, really! I did come across Brasillach and his clique; they filled me with horror. I could only have become attached to a man who was hostile to all that I loathed: the Right, conventional thinking, religion. It was no matter of chance that I chose Sartre; for after all I did choose him. I followed him joyfully because he led me along the paths I wanted to take; later, we always discussed our itinerary together. I remember that, in 1940, receiving his last letter from Brumath, written hurriedly, slightly obscure, there was one

sentence as I read it through for the first time that filled me with terror: was Sartre about to compromise? During the instant that the fear gripped me, I knew from the way I stiffened, from the pain I felt, that if I could not dissuade him we were doomed to spend the rest of our lives in opposite camps.

This does not alter the fact that philosophically and politically the initiative has always come from him. Apparently some young women have felt let down by this fact; they took it to mean that I was accepting the "relative" role I was advising them to escape from. No. Sartre is ideologically creative, I am not; this bent forced him into making political choices and going much more profoundly into the reasons for them than I was interested in doing. The real betrayal of my liberty would have been a refusal to recognize this particular superiority on his part; I would then have ended up a prisoner of the deliberately challenging attitude and the bad faith which are at once an inevitable result of the battle of the sexes and the complete opposite of intellectual honesty. My independence has never been in danger because I have never unloaded any of my own responsibilities onto Sartre. I have never given my support to any idea, any decision, without first having analyzed it and accepted it on my own account. My emotions have been the product of a direct contact with the world. My own work has demanded from me a great many decisions and struggles, a great deal of research, perseverance and hard work. He has helped me, as I have helped him. I have not lived through him.

As a matter of fact, this accusation is just one of the weapons in my adversaries' well-stocked arsenal. For the story of my public life is that of my books, my successes, my failures; and also of the attacks that have been launched against me.

In France, if you are a writer, to be a woman is simply to provide a stick to be beaten with. Especially at the age I was when my first books were published. If you are a very young woman they indulge you, with an amused wink. If you are old, they bow respectfully. But lose the first bloom of youth and dare to speak before acquiring the respectable patina of age: the whole pack is at your heels! If you are conservative, if you yield with grace before the accepted superiority of the male, if you seem insolent and in fact say nothing, then they'll leave you unscathed. I am of the Left, I had things I was trying to say; among others, that women are not just a tribe of moral cripples from birth.

"You've won. You've made all the right enemies," Nelson Algren said to me in the spring of 1960. Yes; the insults I received from *Rivarol,* from *Preuves,* from *Carrefour,* from Jacques Laurent, delighted me. The snag is that ill will spreads like oil in water. Slanders are quick to produce answering echoes, if not in people's hearts at least in their mouths! No doubt this is just one of the forms of the ·dissatisfaction we all feel to some extent at being no more than we are. We are capable of understanding, but we prefer to belittle. Writers are a favorite target of this sort of spite; the public treats them with reverence, knowing full well that they are people just like anybody else, and then feels resentful toward them because of this contradiction; all the outward signs of their common humanity are entered on the debit side of the ledger drawn up against them. An American critic, and one quite well disposed toward me, in his review of *The Prime of Life* said that despite all my efforts I had brought Sartre down off his pedestal: what pedestal? He ended by adding that even if Sartre had lost a bit of his prestige, at least he had been made more lovable. Generally speaking, if the public finds out that you are not superhuman then it classes you down among the lowest of the low—a monster. Between 1945 and 1952, we were particularly subject to such distortions because we were so difficult to classify. Left-wing but not Communists, in fact in very bad odor with the Communist Party, we were also not "bohemians"; I was criticized for living in a hotel, and Sartre for living with his mother; at the same time we rejected middle-class life, we were not part of "society," we had money but we didn't live in style; our lives were intimately linked without either of us being in any way subjected to the other. This complete bypassing of all their touchstones disconcerted and irritated people. I was struck for example by the fact that *Samedi-Soir* should have waxed so indignant over the price we had paid for a taxi from Bou Saâda to Djelfa: to hire a car for a thirty-mile journey is less of a luxury than to own an automobile of one's own. Yet no one criticized me later on when I bought my Aronde; the price of buying a car is a classic expense perfectly acceptable by bourgeois standards.

One of the factors that contributes most to distorting writers' public images is the number of people who include us in their fantasy lives. At one time my sister moved about a great deal in society, where she was always introduced by her husband's name. She used to be stunned by the things that were said when the conversation got

onto the subject of me and my work. "I know her very well . . . she's a great friend of mine . . . I happened to have dinner with her only last week"; this from people I had never even set eyes on. There was a wealth of comments too. With a smile, she stood and listened to a lady who assured her: "She's a fishwife! Swears like a trooper, you know." One year, in New York, Fernand and Stépha asked me reproachfully: "Why have you hidden your marriage to Sartre from us?" I denied that we were married; they laughed. "Oh come now! Our friend Sauvage was a witness at the ceremony; he told us all about it himself." I had to show them my passport to convince them. In about 1949, France Roche featured us in the *France-Dimanche* gossip column: Sartre and I had bought a country house called La Berle and carved two hearts on a tree there. Sartre sent a letter denying it, which was not published, and she told a friend: "But I know it's a fact because it was passed on to me by Z., who had tea with them in their garden." I also remember the young woman who came up to me timidly once in the Deux Magots. "Excuse me for disturbing you, but I'm a very good friend of Bertrand G." I looked at her questioningly and she seemed astonished. "Bertrand G., who has lunch with you every week." I felt awful for her and said hastily: "I expect you've got the names mixed up. My sister's a painter, she's called Hélène de Beauvoir, I expect he's one of her friends . . ."— "No," she said, "it wasn't your sister he meant. I understand now. Excuse me . . ." She left in complete confusion, and the suddenness with which her eyes had been opened was obviously so painful to her that I felt almost guilty. Obviously such people's fantasies are only interesting if they've got some pretty worthwhile facts—such as a secret marriage, or else a spicy detail or two—to divulge. It's not difficult for them to find an audience; the public likes gossip. There are some maniacs for whom no fact is really true unless it has been seen through a keyhole. I recognize that there is some excuse for this peculiarity; official accounts and portraits are always patently full of lies, so people imagine that truth must have its mysteries, its initiates, its hidden channels. Our enemies exploit this credulity.

Two images of me are current: I am a madwoman, an eccentric. (The newspapers in Rio reported in a tone of surprise: "We were expecting an eccentric; we were rather let down to be introduced to a woman dressed like anyone else.") My morals are extremely dissolute; in 1945, a Communist woman told the story that during my youth in Rouen I had been seen dancing naked on the tops of bar-

rels; I have assiduously practiced every vice, my life is a perpetual orgy, etc.

Or, flat heels, tight bun, I am a chieftainess, a lady manager, a schoolmistress (in the pejorative sense given to this word by the Right). I spend my existence with books and sitting at my work-table, pure intellect. "She doesn't live," I've heard a young woman journalist say. "If I were invited to Mme T.'s Mondays I'd be there like a shot." The magazine *Elle*, depicting various categories of women for the benefit of its readers, gave my photograph the caption: *Exclusively intellectual life.*

Apparently a combination of these two portraits involves no contradiction. I can also be an egg-headed whore or a lubricious manageress; the essential is that the figure I cut should be abnormal. If my censors are trying to say that I am different from them, then I take it as a compliment. The fact is that I am a writer—a woman writer, which doesn't mean a housewife who writes but someone whose whole existence is governed by her writing. It's as good a life as any other. It has its reasons, its order and its ends, which one must misunderstand completely in order to think of it as extravagant. Was mine really ascetic, purely cerebral? God knows I don't get the impression that my contemporaries are getting all that much more amusement out of this world of ours than I, or that their experience is any larger. In any case, looking back over my past, there is no one I envy.

I trained myself when young not to care for public opinion. Since then, I have had Sartre and solid friendships to protect me. All the same, there have been certain whispers, certain looks that I have found it hard to bear: the sneering laughter of Mauriac and the young people with him in the Deux Magots. For several years I loathed showing myself in public; I stopped going to cafés, I avoided theater openings and all "Parisian" entertainments. This reserve was in accordance with my distaste for publicity: I have never appeared on television, never talked about myself on the radio, almost never given an interview. I have already explained my reasons for accepting the Goncourt and nevertheless refused even then to exhibit myself in any way. I wished to owe any success I might have to my own efforts and not to outside influences. And I knew that the more the press talked about me, the more I should be misrepresented. It was my desire to establish the truth of these matters that was largely responsible for my writing these memoirs, and many readers have in

fact said that the ideas they entertained of me beforehand could scarcely have been more false. I still have my enemies; I should be very worried if I hadn't. But with time my books have lost their flavor of scandal; age, alas! has conferred on me a certain respectability; and above all I have won for myself a public that listens when I talk to them. At this stage, I am largely spared the unpleasant aspects of notoriety.

As a beginner, I experienced only the pleasures it brings, and even in the years since then they have always come in far fuller measure than the disadvantages. Fame gave me what I desired: that people should like my books, and through them me; that they should listen to me and let me serve them by showing them the world as I saw it. I have known these joys since the day *She Came to Stay* was published. I have not avoided being deceived by false illusions, I have experienced vanity: it flowers as soon as one smiles at one's own image, as soon as one shivers at the sound of one's name. At least I have never become self-important.

I have always taken my failures well; they were nothing but shots off target, never obstacles in my path. My successes, until recent years, have given me pleasures without reserve; for me, the approval of my readers always carried more weight than the praises of the professional critics: letters received, sentences overheard, the traces of an influence, in a book, in someone's life. Since the publication of the *Memoirs of a Dutiful Daughter,* and even more so since that of *The Prime of Life*, my relationship to the public has become ambiguous because the horror my class inspires in me has been brought to white heat by the Algerian war. There is no hope of reaching the wider reading public if one's books are not the sort they like; one is only printed in a cheap edition if the normal first-run edition has sold well. So, willy-nilly, it is the middle classes one is writing for. And among them there are some of course who have torn themselves away from their class, or are at least trying to—intellectuals, young people; with them I am on the same wavelength. But I feel ill at ease if the middle class as a whole gives me a good reception. There were too many women who read the *Memoirs of a Dutiful Daughter* because they enjoyed the accuracy with which I had depicted a milieu they recognized, but without being at all interested in the effort I had made to escape from it. As for *The Prime of Life*, many's the time I've stood gritting my teeth as people congratulated me: "It's

bracing, it's dynamic, it's optimistic," when I was so sickened by everything that I would rather have been dead than alive.

I am by no means insensitive to praise or blame. Yet, if I dig down into myself, it is not long before I reach a bedrock of almost total indifference to the extent of my success. There was a time, as I have said, when pride and caution prevented me from making an estimate of my powers; today, I no longer have any idea of what standard of measurement I should use. Should it be with reference to the public, to the critics, to a few selected judges, to my deep personal convictions, to my publicity, to the lack of it? And what would this estimate be *of?* Fame or quality, influence or talent? And then again: what do those words mean? Not only the possible answers to them, but these questions themselves now strike me as inane. My detachment goes deeper than that; it has its roots in a childhood devoted to the absolute: I have remained convinced of the vanity of earthly successes. My apprenticeship to the world strengthened this disdain; I discovered in the world an amount of misery too immense for me to disturb myself unduly over the place I hold in it or over the rights I may or may not have to occupy a place in it.

Despite this undertow of disenchantment, though all idea of duty, of mission, of salvation has collapsed, no longer sure for whom or for what I write, the activity itself is now more necessary to me than ever. I no longer believe it to be a "justification," but without it I should feel mortally unjustified. There are days so beautiful that you want to shine like the sun, I mean to splash bright words over all the world; there are hours so black that no other hope is left but the cry that you would like to vent. Whence does it come, no less urgent now at fifty-five than it was when I was twenty, this extraordinary power of the Word? I say: "Nothing takes place but the place," or "One and one make one: what a misunderstanding!" and in my throat rises a flame that as it burns exalts me. Words without doubt, universal, eternal, presence of all in each, are the only transcendent power I recognize and am affected by; they vibrate in my mouth, and with them I can communicate with humanity. They wrench tears, night, death itself from the moment, from contingency, and then transfigure them. Perhaps the most profound desire I entertain today is that people should repeat in silence certain words that I have been the first to link together.

There are obvious advantages in being a well-known writer; no more bread-and-butter jobs, but work you are doing because you

want to, meeting people, travel, a more direct grip on events than before. The support of the French intellectuals is sought by a great many foreigners at variance with their own governments; we are often asked as well to demonstrate our solidarity with friendly nations. We are all a bit crushed by the weight of the manifestoes, protests, resolutions, declarations, appeals and messages that we have to draw up or sign. It is impossible to take part in all the committees, conferences, discussions and meetings to which we are invited. But in exchange for the time we do give them, the people who ask for our support keep us informed in a much more detailed, more exact and above all more living way than any newspaper about what is happening in their country: in Cuba, in Guinea, in the Antilles, in Venezuela, in Peru, in the Cameroons, in Angola, in South Africa. However modest my contribution to their struggles is, it gives me the feeling that I do have some little effect on history. Instead of being "well-connected" in the usual sense, I have connections with the world as a whole. An old friend once said reproachfully: "You live in a convent." Perhaps I do; but I spend a great deal of time in the parlor talking to my visitors.

Yet it was with nostalgia and with anxiety that I discovered the full bloom of Sartre's celebrity and my own budding fame. The carefree days were over the moment we became public persons and were always forced to take this new objectivity into account; the adventurous side of our earlier trips was lost forever; we had to give up all sudden whims, all wandering where we chose. To protect our private lives we had to erect barriers—leave hotel and café life behind—and I found it weighed on me to be cut off like that, I had so loved living mixed up together with everyone else. I see a great many people; but most of them no longer talk to me as they would to just anyone, my relations with them have been falsified. "Sartre is never to be seen with anyone except the people who are to be seen with Sartre," Claude Roy wrote once. The same is true of me. I run the risk of understanding them less well simply because I no longer entirely share their lot with them. This difference between us is simply a product of celebrity and of the material ease that follows in its train.

Economically I belong to a privileged class. Since 1954, my books have earned me a great deal of money; in 1952 I bought myself an automobile, and in 1955 an apartment. I don't go out, I don't entertain; I still retain the repugnance to glamorous luxury places that I felt

when I was twenty; I dress without ostentation, I eat sometimes very well, usually very little; but all such things I leave to the caprice of the moment—I never deliberately deprive myself. There are censorious critics who reproach me for the comfort of my life: right-wingers, it goes without saying; on the Left, no one ever condemns another left-wing member on the score of wealth, even if he be a millionaire;[1] they are simply grateful to him for being on the Left. Marxist ideology has nothing to do with Evangelical morality, it demands neither asceticism nor poverty of any individual; to tell the truth, it is not concerned with your private life. The Right is so persuaded of the legitimacy of its claims that its adversaries can justify themselves in its eyes only by making martyrs of themselves; then too, its choices are all dictated by economic interests and it has difficulty in conceiving that the two could possibly be dissociated: a Communist with money, in their estimation, could not possibly be sincere. Finally, and most important, as far as the Right is concerned any stick will do to beat a dog, when it comes to attacking their Leftist enemies. One critic, who was doing his best to be impartial moreover, wrote after reading *The Prime of Life* that I had a taste for "low life" because at a time when I was very poor during the war I lived in several sordid hotels; what wouldn't they find to say now if I elected to move into some cheap tavern! A warm topcoat is a concession to the middle class; a neglected appearance would be construed as affectation or as unseemly behavior. You are accused either of throwing money down every drain or of being a miser. And don't think you can escape by trying to stick to some happy medium or other: they'd soon have a name for that too—petty-mindedness, for example. The only solution is to follow your own conscience and let them say what they will.

Which doesn't mean that I accept my situation with a light heart. The uneasiness it caused me around 1946 still persists. I know that I am a profiteer, and that I am one primarily because of the education I received and the possibilities it opened up for me. I exploit no one directly; but the people who buy my books are all beneficiaries of an economy founded upon exploitation. I am an accomplice of the privileged classes and compromised by this connection; that is the reason why living through the Algerian war was like experiencing a personal tragedy. When one lives in an unjust world there is no use hoping by some means to purify oneself of that injustice; the only

[1] There are left-wing millionaires in South America.

solution would be to change the whole world, and I don't have that power. To suffer from these contradictions serves no good purpose; to blind oneself to them is mere self-deception. On this point too, since I have no solution, I trust to my mood of the moment. But the consequence of my attitude is that I live in what approaches isolation; my objective condition cuts me off from the proletariat, and the way in which I experience it subjectively makes me an enemy of the middle classes. This relatively monastic life suits me quite well because I am always short of time; but it does deprive me of a certain warmth—which I was able to re-experience with such joy during the demonstrations of the past few years—and also, a more serious matter for me, it sets limits to my experience.

To these mutilations of my life, which are only the reverse aspect of my good fortune, must be added another for which I can discern no compensation. Since 1944, the most important, the most irreparable thing that has happened to me is that—like Zazie—I have grown old. That means a great many things. To begin with, that the world around me has changed: it has become smaller and narrower. I can no longer forget that the surface of the earth is finite, finite the number of its inhabitants, of its different plants and animal species, finite too the books, the pictures and the monuments set there. Each element of it can be explained with relation to that whole and refers back only to it; its richness too is limited. When young, Sartre and I often used to meet "personalities on a higher level than our own," which meant that they were impervious to our powers of analysis and so were still endowed in our eyes with some of the magical prestige of childhood. This core of mystery is now dissolved. There are no more oddities, madness is no longer holy, crowds have lost the power to intoxicate me; youth, which once fascinated me, seems now no more than a prelude to maturity. Reality still interests me, but it no longer reveals itself like an awful lightning flash. Beauty yes, beauty remains; even though it no longer stuns me with its revelations, even though most of its secrets have gone flat, there are still moments when it can make time stop. But often I loathe it too. The evening after a massacre, I was listening to a Beethoven andante and stopped the record halfway through in anger: all the pain of the world was there, but so magnificently sublimated and controlled that it seemed justified. Almost all beautiful works have been created for the privileged and by privileged people who, even if they have suffered, have always had the possibility of expressing their

sufferings; they are disguising the horror of misery in its nakedness.[1] Another evening, after another massacre—there have been so many— I longed for all such lying beauty to be utterly destroyed. Today, that feeling of horror has died down. I can listen to Beethoven. But neither he nor anyone else will ever again be able to give me that feeling I used to have of having reached some absolute.

For now I know the truth of the human condition: two-thirds of mankind are hungry. My species is two-thirds composed of worms, too weak ever to rebel, who drag their way from birth to death through a perpetual dusk of despair. In my dreams, ever since my youth, there are objects that have always recurred, in appearance inert, but receptacles of suffering: the hands of a watch that begin to race, no longer moved by a mechanism but by a secret and appalling organic disorder; a piece of wood bleeds beneath the blow of the ax, in a moment a disgustingly mutilated being will be discovered beneath the woody carapace. I feel the terror of these nightmares in my waking hours, if I call to mind the walking skeletons of Calcutta or those little gourds with human faces—children suffering from malnutrition. That is the only point at which I touch infinity: it is the absence of everything, with consciousness. They will die, and that is all that will have happened. The void frightens me less than misery made absolute.

I no longer have much desire to go traveling over this earth emptied of its marvels; there is nothing to expect if one does not expect everything. But I should very much like to know the sequel to our story. The young of today are simply future adults, but I am interested in them; the future is in their hands, and if in their schemes I recognize my own, then I feel that my life will be prolonged after I am in the grave. I enjoy being with them; and yet the comfort they bring me is equivocal: they perpetuate our world, and in doing so they steal it from me. Mycenae will be theirs, Provence and Rembrandt, and all the *piazze* of Rome. Oh, the superiority of being alive! All the eyes that rested before mine on the Acropolis seem to me already to have sunk into the abyss. In the eyes of those twenty-year-olds, I see myself already dead and mummified.

---

[1] Popular art and certain works that I should qualify as "untamed" constitute exceptions to this rule; for example, I have heard the chant of a rabbi for the dead at Auschwitz, and another sung by a Jewish child telling the story of a pogrom. And yet, even in these cases, the very fact that relief has been sought in communication already tends to place one at a remove from the horror, which is, by definition, evil's absolute irrecoverability.

But whom do I see thus? To grow old is to set limits on oneself, to shrink. I have fought always not to let them label me; but I have not been able to prevent the years from enmeshing me. I shall live for a long time in this little landscape where my life has come to rest. I shall remain faithful to the old friendships; my stock of memories, even if there are some additions still to come, will stay as it is now. I have written certain books, not others. And at this point, suddenly, I feel strangely disconcerted. I have lived stretched out toward the future, and now I am recapitulating, looking back over the past. It's as though the present somehow got left out. For years I thought my work still lay ahead, and now I find it is behind me: there was no moment when it took place. It's a bit like the number in mathematics which has no place in either of the two series it separates. I was learning all the time so that one day I could put my store of knowledge to good use. I have forgotten an enormous amount, and for all that still floats on the surface of my memory I can see no possible use. As I retrace the story of my past, it seems as though I was always just approaching or just beyond something that never actually was accomplished. Only my emotions seem to have given me the experience of fulfillment.

The writer nevertheless has the good fortune to be able to escape his own petrifaction at the moments when he is writing. Every time I start on a new book, I am a beginner again. I doubt myself, I grow discouraged, all the work accomplished in the past is as though it never was, my first drafts are so shapeless that it seems impossible to go on with the attempt at all, right up until the moment—always imperceptible, there, too, there is a break—when it has become impossible not to finish it. Each page, each sentence, makes a fresh demand on the powers of invention and requires an unprecedented choice. Creation is adventure, it is youth and liberty.

But then, once my worktable is left behind, time past closes its ranks behind me. I have other things that I must think; suddenly, I collide again with my age. That ultramature woman is my contemporary. I recognize that young girl's face belatedly lingering amid the withered features. That hoary-headed gentleman, who looks like one of my great-uncles, tells me with a smile that we used to play together in the gardens of the Luxembourg. "You remind me of my mother," I am told by a woman of about thirty or so. At every turn the truth jumps out at me, and I find it hard to understand by what

trick it manages to attack me thus from the outside when it lives inside me all the time.

Old age. From a distance you take it to be an institution; but they are all young, these people who suddenly find that they are old. One day I said to myself: "I'm forty!" By the time I recovered from the shock of that discovery I had reached fifty. The stupor that seized me then has not left me yet.

I can't get around to believing it. When I read in print Simone de Beauvoir, it is a young woman they are telling me about, and who happens to be me. Often in my sleep I dream that in a dream I'm fifty-four, I wake and find I'm only thirty. "What a terrible nightmare I had!" says the young woman who thinks she's awake. Sometimes, too, just before I come back to reality, a giant beast settles on my breast: "It's true! It's my nightmare of being more than fifty that's come true!" How is it that time, which has no form nor substance, can crush me with so huge a weight that I can no longer breathe? How can something that doesn't exist, the future, so implacably calculate its course? My seventy-second birthday is now as close as the Liberation Day that happened yesterday.

To convince myself of this, I have but to stand and face my mirror. I thought, one day when I was forty: "Deep in that looking glass, old age is watching and waiting for me; and it's inevitable, one day she'll get me." She's got me now. I often stop, flabbergasted, at the sight of this incredible thing that serves me as a face. I understand La Castiglione, who had every mirror smashed. I had the impression once of caring very little what sort of figure I cut. In much the same way, people who enjoy good health and always have enough to eat never give their stomachs a thought. While I was able to look at my face without displeasure I gave it no thought, it could look after itself. The wheel eventually stops. I loathe my appearance now: the eyebrows slipping down toward the eyes, the bags underneath, the excessive fullness of the cheeks, and that air of sadness around the mouth that wrinkles always bring. Perhaps the people I pass in the street see merely a woman in her fifties who simply looks her age, no more, no less. But when I look, I see my face as it was, attacked by the pox of time for which there is no cure.

My heart too has been infected by it. I have lost my old power to separate the shadows from the light, to pay the price of the tornadoes and still make sure I had the radiance of clear skies between. My powers of revolt are dimmed now by the imminence of my end and

the fatality of the deteriorations that troop before it; but my joys have paled as well. Death is no longer a brutal event in the far distance; it haunts my sleep. Awake, I sense its shadow between the world and me: it has already begun. That is what I had never foreseen: it begins early and it erodes. Perhaps it will finish its task without much pain, everything having been stripped from me so completely that this presence I have so longed to retain, my own, will one day not be present anywhere, not be, and allow itself to be swept away with indifference. One after the other, thread by thread, they have been worn through, the bonds that hold me to this earth, and they are giving way now, or soon will.

Yes, the moment has come to say: Never again! It is not I who am saying good-bye to all those things I once enjoyed, it is they who are leaving me; the mountain paths disdain my feet. Never again shall I collapse, drunk with fatigue, into the smell of hay. Never again shall I slide down through the solitary morning snows. Never again a man. Now, not my body alone but my imagination too has accepted that. In spite of everything, it's strange not to be a body any more. There are moments when the oddness of it, because it's so definitive, chills my blood. But what hurts more than all these deprivations is never feeling any new desires: they wither before they can be born in this rarefied climate I inhabit now. Once, the days slipped by with no sense of haste. I was going even faster than they, drawn into the future by all my plans. Now, the hours are all too short as they whirl me on in the last furious gallop to the tomb. I try not to think: In ten years, in a year. Memories grow thin, myths crack and peel, projects rot in the bud; I am here, and around me circumstances. If this silence is to last, how long it seems, my short future!

And what threats it includes! The only thing that can happen now at the same time new and important is misfortune. Either I shall see Sartre dead, or I shall die before him. It is appalling not to be there to console someone for the pain you cause by leaving him. It is appalling that he should abandon you and then not speak to you again. Unless I am blessed by a most improbable piece of good fortune, one of these fates is to be mine. Sometimes I want to finish it all quickly so as to shorten the dread of waiting.

Yet I loathe the thought of annihilating myself quite as much now as I ever did. I think with sadness of all the books I've read, all the places I've seen, all the knowledge I've amassed and that will be no more. All the music, all the paintings, all the culture, so many

places: and suddenly nothing. They made no honey, those things, they can provide no one with any nourishment. At the most, if my books are still read, the reader will think: There wasn't much she didn't see! But that unique sum of things, the experience that I lived, with all its order and its randomness—the Opera of Peking, the arena of Huelva, the *candomblé* in Bahía, the dunes of El-Oued, Wabansia Avenue, the dawns in Provence, Tiryns, Castro talking to five hundred thousand Cubans, a sulphur sky over a sea of clouds, the purple holly, the white nights of Leningrad, the bells of the Liberation, an orange moon over the Piraeus, a red sun rising over the desert, Torcello, Rome, all the things I've talked about, others I have left unspoken—there is no place where it will all live again. If it had at least enriched the earth; if it had given birth to . . . what? A hill? A rocket? But no. Nothing will have taken place, I can still see the hedge of hazel trees flurried by the wind and the promises with which I fed my beating heart while I stood gazing at the gold mine at my feet: a whole life to live. The promises have all been kept. And yet, turning an incredulous gaze toward that young and credulous girl, I realize with stupor how much I was gypped.

June 1960–March 1963